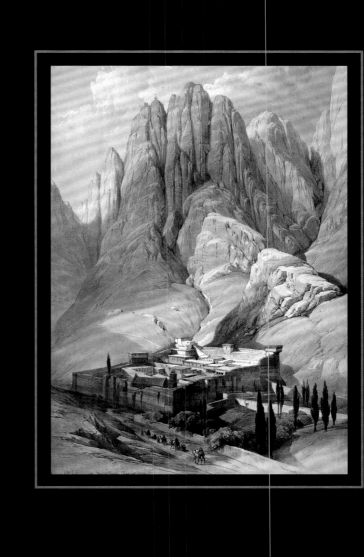

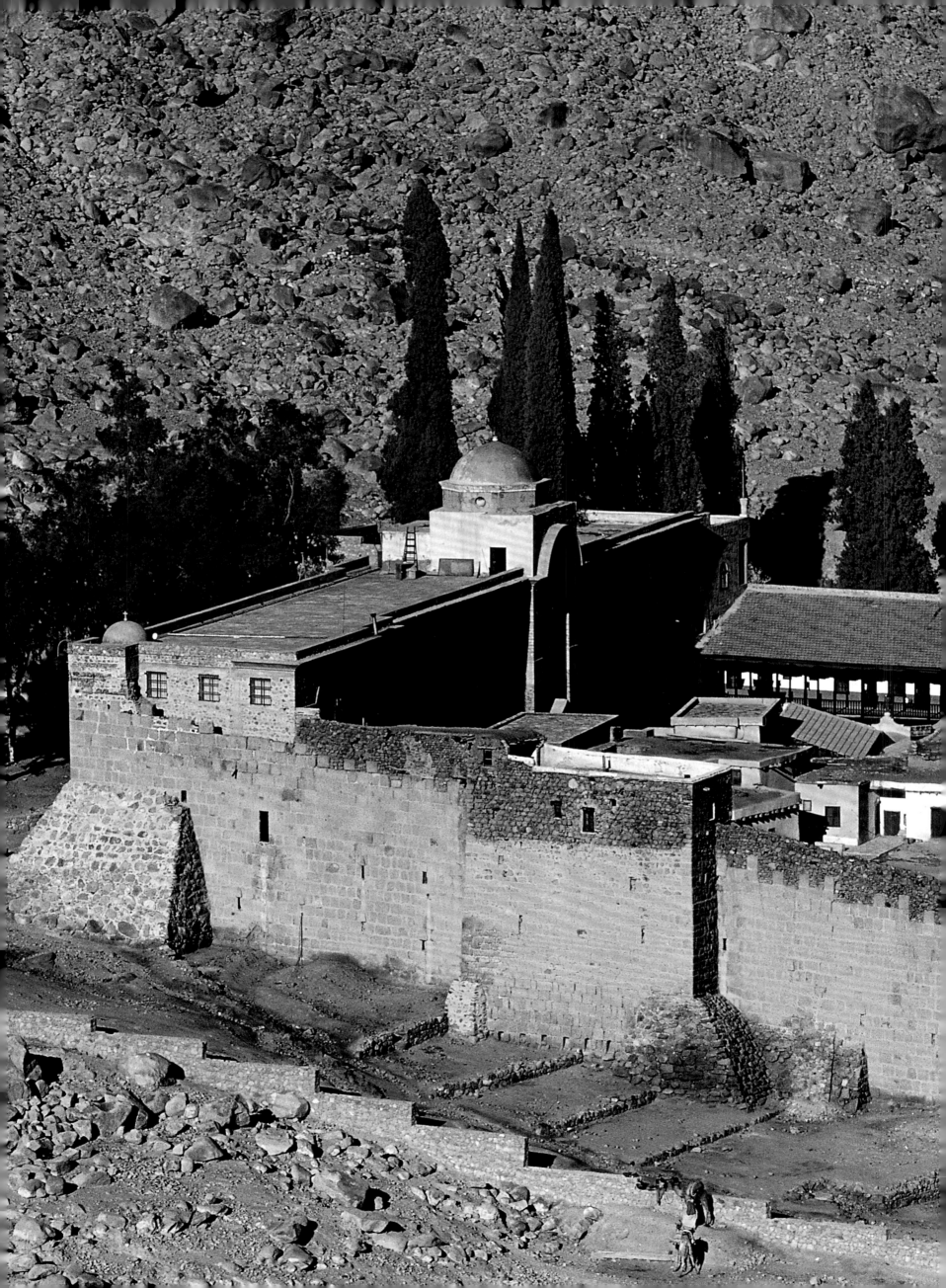

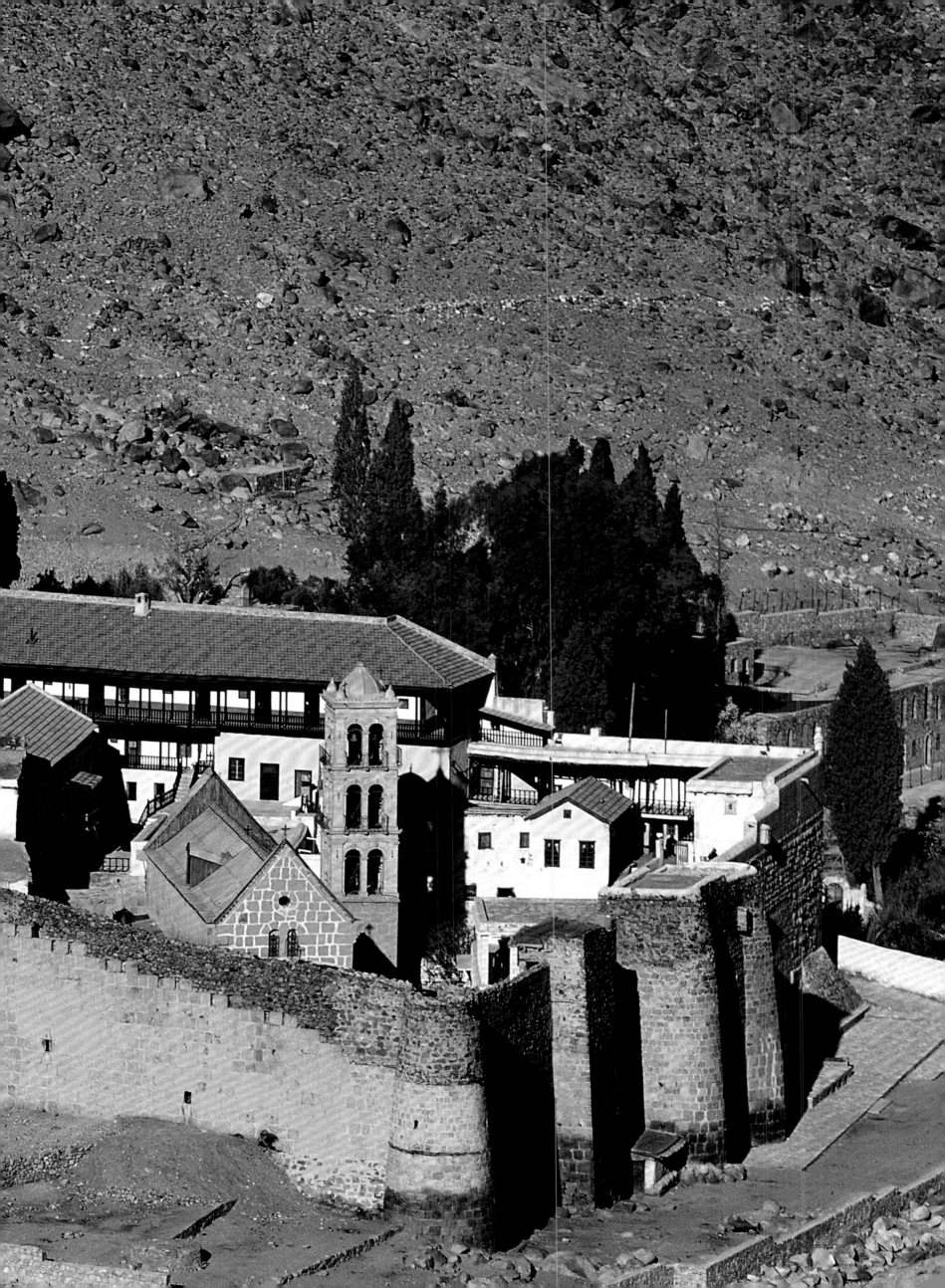

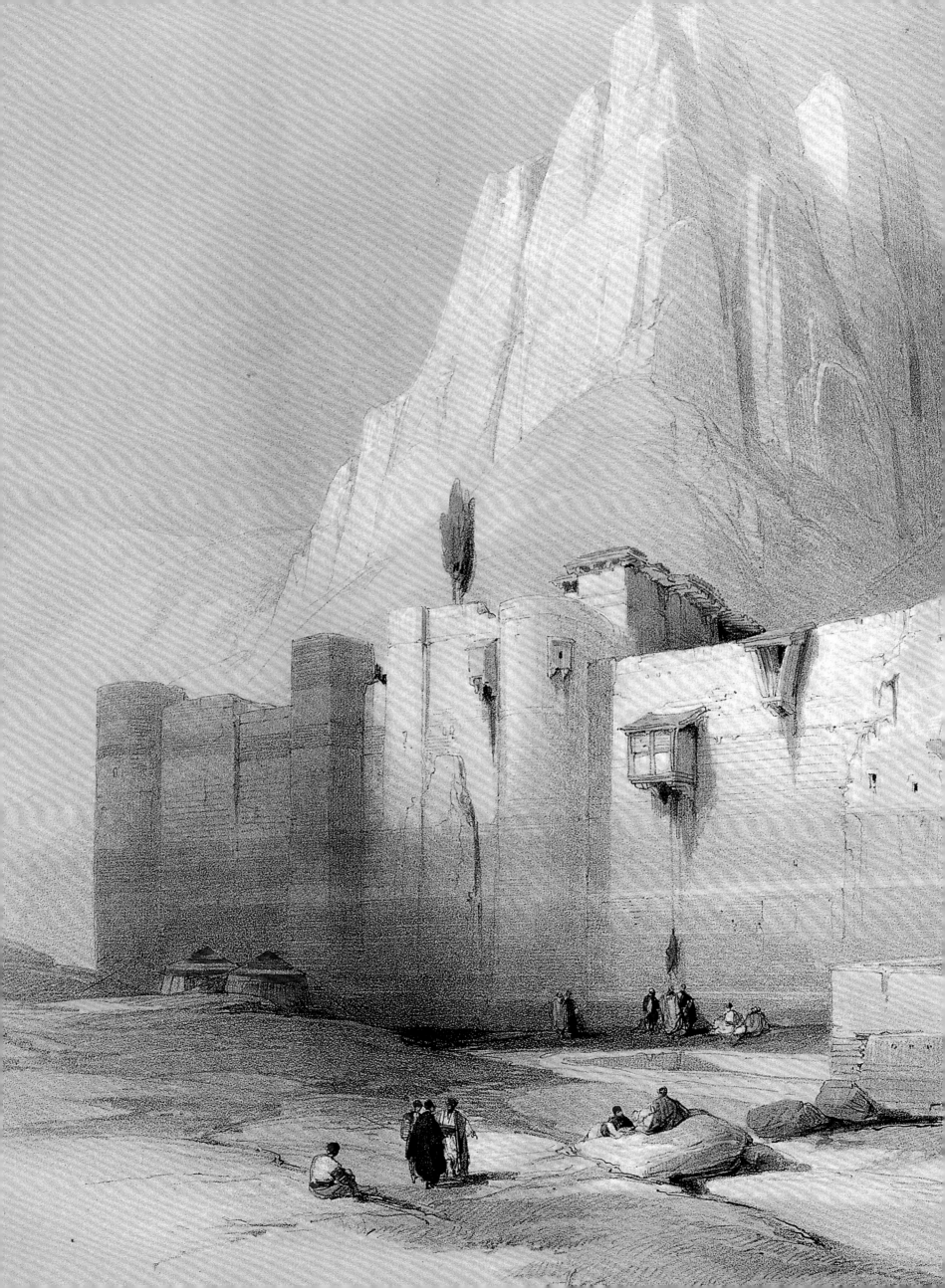

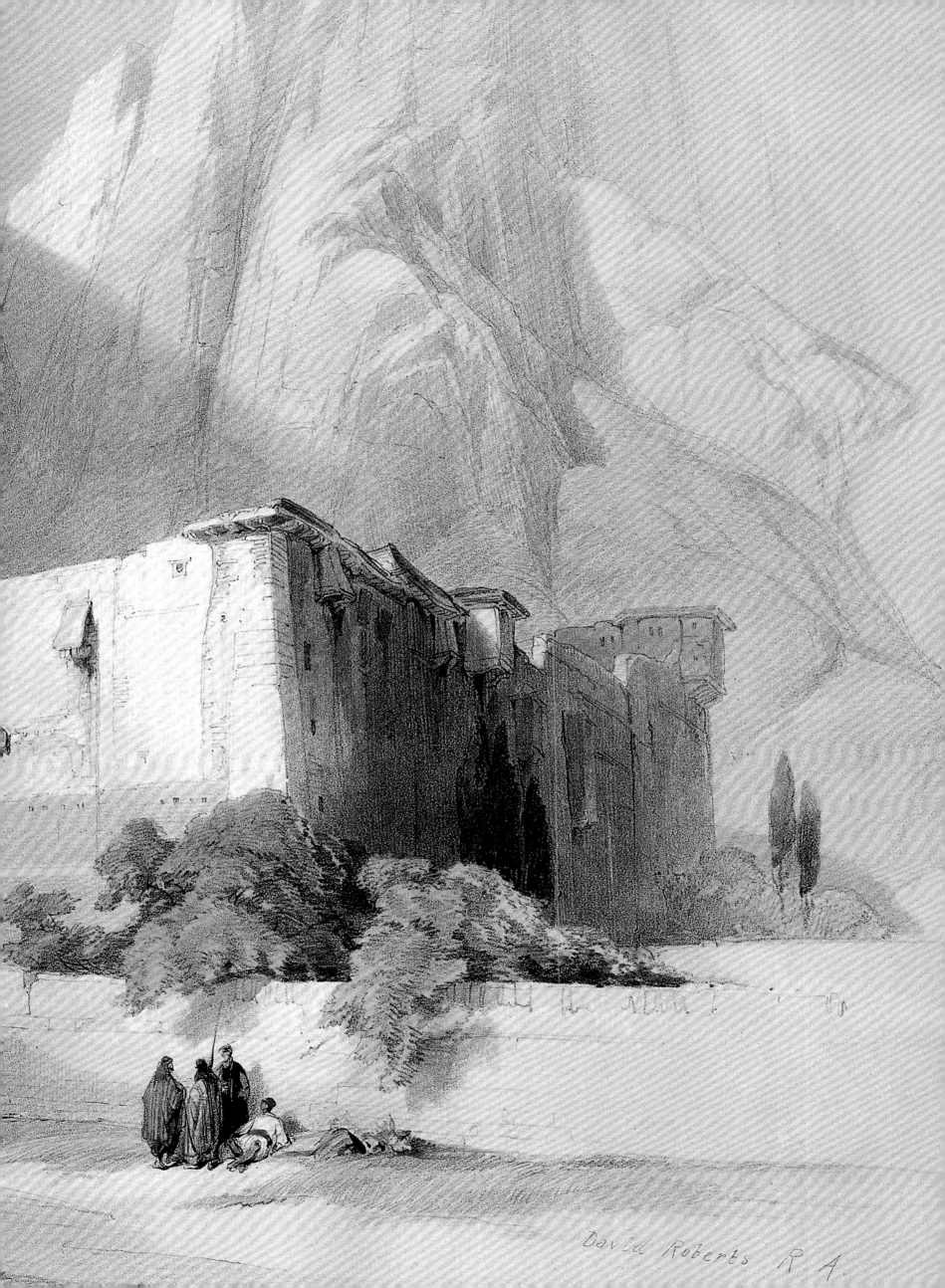

David Roberts R A

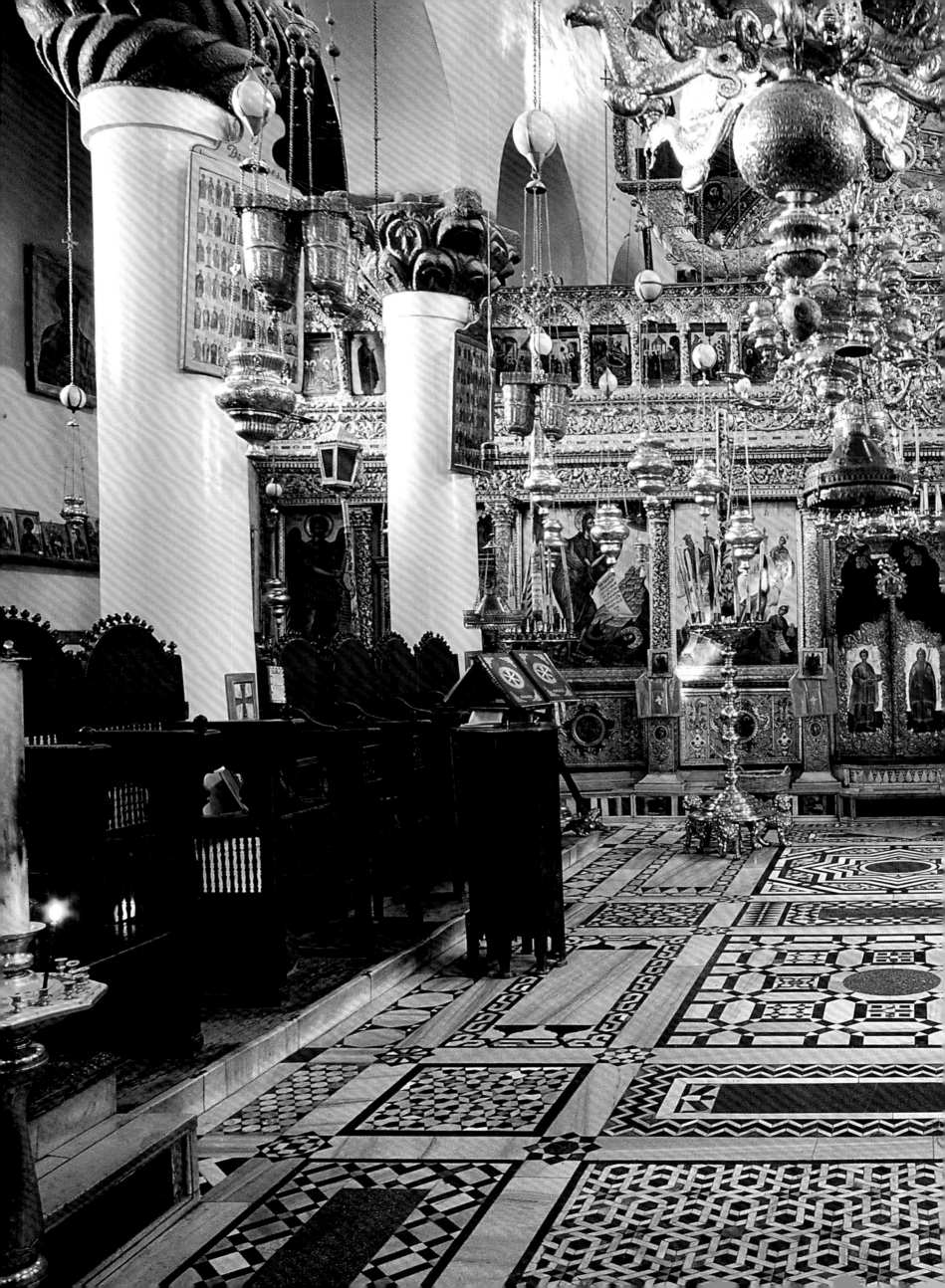

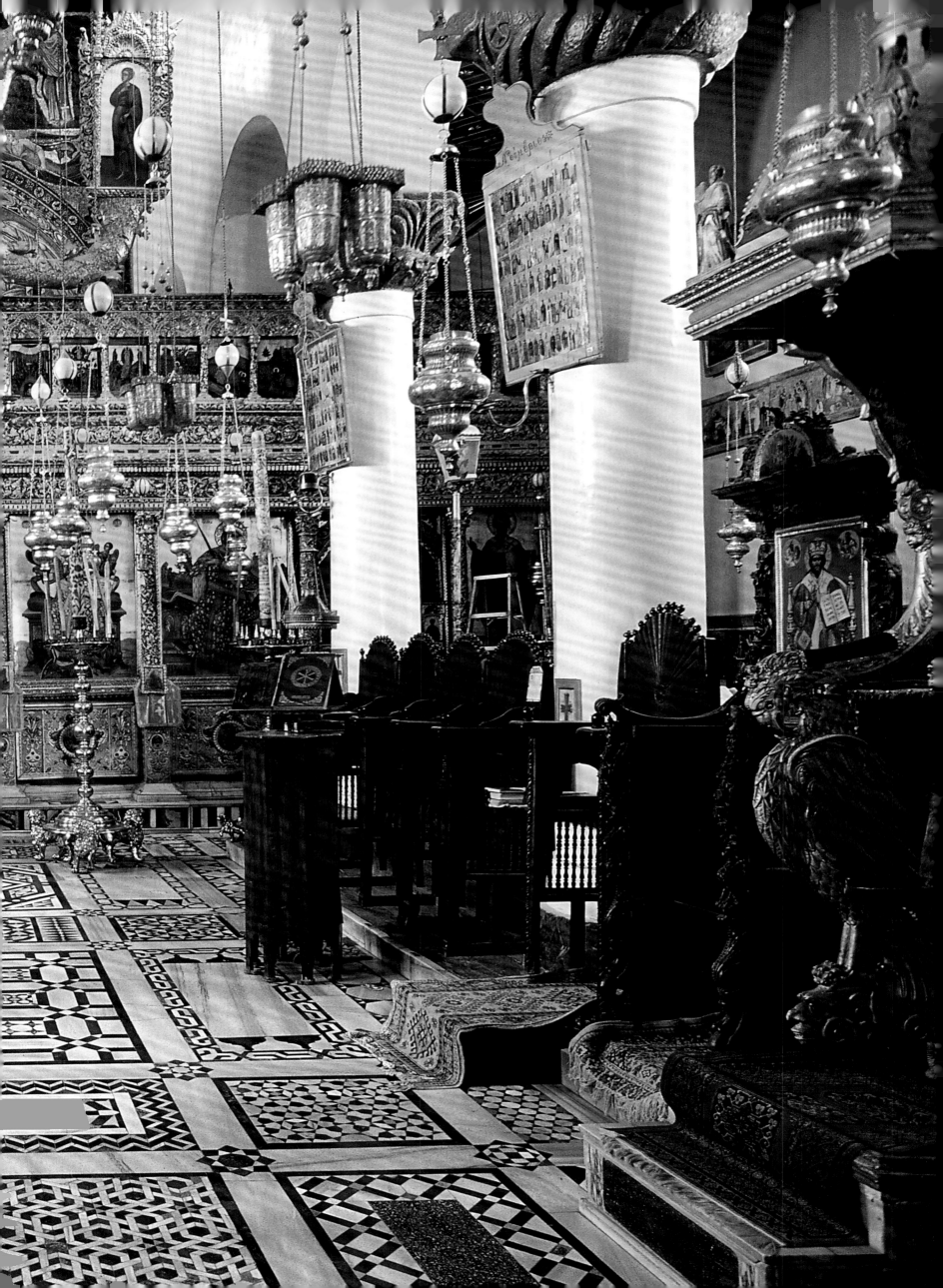

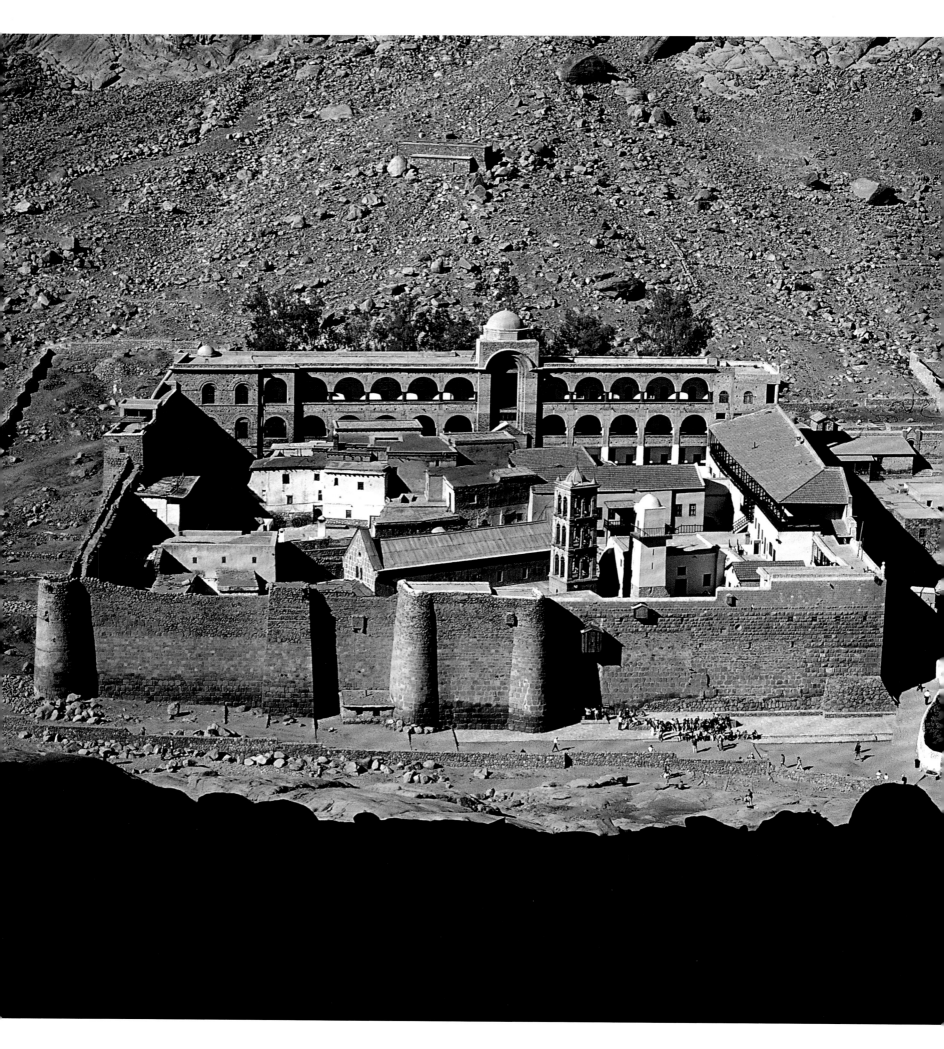

1 AND 4-5 SCOTTISH ARTIST DAVID ROBERTS VISITED THE MONASTERY OF ST. CATHERINE IN 1839 AND MADE A SERIES OF VIEWS OF THE COMPLEX.

2-3 THE MONASTERY OF ST. CATHERINE IS COMPOSED OF A SERIES OF BUILDINGS THAT WERE CONSTRUCTED IN DIFFERENT EPOCHS.

6-7 THE INTERIOR OF THE BASILICA OF ST. CATHERINE IS DECORATED WITH MOSAICS AND PAINTINGS AND IS ENRICHED BY VARIOUS SACRED ORNAMENTS.

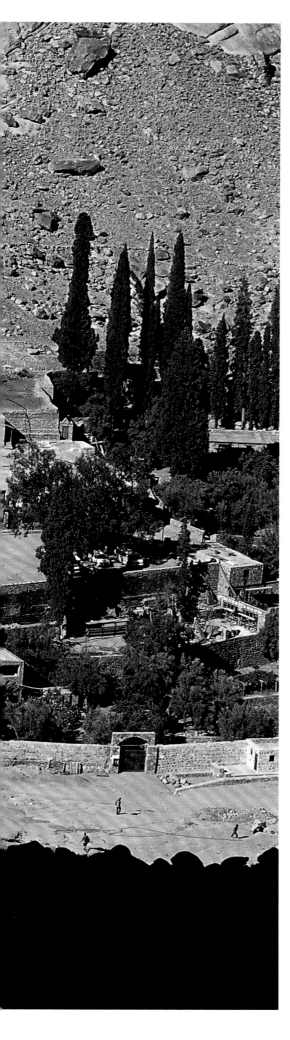

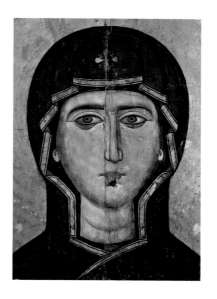

THE TREASURES
OF THE MONASTERY OF
Saint Catherine

text by CORINNA ROSSI

photographs by ARALDO DE LUCA

Project and editorial director
VALERIA MANFERTO DE FABIANIS

Design and graphic layout
CLARA ZANOTTI

CONTENTS

8-9 THE MONASTERY WAS BUILT BY
THE BYZANTINE EMPEROR JUSTINIAN.

9 THIS THIRTEENTH-CENTURY ICON
DEPICTS THE VIRGIN.

WHITE STAR

FOREWORD

IN RECENT YEARS, MANY BOOKS HAVE BEEN WRITTEN ABOUT THE MONASTERY, SOME OF THEM MORE HISTORICAL AND SCHOLARLY, OTHERS FEATURING THE MONASTERY'S TREASURES, COMBINED AT TIMES WITH THE NATURAL BEAUTY OF THE AREA.

The Monastery has itself published such editions, touching on all aspects of the Monastery and various scholarly topics, but trying to concentrate on the early history of the life of the hermits in the mountainous Sinai desert, as well as the very important Bedouin life of all the South Sinai. We are informed by archaeologists that there are remains of some 550 monastic settlements from the fourth century and thereafter in the high granite mountains of the South Sinai, an area comprising some 22,000 square kilometers, and including eleven mountain peaks above 2000 meters in altitude.

The sacred history of the pre-Christian epoch, which is written in the Old Testament (especially in the Book of Exodus), as well as the example of the spiritual life provided by the faithful hermits of Christian times (in particular, by such luminous examples as John Climacus, Philotheus, Gregory of Sinai)—all of this attracted hermits and ascetics to the area, as well as many pilgrims, visitors, and scholars, who came to the area in increasing numbers.

When I became a novice at Sinai in 1961, there seemed only a limited interest in the area. In the intervening forty-five years, I have observed that the fame of the Monastery of Mount Sinai— which is better known in the West as Saint Catherine's Monastery—and its scholarly importance have grown more and more. Visitors have come here in increasing numbers in the past thirty-five years. They now number some 700 per day, and on some days, maybe double that number.

11 ST. JAMES HOLDING THE GOSPEL IN THE APSE OF THE ST. JAMES CHAPEL.

12-13 DEPICTION OF THE MONASTERY OF ST. CATHERINE, THE MOUTH OF THE NILE, AND THE CITY OF ALEXANDRIA.

14-15 THE WALL AROUND THE MONASTERY COMPLEX VARIES IN HEIGHT FROM 9 TO 15 METERS.

16-17 WIND, SAND, SUN, AND WATER HAVE ACTED UPON THE SURFACES OF THESE ROCKS.

18-19 GEBEL MUSA, ARABIC FOR "MOUNT OF MOSES," RISES TO A HEIGHT OF 2,285 METERS.

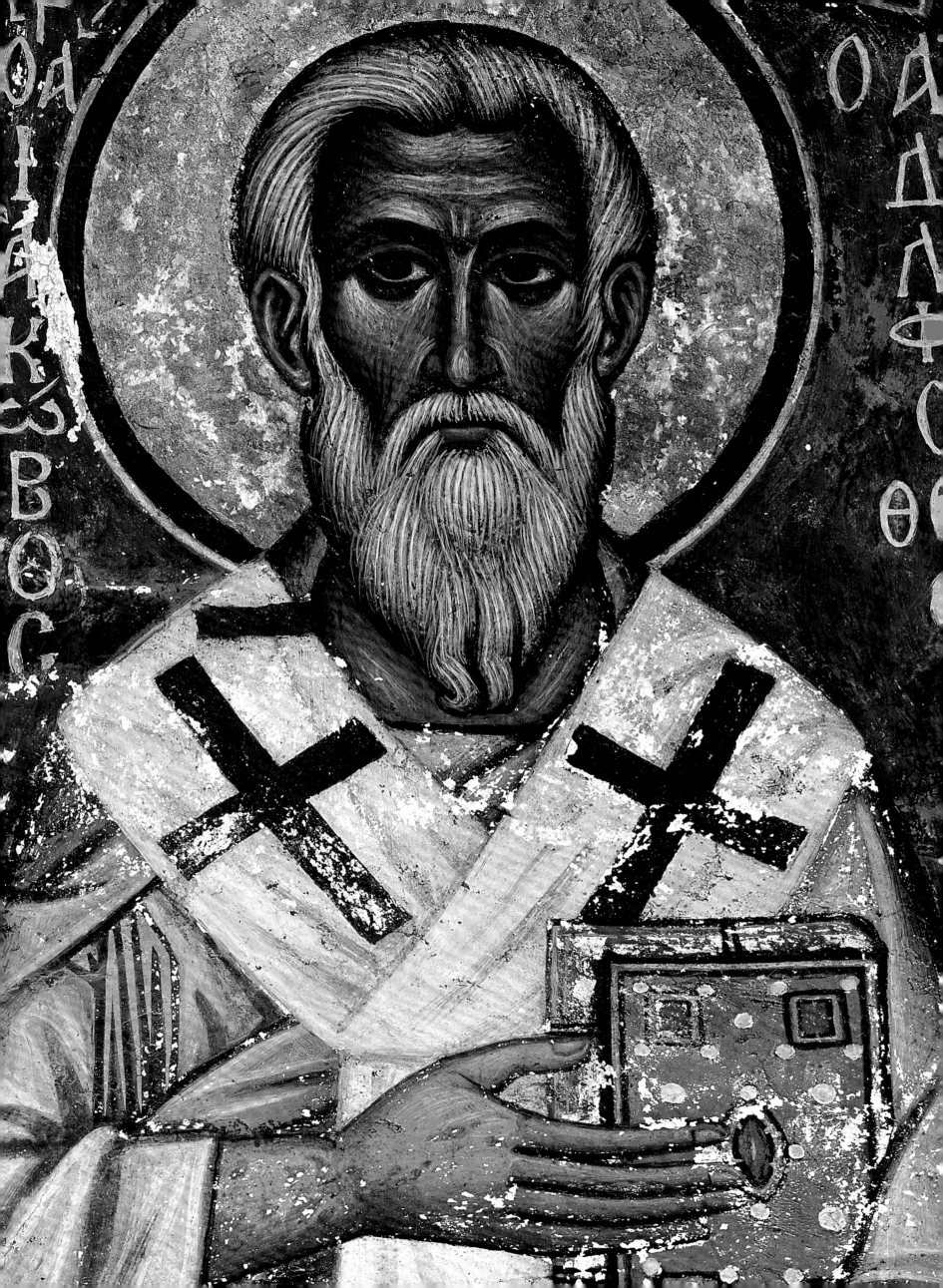

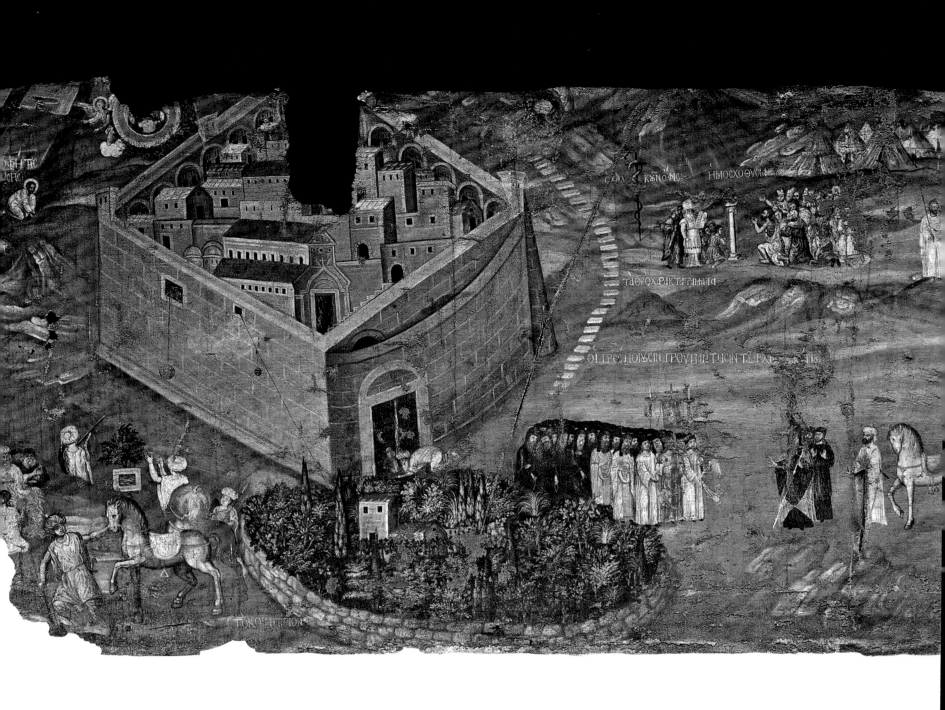

This is due, of course, to the better conditions of the roads and communications, and of course to the care and help which is provided by the Egyptian government.

Visitors are also attracted to the area by Sharm al-Sheikh, on the southern tip of the Sinai peninsula, with its warm climate and the spectacular beauty of the Red Sea. It is a 250 kilometer drive from the sea into the highest mountains of the Sinai, and most visitors to Sharm al-Sheikh also take the occasion to visit the Monastery during the morning hours when it is open to visitors.

The book you have in your hand is one of the best concerning the history of the Monastery. Combined with special quality photographs, it promises to be an excellent guide for everyone who wants to have the best scholarly and aesthetic presentation of the Monastery and its environs. Those who do not have the possibility of visiting the Monastery will be able to study the vivid and joyful presentation of this holy place and its very rich spiritual history, dating back to

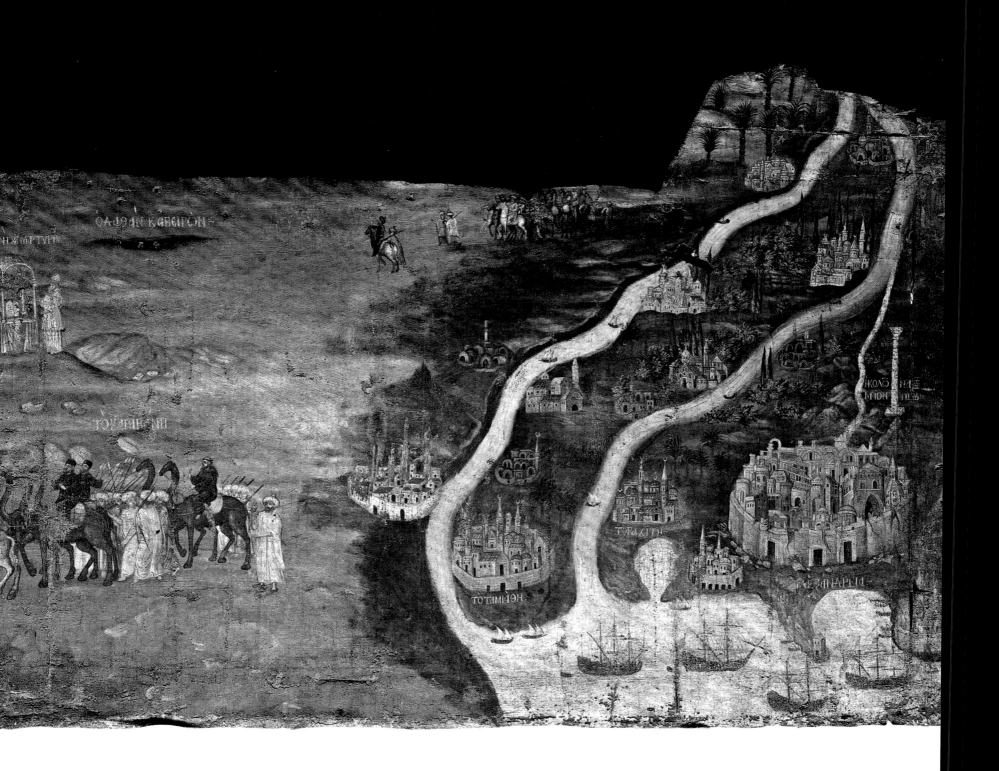

the time of the Holy Prophet Moses some 1,400 years before Christ, to the Holy Prophet Elias some 800 years before Christ, and the continuation of that history with the Christian monastic and heremitic life, dating from the end of the third and beginning of the fourth century. By means of this volume, the reader can absorb the beauty and holiness of Mount Sinai, and can feel transported and purified in mind, soul, and body by the evident grace of God that exists in this area. From the colors and wonders of this natural world, we can ascend to the divine comeliness and beauty, illuminated by the Uncreated Light of the radiance of God.

On behalf of Saint Catherine's Monastery at Sinai,
ARCHBISHOP DAMIANOS OF SINAI

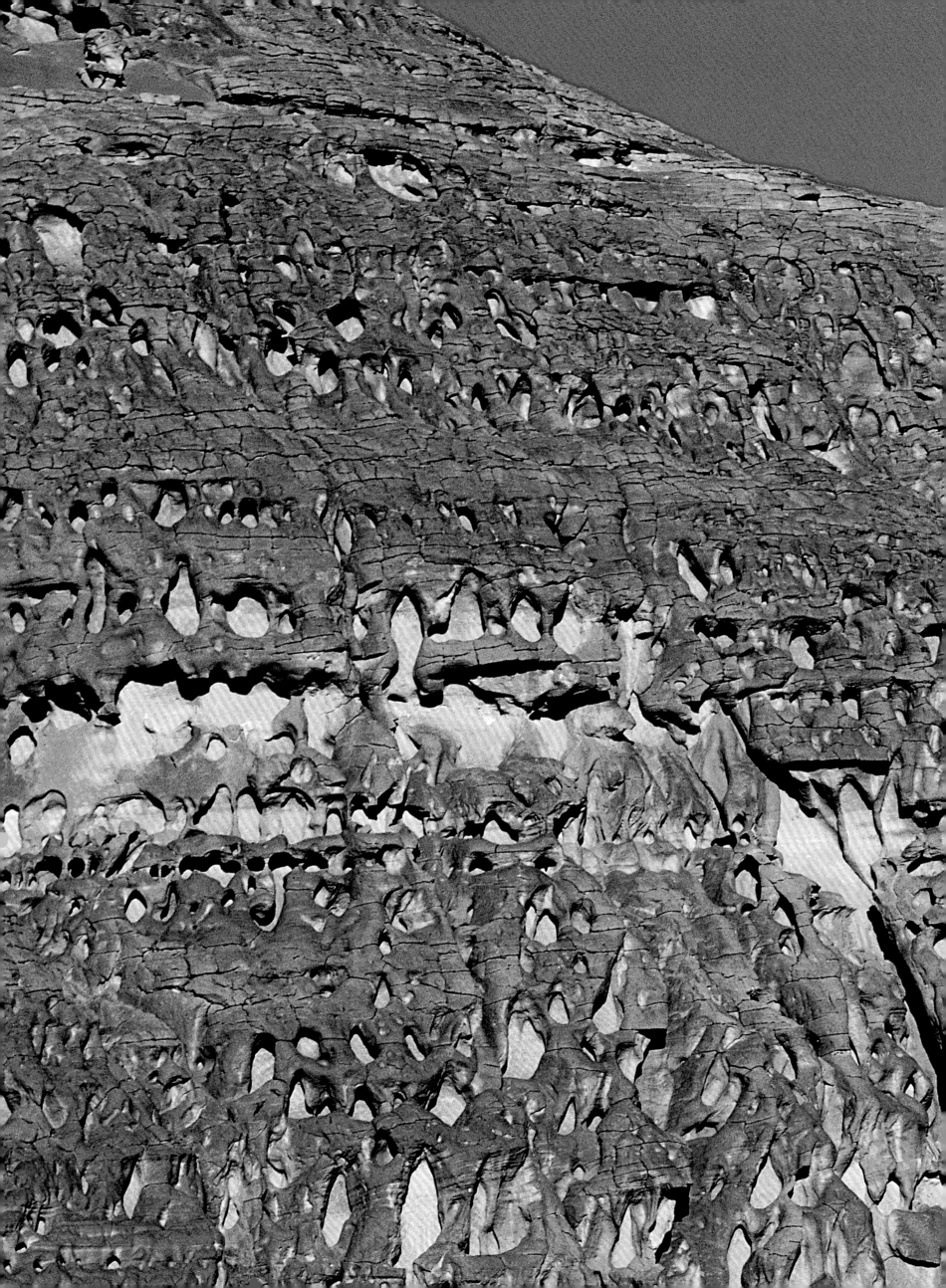

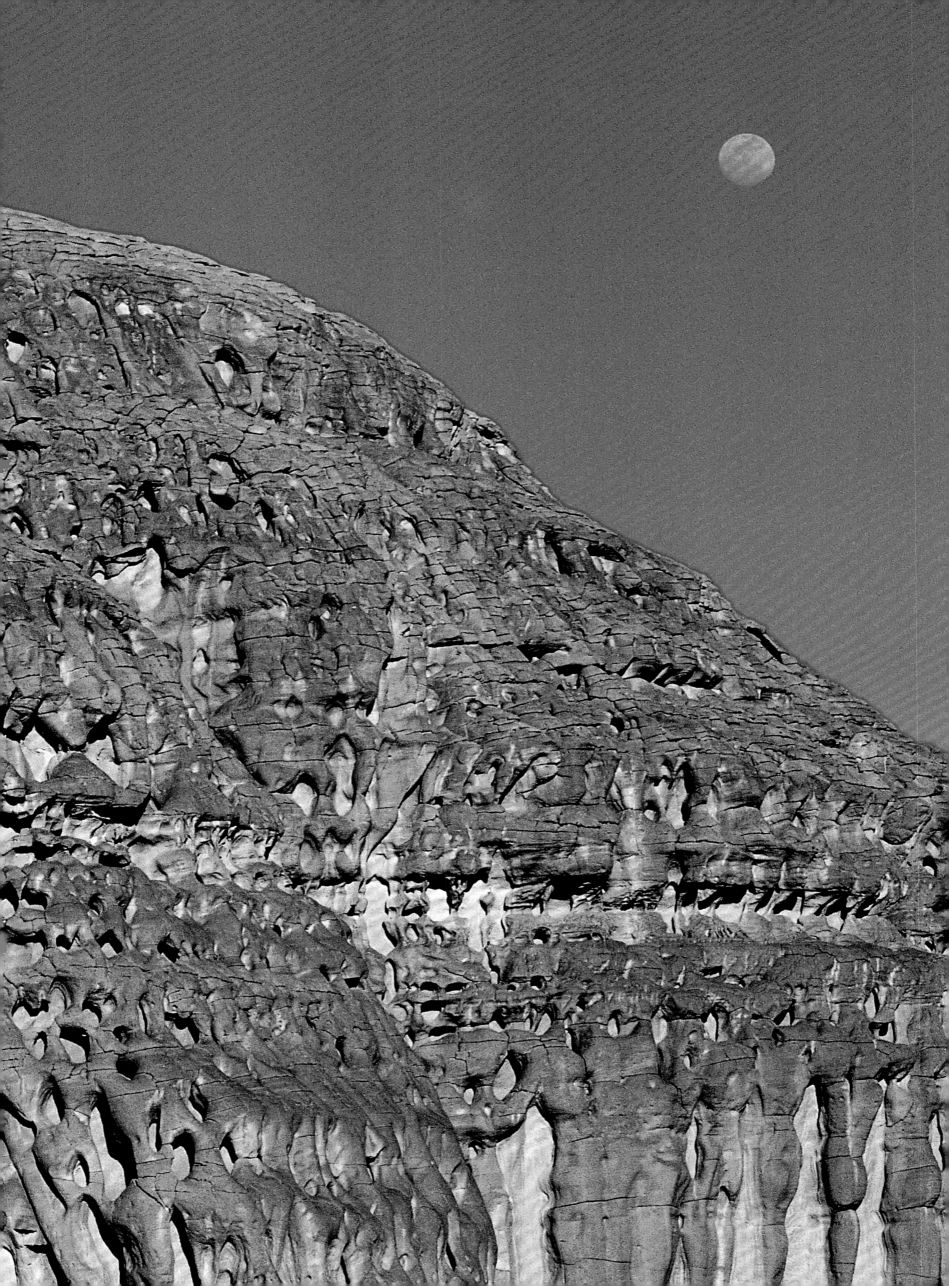

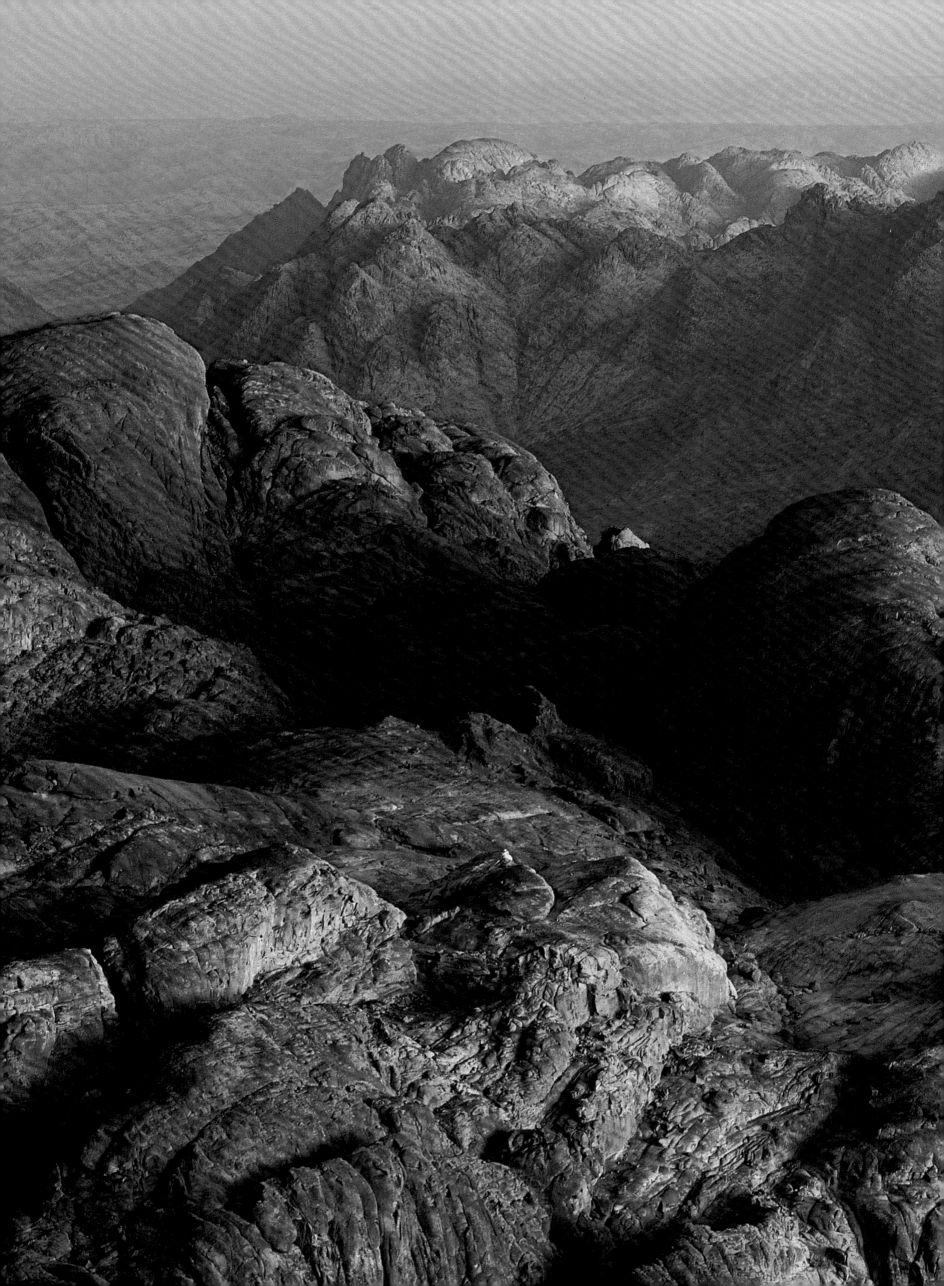

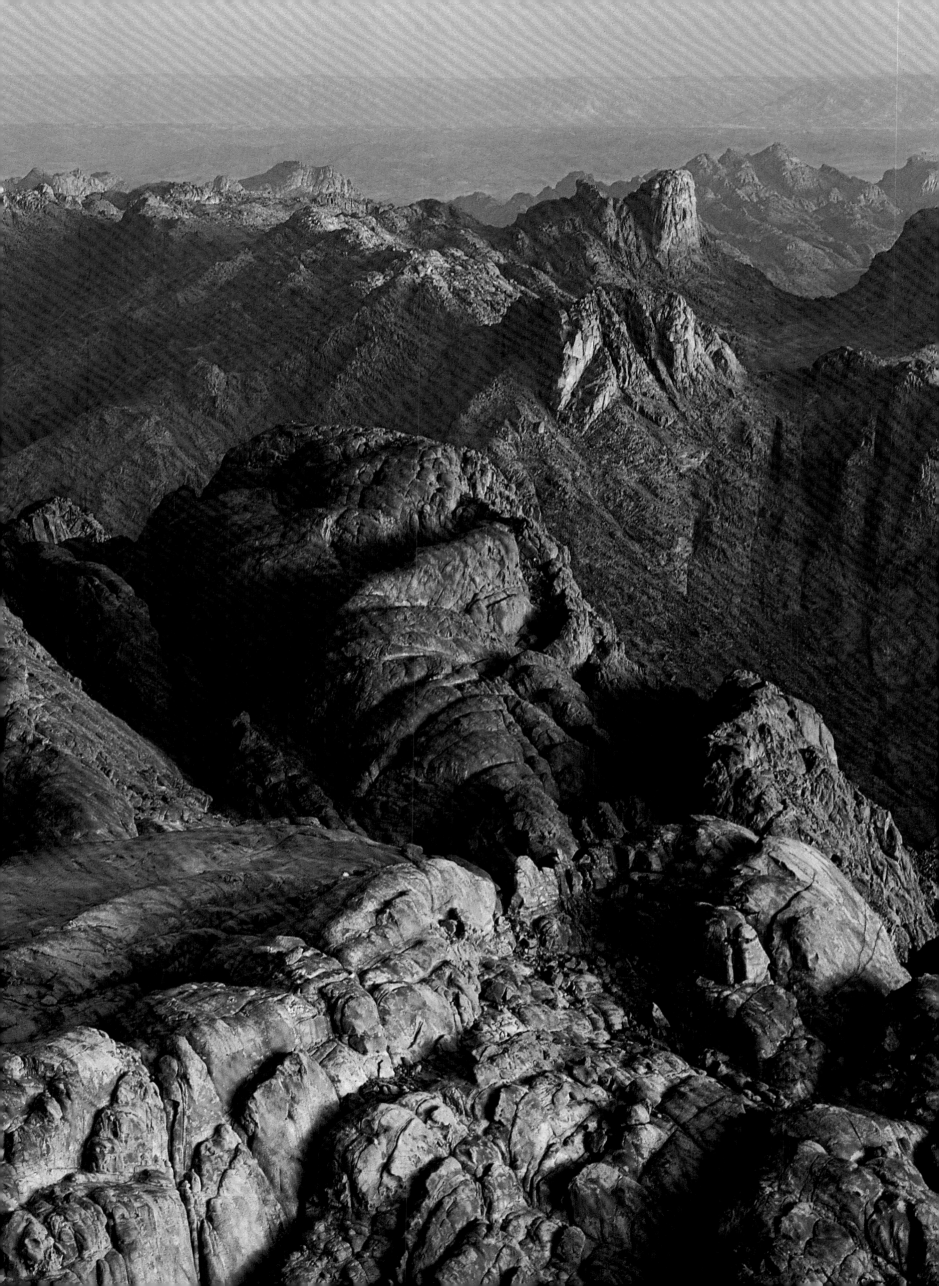

20 The so-called "Stairway of Moses" is presented in this panel by the Scottish artist David Roberts.

20-21 Lithograph by David Roberts presenting a caravan making its approach to the monastery of St. Catherine.

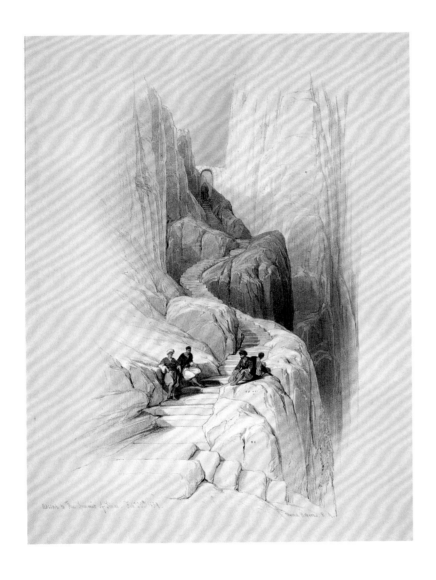

THE GREAT
SINAI
PENINSULA

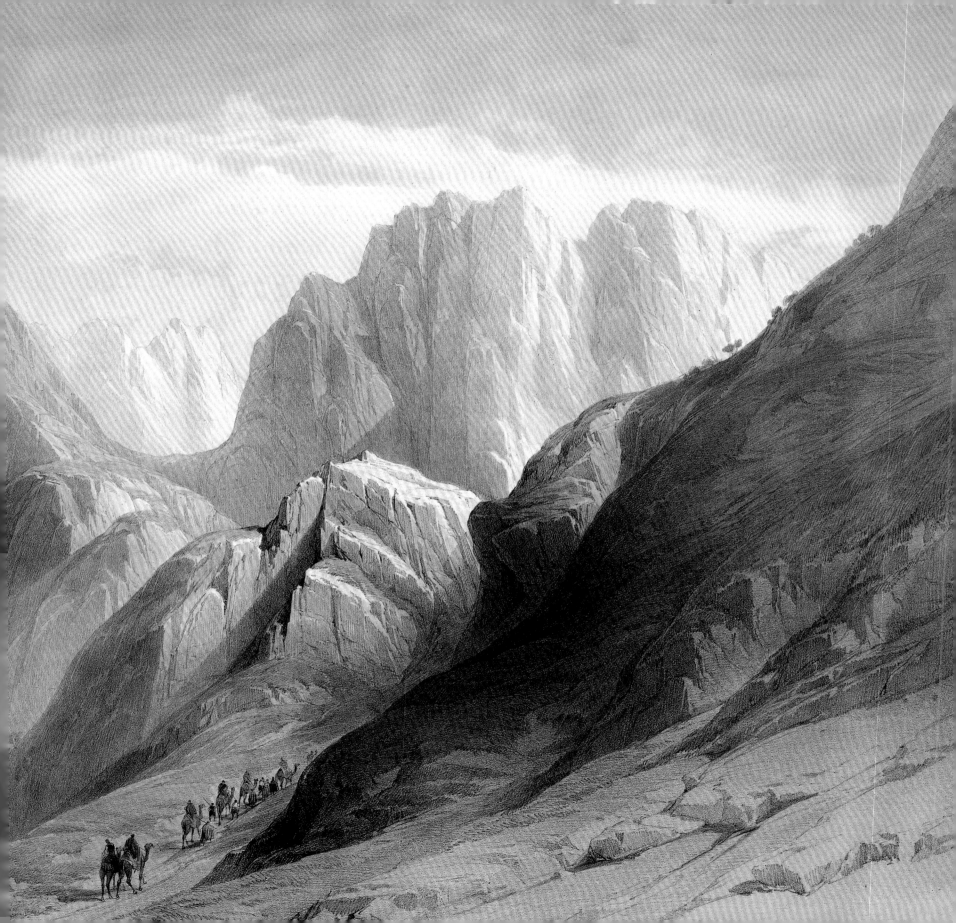

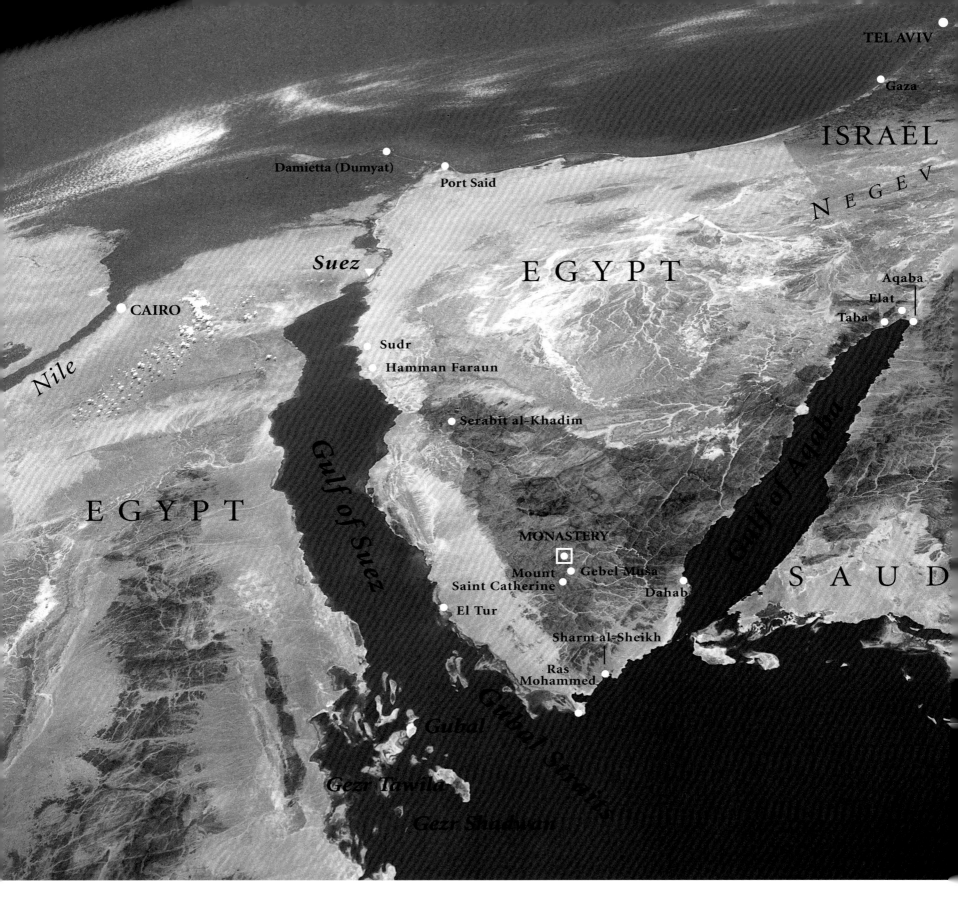

TEL AVIV

Gaza

ISRAEL

N E G E V

Damietta (Dumyat)

Port Said

EGYPT

Suez

Aqaba

Elat

Taba

CAIRO

Sudr

Hamman Faraun

Nile

Serabit al-Khadim

EGYPT

Gulf of Suez

Gulf of Aqaba

MONASTERY

Mount Gebel Musa

Saint Catherine

Dahab

SAUD

El Tur

Sharm al-Sheikh

Ras
Mohammed

Gubal

Gubal Strait

Gezr Tawila

Gezr Shushan

22-23 THE SINAI PENINSULA, SHOWN HERE
IN A SATELLITE PHOTOGRAPH, DIVIDES THE
RED SEA INTO TWO NARROW BRANCHES. THE
STRIP OF FERTILE LAND ALONG THE NILE
RIVER, THE OASIS OF FAYYUM, AND THE NILE
DELTA STAND OUT AGAINST THE YELLOW OF
THE EASTERN DESERT AND THE SINAI. THE
MONASTERY OF ST. CATHERINE LIES IN THE
MOUNTAINOUS HEART OF THE SINAI.

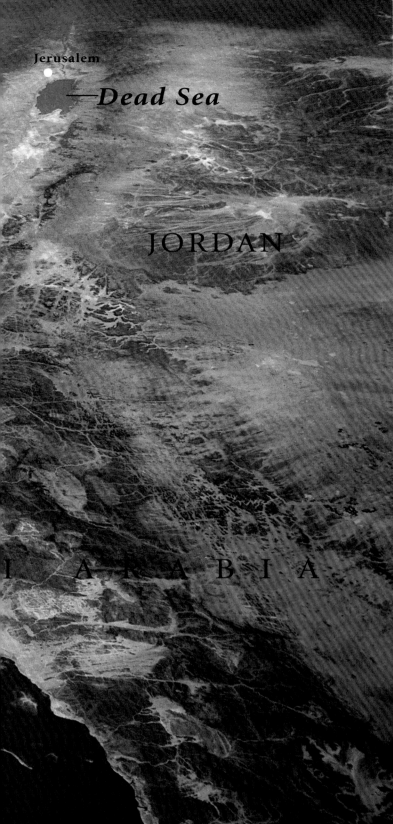

Jerusalem

—*Dead Sea*

JORDAN

I A R A B I A

23 THE SOUTHERN REGION OF THE SINAI
PENINSULA IS OCCUPIED BY LARGE ROCKY
MOUNTAINS CUT BY A NETWORK OF DEEP VALLEYS
SURROUNDED BY VERTICAL WALLS AND PEAKS
THAT STAND OUT AGAINST THE BLUE SKY.

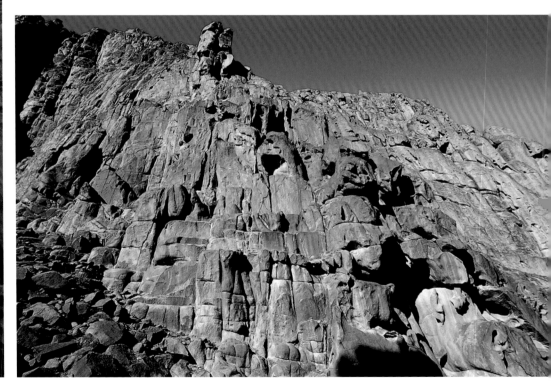

THE GREAT SINAI PENINSULA
DIVIDES THE RED SEA INTO
TWO NARROW ARMS, TO THE
west the Gulf of Suez, named for the city that stands at the opening to the famous canal, and to the east the Gulf of Aqaba, named for the settlement that faces the sea from the Jordanian coast. The southern area of the Sinai is a mountainous region of high peaks, barren and jagged, separated one from the next by a network of twisting sandy wadis (generally dry river beds). Along the coast, between the blue sea and the brown mountains, winds a long road that touches a series of natural parks and passes through such locales as Sharm al-Sheikh and Dahab, which in recent years have become famous for the beauty of their underwater landscapes.

24 IN ANTIQUITY THE SINAI WAS ALREADY KNOWN FOR ITS MINERAL RESOURCES, MOST ESPECIALLY ITS DEPOSITS OF TURQUOISE. ON A ROCKY PLATEAU IN THE HEART OF THE MOUNTAINS STANDS THE TEMPLE OF SERABIT AL-KHADIM, DECORATED BY DOZENS OF STELAE THAT COMMEMORATE ANCIENT EXPEDITIONS IN SEARCH OF THE PRECIOUS MATERIAL.

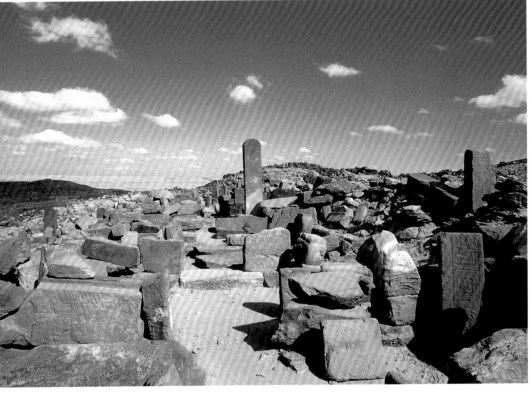

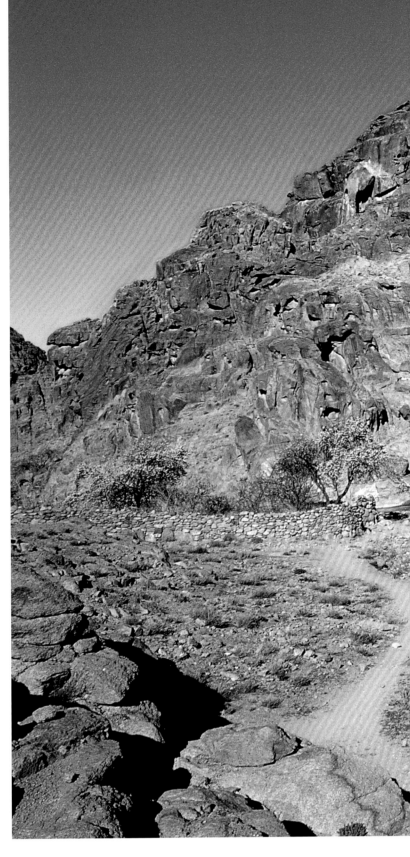

24-25 THE TEMPLE OF SERABIT AL-KHADIM STANDS ON A ROCKY PLATEAU SURROUNDED BY DEEP WADIS CARVED OVER THE COURSE OF MILLENNIA BY WATER FROM THE VIOLENT DOWNPOURS THAT PERIODICALLY STRIKE THE DESERT.

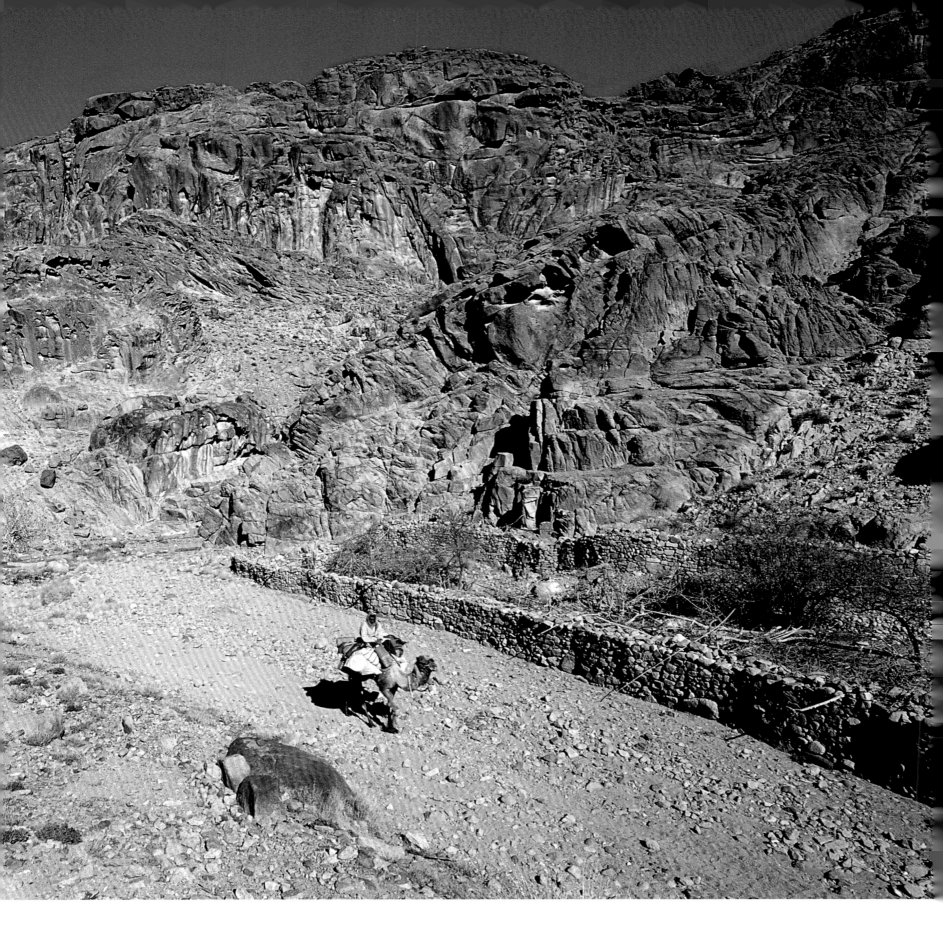

VARIOUS TRAILS AND A FEW ASPHALTED ROADS HEAD INLAND FROM
the coast, leaving the sea behind to penetrate the mountainous region, the destination since the time of the
pharaohs of expeditions sent in search of semiprecious stones, especially turquoise and malachite. For more than
thirty centuries, in fact, the ancient Egyptians used turquoise to make jewelry. Most of the turquoise came from
two quarries in the Sinai, one at Wadi Maghara, used in the Old and Middle kingdoms, and the other a little to
the north at Serabit al-Khadim, exploited during the Middle and New kingdoms. In this region, at an altitude of
more than 800 meters (2,640 feet), deep in the mountains that hid the precious material, stood a temple dedica-
ted to the goddess Hathor, the "Lady of the Turquoise," to whom the miners of various periods dedicated a great
number of stelae, which can still be seen scattered about the area of the ancient construction.

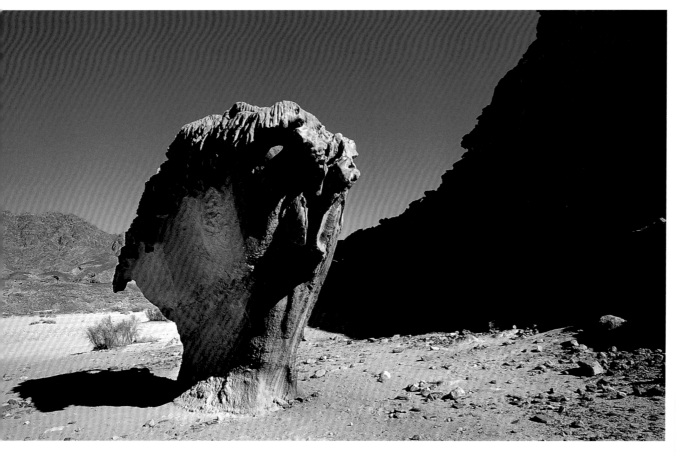

26 AND 26-27 SHAPED BY MILLENNIA OF WIND, SAND, AND WATER, THE ROCKS IN THE DESERT AROUND AIN KHUDRA HAVE ASSUMED STRANGE FORMS THAT STAND OUT AGAINST THE LANDSCAPE ALSO BECAUSE OF THEIR STRIKING COLORS.

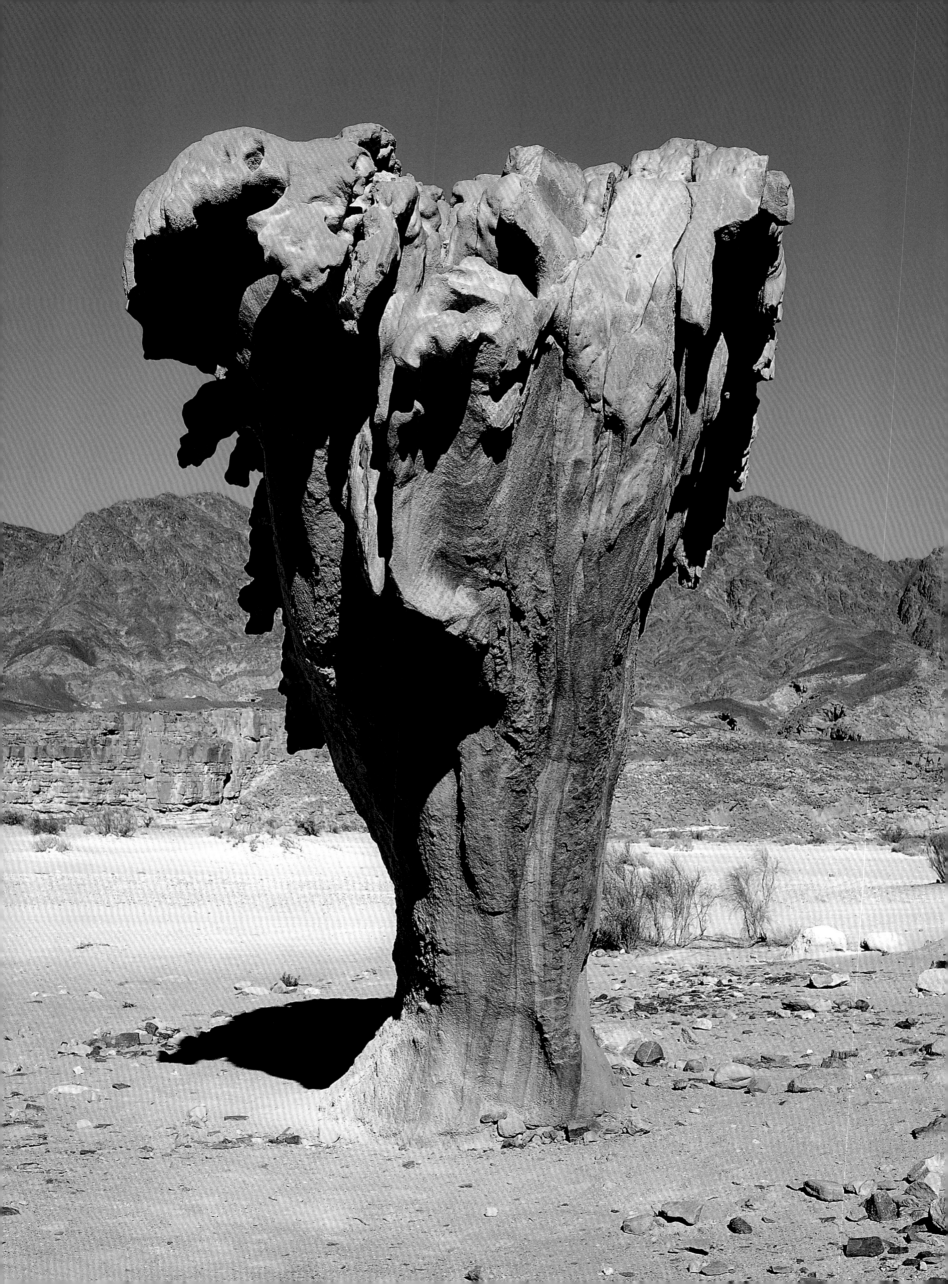

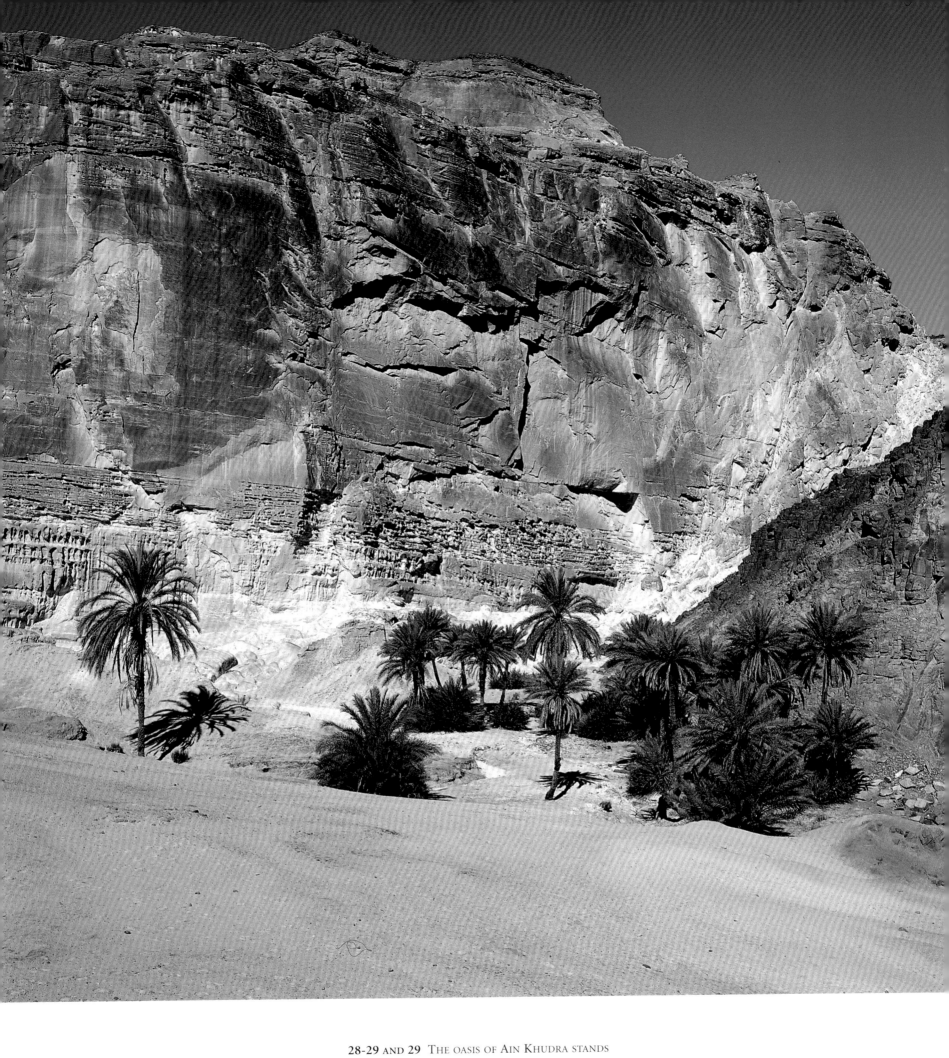

28-29 AND 29 THE OASIS OF AIN KHUDRA STANDS
AROUND A WELL OF PARTICULARLY PURE WATER THAT
PERMITS THE GROWTH OF DENSE VEGETATION AND
SUPPORTS A SMALL BEDOUIN COMMUNITY AND ITS
LIVESTOCK.

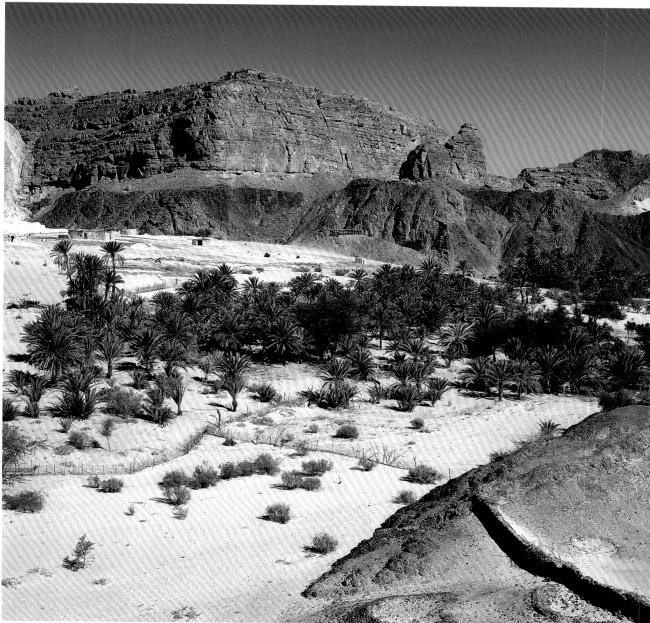

30-31 THE BED OF THE AIN KHUDRA WADI IS COVERED BY THICK VEGETATION THAT CONTRASTS WITH THE YELLOW OF THE SAND AND THE GRAY AND BROWN SHADES OF THE BARE ROCKS THAT RISE TO CONSIDERABLE HEIGHTS ON BOTH SIDES OF THE VALLEY.

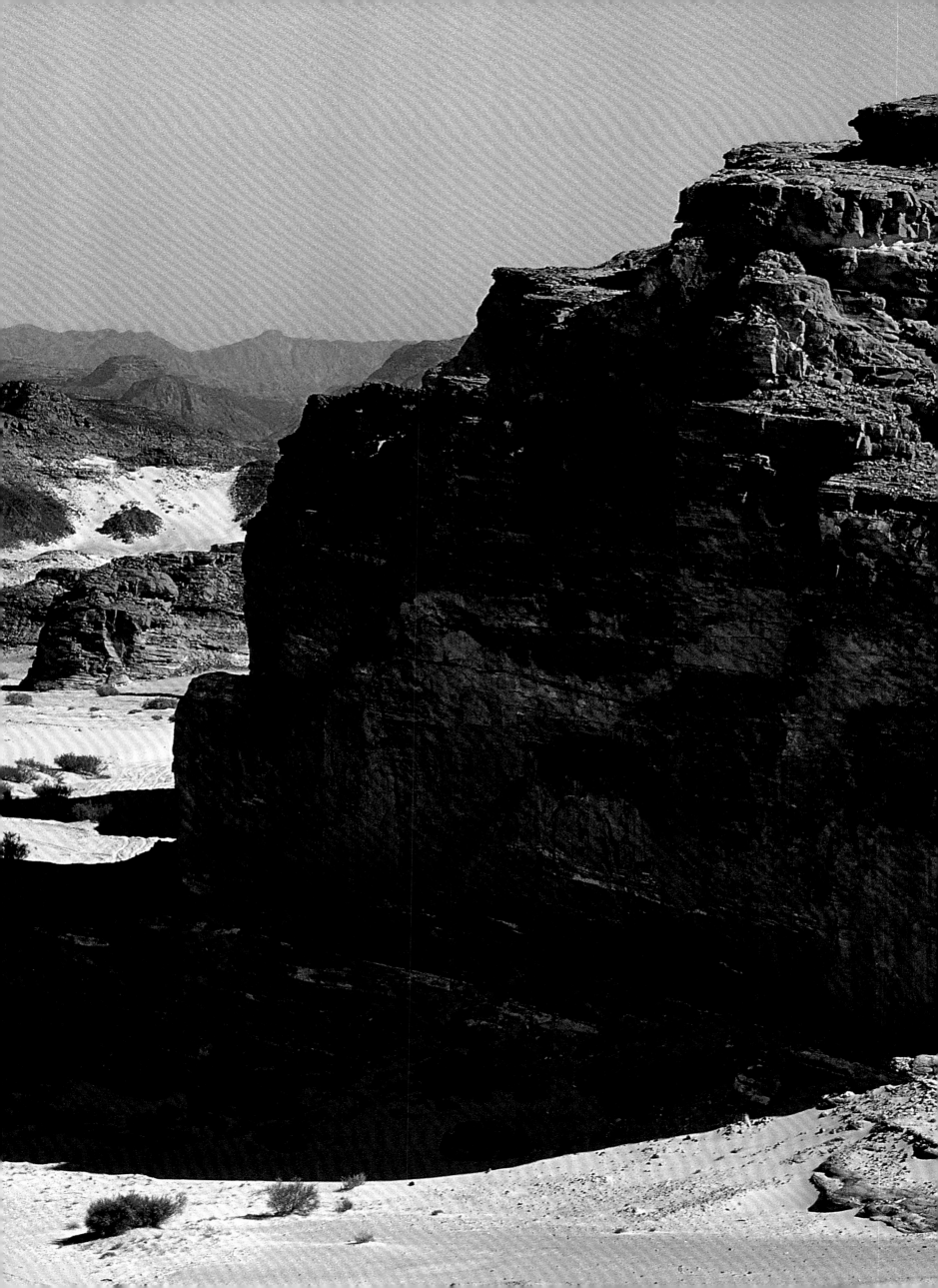

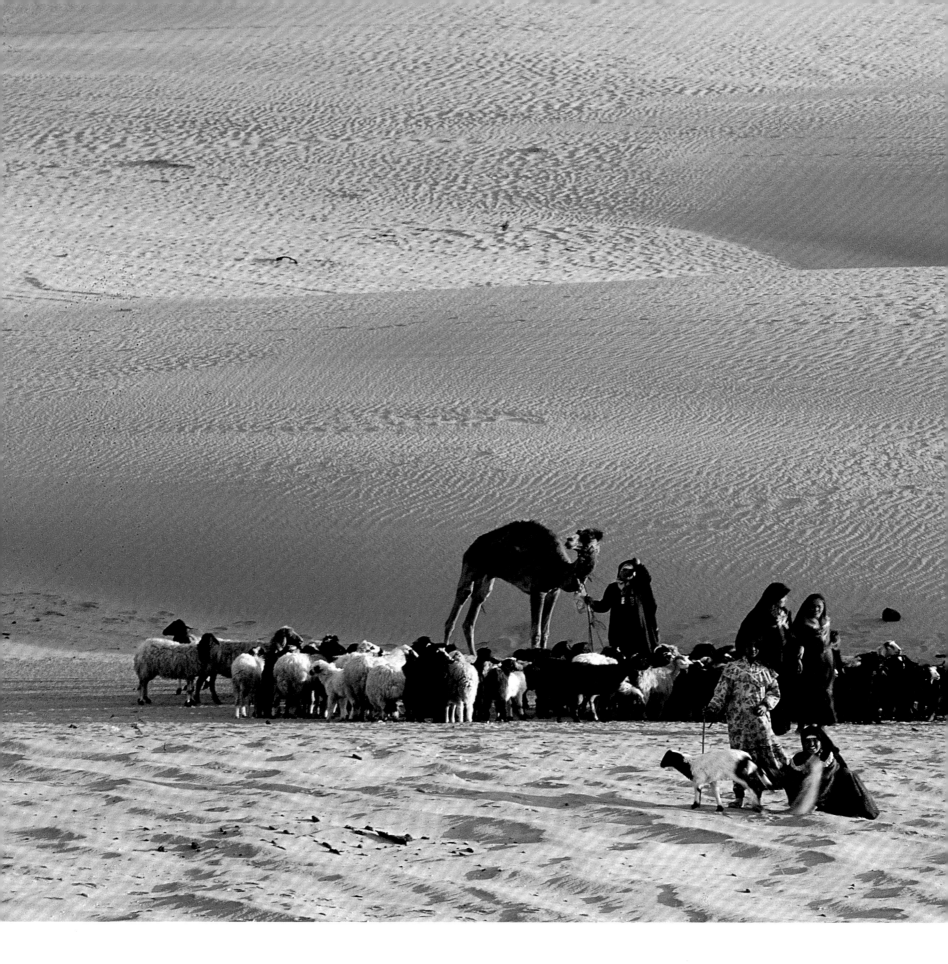

TODAY THE ENTIRE SINAI IS INHABITED BY SMALL GROUPS OF Bedouins, gathered around the few springs that create sudden explosions of green in the brown and yellow of the rock and sand. Divided into fifteen tribes, they maintain traditional habits and customs but have had to adapt to living with a growing number of tourists and visitors. The Bedouin women create handmade articles and embroidery that have become sought-after merchandise, and it is not rare to encounter men willing to act as guides to travelers and to show foreigners the beauties of their land.

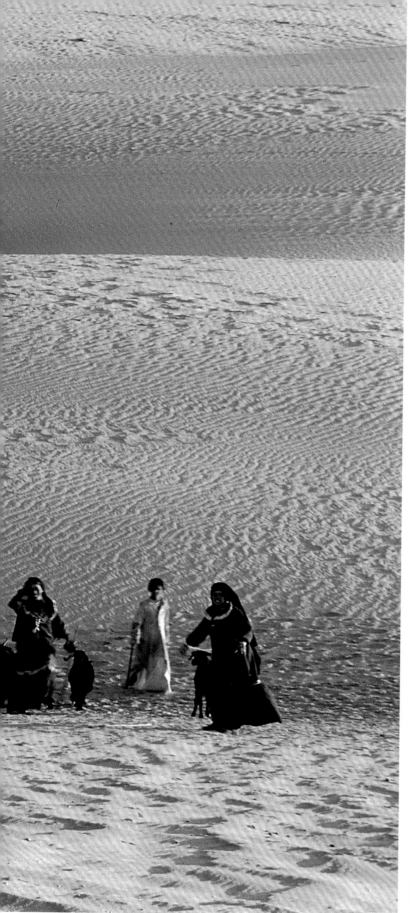

32-33 AND 33 THROUGHOUT THE SINAI DESERT SMALL WATER SOURCES SUPPORT A LARGE BEDOUIN COMMUNITY. DIVIDED INTO ROUGHLY FIFTEEN TRIBES THE BEDOUINS OCCUPY DIFFERENT AREAS OF THE PENINSULA AND PRESERVE THEIR TRADITIONAL CUSTOMS, MOVING ABOUT ACCOMPANIED BY THEIR FLOCKS AND CAMELS.

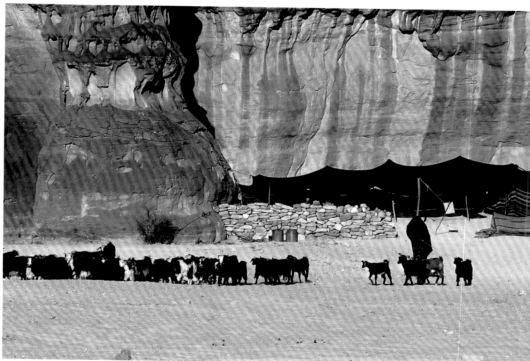

34-35 THE WALLS OF THE WADIS IN THE SINAI OFTEN BEAR GRAFFITI AND INSCRIPTIONS DATING BACK TO VARIOUS HISTORICAL PERIODS, LEFT BY ANCIENT INHABITANTS OF THE ZONE OR BY TRAVELERS. THIS IMAGE PRESENTS A BEDOUIN STUDYING GRAFFITI AT WADI ARADA HAKATAN.

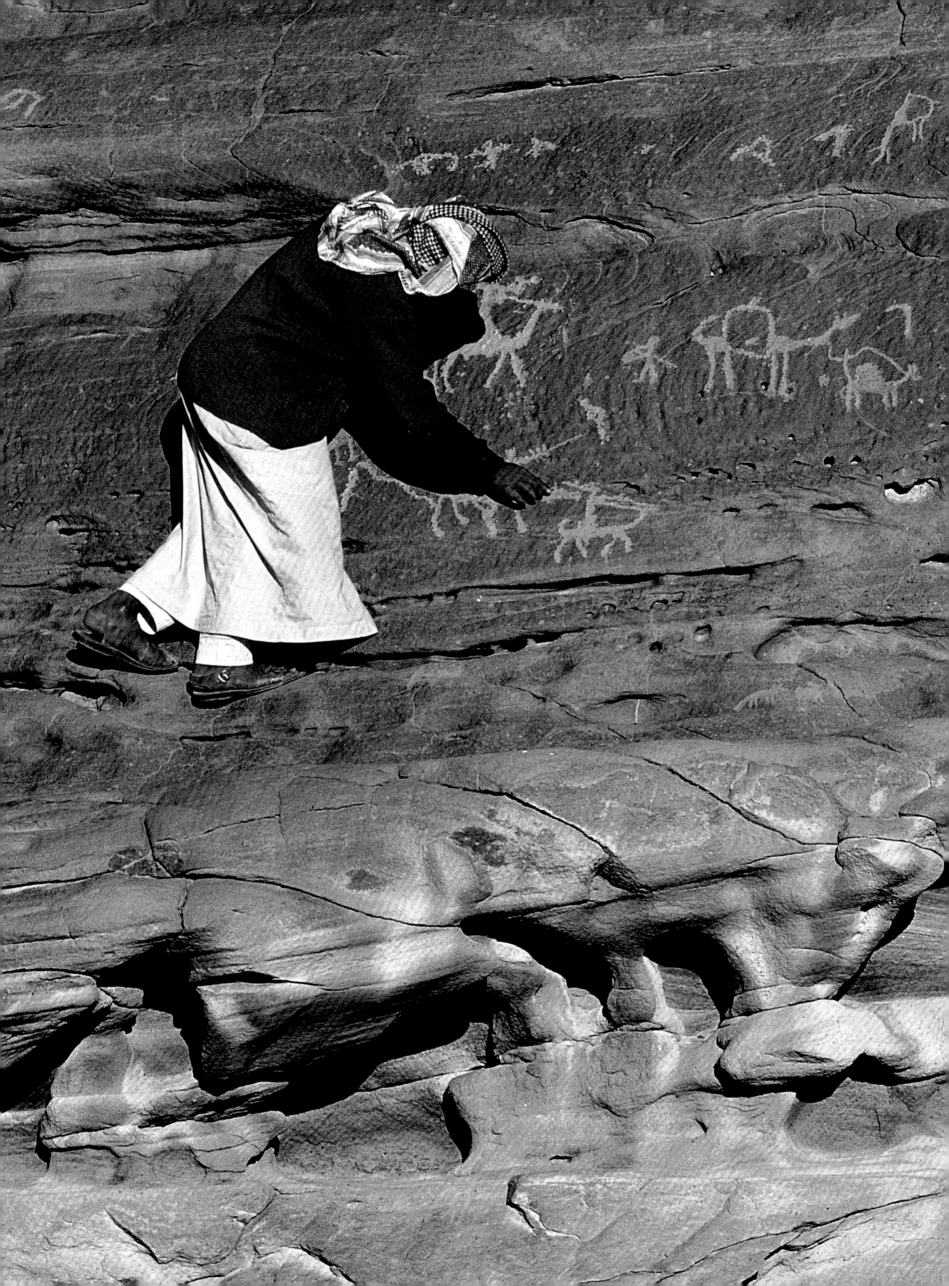

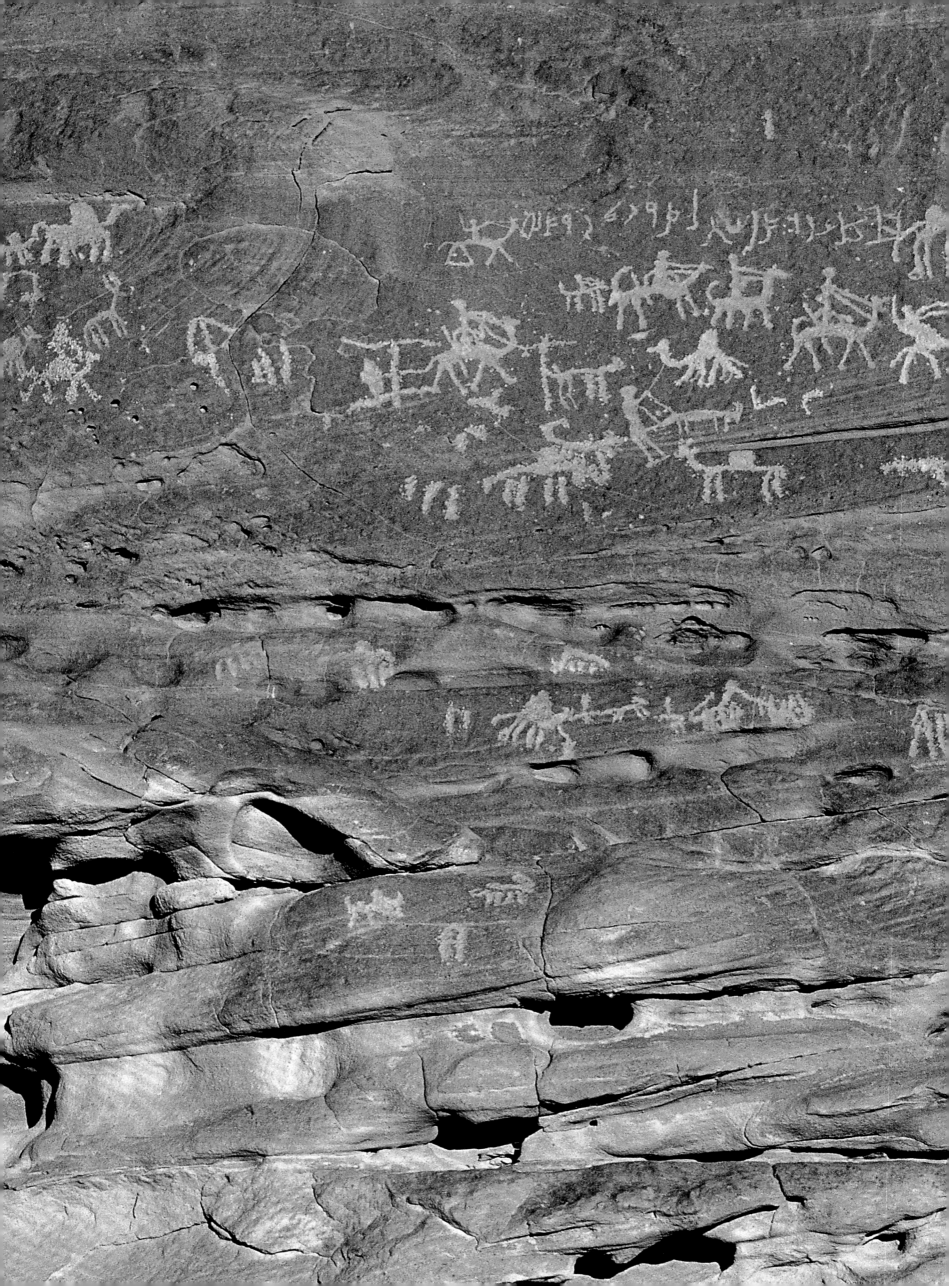

36 AND **36-37** AN ENORMOUS PALM GROVE MARKS THE SITE OF THE OASIS OF WADI FEIRAN (ANCIENT PHARAN). BEFORE ST. CATHERINE WAS BUILT, FEIRAN WAS THE SEAT OF THE BISHOP OF THE SINAI. ITS IMPORTANCE IN ANTIQUITY IS INDICATED BY THE PRESENCE OF NUMEROUS CHURCHES, INCLUDING A BYZANTINE CHURCH, THE RUINS OF WHICH APPEAR IN THE IMAGE AT BELOW LEFT.

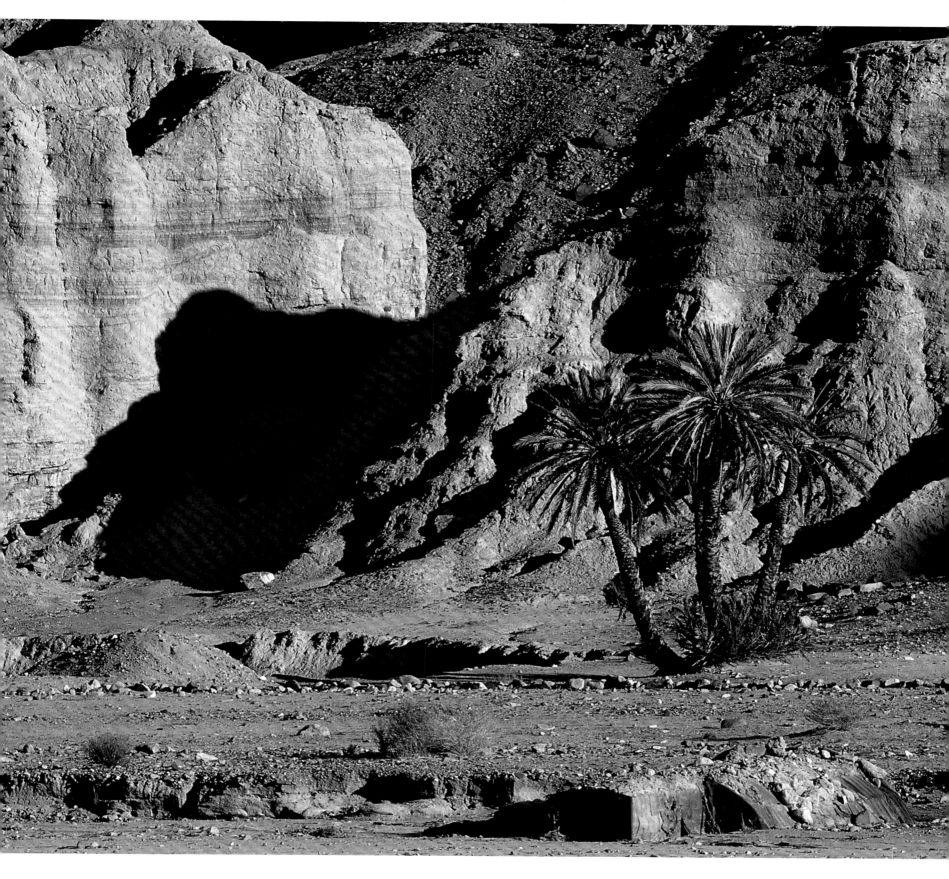

THE SOUTHERN AREA OF THE PENINSULA IS CROSSED
FROM COAST TO COAST BY A SINGLE ROAD. FROM THE
west coast it first crosses a desert valley to Wadi Feiran, site of a village and the largest
and most famous palm grove in the Sinai; it then winds around tall mountains, the
highest peak of which is over 2,000 meters (6,600 feet) in altitude, passing one *wadi*
after another to enter a narrow rocky gorge and finally descend to the east toward the
coastal town of Nuweiba.

38-39 At the end of a long route used for centuries by pilgrims and travelers following the footsteps of Moses stands the monastery of St. Catherine, nestled at the bottom of a rocky wadi near the great mountain called Gebel Musa.

HALFWAY ALONG ITS ROUTE, IN THE HEART OF THE SINAI, at the end of a road used for centuries by travelers and devout pilgrims, and nestled at the end of a wadi at the foot of a tall mountain, stands the monastery of St. Catherine, with its fortified walls, its lush gardens, its ancient religious buildings, and its invaluable library.

Inside a high defensive wall is a series of stone constructions separated by narrow, shady streets that wind among the whitewashed walls. Behind heavily decorated wooden doors the monks of the monastery have for centuries cared for an inestimable patrimony that includes innumerable sacred ornaments in precious metals, more than two thousand icons painted by the monks themselves over the course of the centuries, and more than three thousand ancient manuscripts in at least eleven languages. Beside the main enclosure, the narrow end of the wadi is covered by terraced gardens with orchards and greenery. Fruit trees, cypresses, and olives create a dense green thicket that accentuates the compactness and isolation of the religious complex.

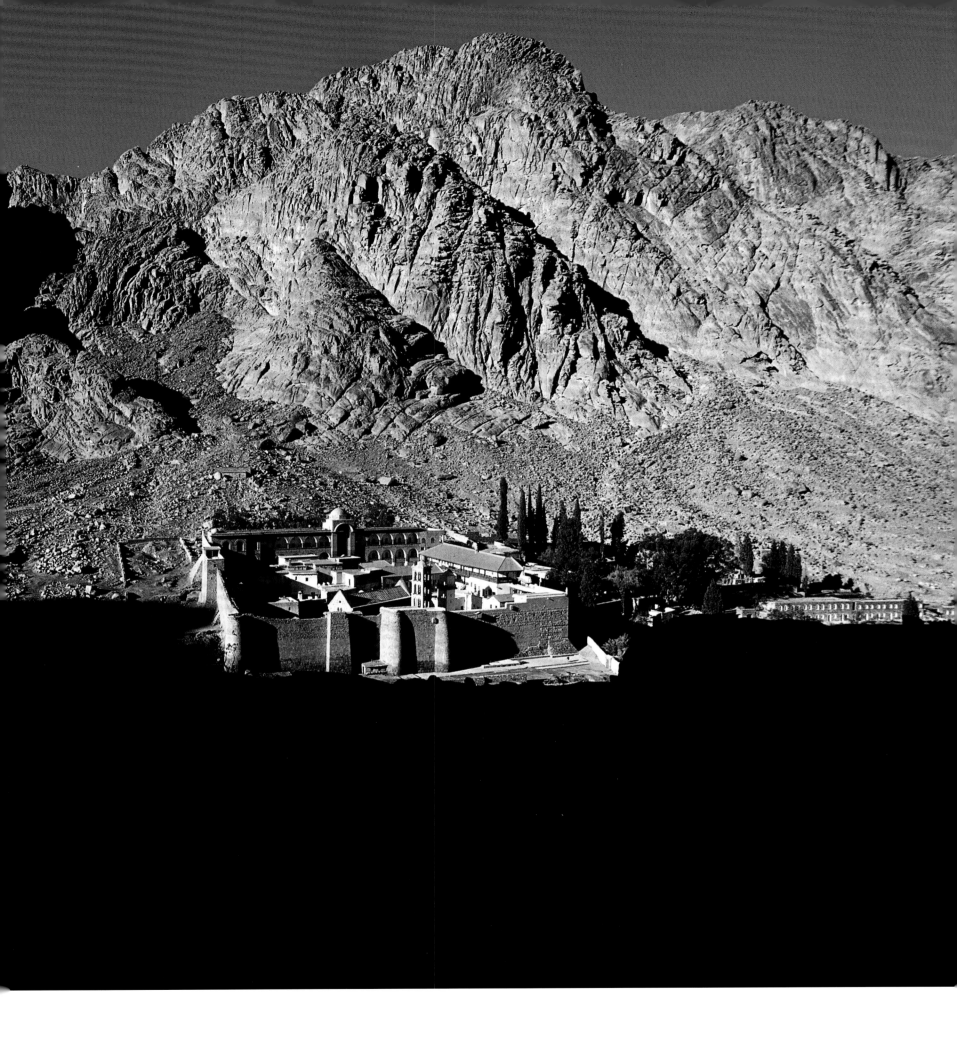

For ages the destination of pilgrims, the monastery still lives according to the ancient rhythms dictated by the monastic traditions of the Greek Orthodox Church. Its doors, however, are not closed to the new type of traveler that has arrived in the Sinai during recent years: the tourist. In accordance with strict rules and precise schedules, outside visitors are permitted to enter this ancient settlement and to get a partial view of the treasures preserved between its walls.

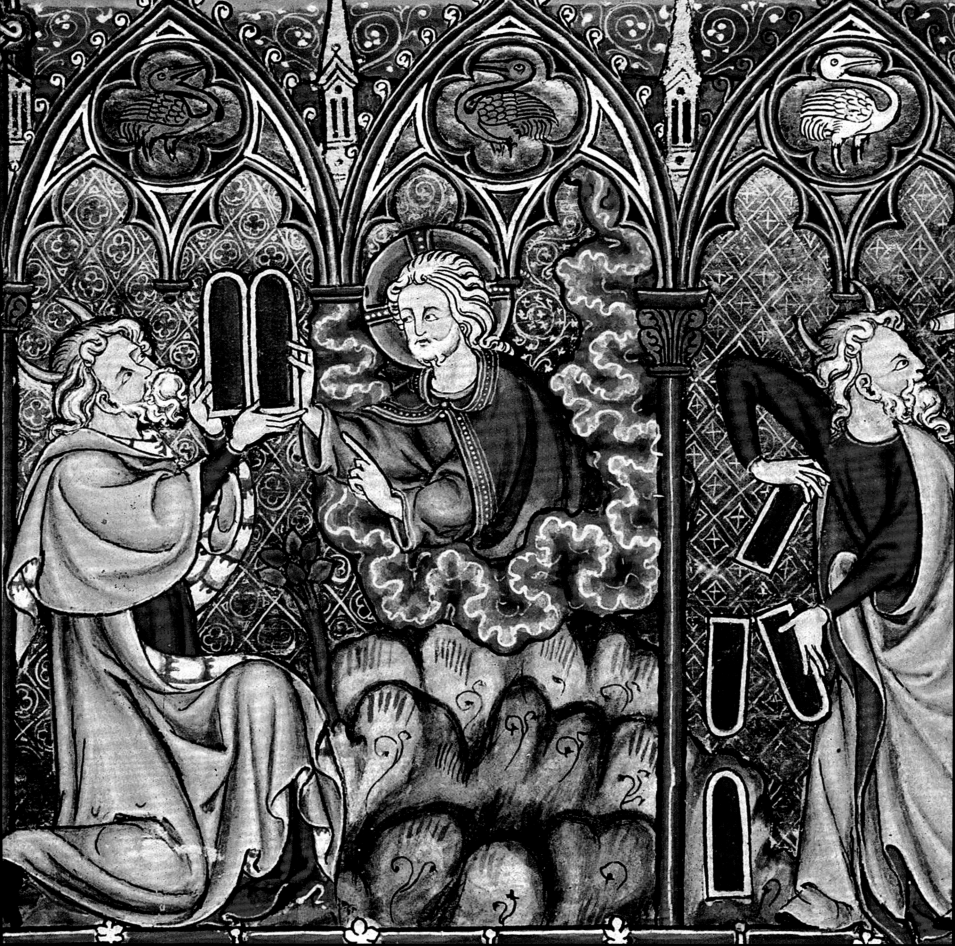

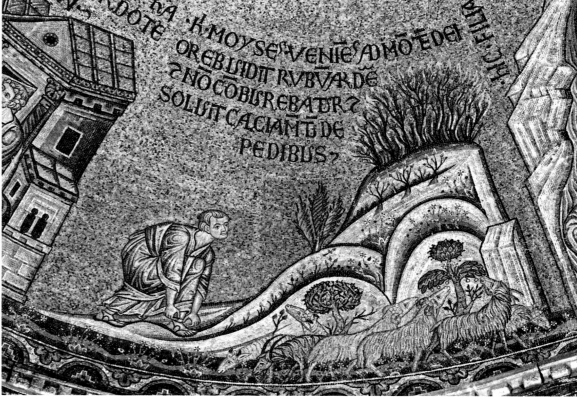

40-41 This miniature from a fourteenth-century manuscript depicts Moses in the act of receiving the Tables of the Law.

41 According to the Biblical account, God asked Moses to remove his sandals so as not to step on the sacred ground around the Burning Bush. In this mosaic, which adorns the dome of St. Mark's in Venice, Moses is presented undoing the laces of his footwear.

IN THE
FOOTSTEPS
OF MOSES

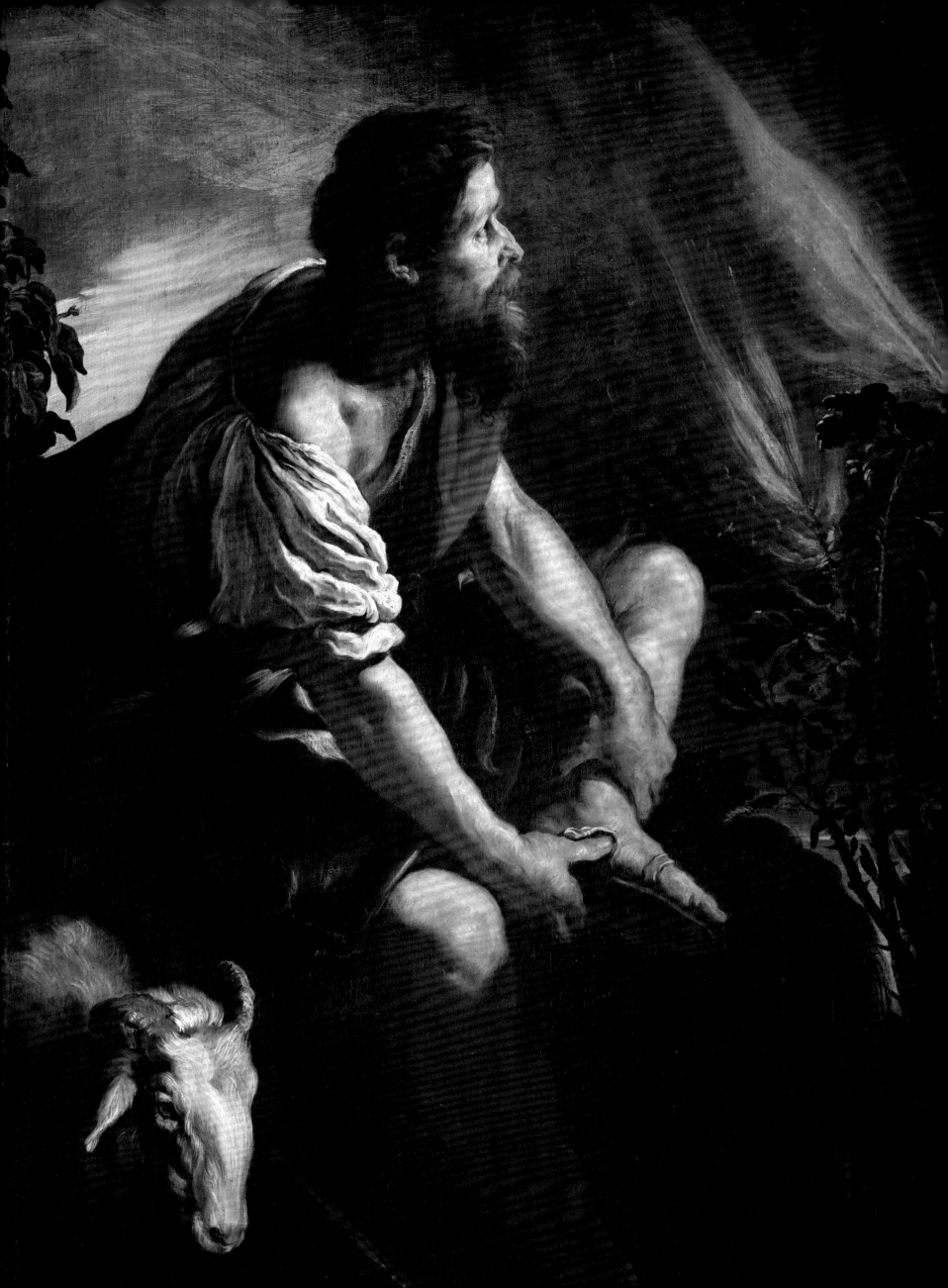

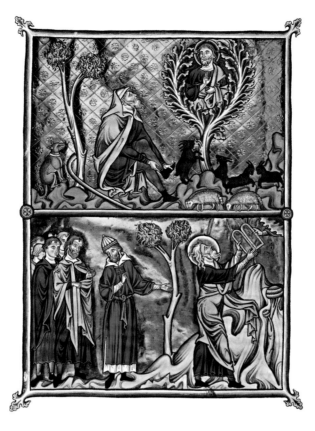

42 MOSES ON MOUNT SINAI AS PRESENTED IN *MOSES BEFORE THE BURNING BUSH*, BY ITALIAN
PAINTER DOMENICO FETTI, OIL ON CANVAS, PAINTED AROUND 1613 AND TODAY IN VIENNA.

43 MOSES WITH THE BURNING BUSH AND RECEIVING THE TABLES OF THE LAW, FROM THE
INGEBORG PSALTER MADE FOR INGEBORG, TODAY IN THE MUSÉE CONDÉ, CHANTILLY.

THE HISTORY AND THE CONSTRUCTION OF THE VARIOUS ELEMENTS THAT CONSTITUTE THE MONASTERY OF ST. CATHERINE ARE CLOSELY

related to the Biblical wanderings of Moses and his people, recounted in the book of Exodus. According to the story, near a well in the Sinai, Moses met the daughters of the shepherd Jethro. He protected them from several shepherds and helped them water their flock. By way of gratitude, Jethro took Moses into his own home and gave him one of his daughters for a wife. One day Moses was watching over his father-in-law's flock when he witnessed a manifestation of the divine: a bush that burned without being consumed. God then spoke to him, saying, "I am that I am" and charging him to free the Israelites from the rule of the Egyptians and lead them to the Promised Land.

Thus Moses and his people set off, crossed the Red Sea, and arrived at the foot of Mount Sinai. Leaving his people camped on the plain beneath the mountain, Moses climbed it alone and received the tables with the Ten Commandments. When he came back down the mountain he found that the people had made a golden calf and were worshiping it as a pagan idol. Moses' rage was tremendous. He broke the tables of the law he had received from God and destroyed the calf. God pardoned the Hebrews, who made an ark to hold the tables of the law known as the Ark of the Covenant in reference to the pact they had with their God. The Hebrews again set off, and after forty years of wandering in the desert came within view of the Promised Land.

44 The Roman emperor Constantine I with his mother, St. Helena, in a thirteenth-century icon, tempera on wood. In 313 AD Constantine issued the edict that ended the persecution of Christians.

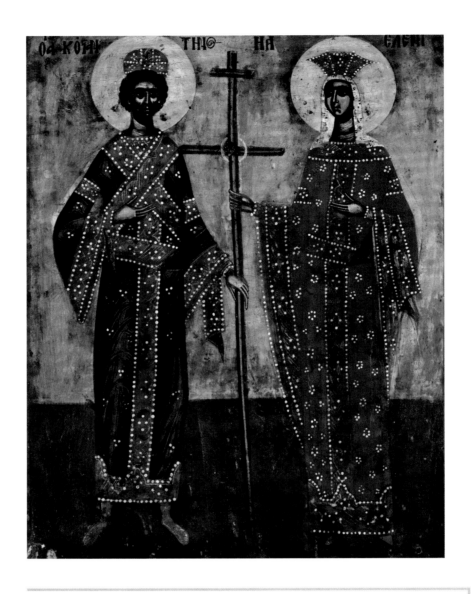

AS EARLY AS THE FOURTH CENTURY AD MONKS AND HERMITS HAD BEGUN TAKING REFUGE IN THE WADIS AT

the foot of the mountain that was traditionally identified as the Mount Sinai of the Bible and that today is called Gebel Musa, meaning Mount Moses. Around 330 AD Empress Helen, mother of Constantine, the emperor who in 313 had issued the famous edict that brought an end to the persecution of the Christians, ordered the construction of a sanctuary around the place where, according to legend, Moses had seen the burning bush. The site of the ancient construction is today occupied by the easternmost chapel of the church of St. Catherine, dedicated to the Burning Bush, the legendary position of which is marked by a small silver plaque. Behind the chapel, encircled by a stone wall at the side of an old building, grows a lush bush that recalls the ancient legend that gave life to the monastery.

45 This illumination from *les Belles Heures*, made between 1405 and 1409 by the three Limbourg brothers for Jean of France, duke of Berry, presents the body of St. Catherine being carried by angels to the Sinai. The manuscript is in the Cloisters, New York.

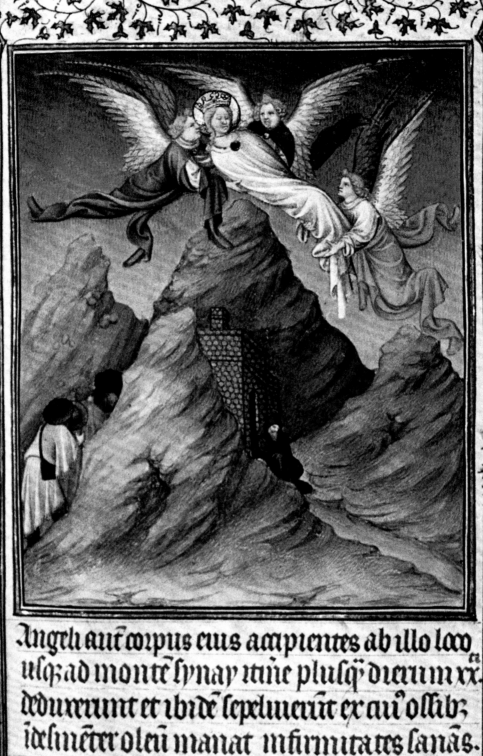

Angeli aut corpus eius accipientes ab illo loco
uscp ad monte synay itine pluscp dieru in xx.
deduxerunt et ibide sepelurint ex quo ossib;
idelin eter oleu manat infirmitates sanas.

47 AT A CERTAIN DISTANCE FROM

GEBEL MUSA STANDS GEBEL

KATARINA, WHICH RISES TO 2,637

METERS. THE BREATHTAKING VIEW

FROM THE TOP EXTENDS ALL THE

WAY TO THE WATERS OF THE GULF

OF SUEZ.

48-49 TWO BUILDINGS STAND ATOP

GEBEL MUSA: A TINY MOSQUE AND A

SMALL CHAPEL BUILT IN THE 1930S

ON THE RUINS OF A MUCH OLDER

CHURCH.

THE IMPORTANCE AND FAME OF GEBEL MUSA GREW QUICKLY IN
THE CHRISTIAN WORLD. TO THE YEAR 384 DATES THE STORY OF THE
Spanish nun named Egeria, who undertook a long trip to the Holy Land that included Mount Sinai. In
her account of the trip she describes how she and her traveling companions reached the foot of the
mountain and then undertook the long, difficult climb to the top, where they were greeted by a group
of monks and by a breathtaking panorama: "From there we were able to see Egypt and Palestine, the
Red Sea and the Mediterranean, which extended toward Alexandria and the boundless lands of the Sara-
cens, all of it so unbelievably far below us, but the holy men indicated them to us one after another."
The monks then showed them, one by one, the sacred places in which the various episodes narrated in
Exodus had taken place, and together they read the ancient texts that recounted the events. Egeria re-
ports that the peak of the mountain was occupied by a small church and by a cave that Moses was said
to have used. Today, sixteen centuries later, the modern visitor who reaches the top of Gebel Musa finds
on the edge of the precipice a chapel dedicated to the Holy Trinity, covered by a sloping roof and a small
dome. Built in the 1930s atop the remains of the ancient building, by then in ruins, the chapel is adja-
cent to a small mosque that stands over the legendary cave.

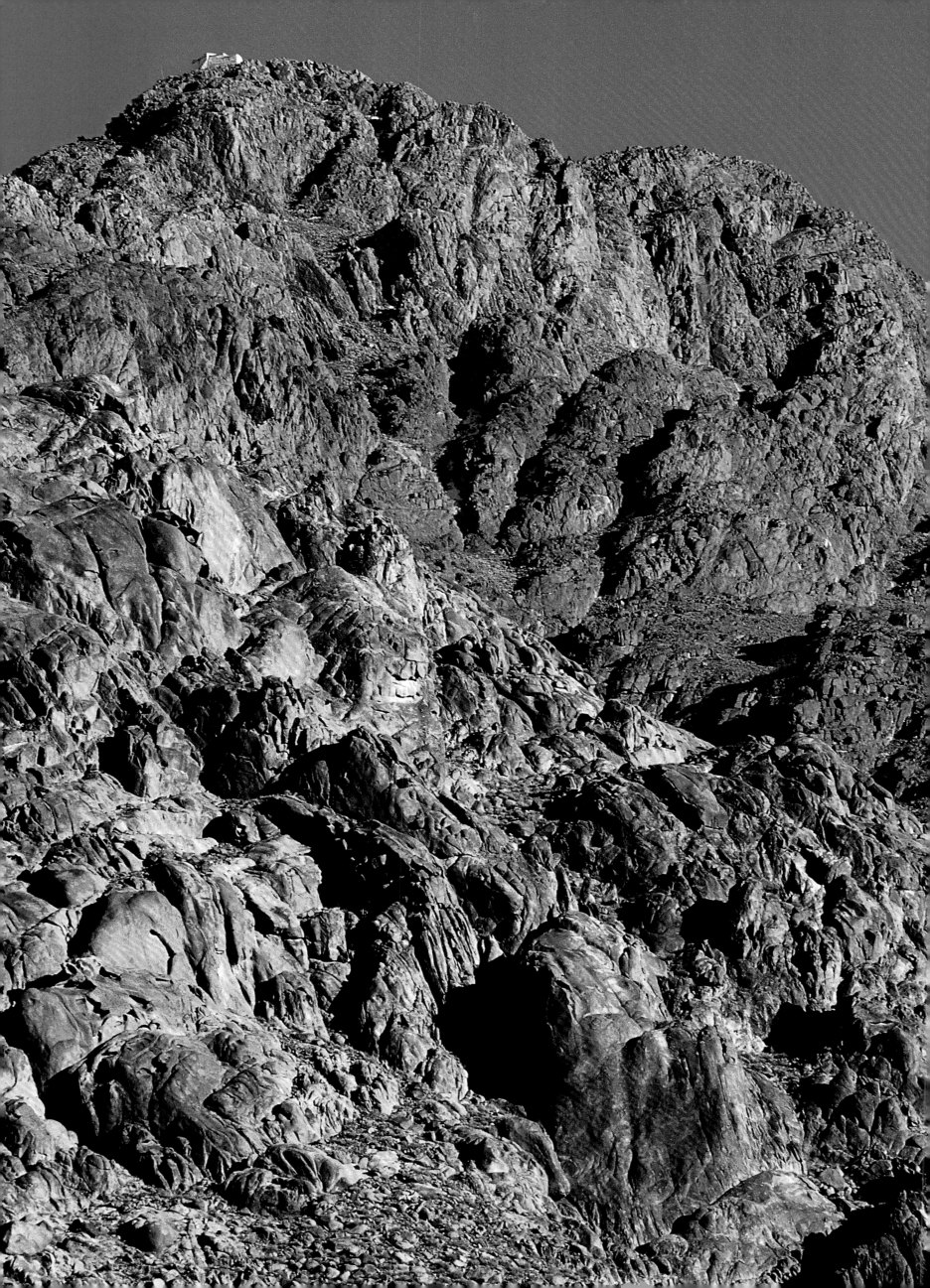

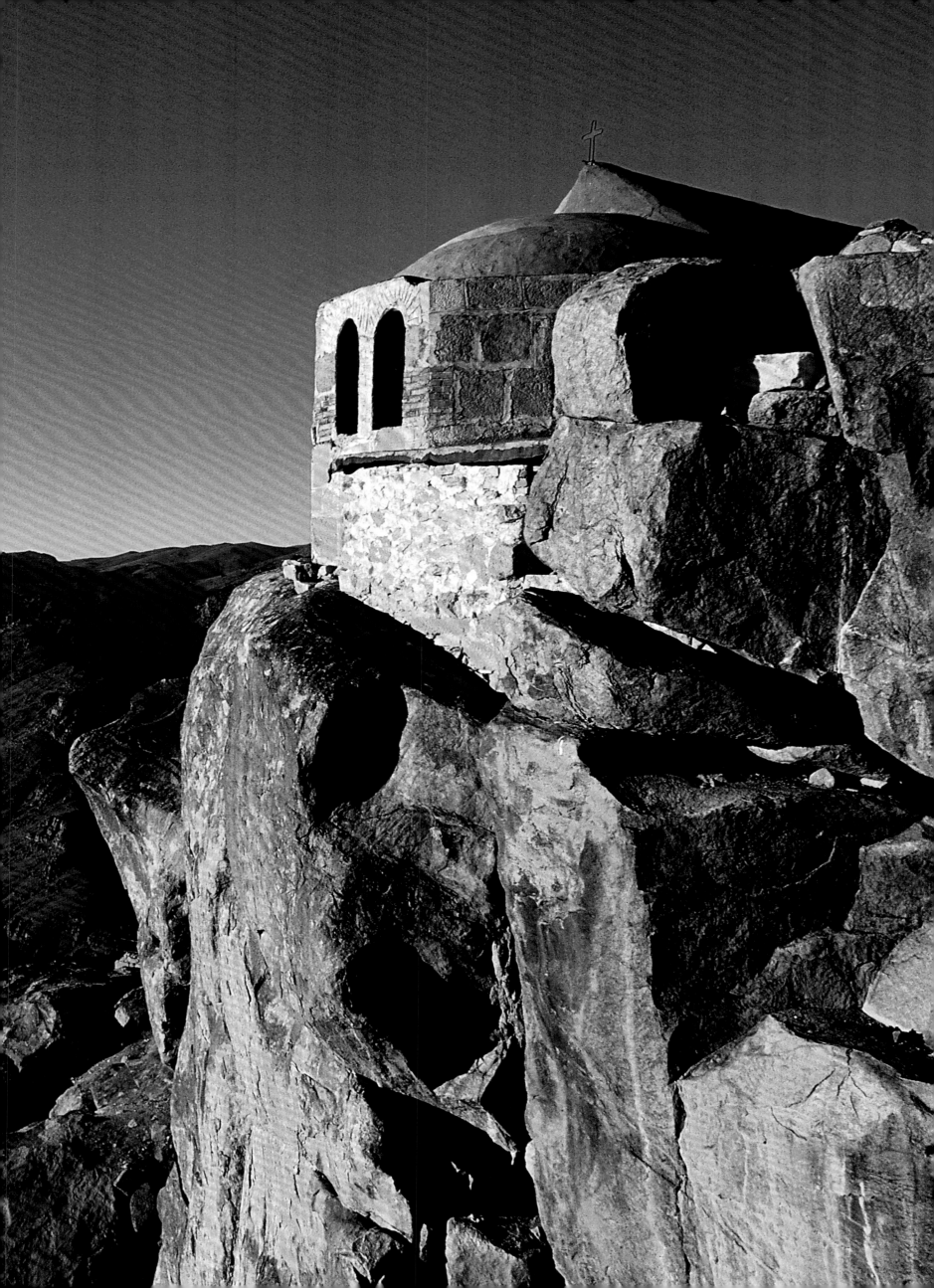

ON THEIR RETURN TRIP, EGERIA AND HER GROUP OF PILGRIMS STOPPED AT THE SO-CALLED PLAIN OF CYPRESSES, ALSO KNOWN as the Amphitheater of the Seventy Elders of Israel, where, according to tradition, seventy elders who accompanied Moses beheld the God of Israel, and did eat and drink (Exodus 24: 9-11). In this narrow open space wedged amid the jagged rocks, a group of cypresses and an olive tree grow today beside a well and the remains of a hermitage and two small shrines. Egeria recounts that, having descended the mountain, the monks showed her and her traveling companions the exact spots where, according to legend, the Hebrews had camped and where the golden calf had been cast, and even the very rock on which Moses had broken the Tables of the Law.

The area of Gebel Musa is not the only area of the Sinai to contain sites venerated for their association with the Bible. According to tradition, Moses and his people arrived at Mount Sinai after a long trip through the desert, and Exodus recounts various episodes that occurred during that trip. The name of Moses shows up in several place names along what is said to have been the route taken by the Hebrews. Ayun Musa, literally the 'Wells of Moses,' which is located along the coast a little below the entrance to the Suez Canal, is traditionally

50 AND 50-51 ACCORDING TO THE LEGEND, SEVENTY ELDERS ACCOMPANIED MOSES IN HIS ASCENT. THEY STOPPED TO WAIT FOR HIM. THIS SPOT IS TODAY KNOWN AS THE PLAIN OF CYPRESSES OR THE AMPHITHEATER OF THE SEVENTY ELDERS.

52-53 BROAD WADIS SNAKE AMONG THE MOUNTAINS OF THE SINAI, SUCH AS THIS DEEP VALLEY THAT EXTENDS ALONG THE OASIS OF AIN UMM AHMAD.

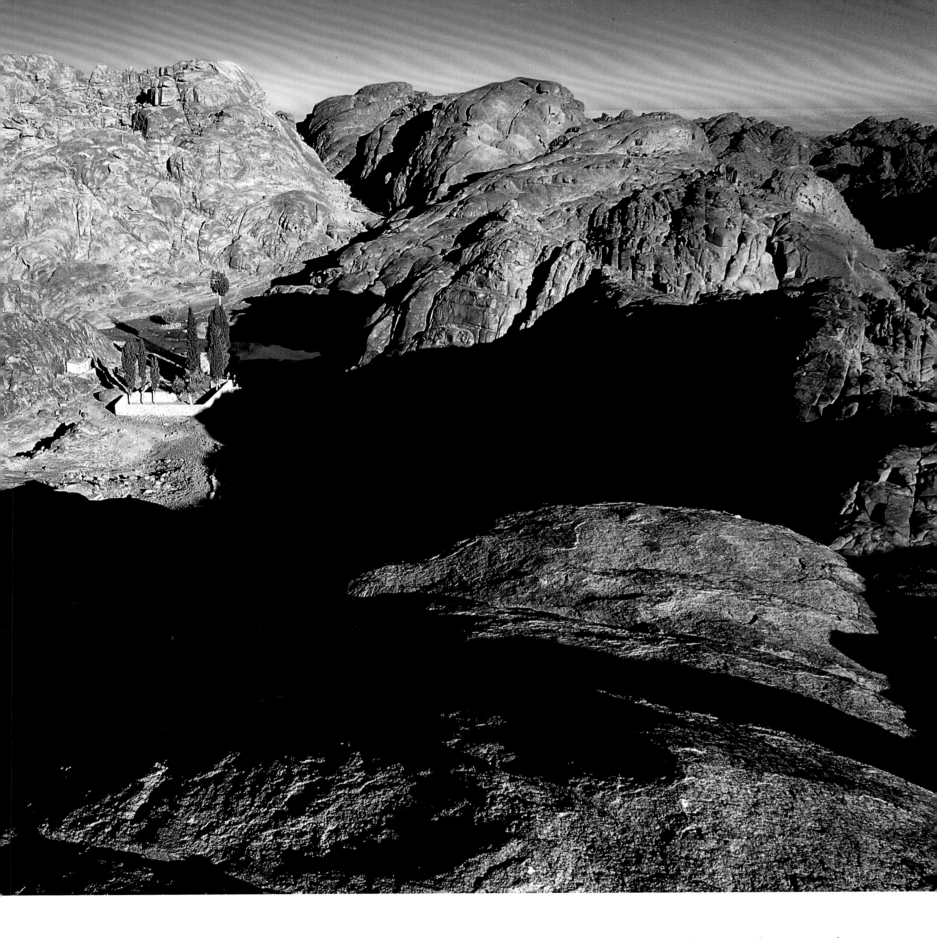

identified with Marah, site of a spring where the Hebrews rested after crossing the Red Sea. According to legend, the water at Marah was too bitter with salt to drink, but with the help of God Moses made it potable so that his people could quench their thirst.

Hammam Musa, the 'Baths of Moses,' is a spa along the coast near the town of al-Tur where warm water bubbles to the surface and creates pools shaded by palm groves. The place seems to resemble Elim, where the Hebrews, according to Exodus, found twelve wells of water and seventy palm trees. There is finally the singular Arabic name Hesi al-Khattatin, which refers to a "well hidden by two scribes." This is applied to a spot along the route to Gebel Musa, the Rephidim of Exodus, where legend says Moses struck a rock with his rod and water burst forth, once again quenching the thirst of his people. The two scribes of the Arabic name are Moses and his brother Aaron, who also here seem to have left a sign of their passage.

54 The peak of Mount Sinai as immortalized in a lithograph by David Roberts.

54-55 Dated February 21, 1839, this lithograph by David Roberts presents the basilica of the Transfiguration.

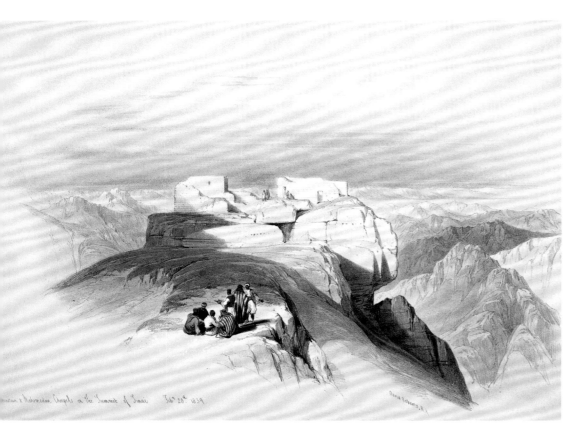

ISOLATION AND TRADITION

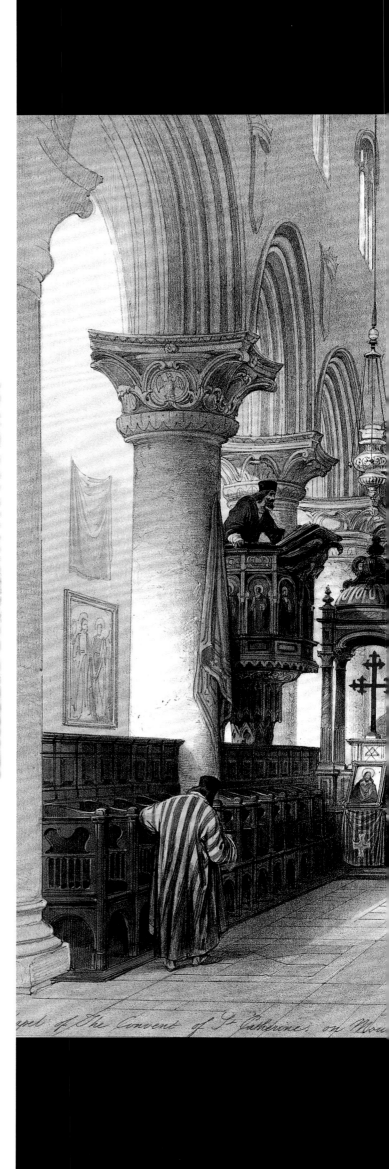

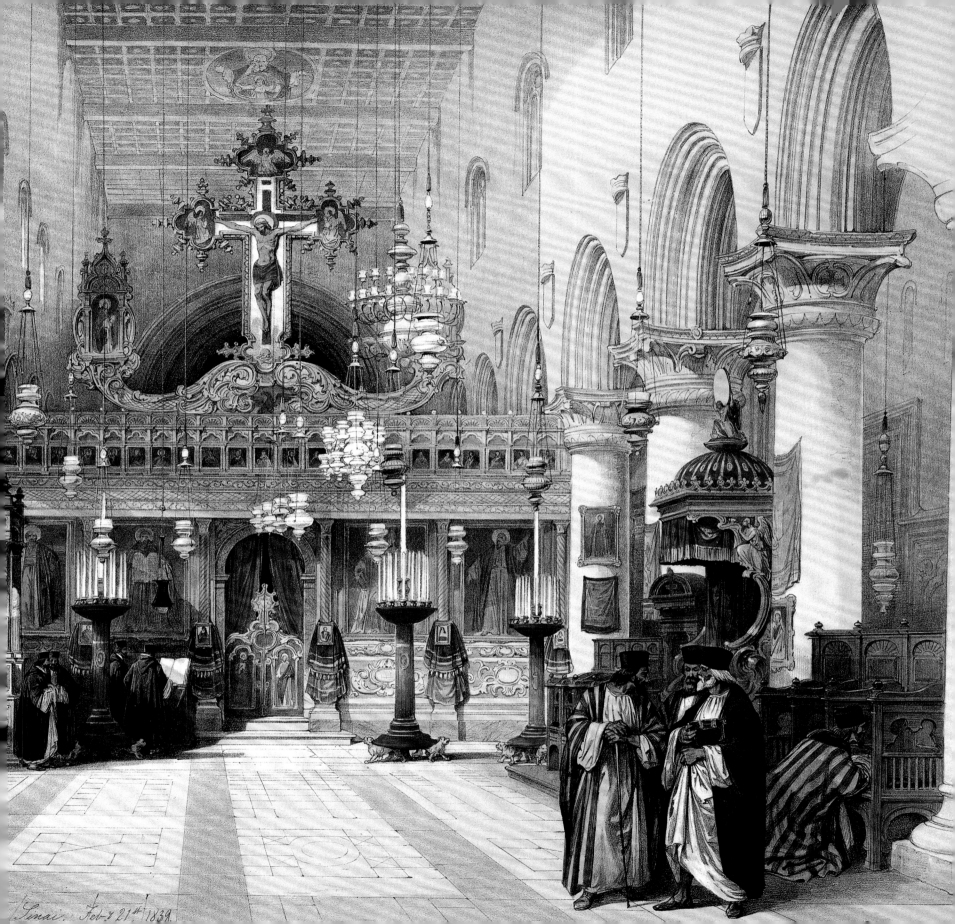

Sinai. Feb.y 21st 1839.

THE MONASTERY AND THE OUTSIDE WORLD

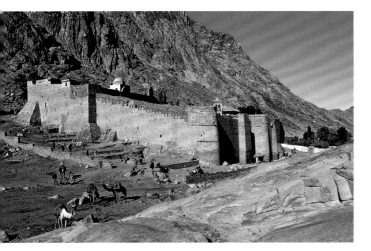

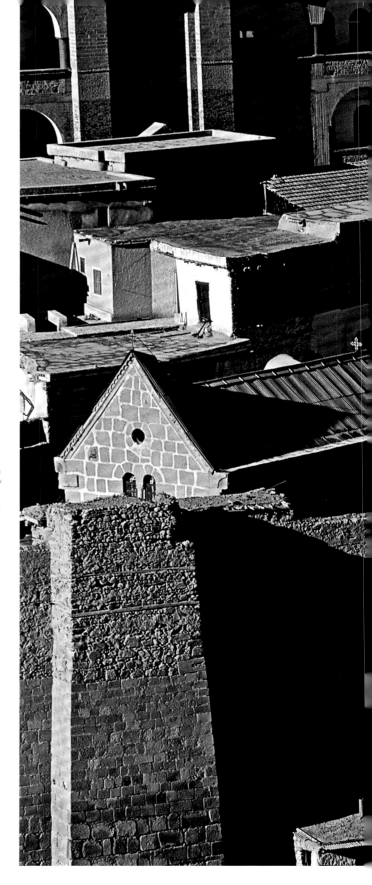

IN ANTIQUITY, THE LIFE OF MONKS LIVING AT THE FOOT OF MOUNT SINAI WAS NOT EASY. CHRONICLES relate that during a violent Bedouin raid forty monks who lived in the local monastery were massacred at Sinai, and another forty at al-Tur. They are remembered in the Deir al-Arbain, or 'Monastery of the Forty,' that stands at the foot of Gebel Musa on the other side from St. Catherine. It was to provide protection for the monks and pilgrims that Emperor Justinian had a stone wall built around the monastery, in 537. Remains of that wall remain at the base of the wall that today surrounds the monastery.

Thirty years later that same emperor installed two hundred soldiers, one hundred from Thrace, and one hundred from Egypt, to protect and serve the monastic community. According to a tradition, the modern Muslim servants that work in the monastery are descendents of the Byzantine soldiers. Thus, a small Muslim community has lived side by side with the Christians for many centuries, as indicated by the small mosque that stands beside the main church. Originally built as a hospice for pilgrims, it was converted into a mosque in the eleventh century, and its 10-meter (33-feet)-high whitewashed minaret rises a short distance from the church's bell tower. The community's isolation and concern for defense were abundantly clear during the last century, when one could enter the monastery only by way of a large basket lifted by ropes to an opening in the upper part of the northern wall. Today, the complex can be entered through a ground-level door opened in the middle of the northern side. This is not the only change that has been made to the

56 AND 56-57 THE WALL AROUND THE MONASTERY, WHICH STANDS ATOP FOUNDATIONS DATING TO THE SIXTH CENTURY, HAS BEEN REWORKED AND RESTORED SEVERAL TIMES. THE BUILDINGS THAT COMPOSE THE MONASTERY WERE BUILT AT DIFFERENT TIMES AND IN DIFFERENT STYLES ONE BESIDE THE OTHER OVER THE PERIOD OF SEVENTEEN CENTURIES. THE BELL TOWER OF THE CHURCH STANDS A SHORT DISTANCE FROM THE MINARET OF THE MOSQUE. BOTH RISE ABOVE THE WALL AROUND THE MONASTERY.

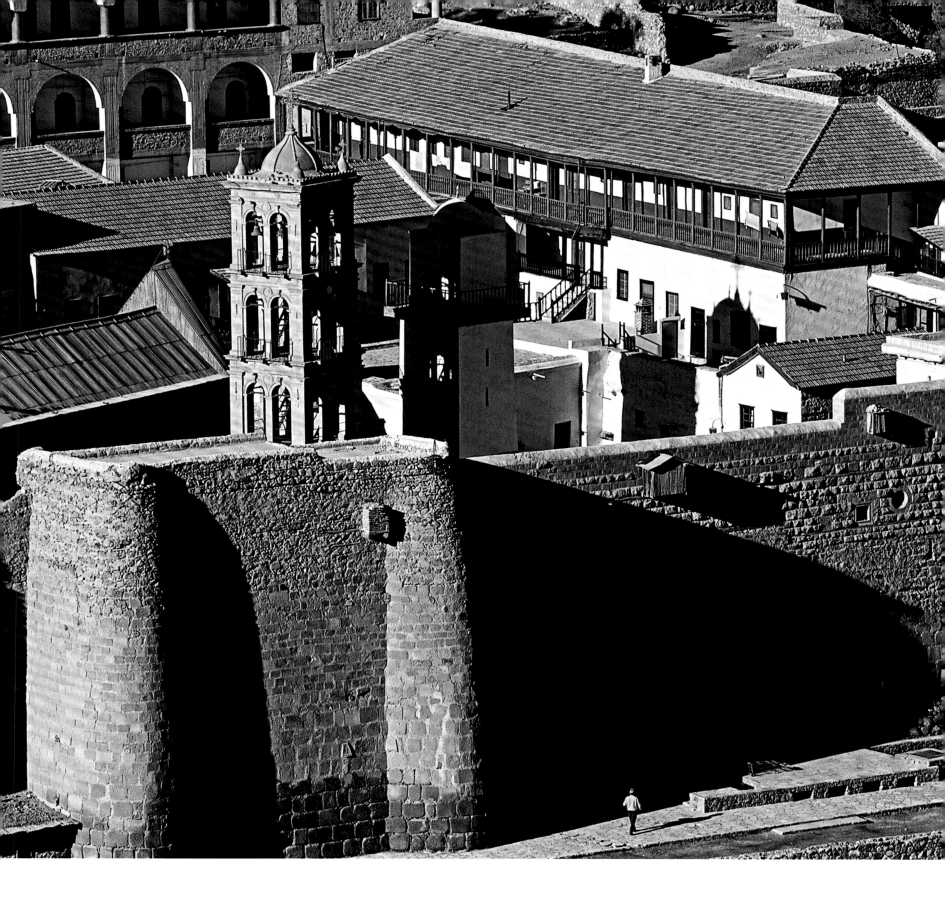

defensive wall, which has been restored several times over the course of the centuries. In particular, between 1800 and 1801 Napoleon ordered the repair of parts of the wall and the construction of reinforcing towers and bastions. The pair of circular towers that stand at the center of the north side bear the name of Jean-Baptiste Kléber, the French general who oversaw the restoration work. Following the French occupation, the Egyptian pasha Muhammad Ali took a benevolent interest in the monastery, promoting further work and the collection of funds. By far the most generous benefactors of the monastery were Russia's czars, who saw themselves as the natural successors to the Byzantine emperors. The church's bell tower and many precious objects that still can be found within the complex are the most visible signs of the great interest shown by the Russians in the religious complex and their notable contributions to its development. The last three centuries of the monastery's life have been a period of stability and peace, but the life of the institution has not always been easy. During the three preceding centuries the number of monks fluctuated in a significant manner, but the monastery tradition is that it was never abandoned.

GOING BACK IN TIME, ONE OF THE MOST SERIOUS CRISES TOOK
PLACE IN THE NINTH CENTURY. The monastery, which had remained faithful to
the Orthodox doctrine, had passed unharmed through the turbulent period in which a series of
bitter theological disputes had shaken the Christian world, rebounding across the Mediter-
ranean. Not everyone made it through unharmed: the nearby community of Wadi Feiran, for ex-
ample, which had long been the region's most important religious center, went into a rapid and
unstoppable decline. Religious disputes had undermined its power, and following the Arab con-
quest of Egypt, which took place in 641, the continuous attacks from aggressive nomad tribes in

58-59 AND 59 UNTIL RECENTLY, ONE
ENTERED THE MONASTERY OF ST.
CATHERINE BY BEING LIFTED IN A LARGE
BASKET TO THE LEVEL OF AN ANCIENT
PORTAL IN THE WALL LOCATED SEVERAL
METERS OFF THE GROUND. THERE ARE
VERY FEW WINDOWS IN THE THICK
WALLS, ALONG WITH A SINGLE SMALL
CHAPEL THAT DATES TO THE SIXTH
CENTURY.

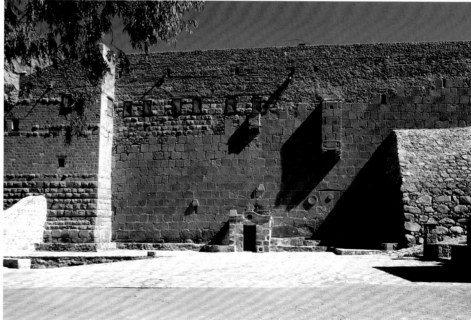

the region led to the gradual abandonment of the complex. The community at Gebel Musa maintained good relations with the new conquerors and was undisturbed for about two centuries, during which it consolidated its power and its independence. In the ninth century, however, the monastery was in peril, and it seemed that the religious center was doomed to disappear. It was then that St. Catherine arrived to change the monastery's fate.

60 AND 61 THE THICK WALL AROUND THE MONASTERY WAS BUILT OF BLOCKS OF RED GRANITE QUARRIED FROM THE SURROUNDING MOUNTAINS. THE SMOOTH SURFACE OF THE BLOCKS IS OCCASIONALLY INTERRUPTED BY BLOCKS BEARING RELIEF CARVINGS OF RELIGIOUS SYMBOLS. THE ELEMENT THAT APPEARS MOST OFTEN IS THE CROSS, WHICH IS SEEN ALONE OR ACCOMPANIED BY OTHER SYMBOLS. IT IS OFTEN SHOWN IN A SMALL SHRINE AND IS SOMETIMES INSCRIBED WITHIN A CIRCLE.

ST. CATHERINE

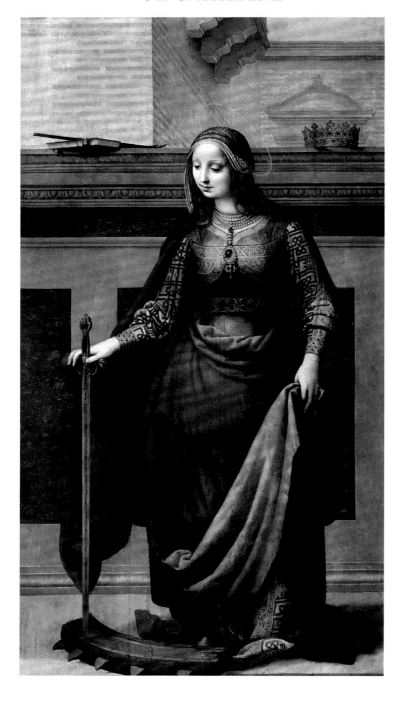

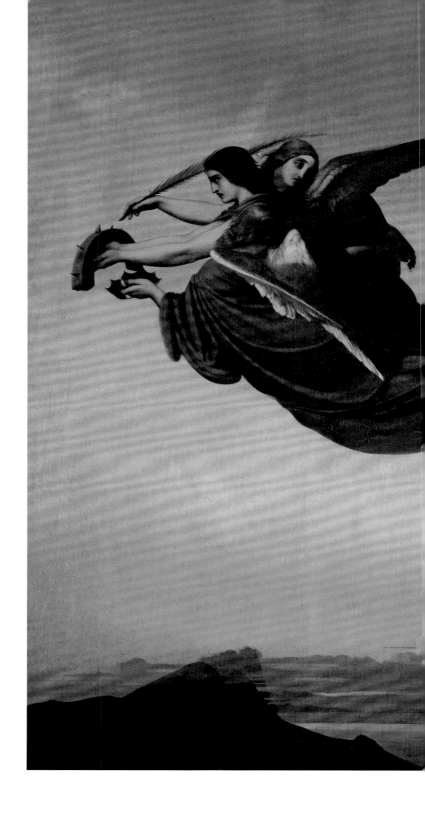

ST. CATHERINE HAD LIVED AND DIED FIVE HUNDRED YEARS EARLIER.

62 St. Catherine was a favored subject with medieval painters and maintained her popularity into the Renaissance, as indicated by this oil painting by the Spanish artist Fernando Yáñez de la Almedina, painted between 1505 and 1510 and is now in the Museo del Prado, Madrid.

62-63 The body of St. Catherine is carried toward the Sinai by a group of angels in this oil painting by the German artist Henri Lehmann, painted in 1839 and is now in the Musée Fabre, Montpellier.

Born in Alexandria around 292 to a family of the royal line, she had died a martyr at age eighteen. Her legend recounts that she protested to Emperor Maxentius because he worshiped pagan idols, and that the emperor, to break her faith, had her confronted by fifty philosophers. Their attempts to convince her that Christ, having died on the cross, could not be God failed miserably, and in fact the learned and intelligent girl refuted all their arguments so convincingly that the fifty philosophers converted to Christianity.

Maxentius had the philosophers burnt alive,

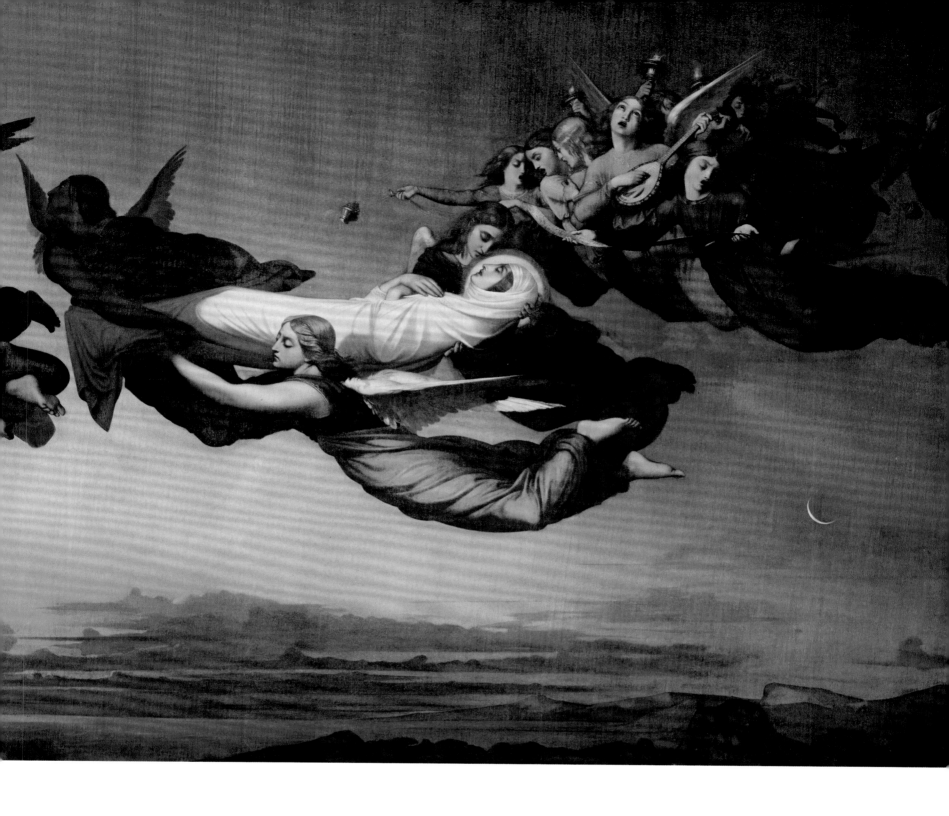

who thereby earned the title of martyrs, and he condemned Catherine to be tortured on the wheel. At her approach, however, the wheel miraculously fell to pieces, at which she was taken out of the city and decapitated. According to legend, milk flowed from her severed neck in place of blood, for which reason she became the patron saint not only of teachers, booksellers, and lawyers, but also of wet-nurses.

Catherine was buried at Alexandria, but angels were said to have descended from the sky to take up her body and carry it to the peak of Mount Saint Catherine. There, in the ninth century, the monks of Sinai announced the discovery of the remains of the saint, which were brought into the monastery and buried in the church. This church, which Emperor Justinian had had built around 550 in memory of his wife Theodora, had originally been called the Basilica of the Transfiguration after the beautiful mosaic that decorates the upper part of the apse. From then on, however, the church and the entire complex adopted the name of St. Catherine.

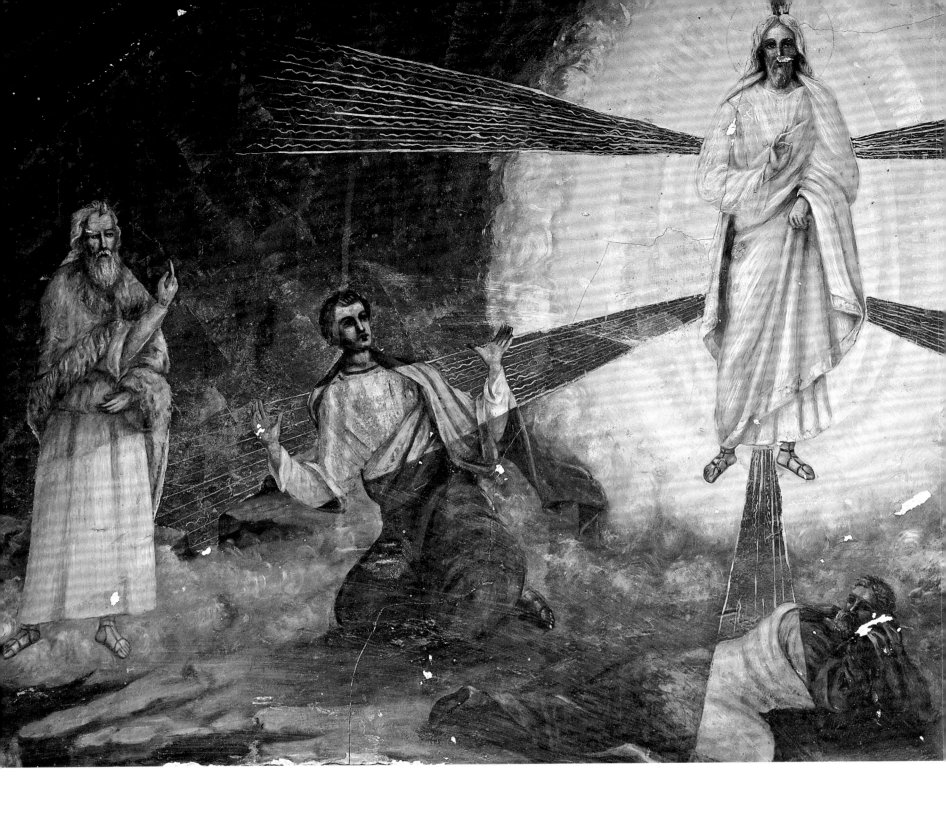

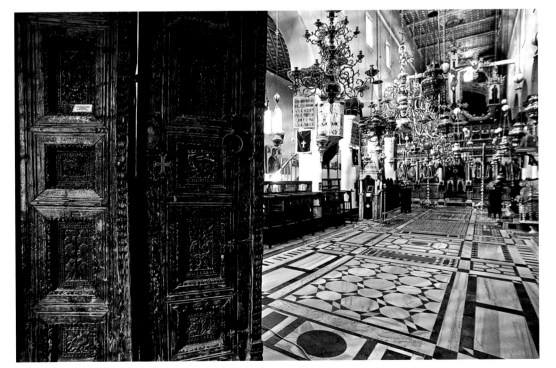

64-65 The episode of the Transfiguration of Christ, the subject of the mosaics decorating the apse of the basilica, also appears on the intrados of the vault over the western entrance to the church, which leads to the narthex.

64 bottom Access to the monastery church is by way of precious wood doors that date to the sixth century. The doors are composed of four panels that bear relief carvings of plants, birds, fish, and mammals.

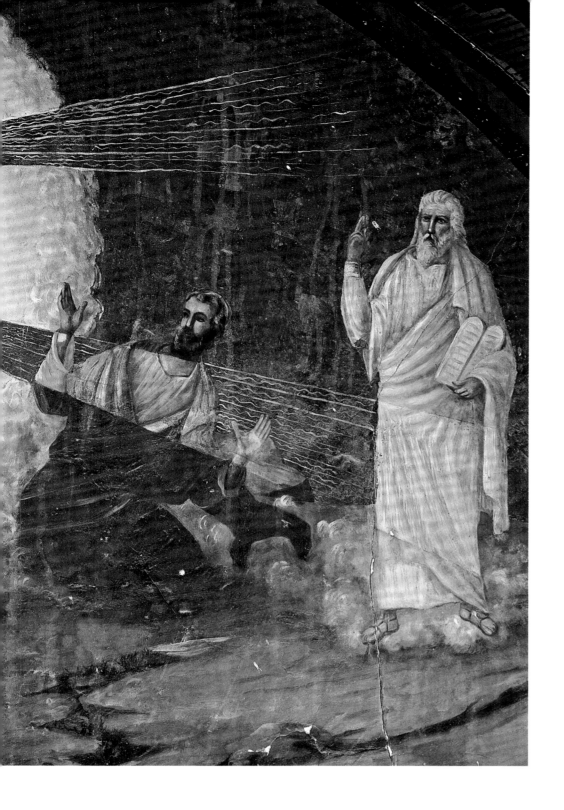

STILL THE MONASTERY'S MOST IMPORTANT BUILD-ING, the church is divided into a nave and side aisles by two rows of free-standing granite columns. An icon is hung on each of the twelve columns that corresponds to a month of the year and that depicts, against a gilt background, the saints that are celebrated during that month. The succession of the months is marked by a candle lit in front of the icons. The basilica is flanked by chapels dedicated to Saints Cosmas and Dami-an, to Saint Simeon the Stylite, Saints Joachim and Anna, the Forty Martyrs of the Sinai, and to St. James the Less, St. Antipa, to Saints Constantine and Helen and finally to St. Marina, who was from Pisidia of Cilicia. She became a martyr for Christ at the age of fifteen, in the year 270. Her memory is celebrated on July 17.

1 • Crusader Doors

2 • Narthex

3 • Ancient Doors

4 • Pulpit

5 • Bishop's chair

6 • Iconostasis

7 • Altar

8 • Chancel

9 • Mosaic of the Transfiguration

10 • Chapel of the Burning Bush

11 • Chapel of St. Marina

12 • Chapel of Sts. Constantine and Helen

13 • Chapel of St. Antipas

14 • Sacristy

15 • Chapel of St. James

16 • Chapel of the Martyrs of the Sinai

17 • Sarcophagus of St. Catherine

18 • Chapel of Sts. Joachim and Anna

19 • Chapel of St. Symeon the Stylite

20 • Chapel of Sts. Cosmas and Damian

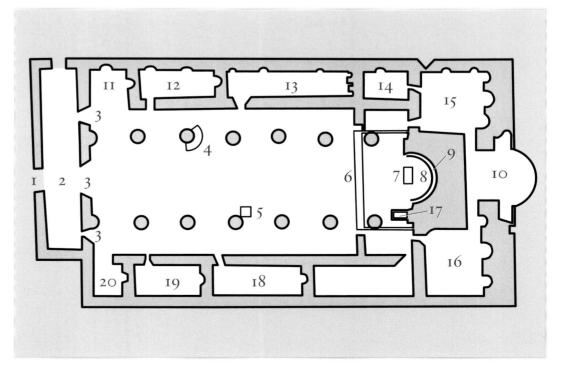

66 LEFT LOCATED BESIDE THE THIRD COLUMN ON THE RIGHT OF THE NAVE OF THE

BASILICA IS THE BISHOP'S CHAIR, WHICH DATES TO THE EIGHTEENTH CENTURY.

66 RIGHT THE BASILICA IS DIVIDED INTO A NAVE AND SIDE AISLES BY MASSIVE GRANITE

COLUMNS. ARRANGED BETWEEN THESE COLUMNS ARE ROWS OF WOODEN CHAIRS.

67 THE INTERIOR OF THE BASILICA IS DECORATED WITH DOZENS OF PRECIOUS

LAMPS EXQUISITELY MANUFACTURED THAT HANG FROM THE CEILING.

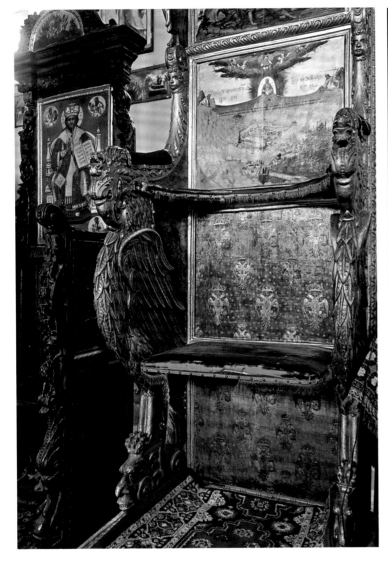

68 AND 69 THE FLOOR OF THE

BASILICA IS COVERED BY GEOMETRIC

DESIGNS MADE WITH COLORED

STONES BY NAZRALLAH, A

CHRISTIAN ARTISAN FROM

DAMASCUS, IN THE YEAR 1715.

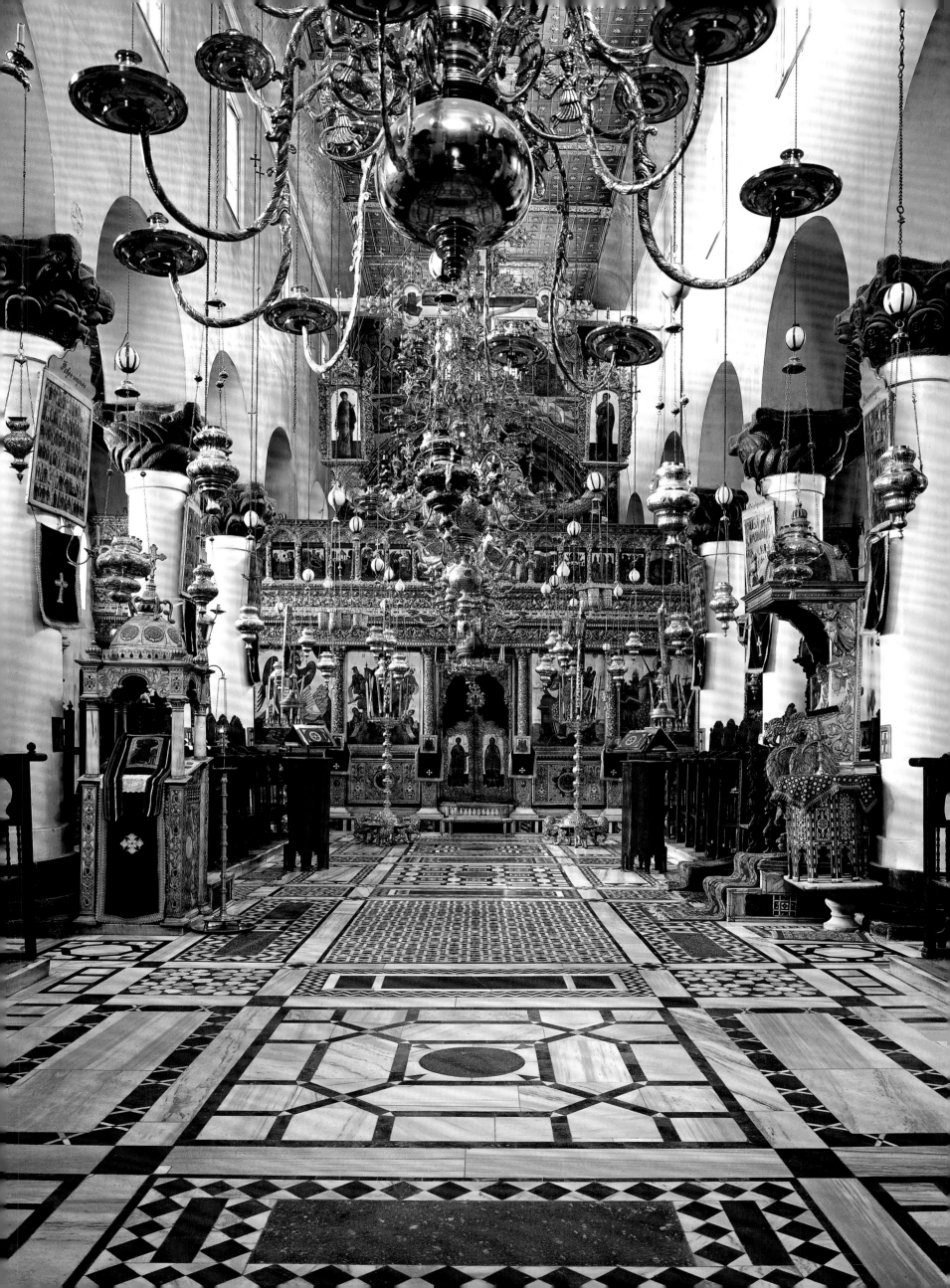

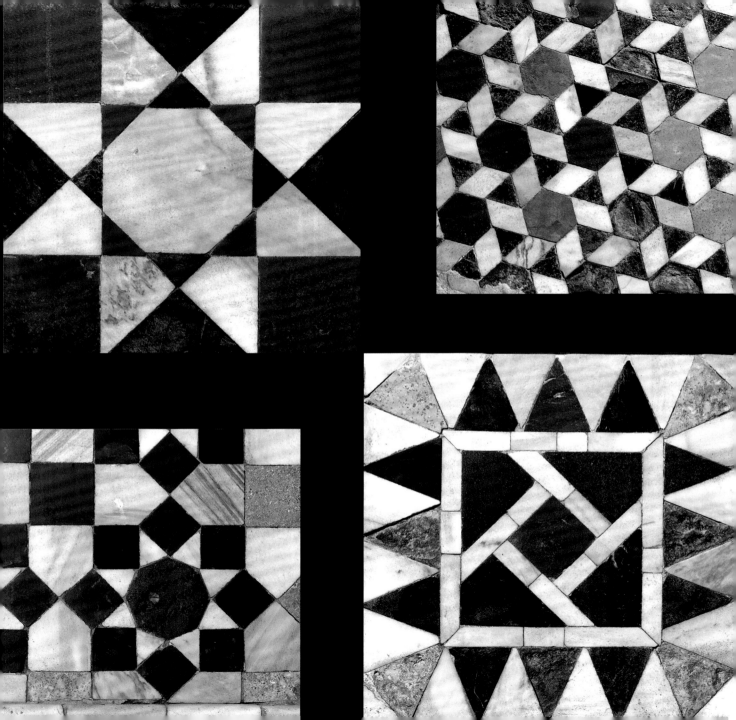

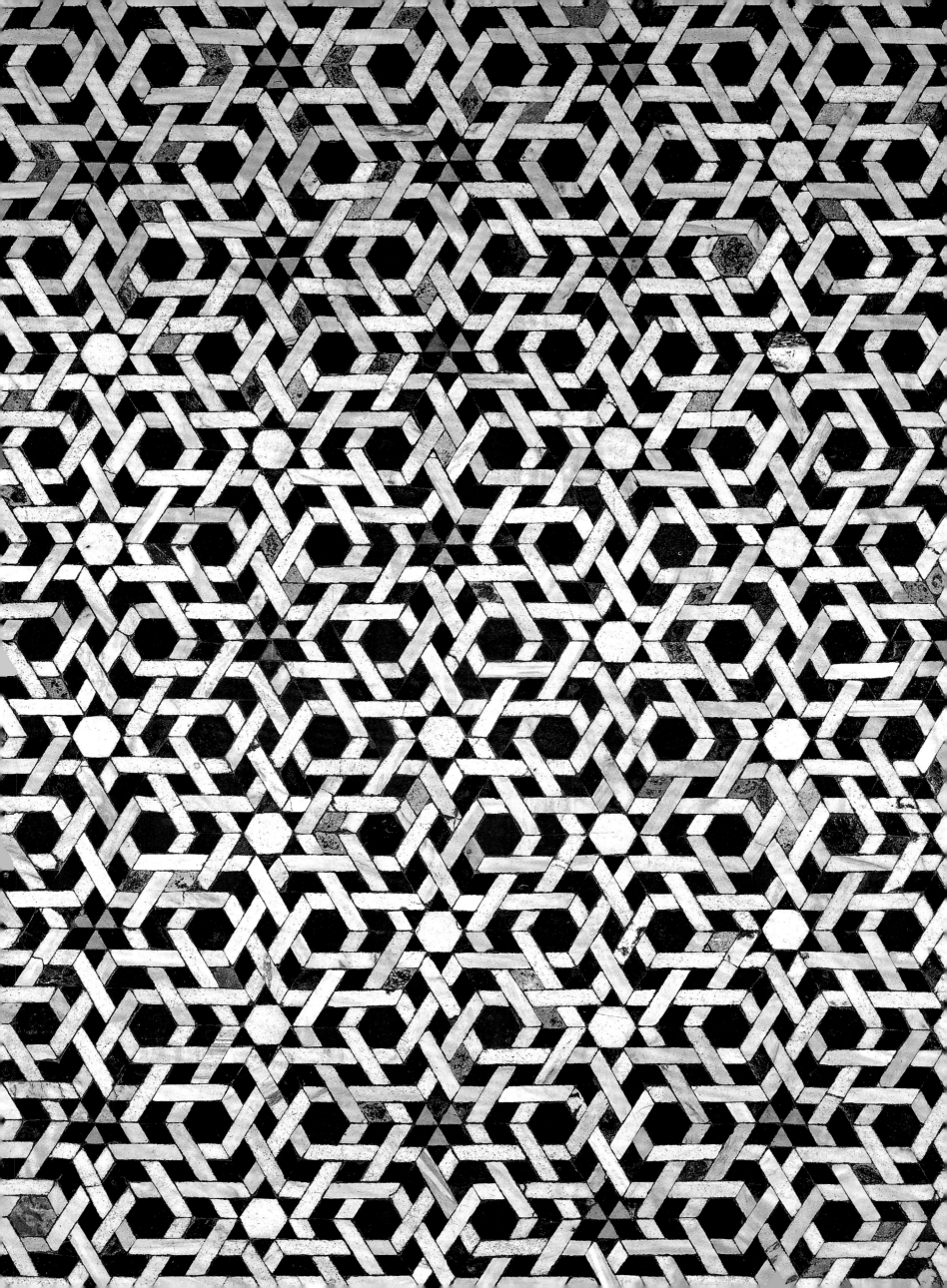

70 The first chapel on the right in the basilica is dedicated to Saints Cosmas and
Damian. These twin brothers lived in Cilicia in the third century and practiced
medicine. They were decapitated during the persecution of Christians unleashed by
Emperor Diocletian.

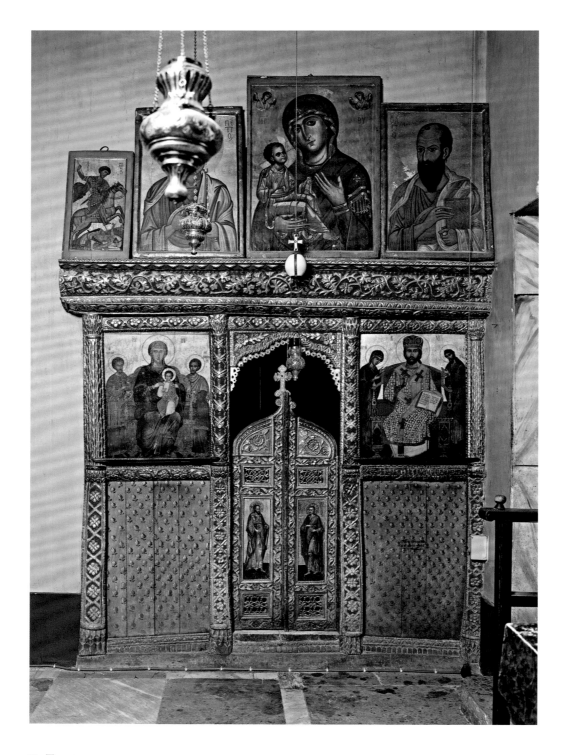

71 The central body of the basilica
is flanked by two rows of chapels
dedicated to various saints. The
first chapel on the left is dedicated
to the worship of St. Marina, who
became a martyr at the age of
fifteen in Pisidia of Cilicia.

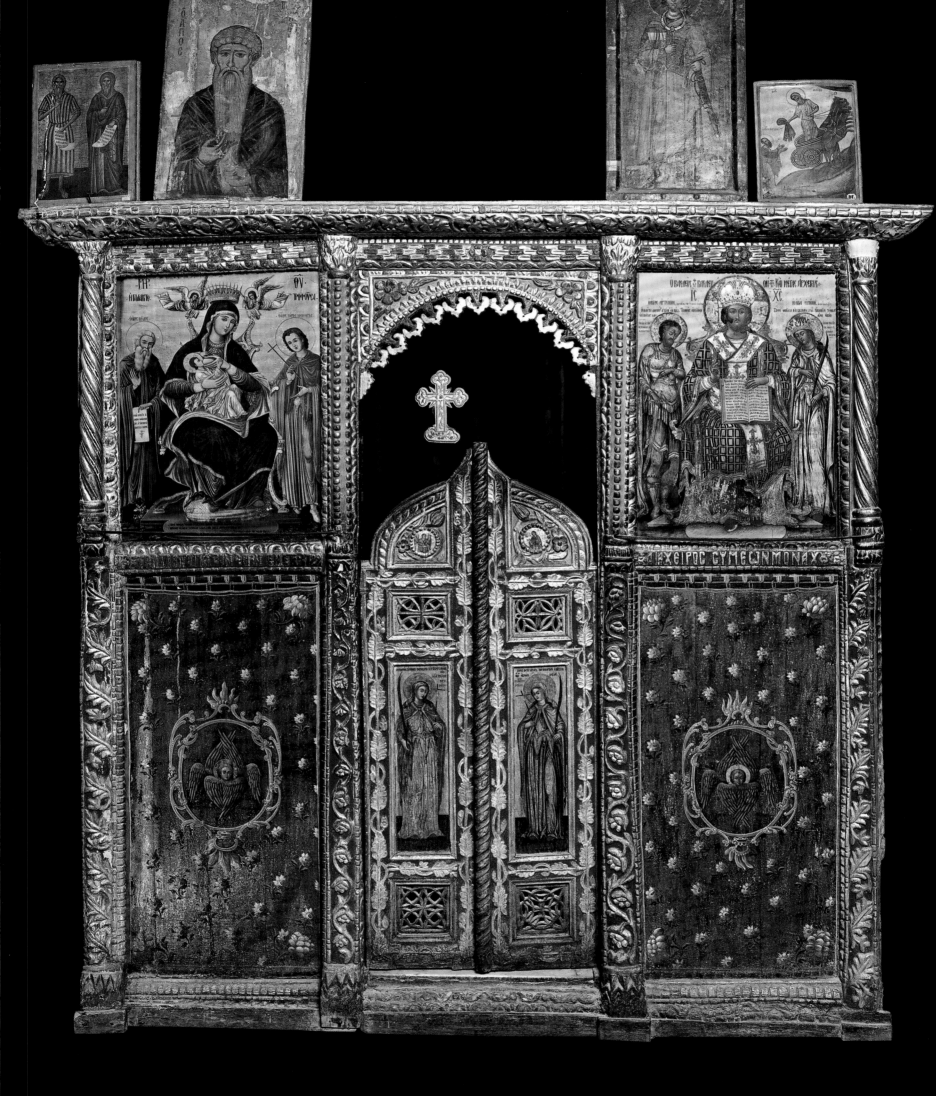

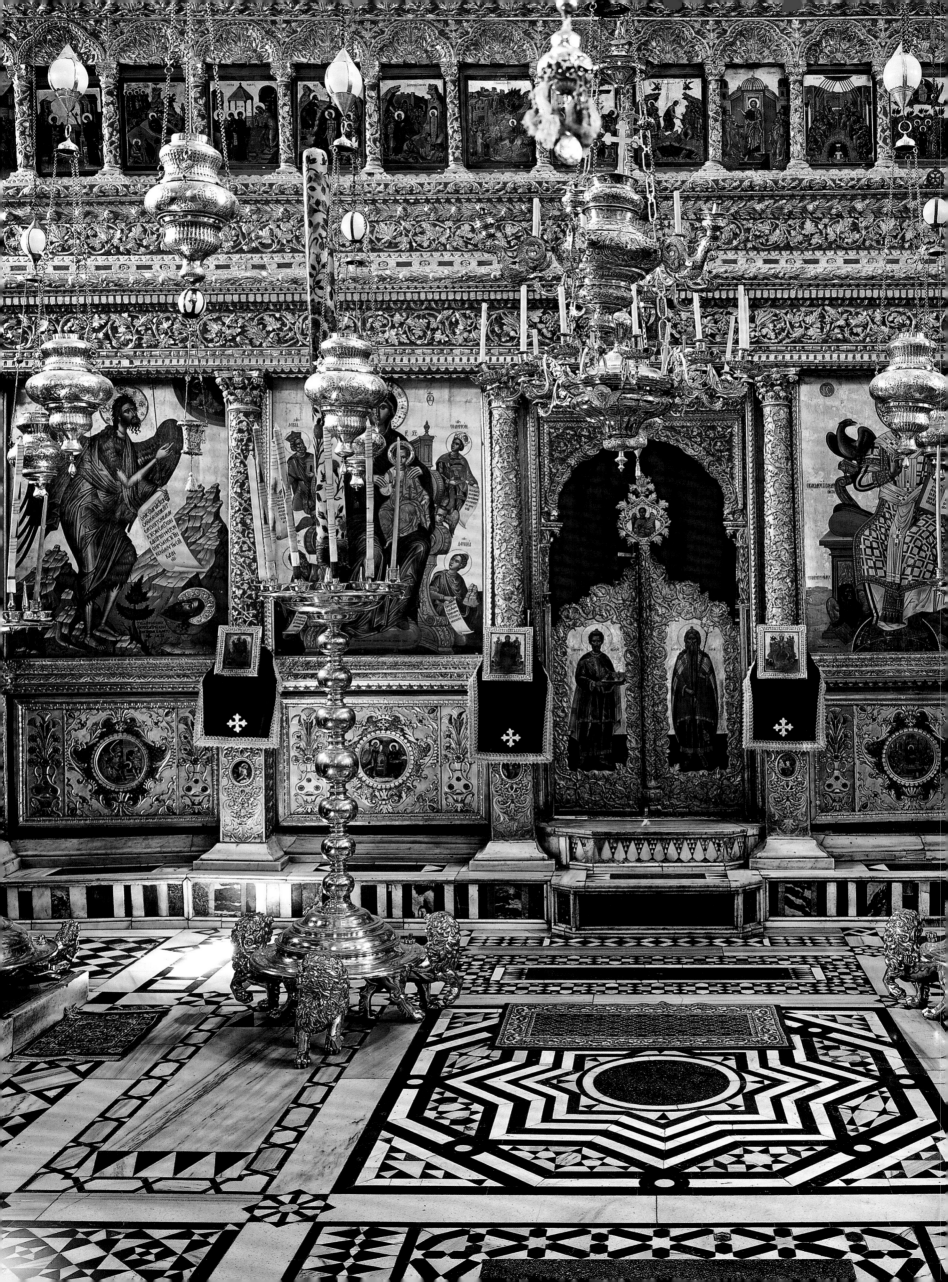

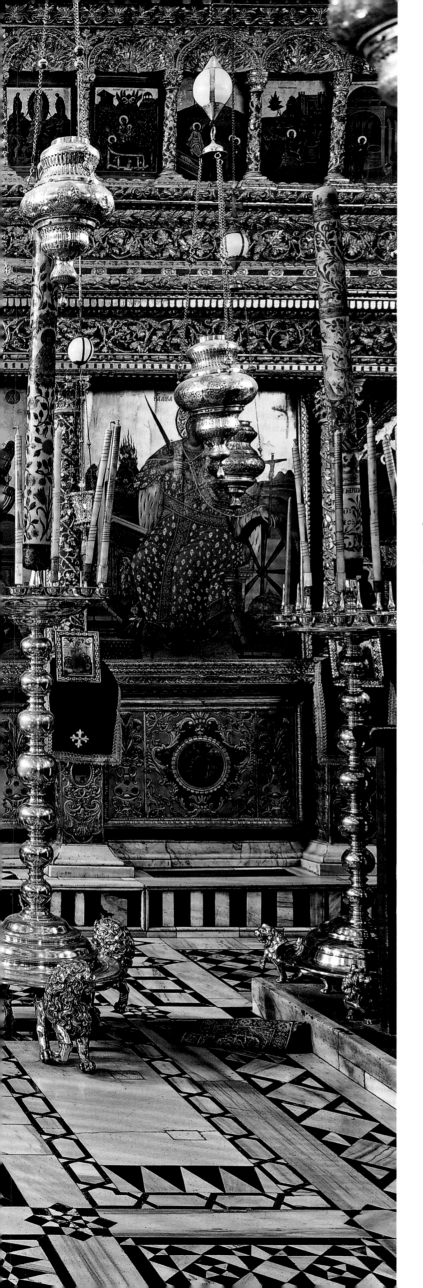

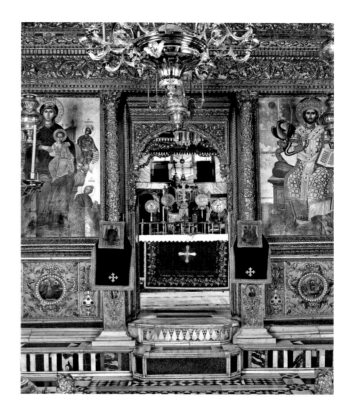

THE APSE OF THE CHURCH OF ST. CATHERINE IS SEPARATED FROM THE NAVE BY AN ICONOSTASIS,

a large, richly decorated panel that acts as partition. Made in 1778, the iconostasis bears large depictions of Jesus, Mary, John the Baptist, and St. Catherine, painted by the monk Jeremiah of Crete, accompanied by smaller icons and framed by finely carved gilt-wood bands. The effect of opulence is increased by precious candelabra and by the many lamps that hang from the ceiling, which in turn is decorated with gold stars on a green ground.

72-73 AND 73 THE REAR WALL OF THE CENTRAL NAVE IS CLOSED OFF BY AN ICONOSTASIS, A LARGE WOODEN PANEL COVERED BY DECORATIONS. PAINTED BY THE MONK JEREMIAH OF CRETE IN 1778 IT CONTAINS FOUR DEPICTIONS OF JESUS, MARY, JOHN THE BAPTIST, AND ST. CATHERINE ACCOMPANIED BY A SERIES OF ICONS. A DOOR LOCATED IN THE CENTER OF THE ICONOSTASIS GIVES ACCESS TO THE AREA BEHIND IT, WHICH IS OCCUPIED BY THE ALTAR.

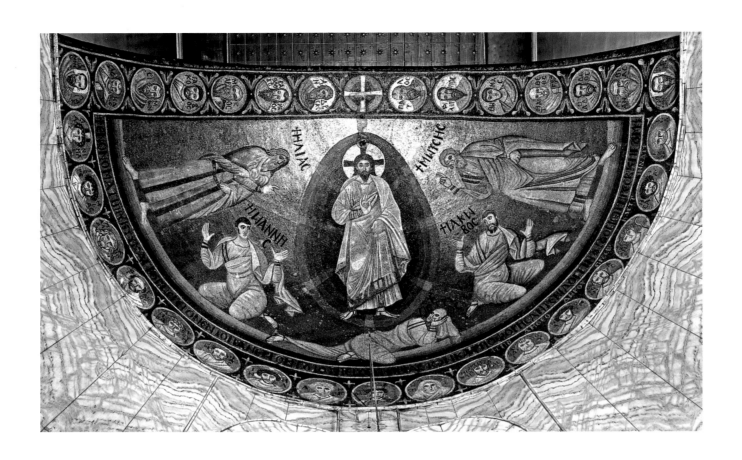

BEHIND THE ICONOSTASIS IS THE APSE, DECORATED WITH THE CELEBRATED MOSAIC OF THE *TRANSFIGURATION OF CHRIST,* WHICH WAS MADE DURING THE

74 AND 75 THE HALF-DOME OVER THE APSE OF THE BASILICA IS DECORATED WITH THE TRANSFIGURATION. MADE IN THE SIXTH CENTURY BY ARTISTS OF THE IMPERIAL SCHOOL OF CONSTANTINOPLE, THIS IS ONE OF THE MOST BEAUTIFUL AND REFINED OF BYZANTINE MOSAICS. CHRIST IS PRESENTED AT THE CENTER IN THE ACT OF REVEALING HIS DIVINE NATURE TO THE DISCIPLES PETER (AT HIS FEET), JOHN, AND JAMES, AND IN THE PRESENCE OF MOSES AND ELIAS. SURROUNDING THE CENTRAL SCENE ARE MEDALLIONS WITH PORTRAITS OF PROPHETS, APOSTLES, AND SAINTS.

period of Justinian and which originally gave its name to the church. Its style and technical execution suggest that the mosaic was the work of artists of the imperial school in Constantinople. Christ is shown at the center, surrounded by a blue mandorla that makes him stand out against the gilt background of the composition and from which rays of light emerge. He is accompanied by the figures of Moses, Elias, St. James, St. John, and St. Peter. This central group is surrounded by a series of portrait medallions of prophets, apostles, and saints, all on gilt backgrounds. Above these are other scenes, including, to one side, *Moses Receiving the Ten Commandments,* in which he is presented clothed in a robe whose folds are rendered in a highly detailed manner, and, on the other, *Moses Removing His Sandals before the Burning Bush.*

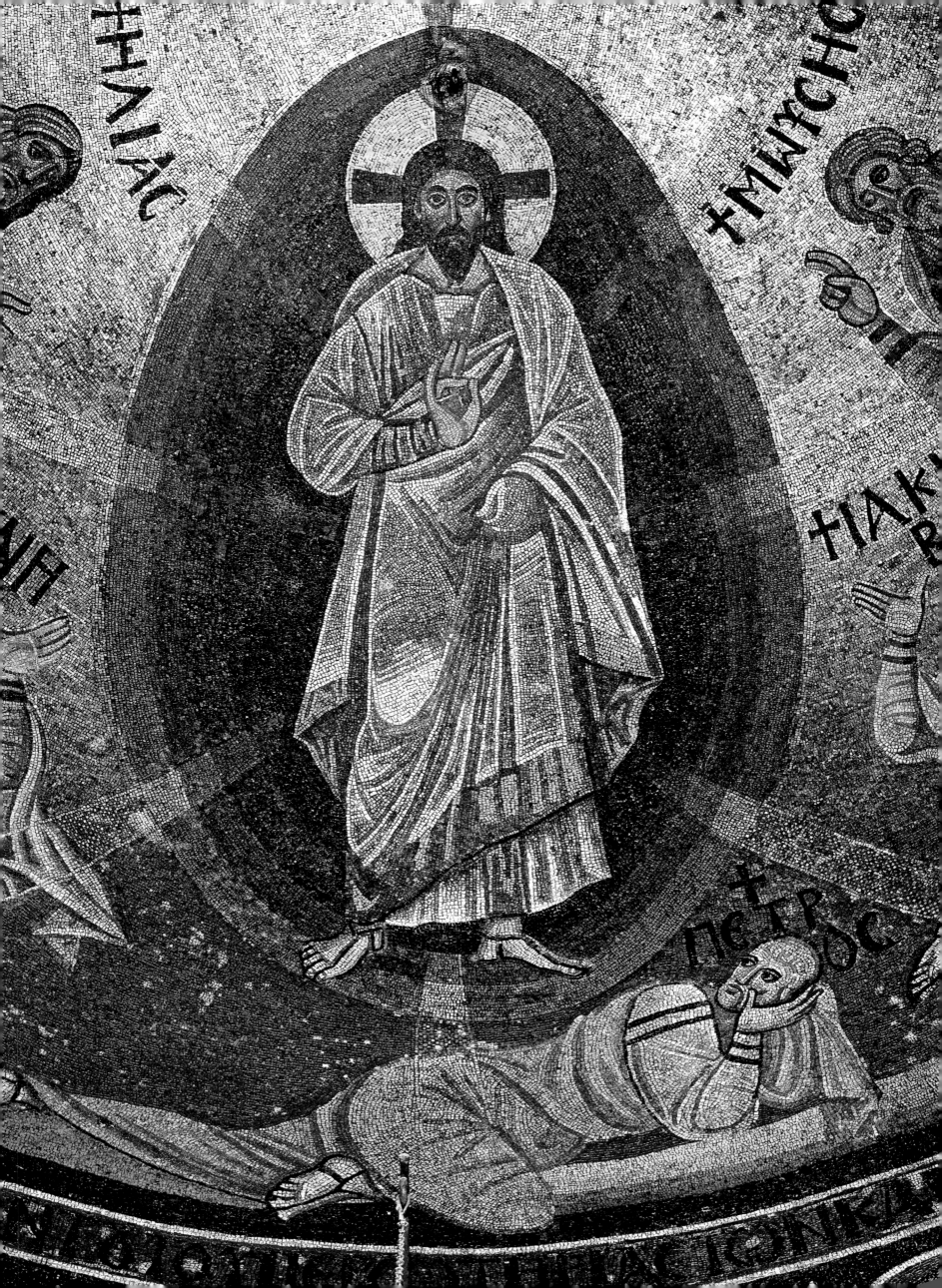

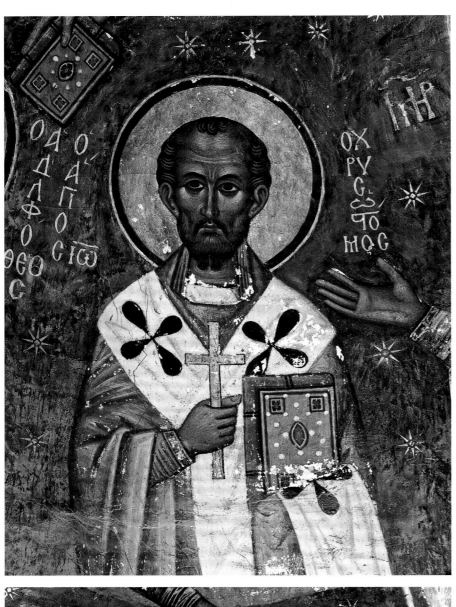

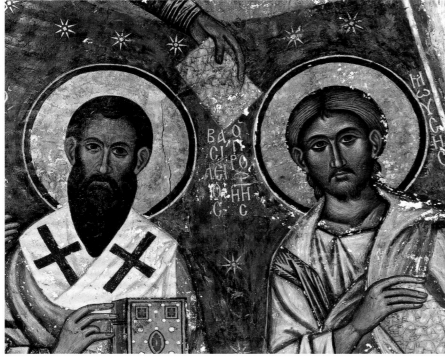

76 THIS FRESCO IS IN THE APSE OF THE ST. JAMES CHAPEL.

MADE IN THE SECOND HALF OF THE FIFTEENTH CENTURY, IT

PRESENTS CHRIST PANTOCRATOR WITH THE VIRGIN AND

SAINTS JOHN CHRYSOSTOM, JAMES, BASIL, AND MOSES.

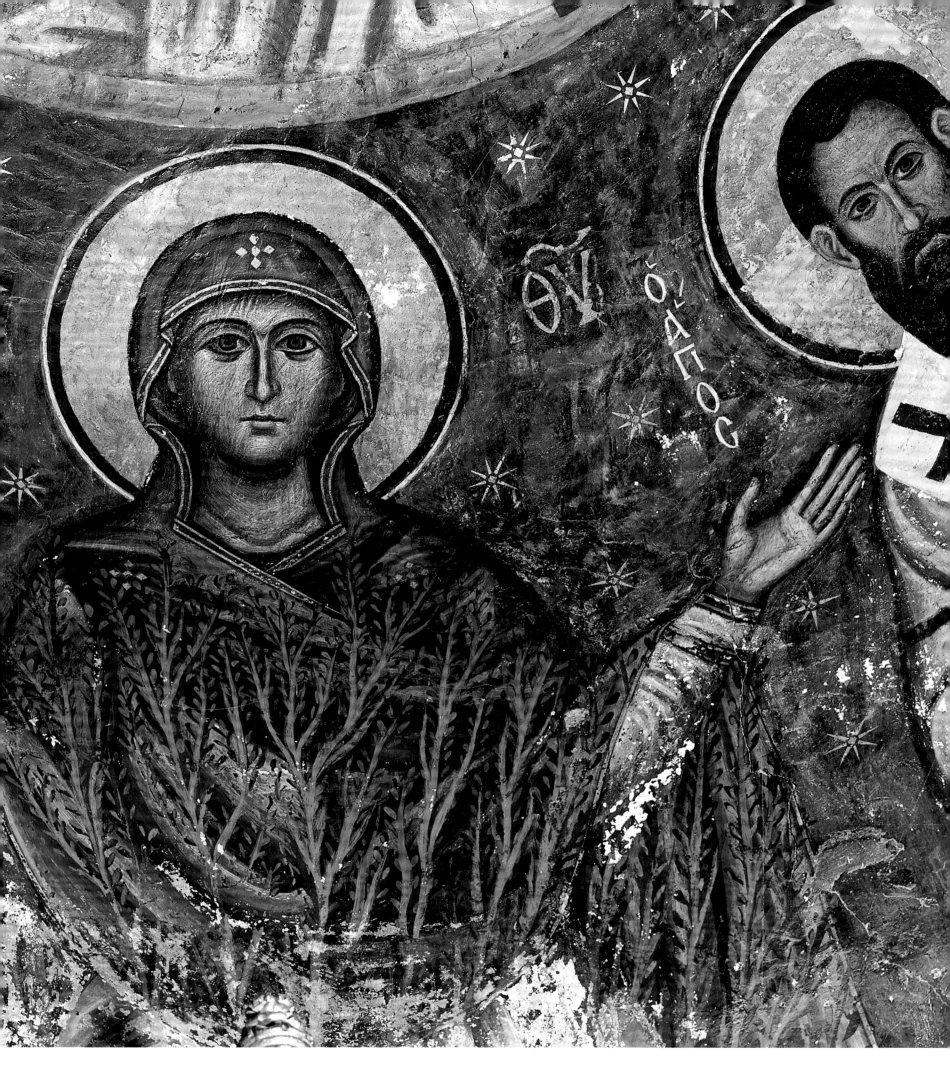

76-77 The figures in the fresco in the St. James chapel are dressed in garments of red and white and are identified by names written beside their heads, which are encircled by brilliant gold halos that stand out against the background of a starry blue sky.

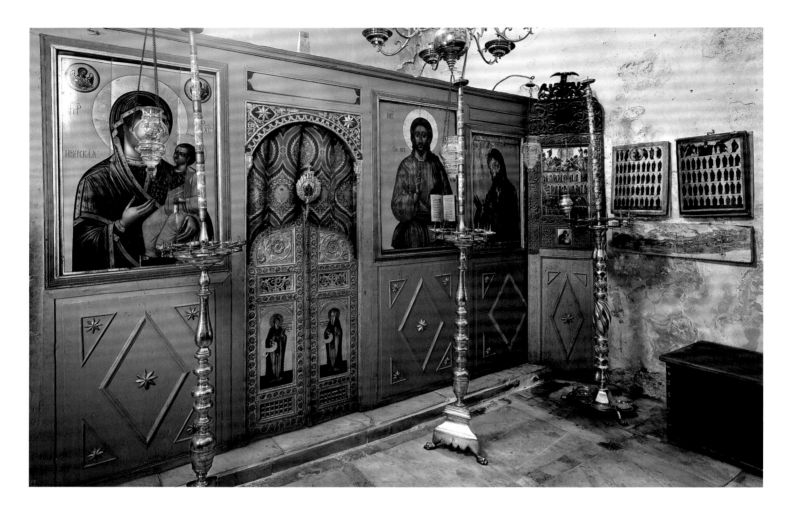

78 TOP THE CHAPEL OF THE BURNING BUSH IS FLANKED BY TWO SMALLER CHAPELS, ONE OF WHICH IS DEDICATED TO THE FORTY MARTYRS OF THE SINAI. DIVIDED IN TWO BY A BEAUTIFUL WOODEN ICONOSTASIS DECORATED WITH PAINTINGS AND ICONS, THE CHAPEL IS FURTHER ADORNED BY PRECIOUS LAMPS AND BRASS CANDLE STANDS.

78 BOTTOM AND 79 THE APSE OF THE BASILICA IS DRESSED PARTLY IN BOOKMATCHED PANELS OF GRAINED MARBLE, PARTLY WITH DESIGNS MADE WITH TESSERAE OF COLORED MARBLE IN THE LOWER AREA.

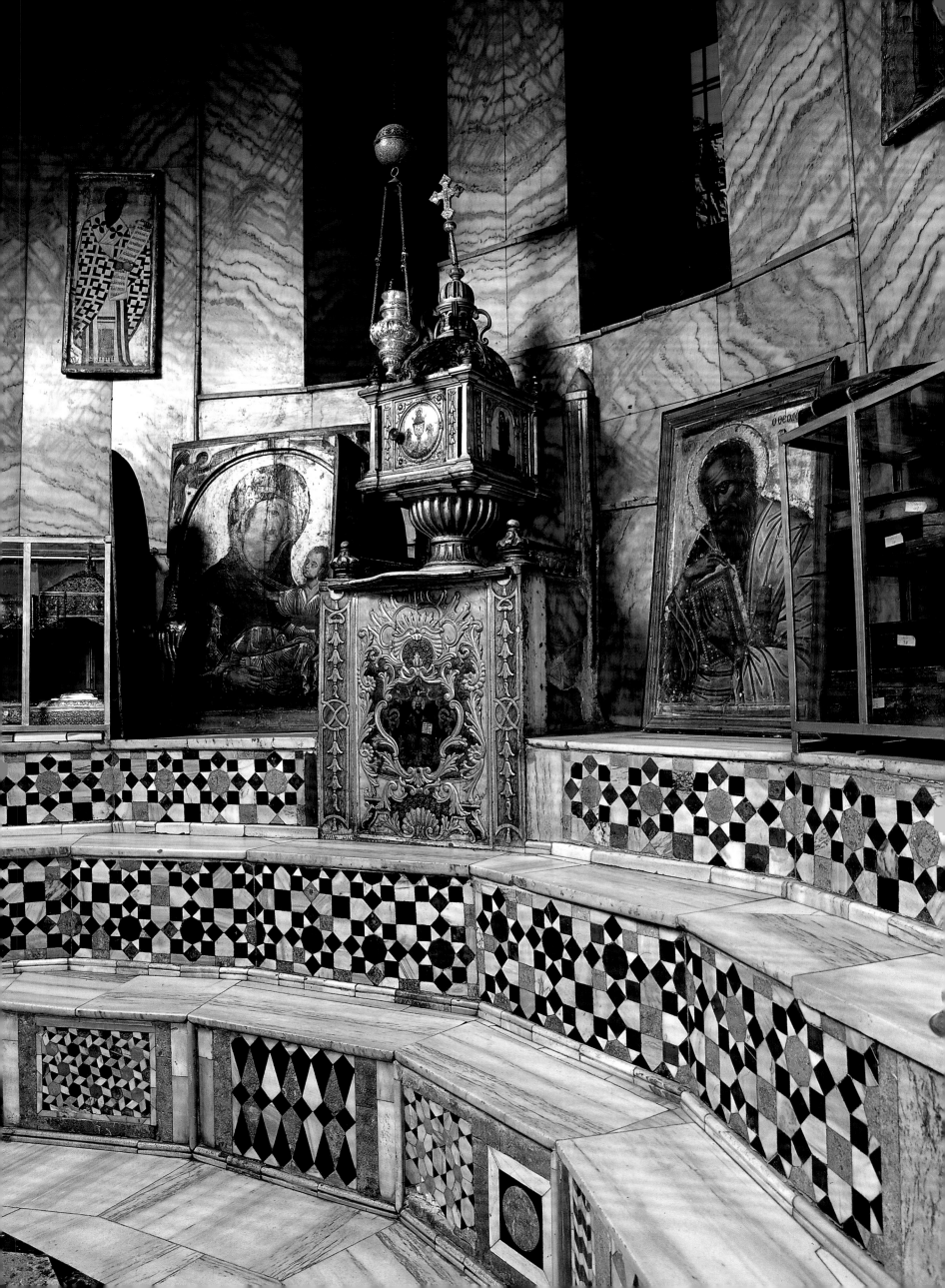

80 and 80-81 In the rear of the basilica of St. Catherine, hidden by the many wonders of the church, is the Chapel of the Burning Bush, dressed in bright blue-and-white tiles and decorated with precious icons and sacred ornaments in silver. The precise spot where the bush is believed to have stood is indicated by a silver plaque. This area was not included within the original church that Justinian built and was incorporated into the building at a slightly later date.

ON THE SIDE OF THE CHOIR IS THE TOMB OF ST. CATHERINE, which preserves the saint's skull wearing a crown and her jeweled left hand. Behind the apse is the Chapel of the Burning Bush, decorated with seventeenth-century tiles from Damascus. It stands on the site of the very first sanctuary, which Empress Helen had built around the year 330. The church also has a square bell tower that has three tiers with a succession of pairs of arches and was built in 1871, with bells donated by the Russian church.

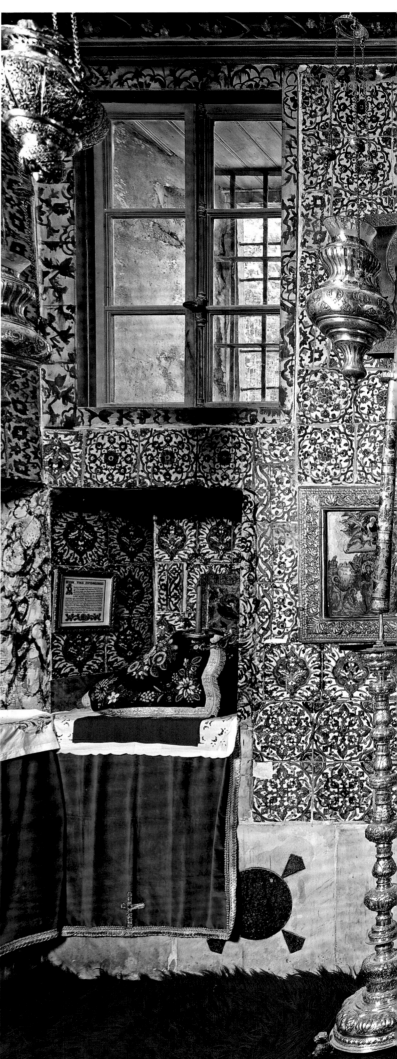

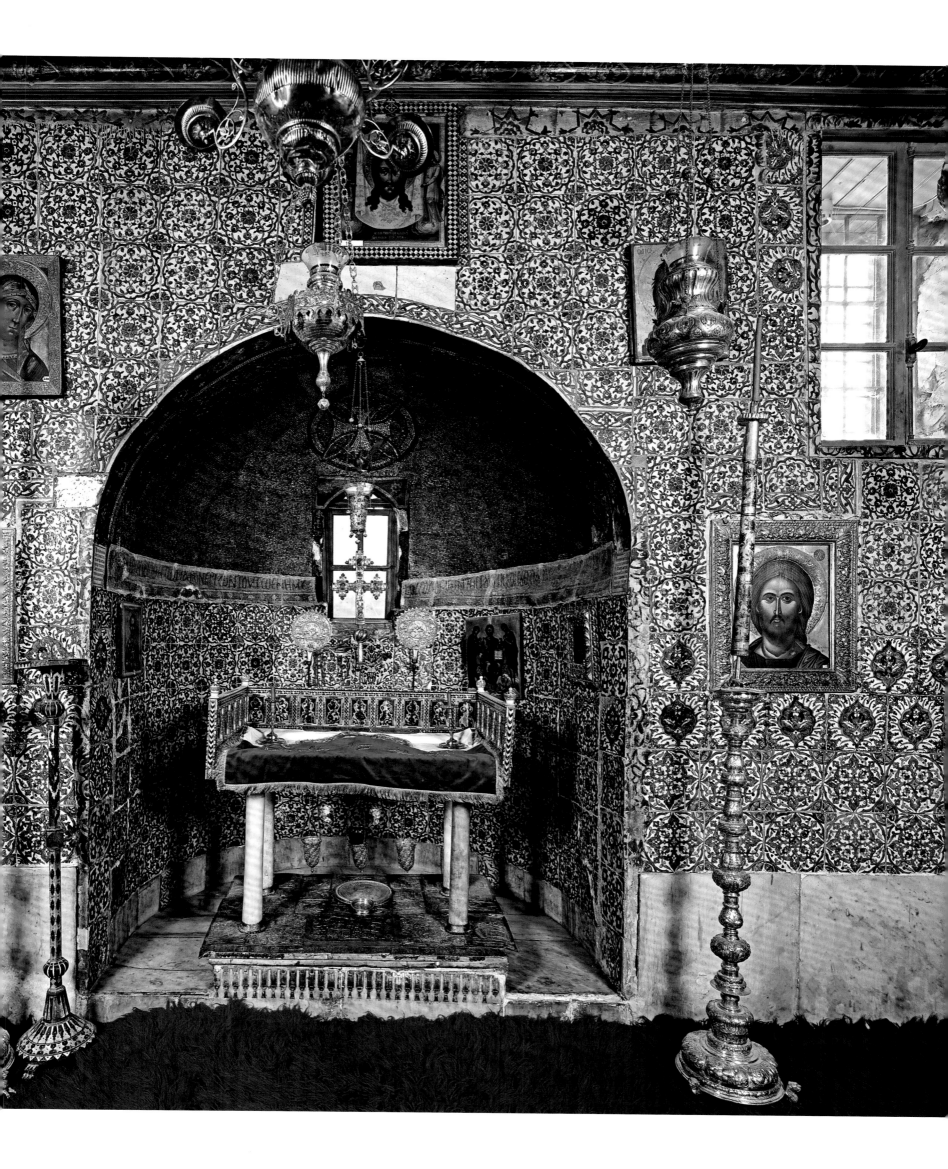

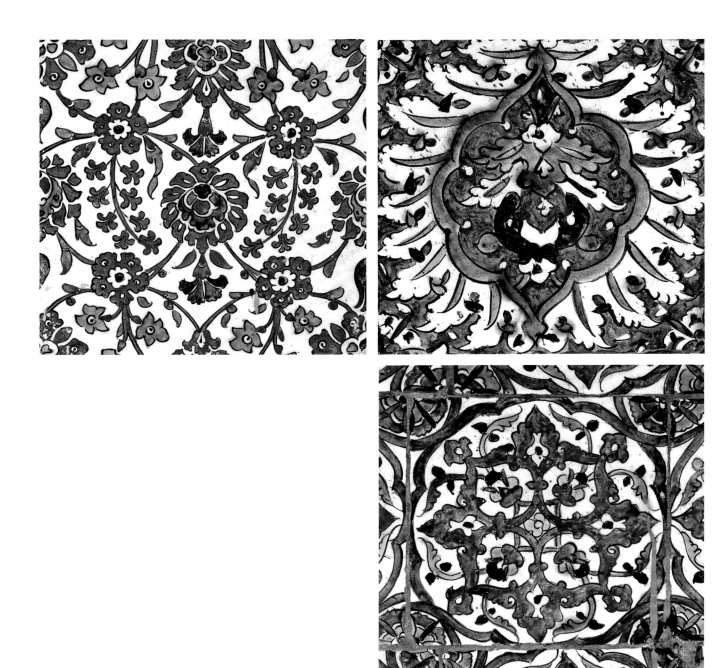

82 AND 83 THESE IMAGES OFFER VIEWS OF
THE VARIETY OF THE TILES THAT DECORATE
THE CHAPEL OF THE BURNING BUSH.
THESE DATE TO THE SEVENTEENTH
CENTURY AND WERE MADE WITH
ELABORATE GEOMETRIC AND VEGETAL
MOTIFS IN BLUE, TURQUOISE, AND GREEN
WITH TOUCHES OF LILAC THAT STAND OUT
AGAINST THE WHITE BACKGROUND.

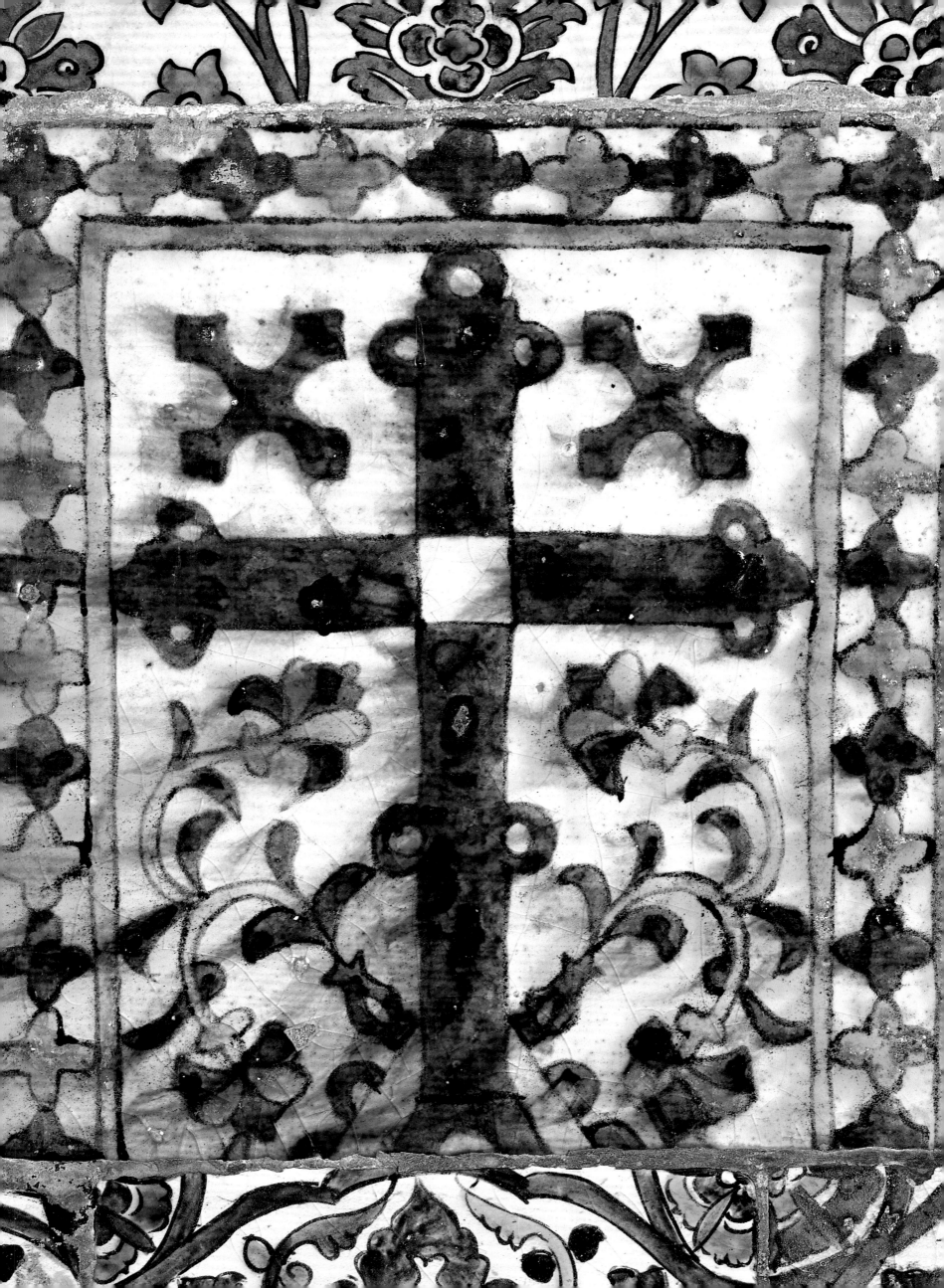

84 THE MONASTERY AND THE VASTNESS OF THE DESERT PRESENTED IN A NINETEENTH-CENTURY LITHOGRAPH BY DAVID ROBERTS.

84-85 DAVID ROBERTS PORTRAYED THE MONKS OF THE MONASTERY OF ST. CATHERINE IN THIS EVOCATIVE PANEL.

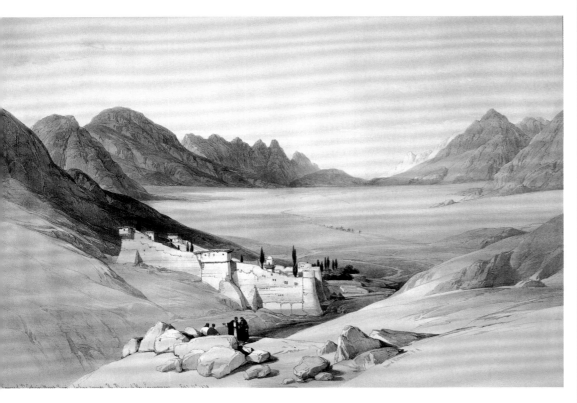

THE TREASURES
OF THE
MONASTERY

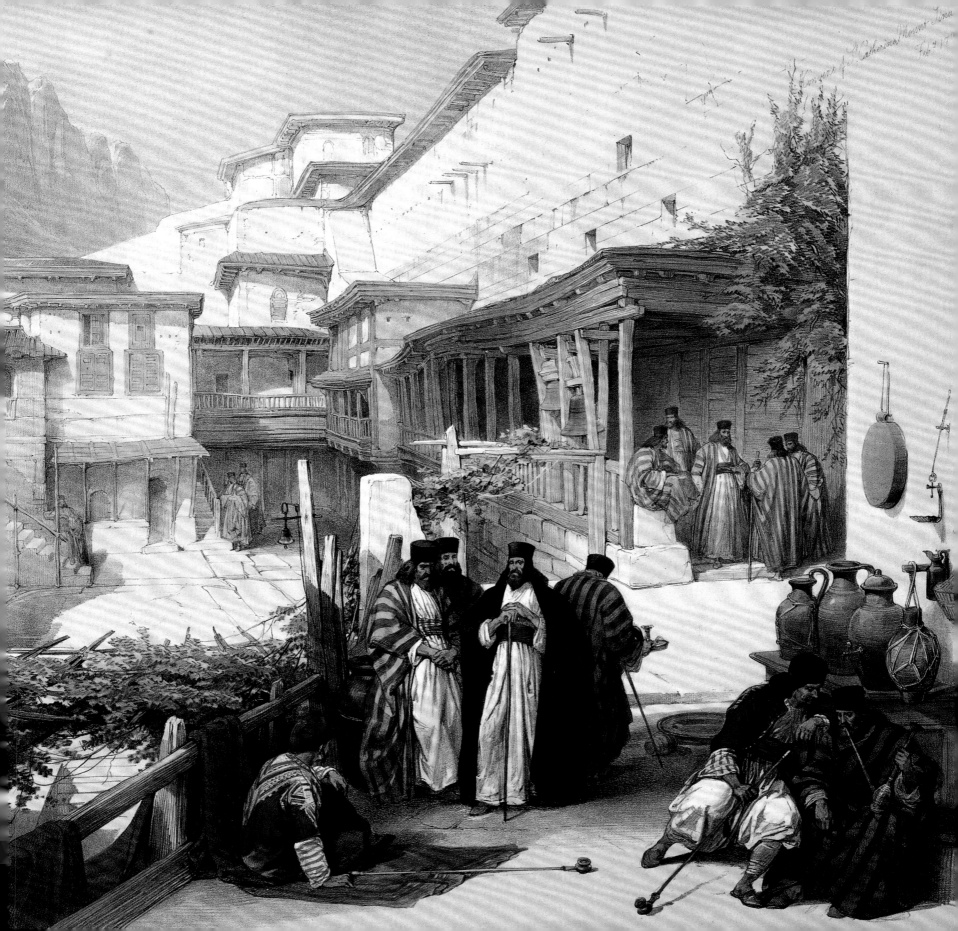

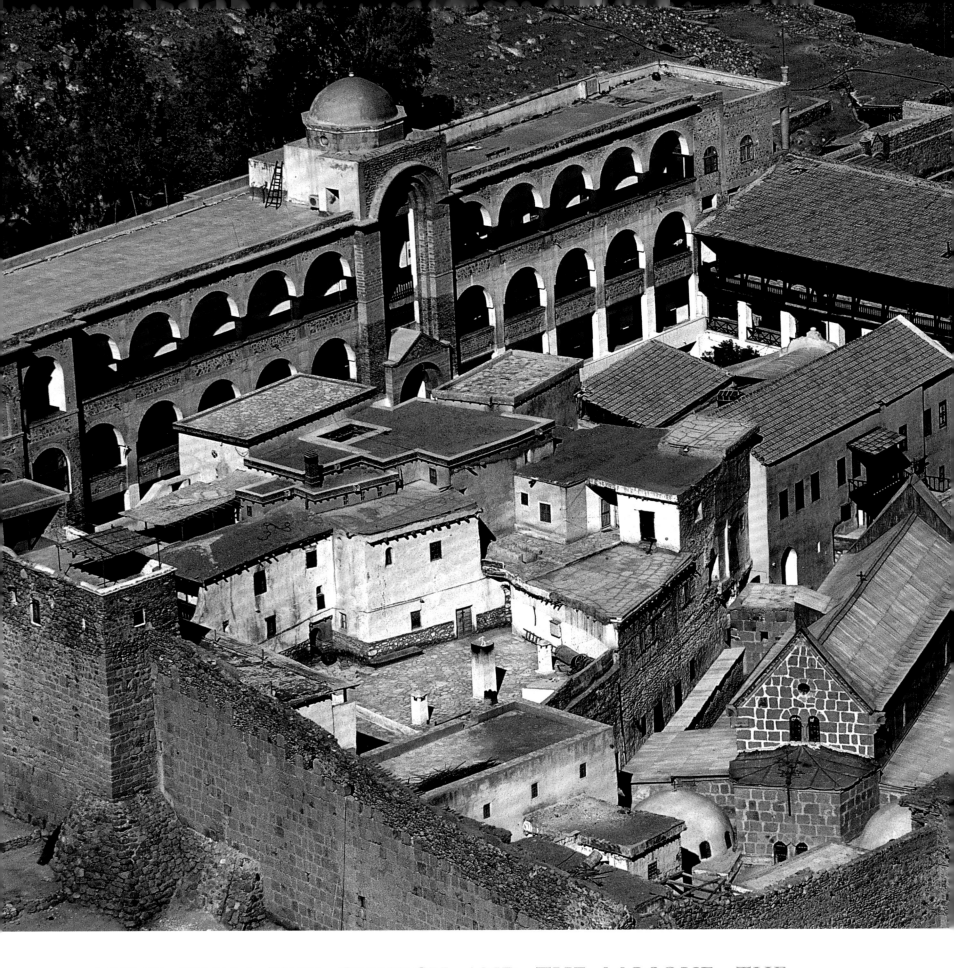

ASIDE FROM THE CHURCH AND THE MOSQUE, THE QUADRANGLE WITHIN THE MONASTERY IS OCCUPIED

by a series of structures built at different times and in different styles. These serve the various functions and activities of the religious complex. The eastern side is partially occupied by a small, unpretentious rectangular structure where the monks live. The monks live in accordance with monastic rules extending to the dawn of Sinai monasticism in the early fourth century. The monks follow a Spartan regime, with fixed times for prayers and religious rites that begin before dawn and end after sunset.

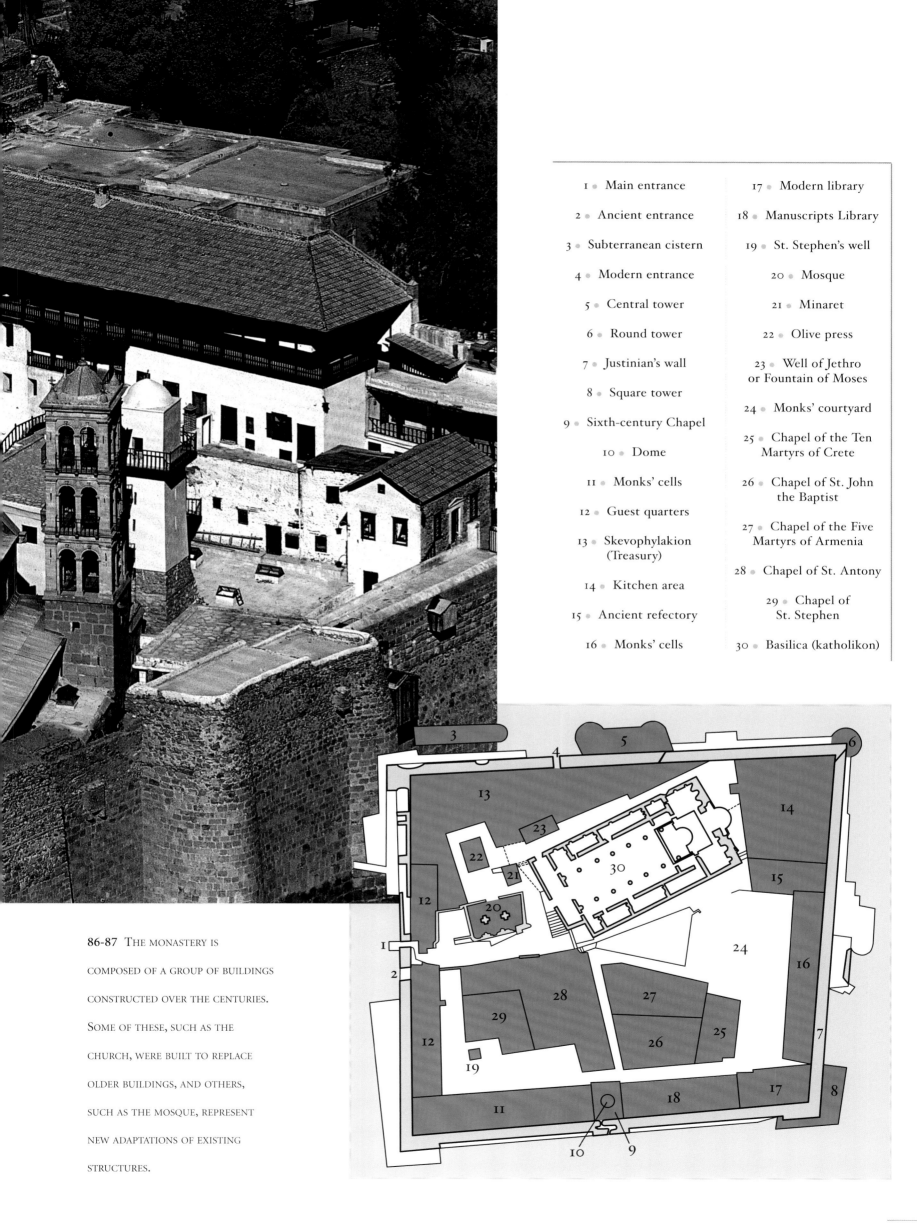

1 • Main entrance
2 • Ancient entrance
3 • Subterranean cistern
4 • Modern entrance
5 • Central tower
6 • Round tower
7 • Justinian's wall
8 • Square tower
9 • Sixth-century Chapel
10 • Dome
11 • Monks' cells
12 • Guest quarters
13 • Skevophylakion (Treasury)
14 • Kitchen area
15 • Ancient refectory
16 • Monks' cells

17 • Modern library
18 • Manuscripts Library
19 • St. Stephen's well
20 • Mosque
21 • Minaret
22 • Olive press
23 • Well of Jethro or Fountain of Moses
24 • Monks' courtyard
25 • Chapel of the Ten Martyrs of Crete
26 • Chapel of St. John the Baptist
27 • Chapel of the Five Martyrs of Armenia
28 • Chapel of St. Antony
29 • Chapel of St. Stephen
30 • Basilica (katholikon)

86-87 THE MONASTERY IS COMPOSED OF A GROUP OF BUILDINGS CONSTRUCTED OVER THE CENTURIES. SOME OF THESE, SUCH AS THE CHURCH, WERE BUILT TO REPLACE OLDER BUILDINGS, AND OTHERS, SUCH AS THE MOSQUE, REPRESENT NEW ADAPTATIONS OF EXISTING STRUCTURES.

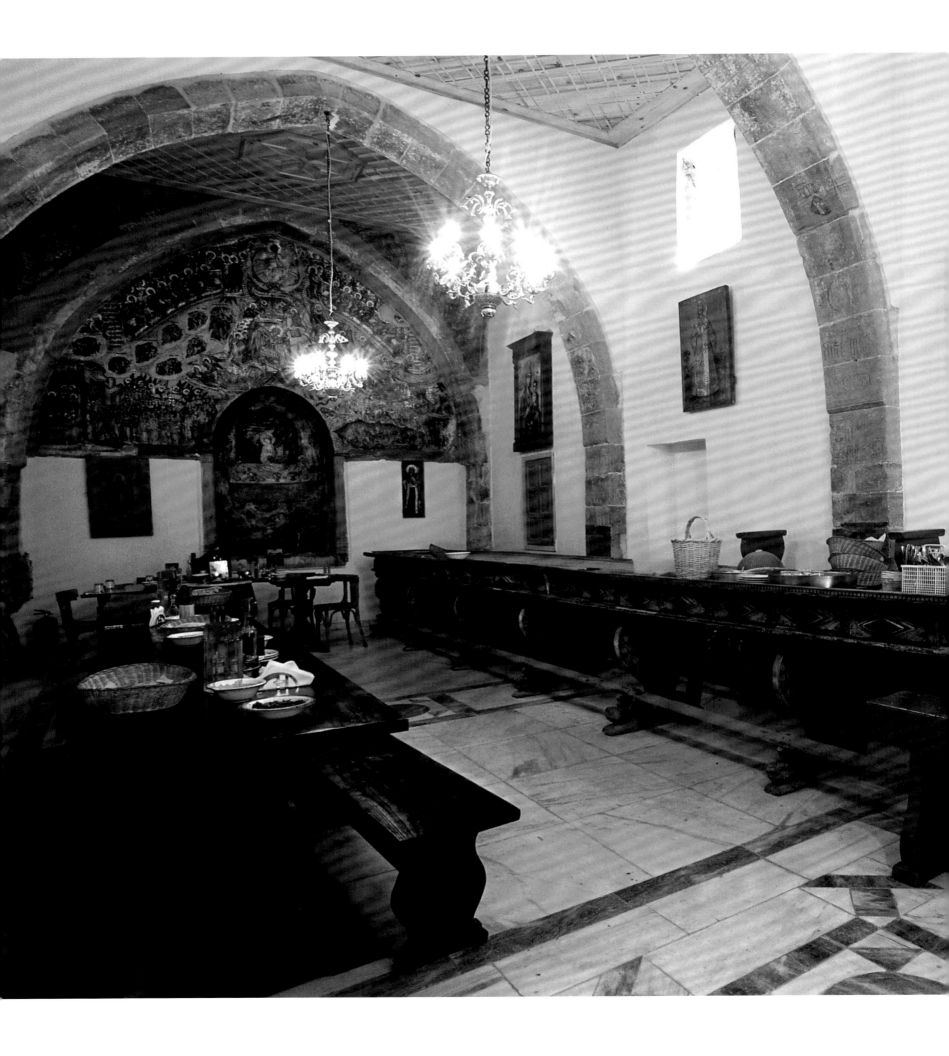

88-89 and 89 The monastery's Old Refectory is a long rectangular room marked off by pointed arches and furnished with a long wooden table brought from Corfu in the eighteenth century. Its decorations include a large fresco on the rear wall.

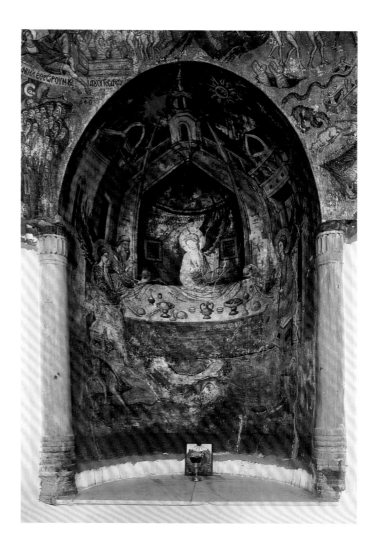

BESIDE THE MONKS' RESIDENCE STANDS A MEDIEVAL REFECTORY COMPOSED OF A vaulted room occupied by a large wooden table. One of its walls is entirely taken up by a large sixteenth-century painting of the *Last Judgment*, and almost all the wooden surfaces are covered with graffiti left by visitors and pilgrims from the West in the Middle Ages.

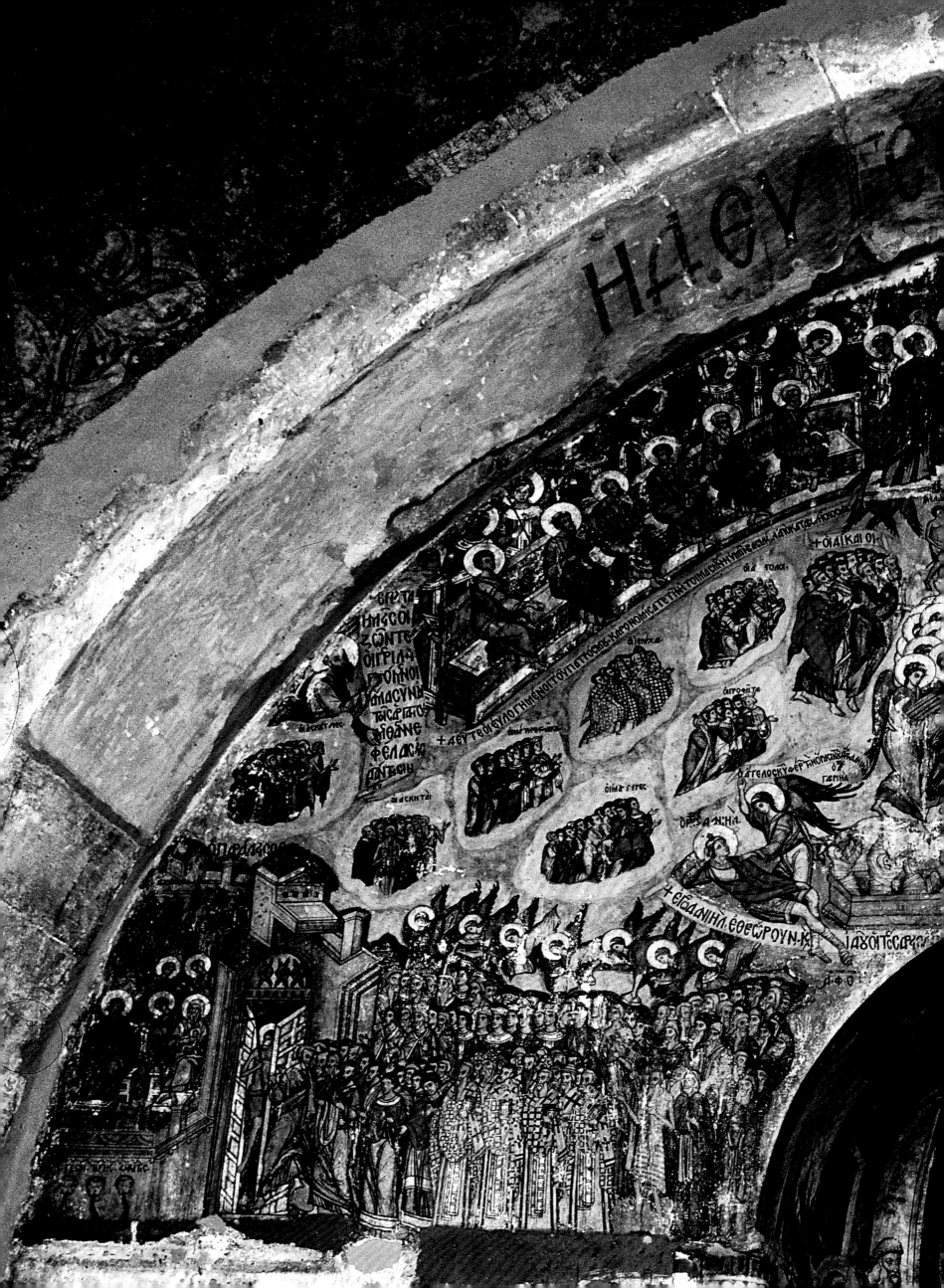

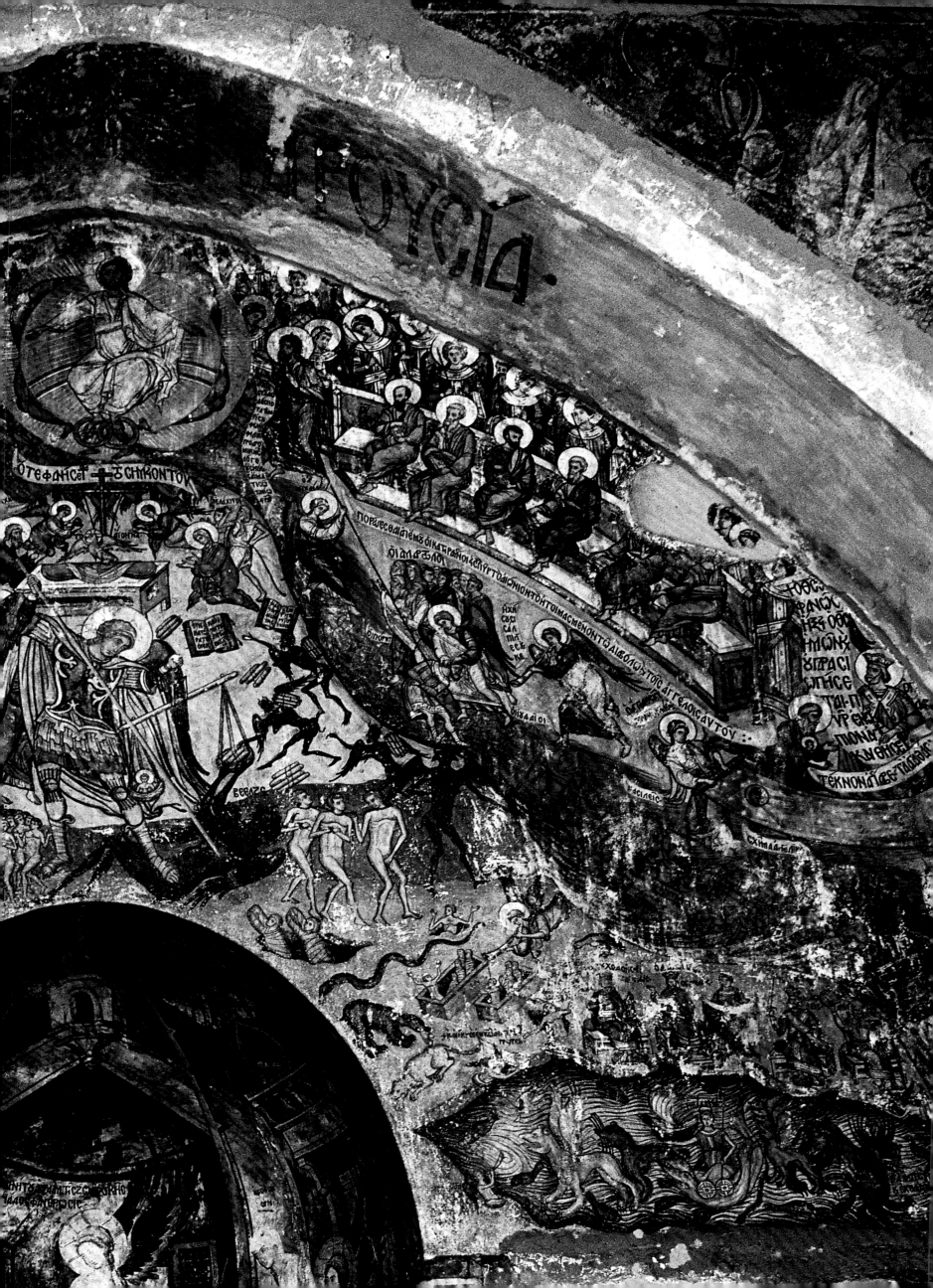

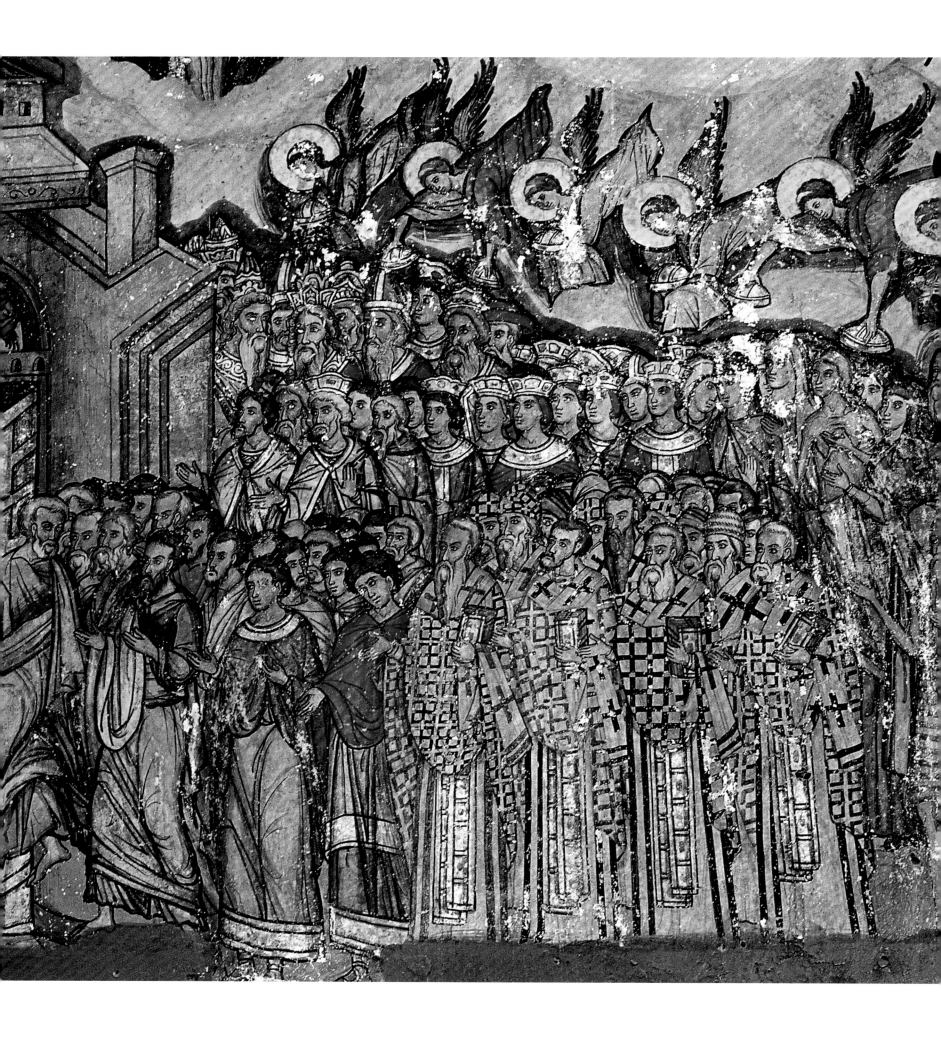

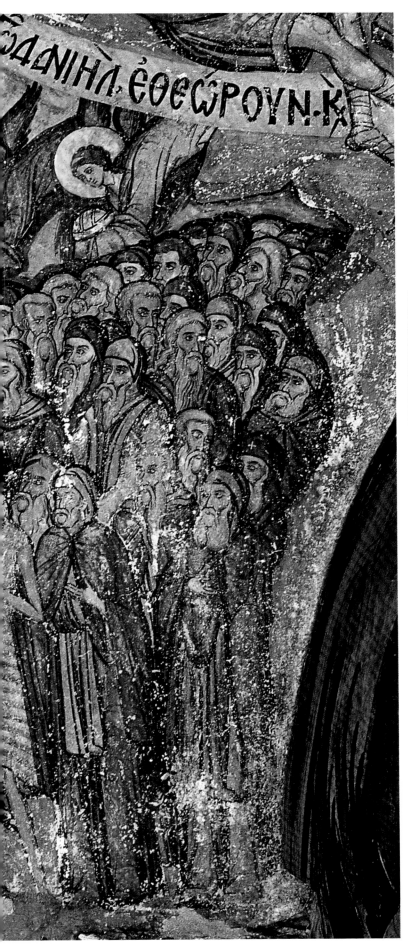

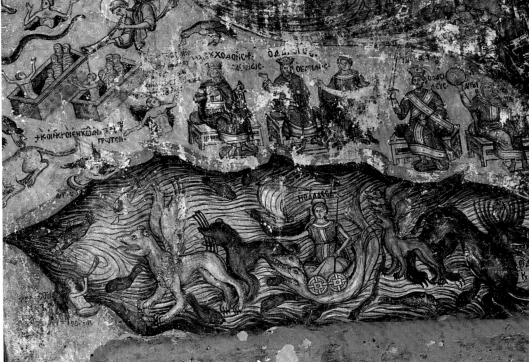

90-91, 92-93 AND 93 THE LARGE FRESCO THAT COVERS THE CENTRAL NICHE AND REAR WALL OF THE OLD REFECTORY WAS PAINTED IN 1573 BY A CRETAN ARTIST AND DEPICTS THE LAST JUDGMENT. CHRIST IS PRESENTED AT THE CENTER ABOVE, FLANKED BY TWO WINGS OF ANGELS AND SAINTS. STANDING AT THE CENTER OF THE SCENE IS AN ARCHANGEL HOLDING THE SCALES OF JUSTICE WHILE AT THE SAME TIME PIERCING THE DEVIL THAT ATTEMPTS TO ALTER THE JUDGMENT BY PULLING ON THE SCALEPAN. THE REST OF THE SCENE IS TAKEN UP BY GROUPS OF SOULS ACCOMPANIED TOWARD THEIR AFTERLIFE BY HOSTS OF ANGELS.

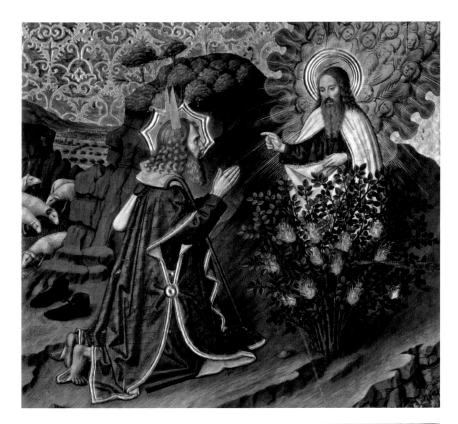

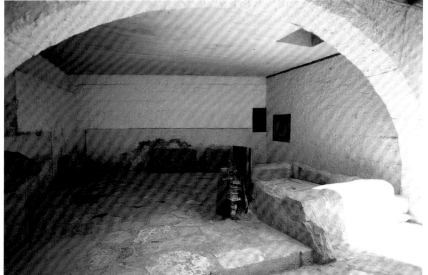

94 BOTTOM THE MONASTERY'S PRIMARY SOURCE OF WATER IS LOCATED INSIDE THE WALL OF THE MONASTERY, BENEATH ONE OF THE BUILDINGS IN WHICH THE MONKS LIVE. LEGEND HAS IT THAT THE FOUNTAIN IS LOCATED ON THE PRECISE SPOT WHERE MOSES MET THE SEVEN DAUGHTERS OF JETHRO.

THE NORTHEAST CORNER OF THE MONASTERY IS OCCUPIED BY AN OLD WHITEWASHED BUILDING

beside which grows the bush that celebrates the legend of the Burning Bush. The entire northeast corner is taken up by the Skevophylakion, which also incorporates the monastery's most important water source, the fountain where, according to tradition, Moses met the daughters of Jethro.

95 OUTSIDE THE BASILICA IN THE AREA BEHIND THE CHAPEL OF THE BURNING BUSH IS A BUSH SURROUNDED BY A HIGH STONE WALL. IT IS ADJACENT TO THE CHAPEL OF THE BURINIG BUSH, BELIEVED TO BE THE SITE WHERE MOSES STOOD.

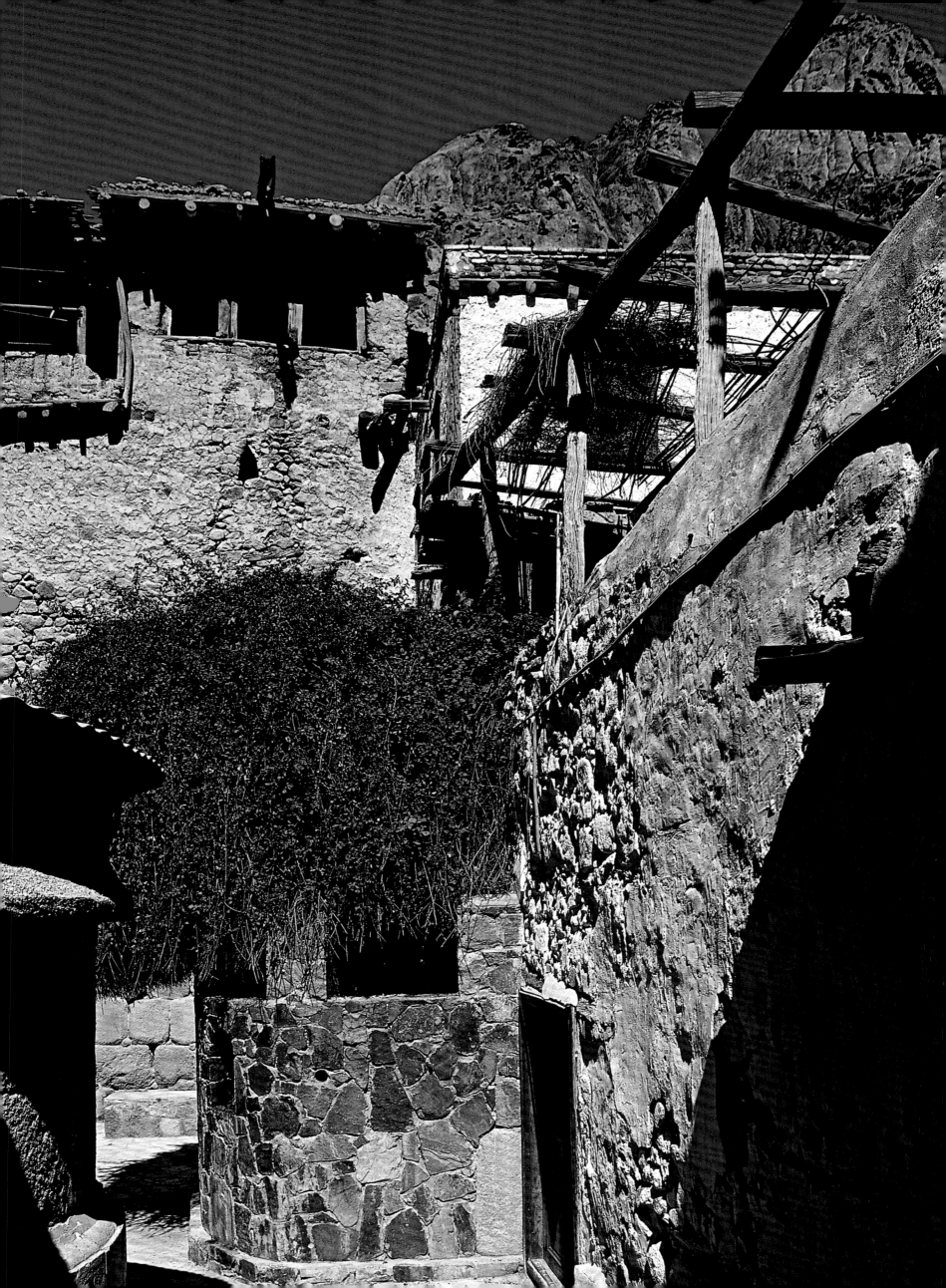

96 A SERIES OF MINOR CHAPELS IS LOCATED WITHIN THE MONASTERY COMPLEX. ONE IS DEDICATED TO ST. ANTHONY, ONE TO ST. JOHN, ONE TO THE TEN MARTYRS OF CRETE, AND ONE, THE OPENING TO WHICH APPEARS IN THIS IMAGE, TO ST. STEPHEN.

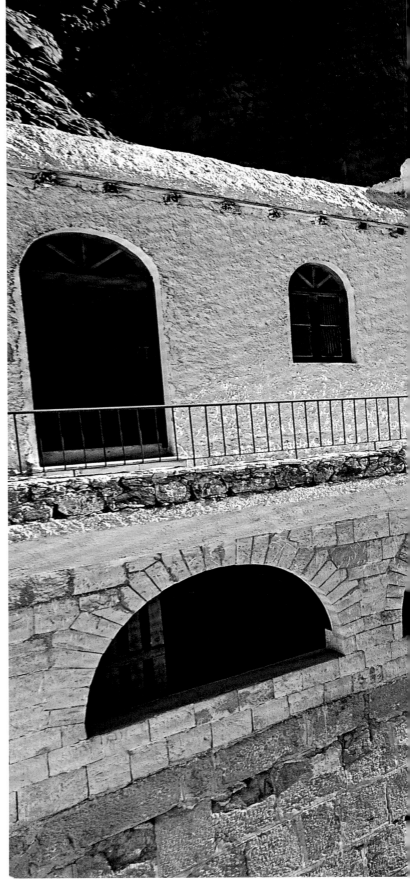

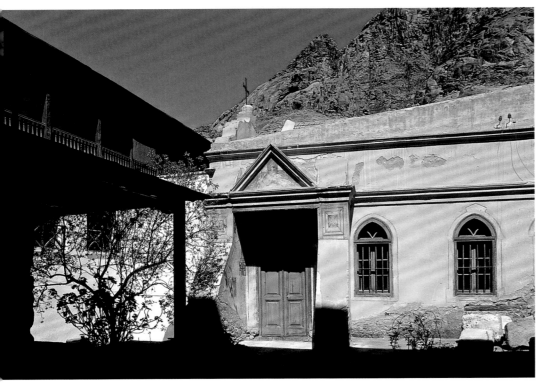

96-97 OVER THE COURSE OF THE CENTURIES THE BUILDINGS THAT COMPOSE THE MONASTERY HAVE BEEN REMODELED OR REPLACED, COMING TO PRESENT THE PICTURESQUE ASSEMBLY OF DIFFERENT SHAPES AND MATERIALS SEEN TODAY.

THE WESTERN SIDE OF THE COMPLEX IS TAKEN UP BY A BUILDING HOUSING THE GUEST QUARTERS.

In front of it, the area of the quadrangle left open by the church and the mosque is occupied by a courtyard reserved to the monks and by three blocks that contain the monastery's archives and a series of chapels. One of these is dedicated to St.

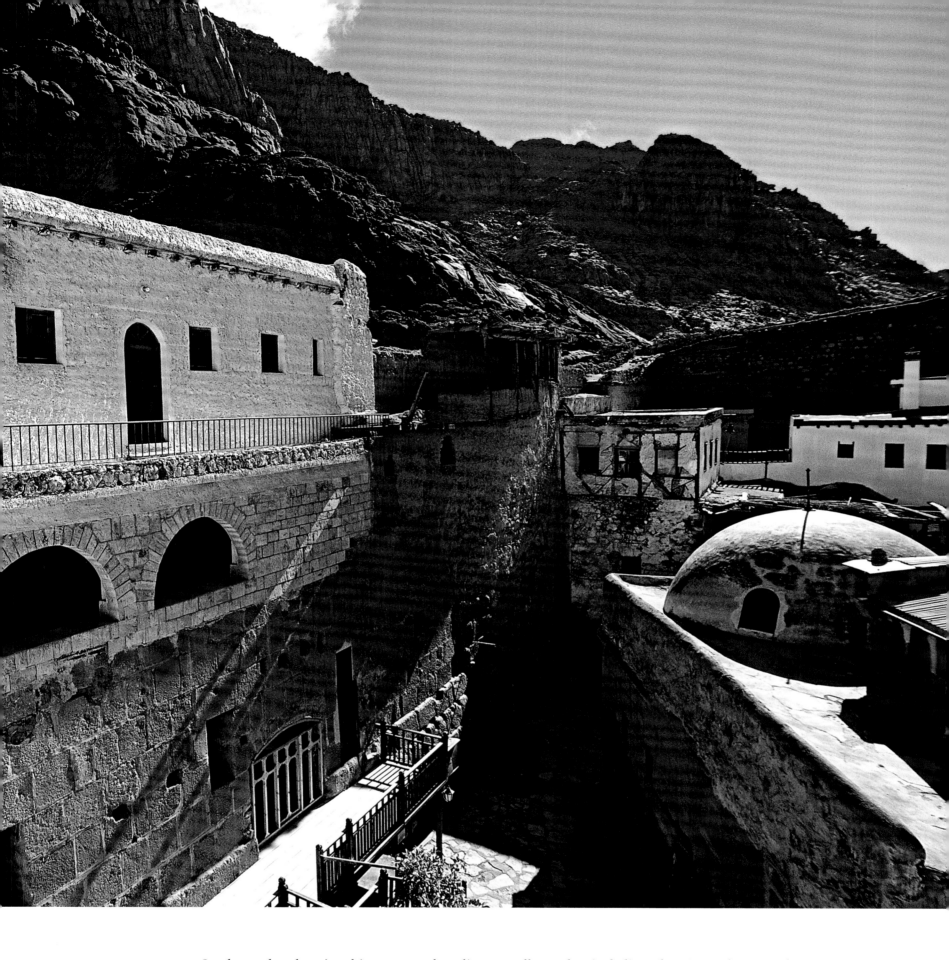

Stephen, who also gives his name to the adjacent well; another is dedicated to St. Anthony; and a third to St. John. Two others are dedicated to the Ten Martyrs of Crete, ten Christians who lost their lives at the time of the persecution of the Roman Emperor Decius, in the year 250, and to the Five Martyrs of Greater Armenia. The entire south side of the monastery's enclosure is occupied by a long, high building divided in two by a central stairway topped by a dome and organized in rows of rooms served by external passageways that run under broad arcades. This structure houses cells for the monks at the lower floors, and above, the icon storage room and library, which contains some of the monastery's most precious treasures.

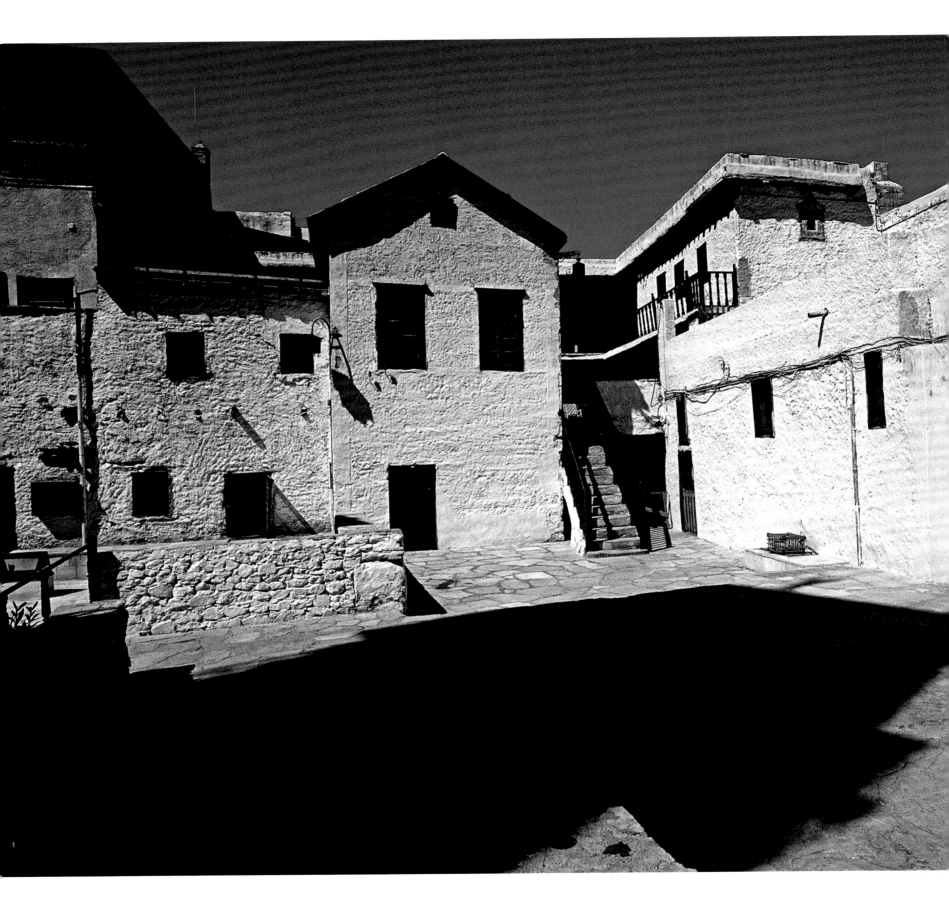

98-99 THE NORTHWEST CORNER OF
THE COMPLEX IS OCCUPIED BY THE
SKEVOPHYLAKION AND THE CHAPEL TO
ST. JOHN THE THEOLOGIAN, A GROUP
OF TIDY BUILDINGS IN WHITE MASONRY.

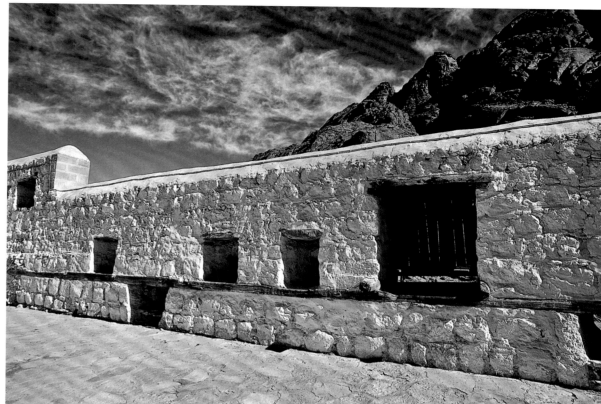

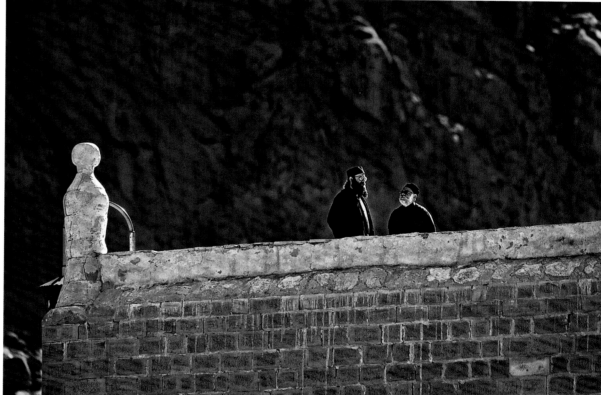

99 ALL THE ACTIVITIES OF THE MONASTERY TAKE PLACE

WITHIN THE SMALL SPACE OF ITS COMPACT ENCLOSURE,

AGAINST THE BACKGROUND OF THE HIGH MOUNTAINS

THAT TOWER OVER THE COMPLEX AND STAND OUT

AGAINST THE SKY.

100 AND **101** THE DETAILS PRESENTED IN THESE IMAGES REVEAL DIFFERING

EPOCHS OF CONSTRUCTION, FROM ANCIENT COLUMNS WORN AWAY BY TIME TO

CARVINGS IN THE KEYSTONES OF THE ARCHES OF THE BELL TOWER.

102 TOP AND **103** THE VARIOUS BUILDINGS THAT COMPOSE THE MONASTERY

COMPLEX ARE SEPARATED BY NARROW STREETS. HERE SHADOWY PASSAGEWAYS

AND ANCIENT ARCHES OFFER MANY PICTURESQUE VIEWS.

102 BOTTOM THIS NICHE IS

DECORATED WITH A FRESCO

DAMAGED BY THE PASSAGE OF TIME.

THE VIRGIN APPEARS IN THE

BACKGROUND, SURROUNDED BY A

SERIES OF MEDALLIONS THAT

REPRESENT SAINTS.

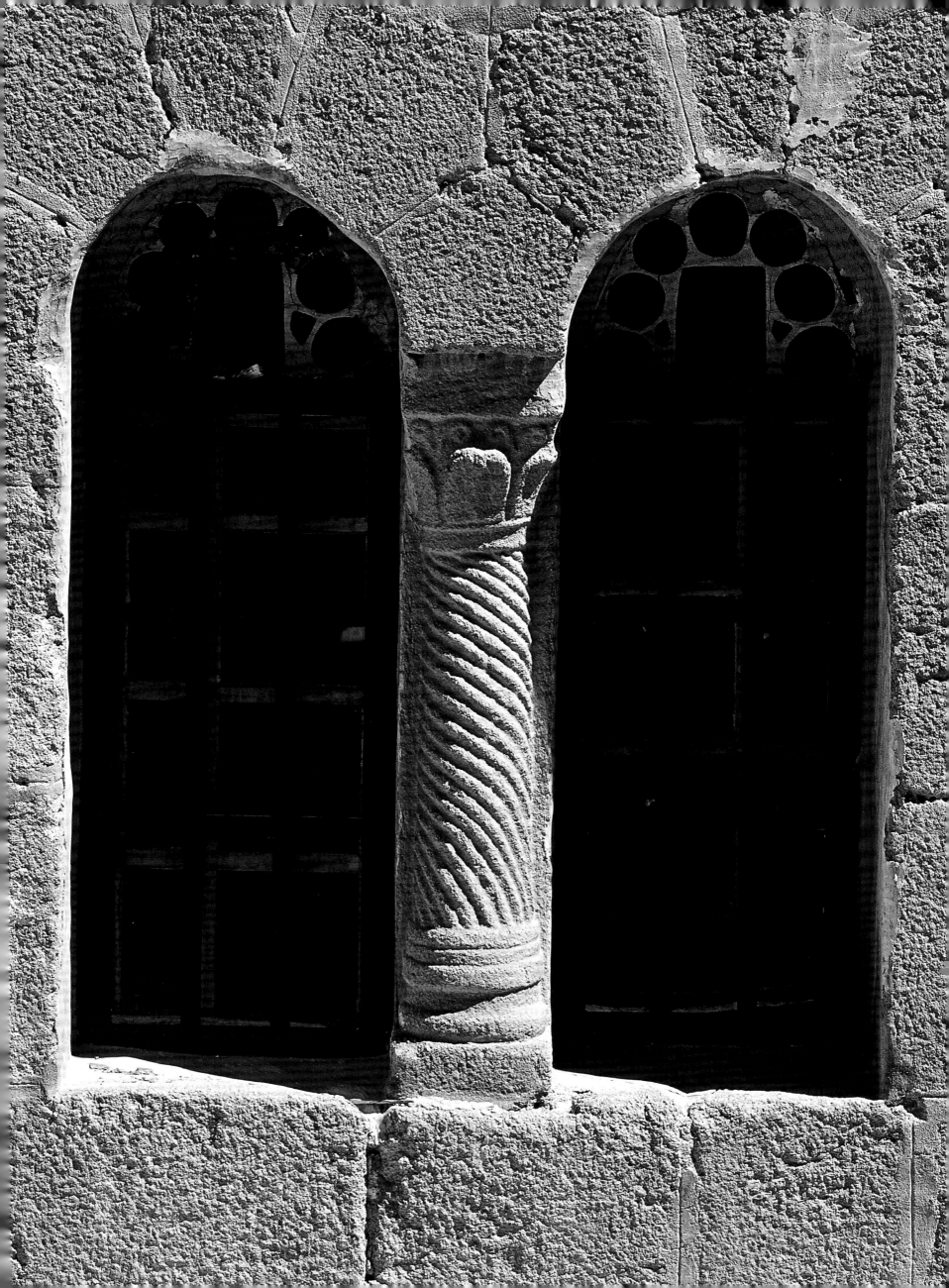

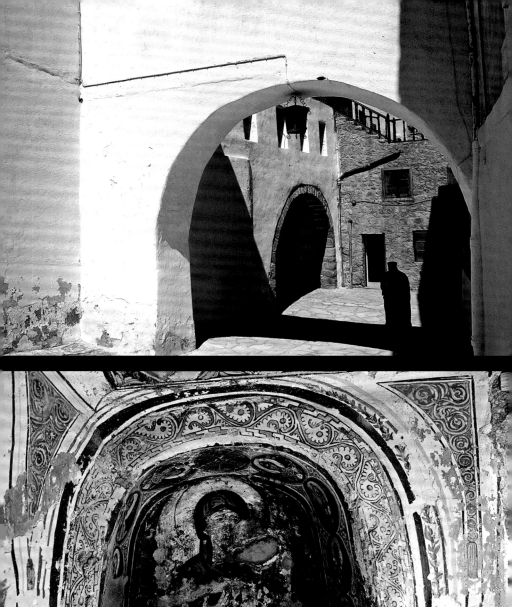

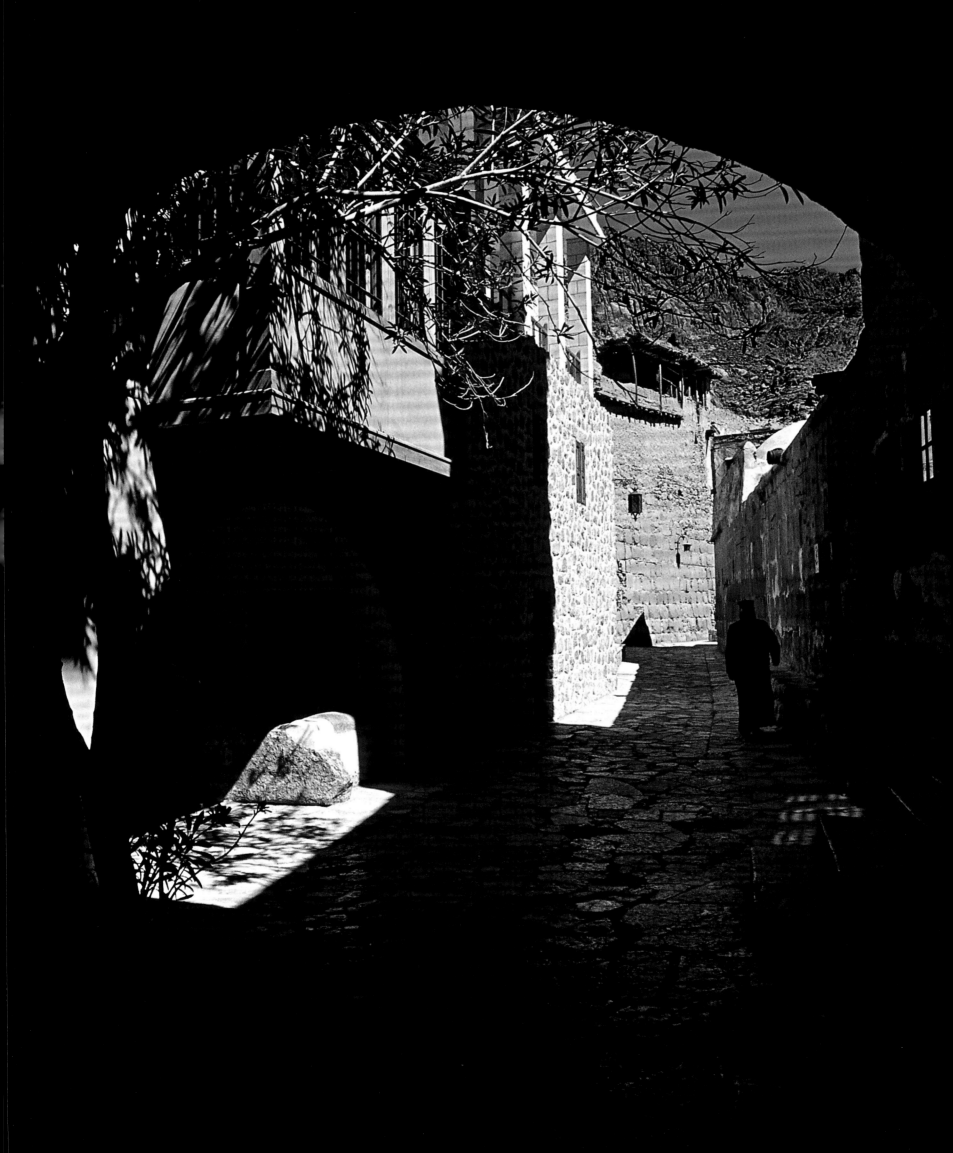

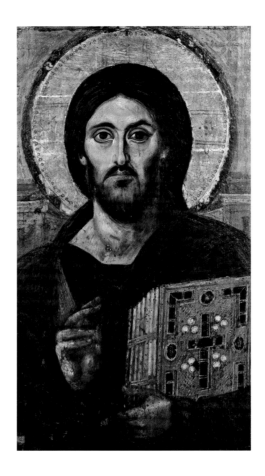

THE ICON STORAGE ROOM CONTAINS MORE THAN TWO THOUSAND ICONS PAINTED AT ST. CATHERINE'S OR MADE ELSEWHERE FOR THE COMMUNITY OF A Gebel Musa and patiently collected by the monks beginning in the sixth century. Most of these were painted in the period between the tenth and fifteenth centuries and follow a precise local style that became famous throughout the Christian world and was taken up by artists active in distant lands. The oldest icons were made using the encaustic method, which involves mixing the paint with melted wax and then applying it to wooden panels. Even today, the lively, brilliant colors and the skill of execution are clear testimony to the skill of the monks who created them centuries ago.

One of the most famous icons in the monastery's collection is the Christ Pantokrator, or Christ Omnipotent, in which Christ is presented in the act of blessing with his right hand while holding a closed gospel book in his left. Made in the first half of the sixth century, it is the oldest known panel icon to depict Christ. The composition is simple, the colors are clear: the dark hair, beard, and tunic contrast with the gold aureole, the decorations of the sacred book, and the pallor of the face, and the remaining space of the panel is filled with a glimpse of architecture. The most singular aspect of the work is that the two halves of Christ's face express different emotions: on the side on which he holds the gospel book, his features are hard and severe, representing Christ as the Judge who sees all, while the expression on the side with the blessing hand is calm and serene, representing Christ in his role of Savior.

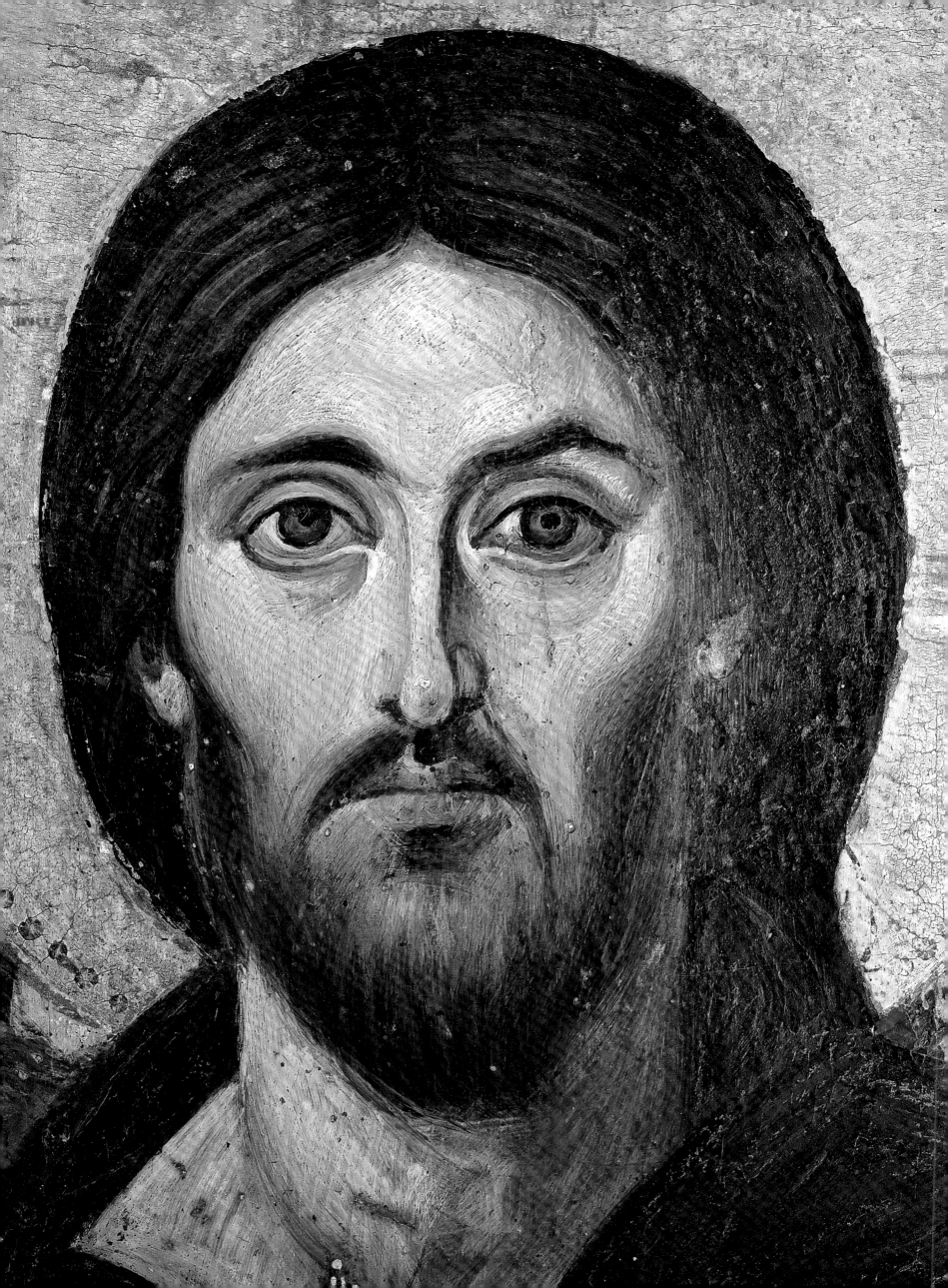

107 Icon of the Ladder to Paradise of St. John Climacus, tempera and gold on wood, 41 by 29.5 cm, end twelfth century. This image is based on the book *The Ladder to Paradise* written in the seventh century by St. John Climacus. The ladder is an allegory of the difficult path monks must follow to attain moral perfection. As they make their way up, rung by rung, they are assailed by devils, symbolic of sins and temptations, that do their utmost to make them fall.

ANOTHER GEM IN THE COLLECTION IS A REPRESENTATION OF THE LADDER TO PARADISE, BASED ON THE WORK OF THAT NAME, BY ST. JOHN CLIMACUS, WHICH IS PRESERVED IN THE MONASTERY LIBRARY.

Against the gilt background typical of Byzantine miniatures, a row of monks is presented attempting to climb a long ladder that rises to heaven, where Christ awaits them, but they must withstand the attacks of wicked black devils that try to make them fall. A group of angels observes the scene from above, while below a small crowd of monks encourages their brothers who are struggling up the ladder. The image is a clear allegory of the difficult path the monks follow to reach purification, a path strewn with dangers and temptations that can divert them from their final goal.

St. Anthony the Abbot, who was born and lived in Egypt between the third and fourth centuries, is considered one of the founders of Eastern monasticism and is the main subject of another beautiful icon in the monastery. The saint is presented at the center, standing with a staff in one hand and a papyrus scroll in the other, surrounded by the busts of other figures. Along with various monks and hermits, the images of Christ, the Virgin, and St. Catherine appear above. The skill of the artist who made the work is clearly visible in the delicacy of the details in the representations of the faces, the hair, and the clothes of the figures, in which bright colors stand out against the gilt background typical of so many Byzantine sacred scenes.

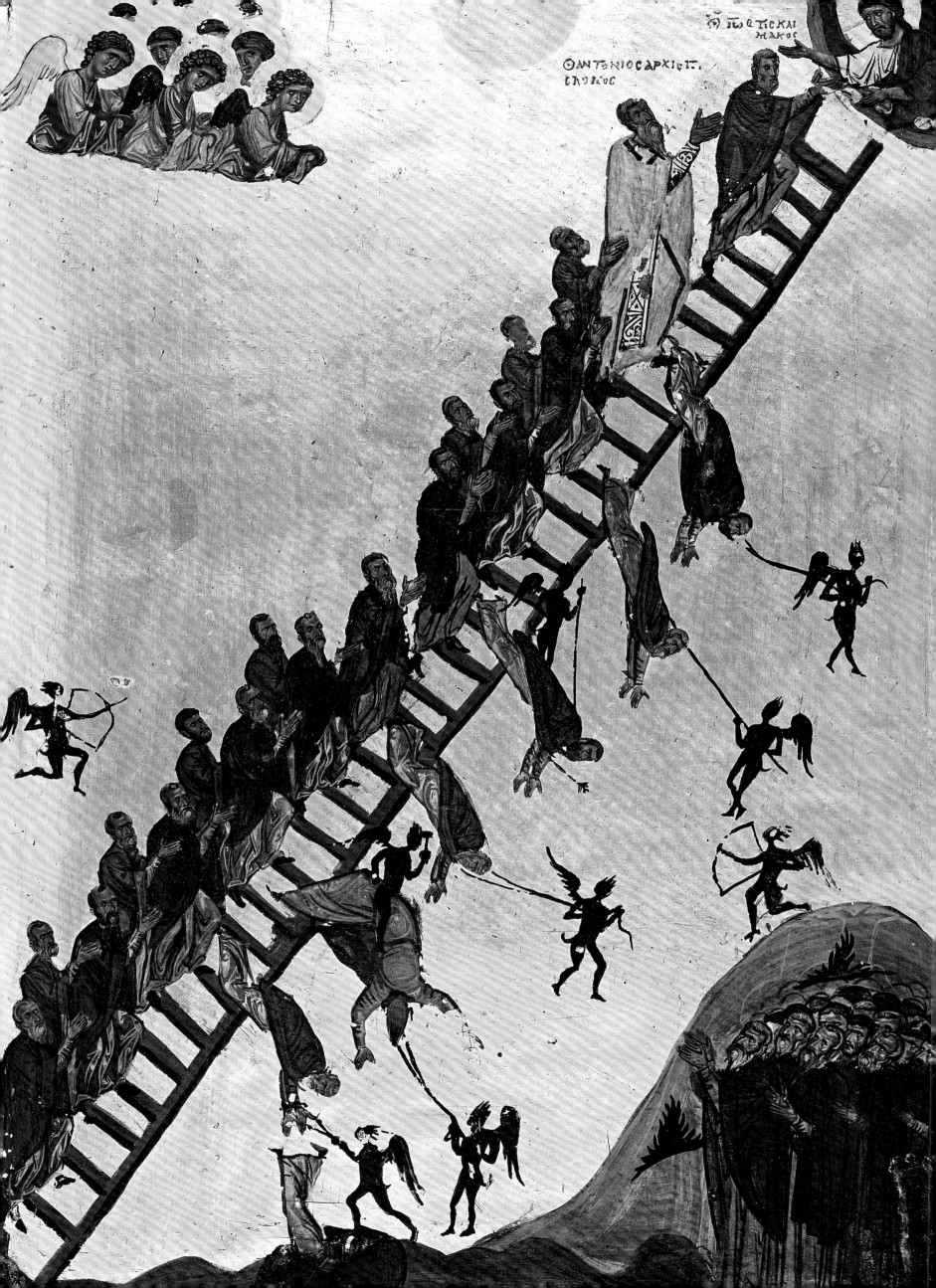

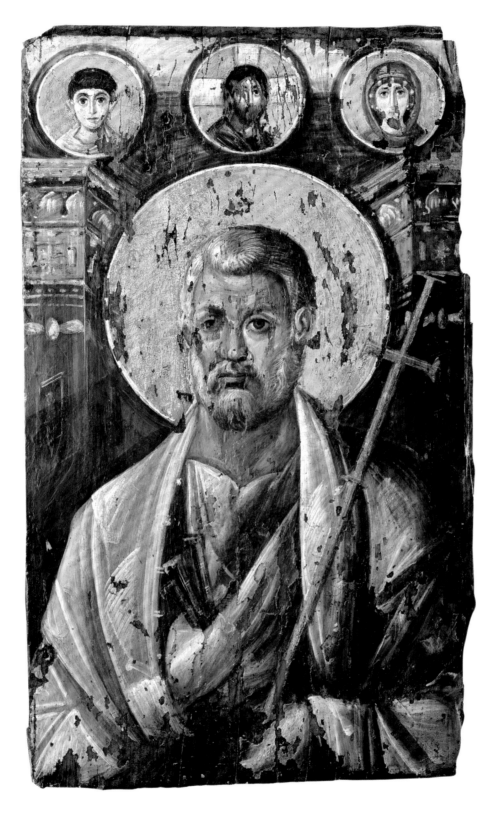

THE MONASTERY COLLECTION INCLUDES ANOTHER TWO PRECIOUS ICONS DATING TO THE SIXTH century. One is a representation of St. Peter, whose head, framed by a gray beard and hair, stands out against a large gilt aureole; the other is a presentation of the Virgin seated on a throne with the Child on her lap and flanked by St. George and St. Theodore. The work is striking for its perfectly symmetrical design and its bright, lively colors.

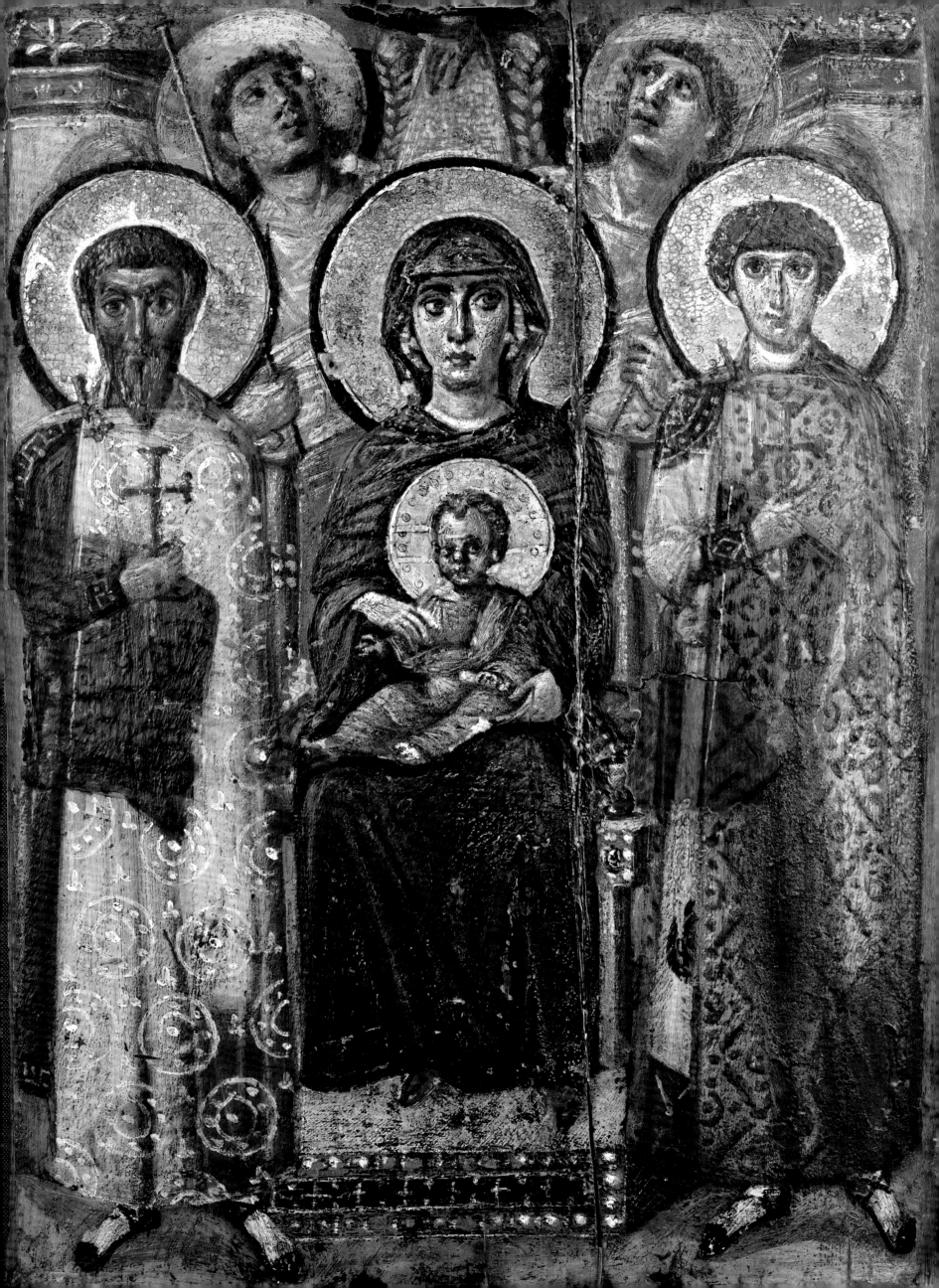

110 In the garden is the Charnel House, which contains the bones of all the monks that have lived in the monastery, arranged in orderly piles. The visitor is welcomed to the Charnel House by the skeleton of St. Stephanos.

110-111 Outside the walls of the monastery are its extensive gardens and orchards, with cypresses and fruit trees that create an area of green in sharp contrast to the colors of the surrounding desert.

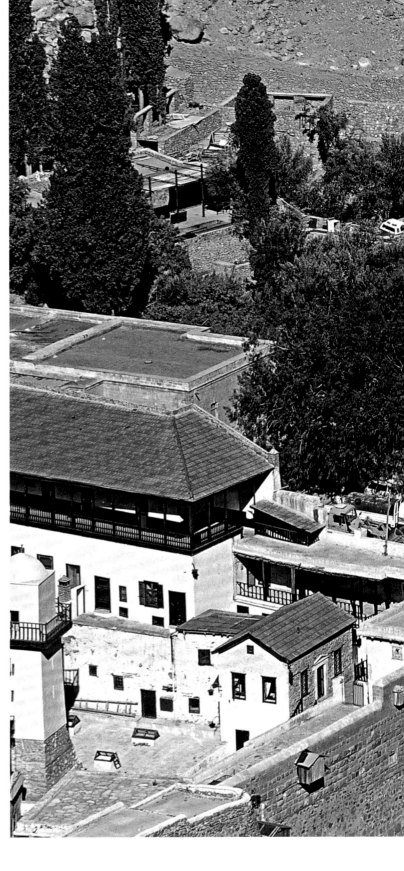

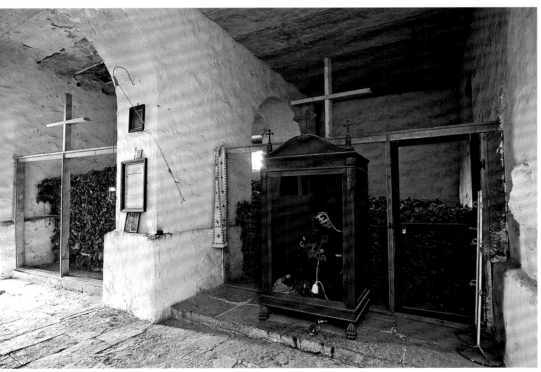

112-113 Encircled by a low stone wall, palms, cypresses, and fruit trees grow along the bed of the wadi alongside the monastery walls, against a background of rocky walls and sky.

IMMEDIATELY OUTSIDE THE LARGE WALLS THAT ENCLOSE THE MAIN BUILDINGS OF THE MONASTERY is a large green area that extends to the west of the complex. Cypresses, olive trees, and fruit trees grow luxuriantly on different levels of terraces surrounded by stone walls and by service buildings, all built using blocks of the bright brown local stone. Inside the garden is a small

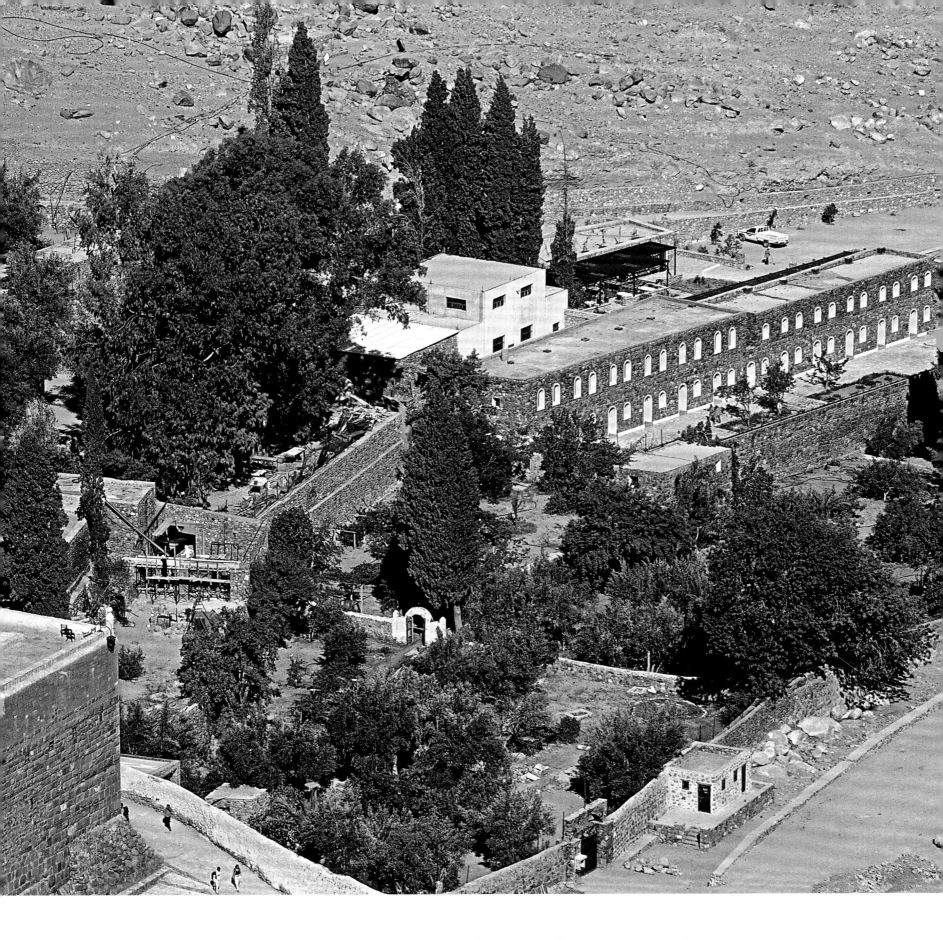

cemetery in which the monks have been buried for centuries. Because of the cemetery's limited size, each time a monk is buried, the body of the monk that has been there the longest is exhumed and his bones are moved to the ossuary beneath the small chapel dedicated to St. Trypho.

At the entry to this chapel the visitor encounters a truly striking sight: the seated body of St. Stephanos, a monk who lived in the sixth century, dressed in purple vestments, his staff clasped in his skeletal hand. Inside, to one side are the bones of martyrs and archbishops displayed in open sarcophagi; to the other side are the countless bones of the simple monks who have died in the shadow of Gebel Musa. These are divided in a large pile of skulls, with the other bones in the adjacent area.

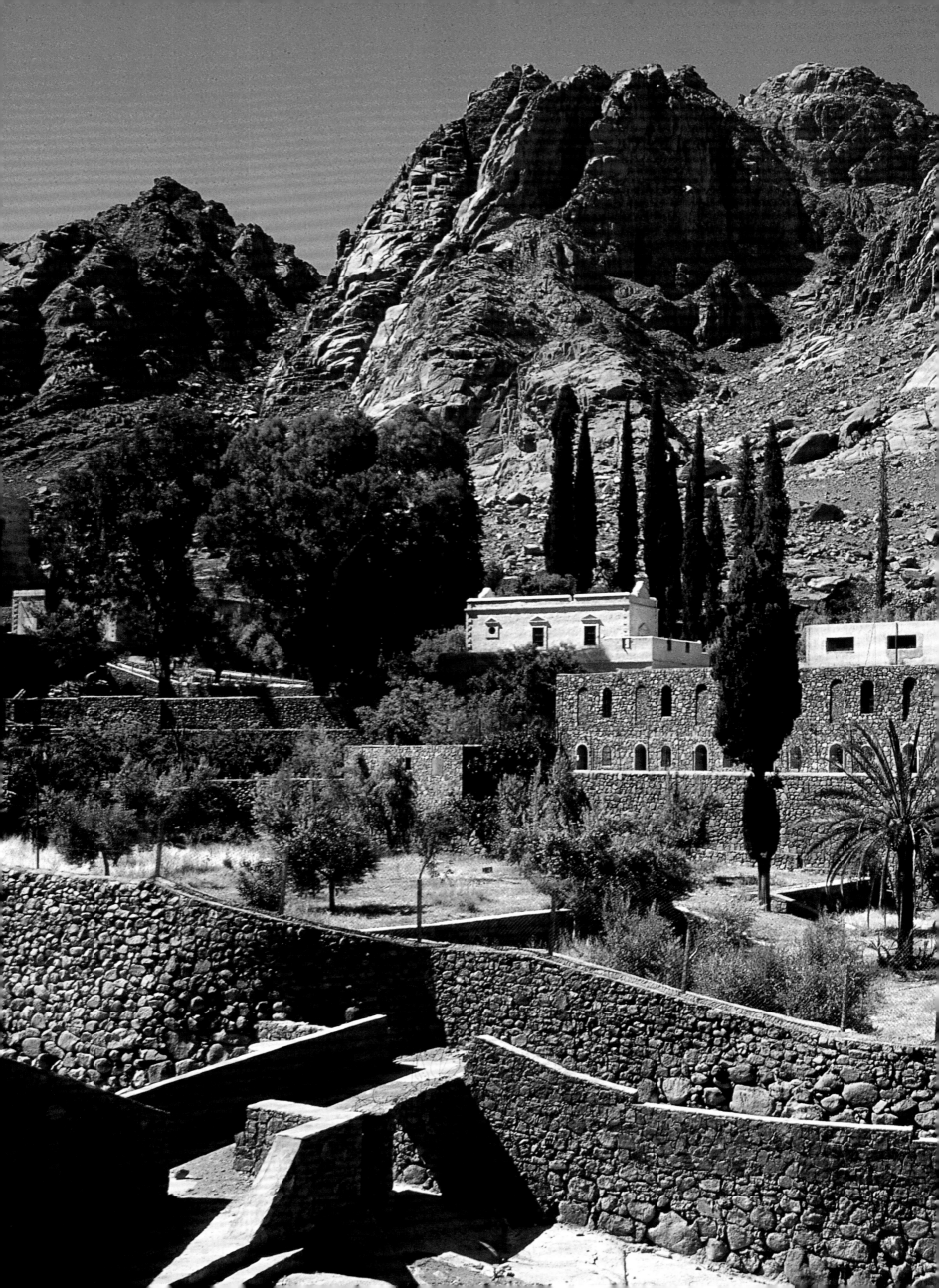

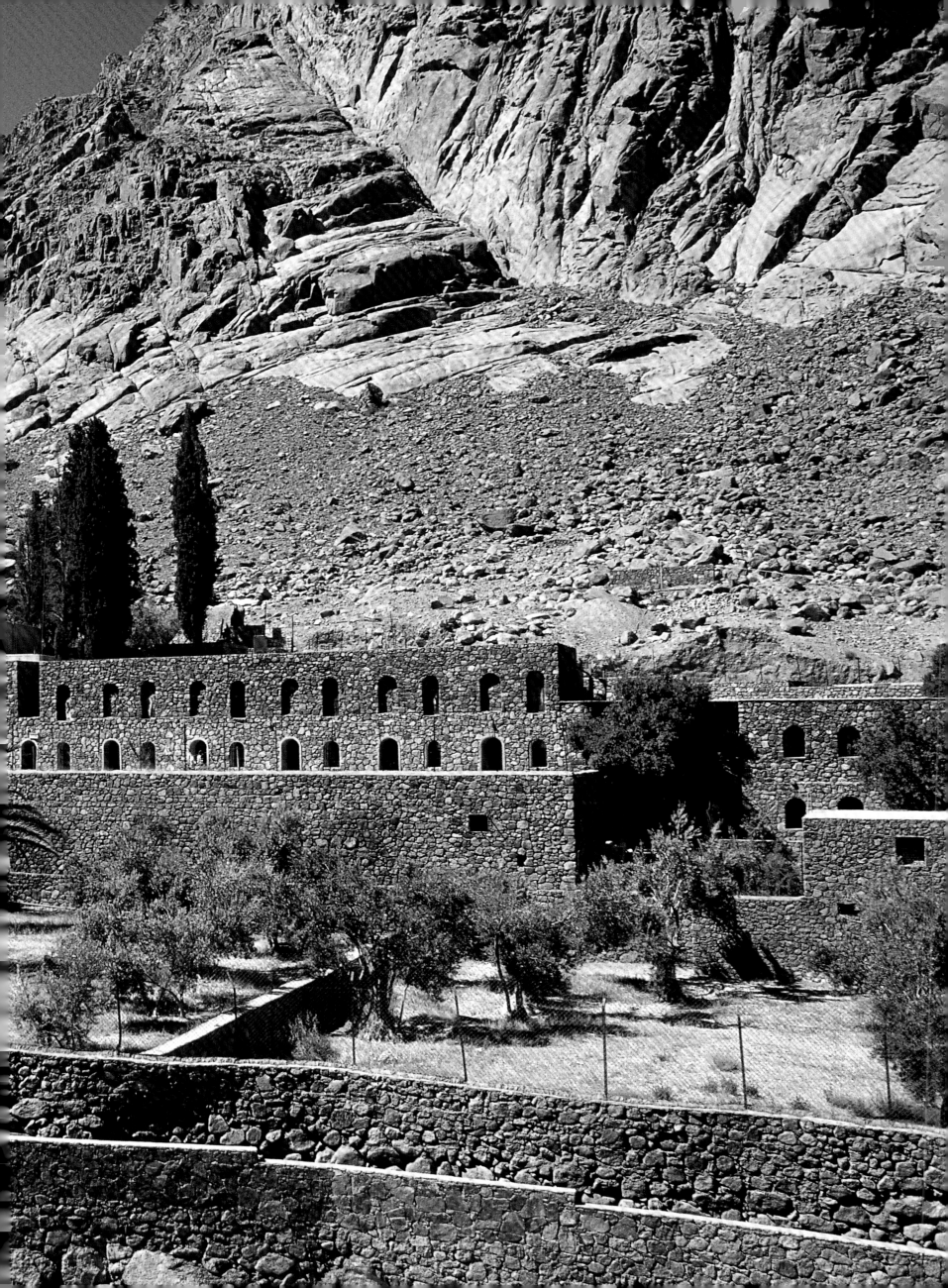

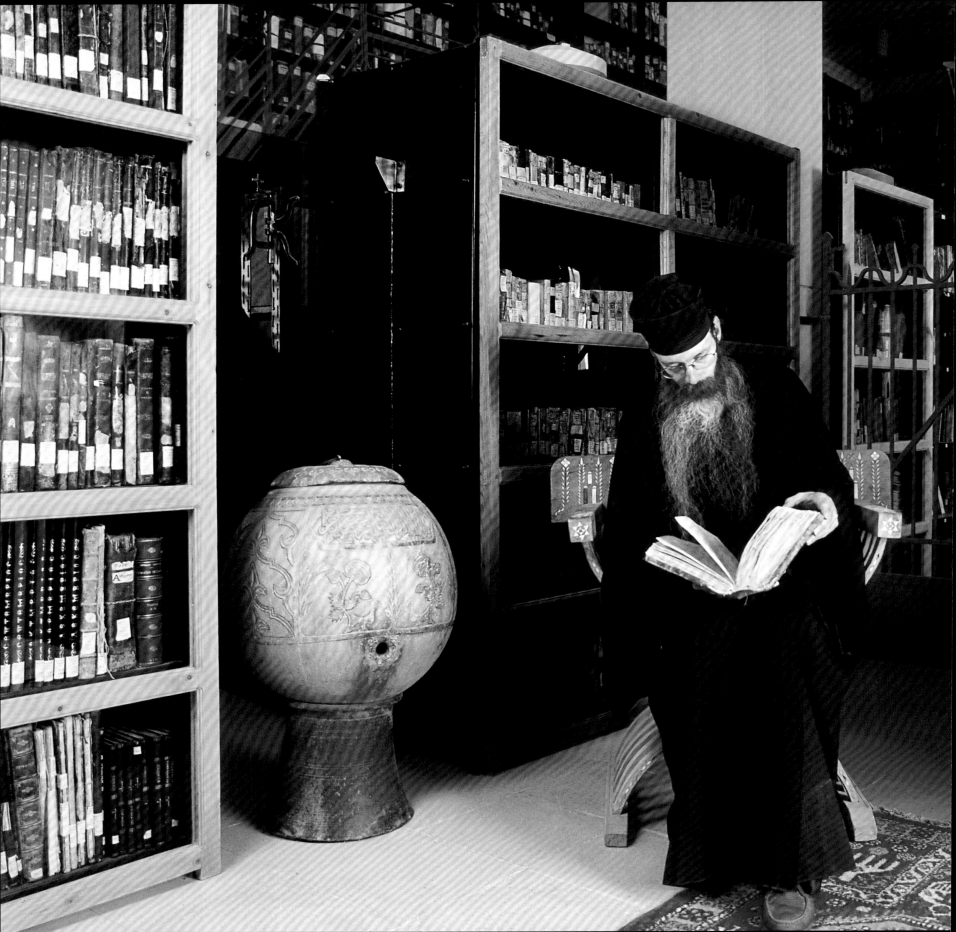

114-115 AND 115 PERHAPS THE MOST IMPORTANT
TREASURE IN THE MONASTERY IS ITS SPLENDID
LIBRARY, WHICH CONTAINS A COLLECTION OF
THOUSANDS OF MANUSCRIPTS THAT IS SECOND ONLY
TO THAT OF THE VATICAN.

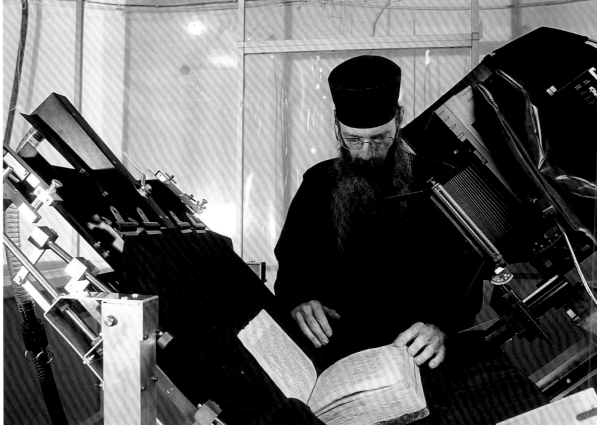

ALL THOSE WHO HAVE LIVED AT THE
MONASTERY OF ST. CATHERINE HAVE IN
SOME WAY CONTRIBUTED to the preservation of
the enormous artistic and literary patrimony that has been
assembled over time within its walls. Without doubt, one of
the most important collections is that contained in the
library, which is housed above the icon storage room and
contains thousands of manuscripts, copied and decorated by
the generations of patient monks whose remains now rest in
the small ossuary immersed in the green of the garden.

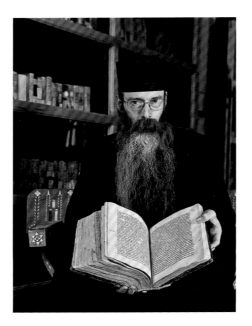

THE LIBRARY OF THE MONASTERY OF ST. CATHERINE IS CONSIDE-
RED THE SECOND IN IMPORTANCE IN THE WORLD AFTER THAT OF
THE VATICAN MUSEUMS IN ROME.

It holds thousands of manuscripts, three thousand of them antique works of inestimable value. About two thousand are written in Greek, seven hundred in Arabic, three hundred in Syriac, one hundred in Georgian and Armenian, forty in Slavonic, and one in Latin.

The most important manuscript in the collection is the so-called *Codex Syriacus*, a *Syriac* religious text of the fifth century, the significance of which was first grasped by two exceptional women, the Scottish sisters Agnes Lewis and Margaret Gibson, in 1892. Identical twins, they were learned and gifted in ancient and modern languages. Unlike most of the women of their time, they dedicated themselves to the study and exploration of foreign lands. Both read and spoke modern Greek, Arabic, and Hebrew, and before setting sail for the Sinai they learned Aramaic in order to be able to read ancient texts.Agnes Lewis recounted that the oldest manuscripts in the library of St. Catherine were at that time kept in dark closets, and that their pages, which had not been turned for centuries, were stuck together and had to be handled with extreme care. One of the most difficult documents to deal with was revealed to be a palimpsest, a manuscript on which an old text has been erased so that the pages can be reused for a new text. In this case, the more recent text was the history of the life of certain saints, but Agnes Lewis succeeded in making out some of the words of the earlier text—"evangelion," "Mathi," "Luca"—and understood that it was an ancient version of the Gospel, written in the fifth century. The importance of the document, aside from its age, was the language used, which had to be close to that used by Jesus and the apostles.The sisters returned to the Sinai the next year, accompanied by three experts, and in forty days they succeeded in reading and copying the precious document. Agnes Lewis returned to Sinai another five times and made other highly important discoveries, earning international renown and honorary recognitions from many British and German universities.

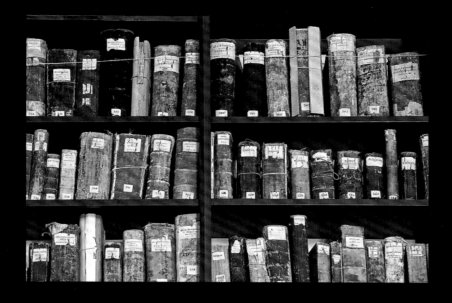

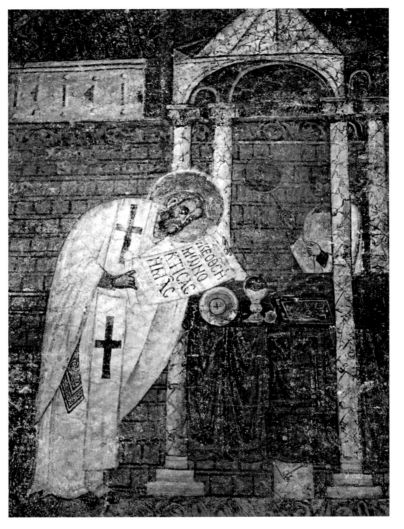

STANDING OUT AMONG THE OTHER MANUSCRIPTS IN THE MONASTERY LIBRARY IS THE *LADDER TO PARADISE* BY ST. JOHN CLIMACUS.

The author became a monk at St. Catherine when only sixteen years old and served late in life as its abbot. In this work, the idea of a progressive approach to heaven and to God is rendered with the image of a thirty-rung ladder, each rung corresponding to the acquisition of a virtue or the defeat of a vice. In the text, each of the rungs toward the saint's attainment of spiritual perfection is illustrated by a miniature of highly refined workmanship.

St. Gregory of Nazianzus was an outstanding figure on the religious scene of Constantinople for many years, and in old age retired in his birthplace, where he composed a large number of sermons and poetic works. One of his works is preserved in the monastery library: made in Constantinople, the manuscript has some of the most beautiful miniatures in the entire collection.

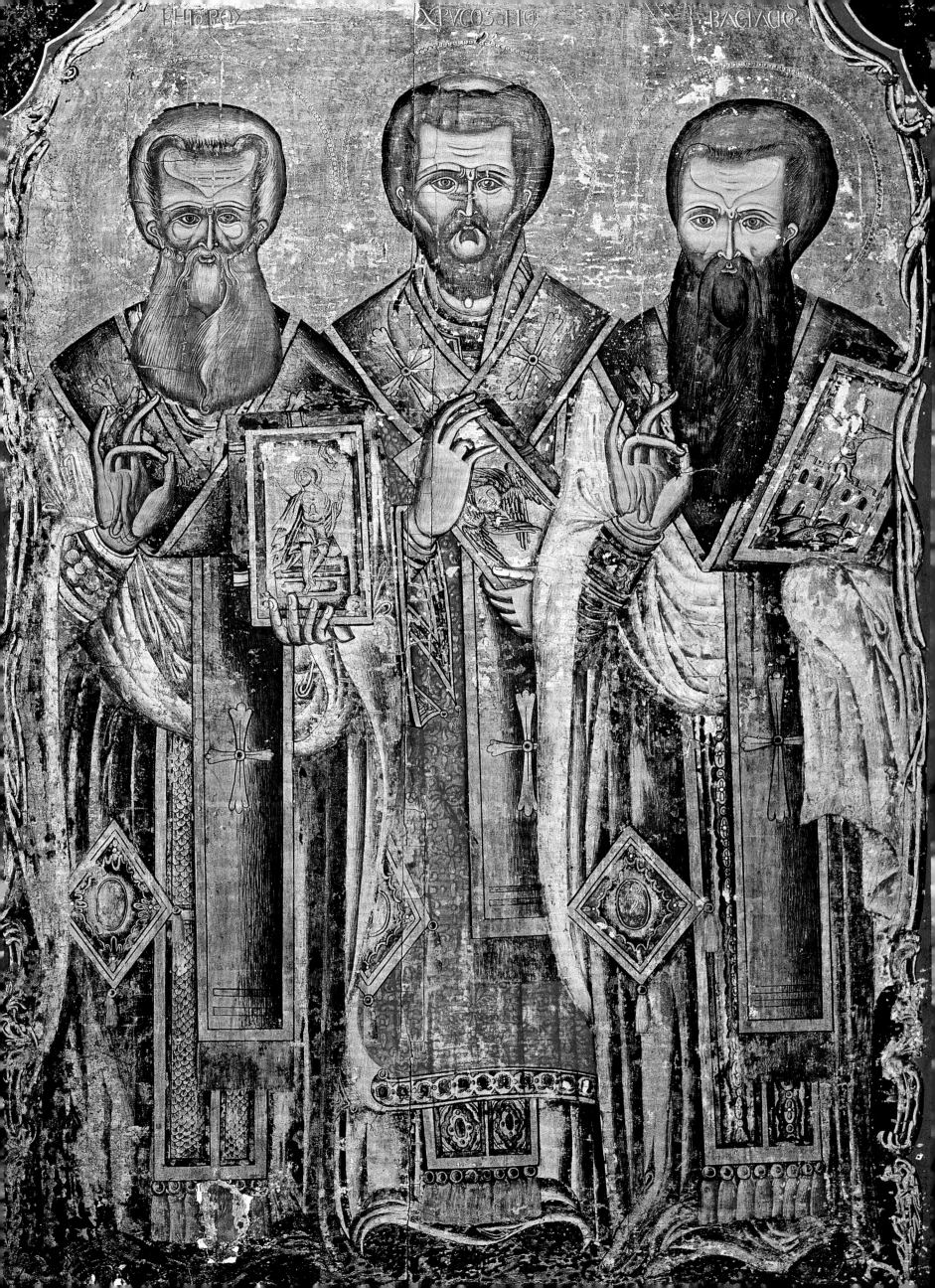

Τῇ περαν τȣ Ꙍκεανȣ ἐνθα πρὸ τȣ κατακλυσμȣ

Terre au delà de l'Océan où les hommes habitaient avant le d

Τῇ περαν τȣ Ꙍκεανȣ

Terre au delà de l'Océan

EUROPE

Ρωμαινος κολπος
Golfe Romain

AFRIQUE

Καστια θα

ASI

Golfe Arabique

Tigre

Euphrates

Géon

ANOTHER SINGULAR TEXT IN THE MONASTERY DATES TO THE SIXTH CENTURY. THIS IS THE *TOPOGRAPHIA CHRISTIANA* BY COSMAS OF ALEXANDRIA. A merchant from Alexandria, he was nicknamed Indicopleustes ('Indian Traveler') because of his many commercial voyages. He became a hermit and wrote a series of literary works, including the twelve-volume Topographia Christiana. This work was written at a particular time in history and for a precise reason: to disprove the version of the earth proposed by Greek astronomers, which he considered pagan, and to prove the validity of the version promulgated by Christians. From Eratosthenes, in the third century BC, to Ptolemy, who lived in the second century AD, the Greeks has understood that the earth was spherical and had begun to construct geometric models with which they could position on the surface of the

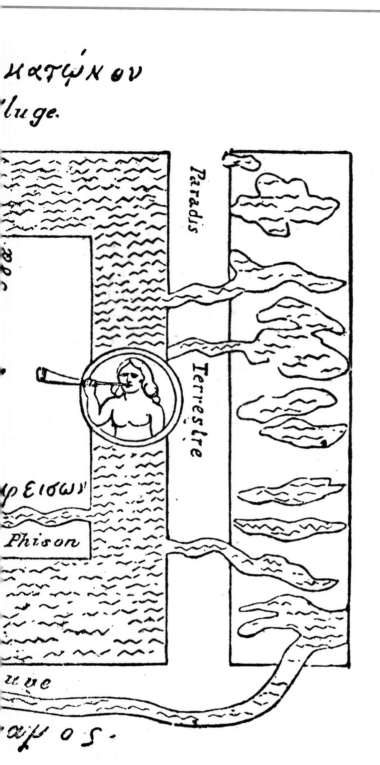

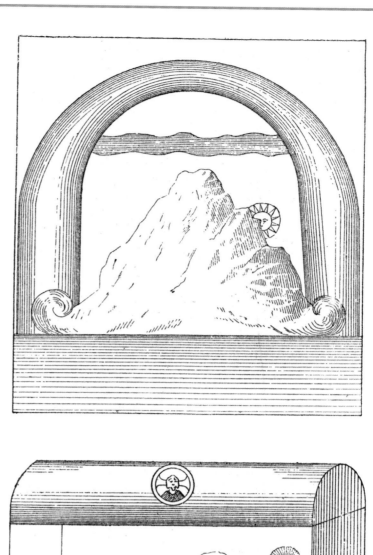

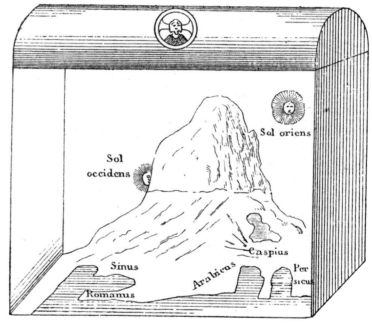

globe the lands then known. The Christians preferred to believe in their sacred writings and decided the tabernacle that God described to Moses, meaning a large rectangular tent supported by four columns, could be taken as the model for the shape of the earth and the sky. Thus Cosmas described the earth as a large rectangle, surrounded by an Ocean and by walls that rose to join above and form the sky. The attempts of scholars to defend the studies of the Greek astronomers and geographers came to nothing: they were derided and invited to accept the truth of the Bible.

120-121 AND 121 THE WORLD ACCORDING TO COSMAS INDICOPLEUSTES, WHO COMPILED HIS MONUMENTAL *CHRISTIAN TOPOGRAPHY* TO DISPROVE THE GREEK ASTRONOMERS WHO HAD SUGGESTED THAT THE EARTH WAS ROUND AND TO PRESENT A RECONSTRUCTION OF THE WORLD ENTIRELY BASED ON HOLY SCRIPTURES. ACCORDING TO HIS RECONSTRUCTION, THE EARTH IS FLAT, WITH A SINGLE LARGE CONTINENT THAT RISES LIKE A MOUNTAIN AND IS SURROUNDED BY A LARGE SEA AND IS COVERED BY A SKY SIMILAR TO THE TABERNACLE THAT MOSES BUILT ON THE BASIS OF GOD'S INSTRUCTIONS.

PERHAPS THE MOST PRECIOUS MANUSCRIPT EVER FOUND IN THE MONASTERY IS THE SO-CALLED *CODEX SINAITICUS*, THE GREATER PART OF WHICH IS TODAY IN

the British Library. Dating to the fourth century, it is the second oldest Bible in the world, coming immediately after the Codex Vaticanus preserved in Rome, which must have been written a few years before it. This precious document was discovered in the monastery in 1844 by Constantin von Tischendorf, a professor of Bible studies at the University of Leipzig, and due to a series of events it wound up first in Russia, then in Britain.

Von Tischendorf made his first visit to the monastery of St. Catherine in 1844. On that occasion he was shown a number of manuscripts resting in a basket. Among these pages the scholar recognized several from an Old Testament written in Greek and obtained permission to take one-third of the pages. Despite his entreaties, the rest of the documents stayed in the monastery. When he returned to Saxony, Von Tischendorf showed his finds to his scholarly colleagues and published them there, keeping secret, however, the place

where they had been discovered, hoping to return and find the rest. At that point he tried to open diplomatic channels with the monks of the monastery, but the monks had become aware of the value of the documents they possessed and were less accommodating.

In 1853, Von Tischendorf again visited the monastery of St. Catherine. On this second occasion he found several important documents but no trace of the manuscript he was seeking. Under the patronage from Czar Alexander II of Russia, he organized a further expedition, in 1859, during which his efforts were fully repaid just when he had decided to give up. On the very day when he had told the Bedouins that accompanied him to be ready to leave the monastery, one of the monks invited him into his cell and showed him not only the pages he had spotted fifteen years earlier, but also all the rest of the Old and New Testaments, along with other documents. Von Tischendorf managed to contain

himself while still in the company of the monk, but once he was alone in his cell he gave free rein to his joy.

The next morning he asked permission to bring the manuscript to Cairo to have a complete copy made, but a problem arose: permission could come only from the prior of the monastery, and he himself was on his way to Cairo, part of a trip to Constantinople to take part in the election of a new archbishop. Von Tischendorf caught up to the prior in Cairo and succeeded in obtaining his permission. A Bedouin was sent to the monastery to get the manuscript; over a period of nine days, this man, riding a camel, reached St. Catherine and returned to Cairo with the precious document.

Von Tischendorf worked three months on the transcriptions, but then realized that any edition would be unreliable unless the original was at hand to ensure its correctness. He was able to obtain permission to take the manuscript to Russia by promising to return it at the monastery's first request. (This letter is still in the monastery archive.) The publication of the copy of the manuscript took Von Tischendorf three years and involved frequent trips to Russia, but its appearance had an enormous impact on the entire Christian world. The original manuscript, however, was never returned to the monks of St. Catherine. It remained in Russia through the 1917 Revolution and was acquired in 1933 by the British Library for the enormous sum of £100,000.

Taken from the desert mountains of the Sinai, where it had been held for centuries, kept for a period on the cold plains of Russia, the Codex Sinaiticus today rests in a case in the British Library in London, surrounded by other manuscripts of inestimable historical value. Although deprived of this important document, the monastery of St. Catherine has a collection that is unique in the world in terms of its historical, artistic, and religious importance. Over the seventeen hundred years of its life, the small complex that stands at the foot of Mount Sinai has been one of the most significant outposts of the Christian world, and the treasures it holds within its high stone walls are clear testimony to its continuing importance.

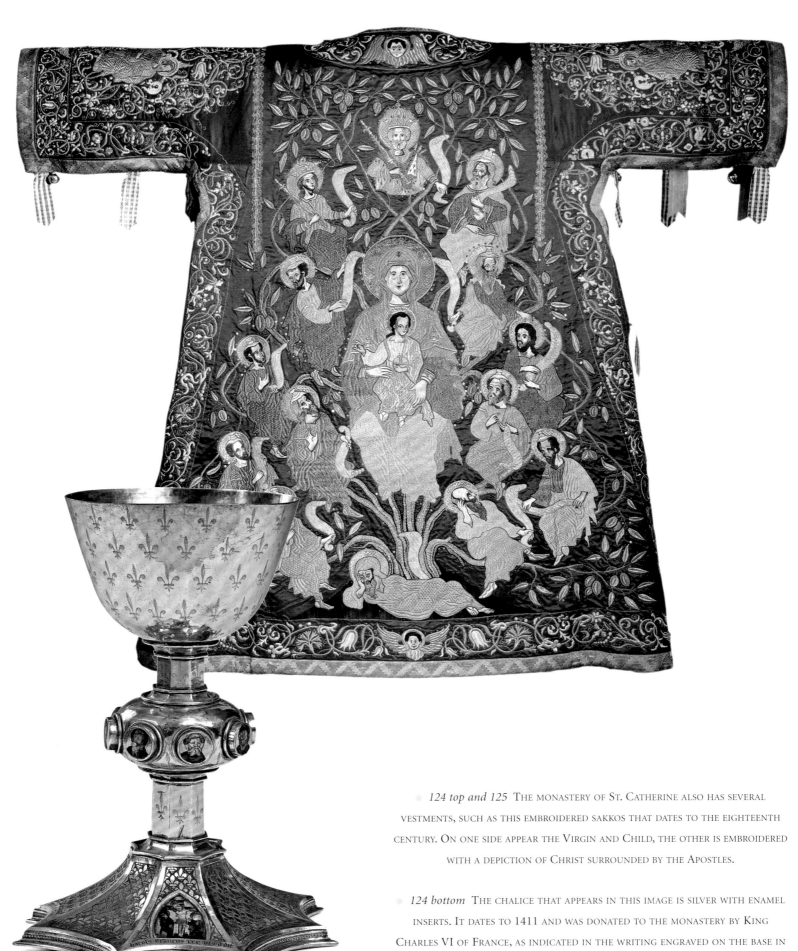

124 top and 125 THE MONASTERY OF ST. CATHERINE ALSO HAS SEVERAL VESTMENTS, SUCH AS THIS EMBROIDERED SAKKOS THAT DATES TO THE EIGHTEENTH CENTURY. ON ONE SIDE APPEAR THE VIRGIN AND CHILD, THE OTHER IS EMBROIDERED WITH A DEPICTION OF CHRIST SURROUNDED BY THE APOSTLES.

124 bottom THE CHALICE THAT APPEARS IN THIS IMAGE IS SILVER WITH ENAMEL INSERTS. IT DATES TO 1411 AND WAS DONATED TO THE MONASTERY BY KING CHARLES VI OF FRANCE, AS INDICATED IN THE WRITING ENGRAVED ON THE BASE IN TWO LANGUAGES, LATIN AND GREEK.

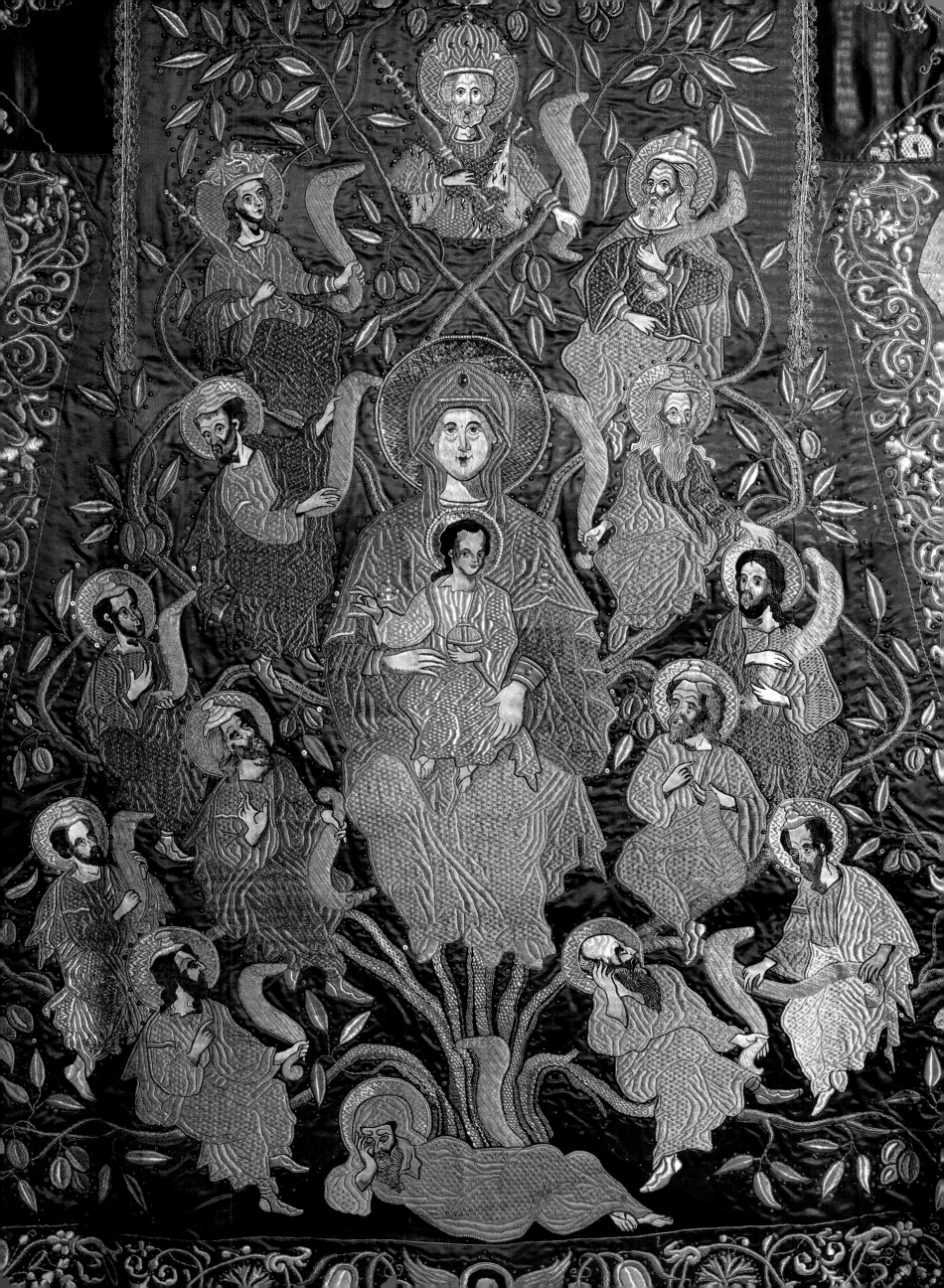

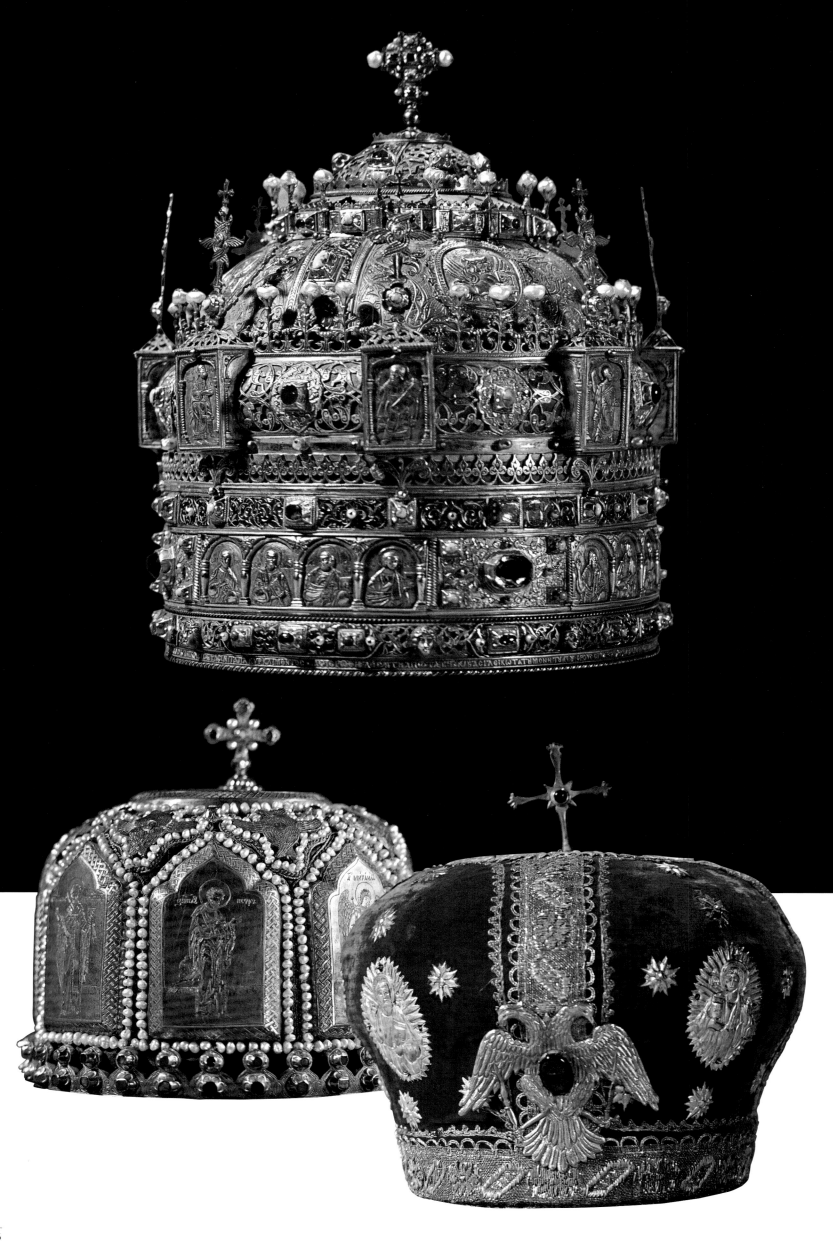

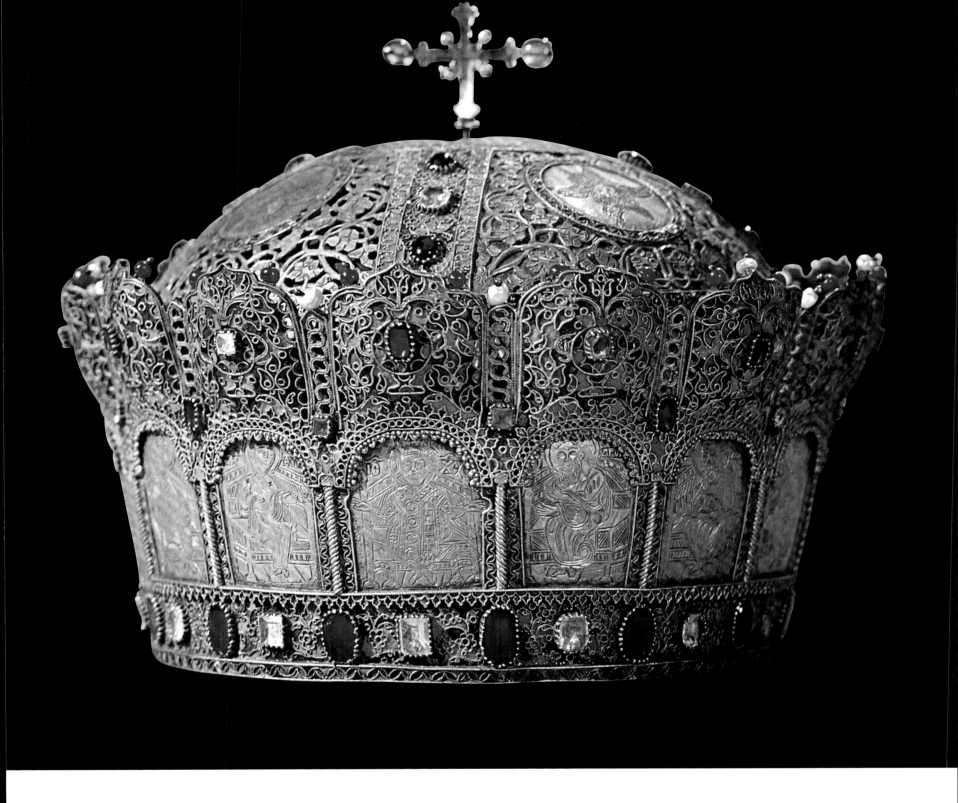

126 SUMPTUOUSLY AND INTRICATELY DECORATED ARCHBISHOPS' CROWNS. THE ONE AT THE TOP IS MADE OF GOLD STUDDED WITH PRECIOUS GEMS AND ADORNED WITH HORIZONTAL STRIPS THAT ALTERNATE GEOMETRIC MOTIFS WITH SMALL EMBOSSED PORTRAITS. THE LOWER ONE IS COMPOSED OF GOLD PLATES ENGRAVED WITH THE FIGURES OF SAINTS AND ANGELS. THE PLATES ARE OUTLINED WITH HUNDREDS OF PEARLS AND A DOUBLE ROW OF PRECIOUS STONES RUNS ALONG THE BASE. THE RED VELVET MITRE IS SIMPLER AND DECORATED WITH ELABORATE EMBROIDERY, PRECIOUS STONES, AND GILT INSERTS. AN EMBROIDERED STRIP RUNS AROUND THE BORDER AND DIVIDES THE BODY INTO FOUR SECTIONS, SURMOUNTED BY A GOLD CROSS.

127 THE DECORATION OF THIS ARCHBISHOP'S CROWN IS MADE WITH MINUTE GEOMETRIC AND VEGETAL MOTIFS TO FORM AN INTRICATE DESIGN THAT INCLUDES ENGRAVED GOLD PLATES AND LARGE PRECIOUS STONES IN VARIOUS COLORS.

128 and 129 THE COVER FOR A GOSPEL BOOK THAT APPEARS IN THESE IMAGES WAS MADE IN 1587 IN ENGRAVED AND CHASED SILVER. ON EACH SIDE A MAJOR SCENE IS ENCIRCLED BY PORTRAITS OF SAINTS IN SMALLER FRAMES. ONE SIDE PRESENTS MOSES WATERING HIS FLOCK, WITH THE BURNING BUSH, AND RECEIVING THE TABLES OF THE LAW; THE OTHER SIDE IS DECORATED WITH A SOLEMN CRUCIFIXION. THE BACKGROUND OF BOTH SCENES IS DECORATED WITH VEGETAL MOTIFS.

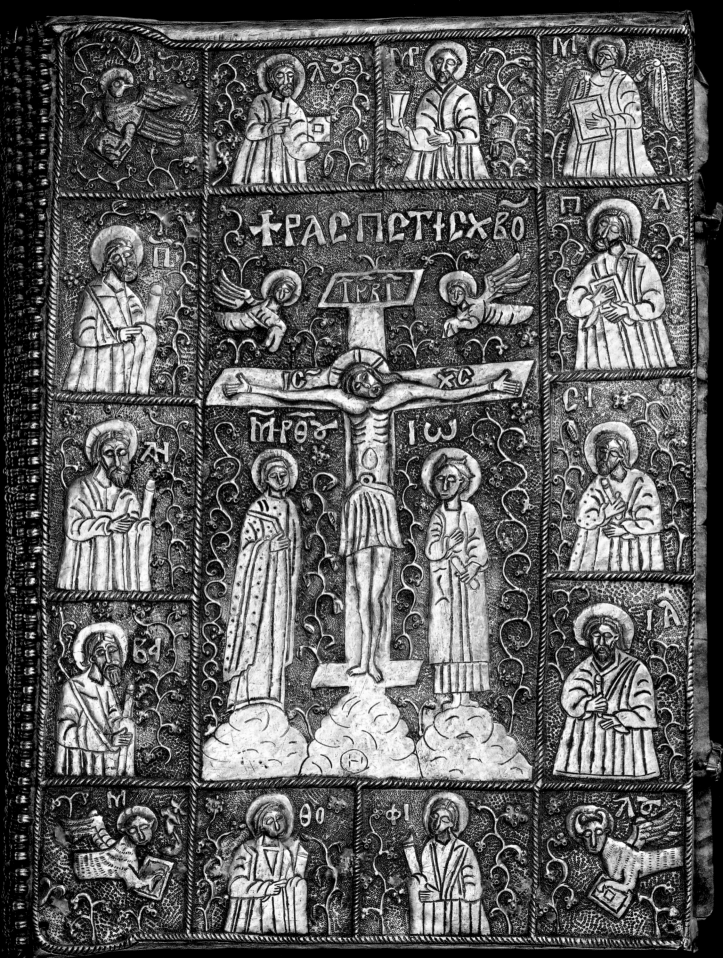

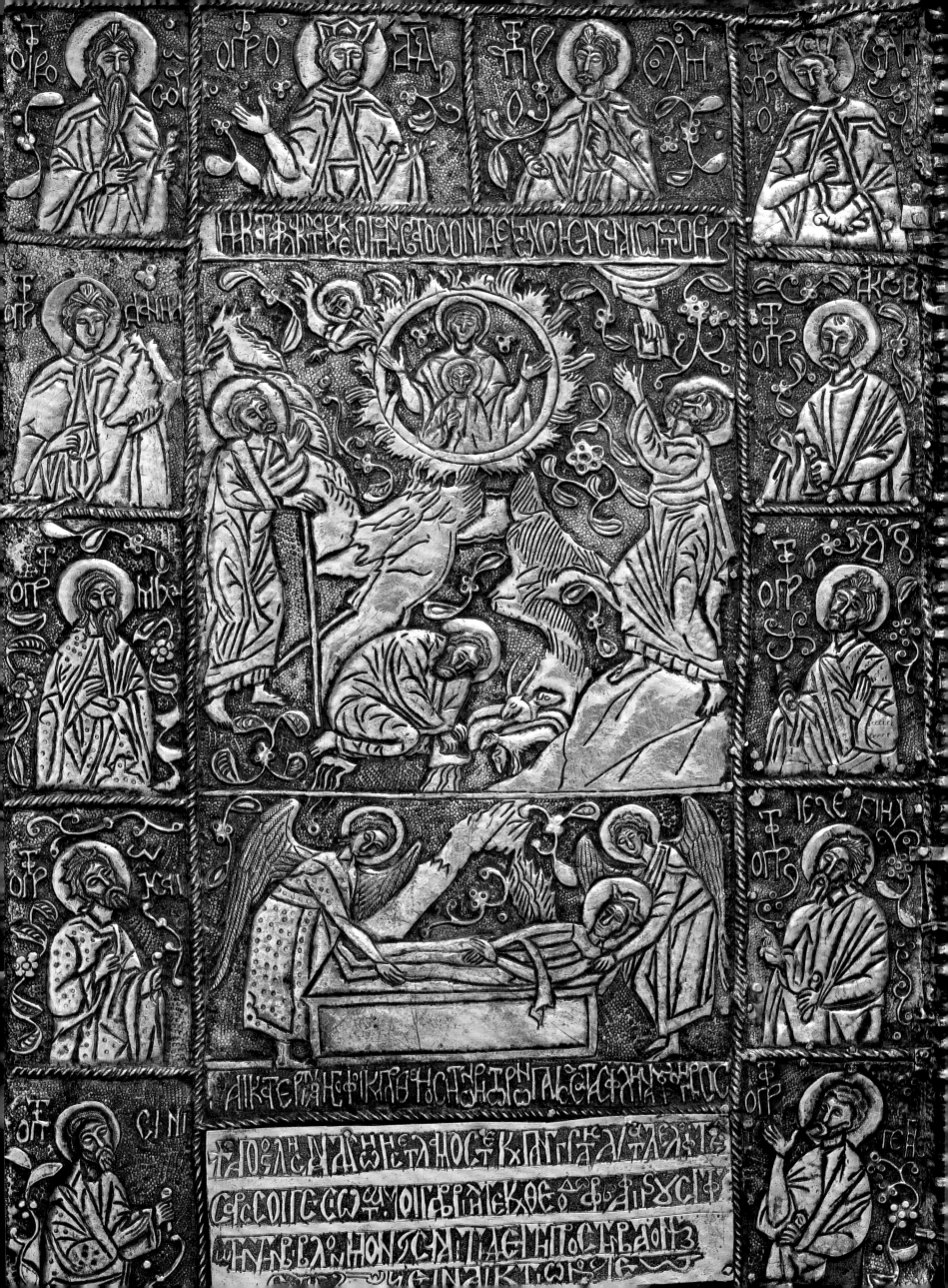

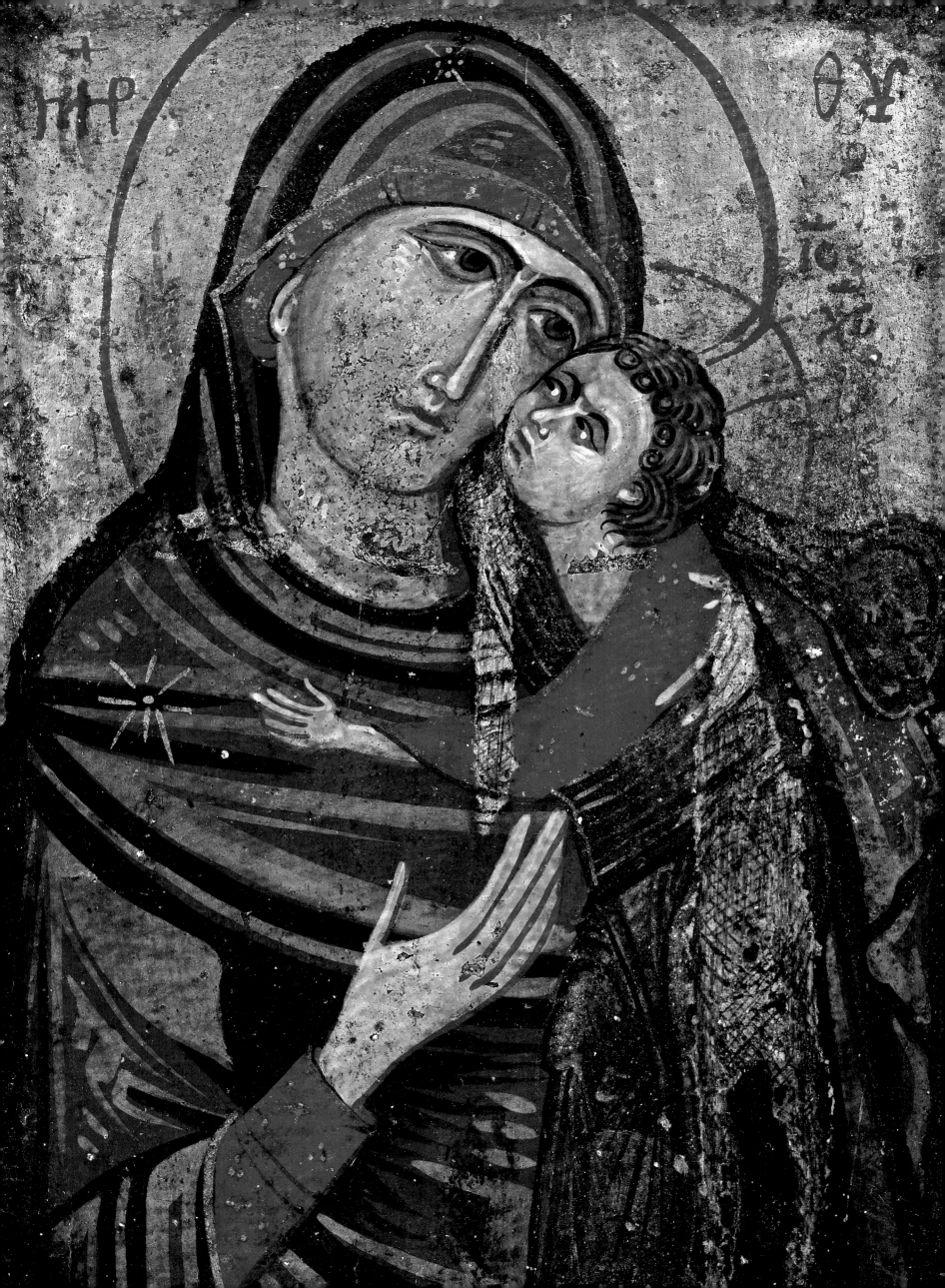

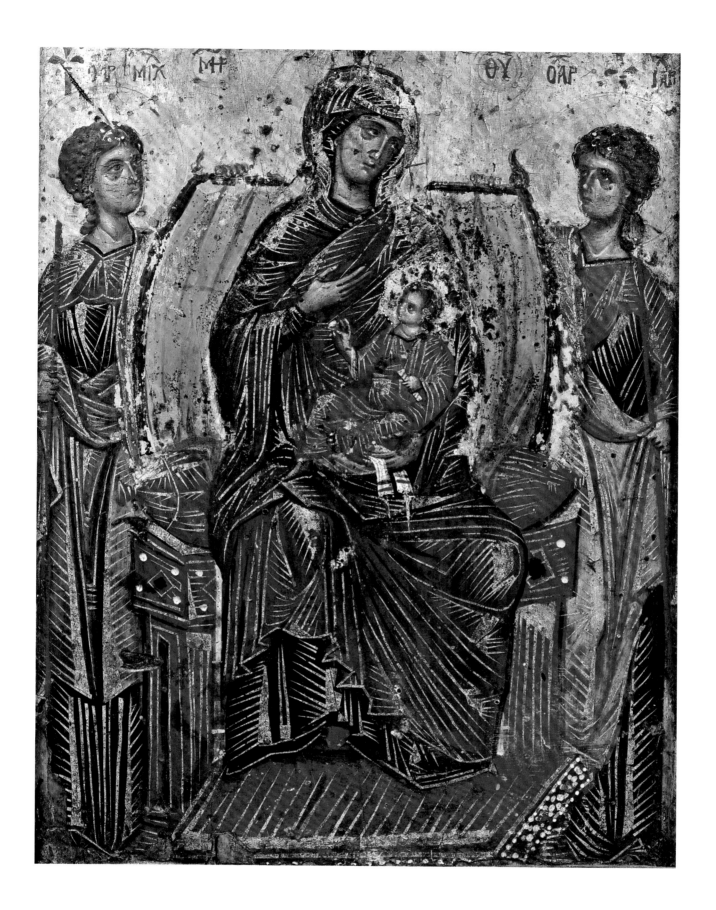

● *130* IN THE VIRGIN AND CHILD ICON, TEMPERA AND GOLD ON WOOD, 25.4 X 17.8 CM, THIRTEENTH CENTURY, MARY IS DEPICTED AFFECTIONATELY EMBRACING THE CHRIST CHILD, WHO IS PAINTED AS THOUGH STANDING ON THE LOWER EDGE OF THE ICON.

● *131* ICON OF THE VIRGIN AND CHILD ENTHRONED, TEMPERA ON WOOD, 35 X 26 CM, LATE THIRTEENTH CENTURY. THE VIRGIN, SEATED ON A THRONE, HOLDS THE CHILD IN HER LAP. TO THE SIDES ARE THE ARCHANGELS MICHAEL AND GABRIEL.

● *132 and 132-133* ICON OF THE CRUCIFIXION AND THE NATIVITY, TEMPERA ON WOOD, 43.9 X 30.8 CM, LATE THIRTEENTH CENTURY–EARLY FOURTEENTH CENTURY. THE DARK BLUE BACKGROUND SPREAD WITH GOLDEN STARS UNITES THE TWO SCENES, WHICH REPRESENT THE BEGINNING AND END OF CHRIST'S EARTHLY LIFE. THE LOWER HALF OF THE ICON PRESENTS THE NATIVITY IN A BUCOLIC LANDSCAPE WATCHED OVER FROM ABOVE BY FOUR ANGELS; THE BUNDLED CHILD LIES BESIDE THE VIRGIN, ATTENDED BY THE OX AND DONKEY WHILE THE MAGI OFFER THEIR PRECIOUS GIFTS. THE UPPER PORTION PRESENTS THE CRUCIFIXION.

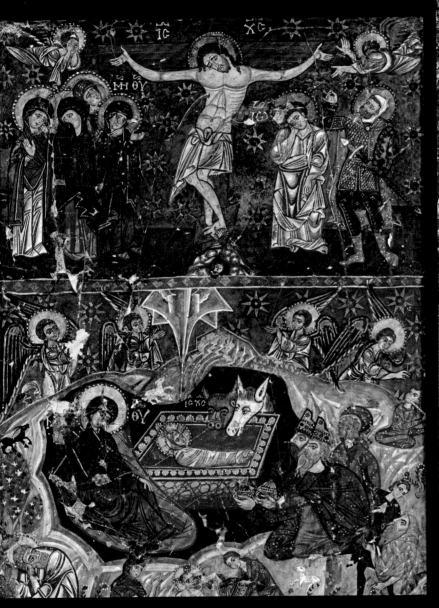
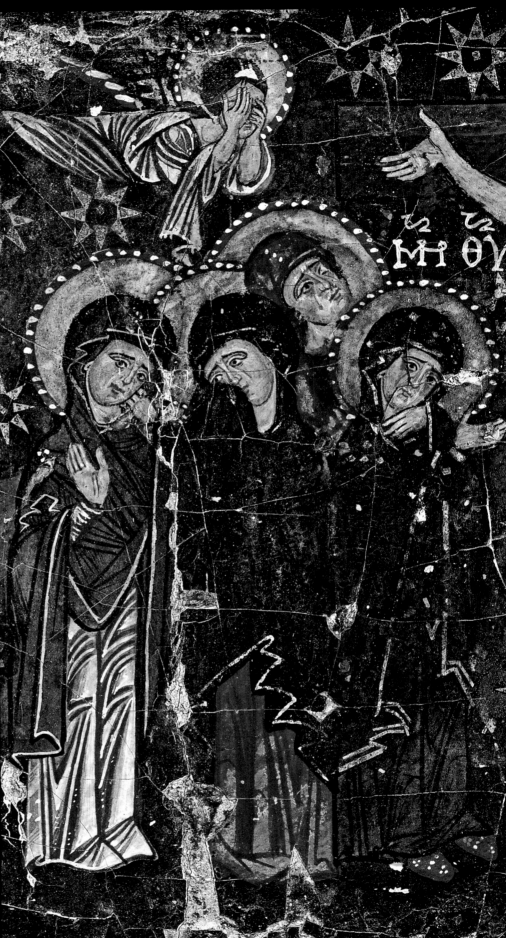

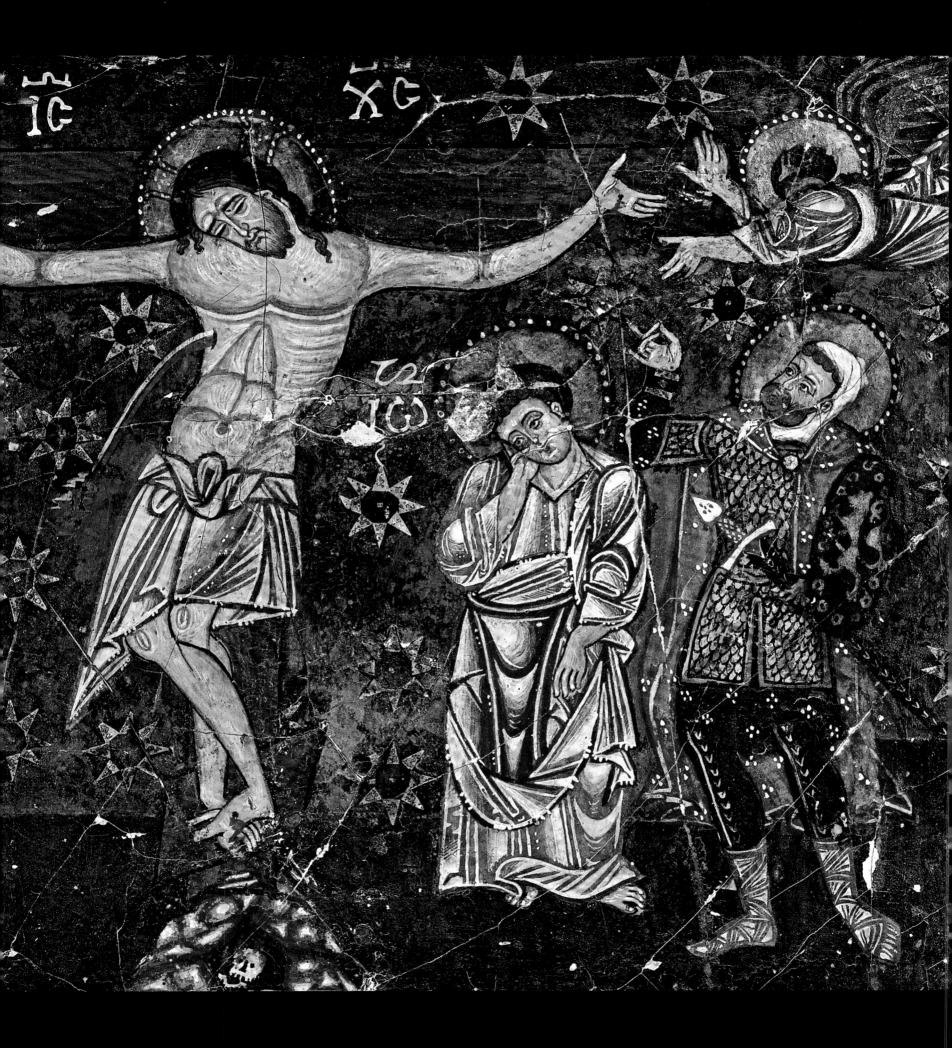

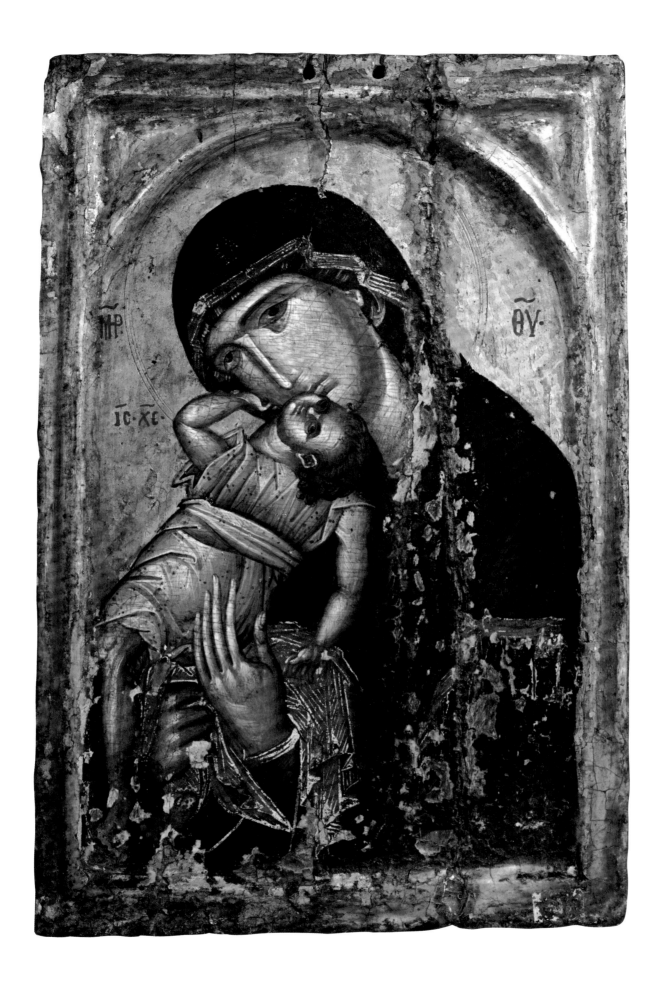

134 and 135 Icon of Virgin and Child, tempera on wood covered by gesso, 28.5 x 18.9 cm, early fifteenth century. In this small icon, probably made for private worship, the Child is presented in a playful pose, turned around with a hand on his mother's face. The Virgin has a sad expression and is dressed in dark tones; she holds the bare-legged child on a gold cloth. The icon is broken into two parts. The clearly visible vertical fracture has caused the loss of a portion of the painting on the right side.

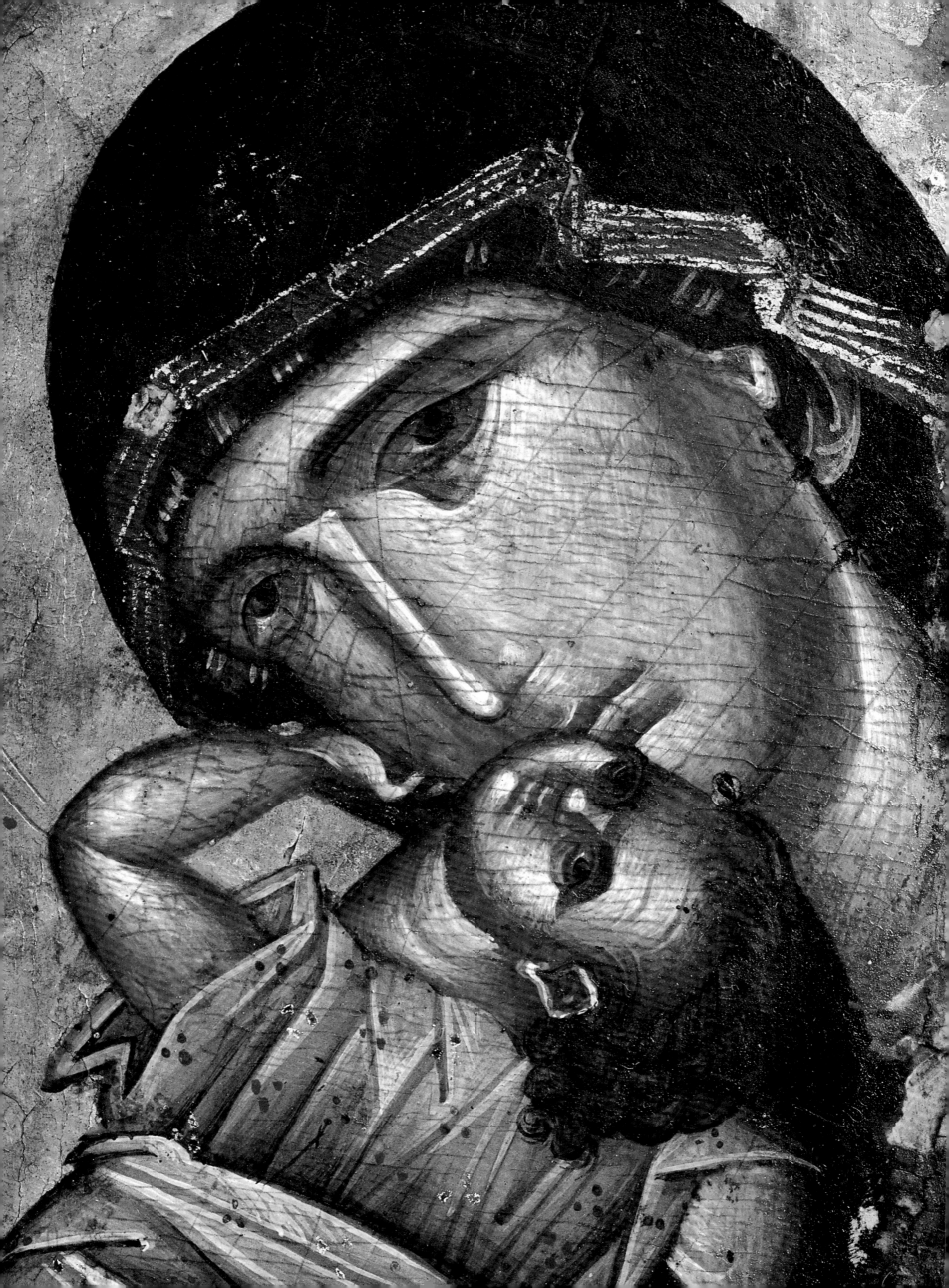

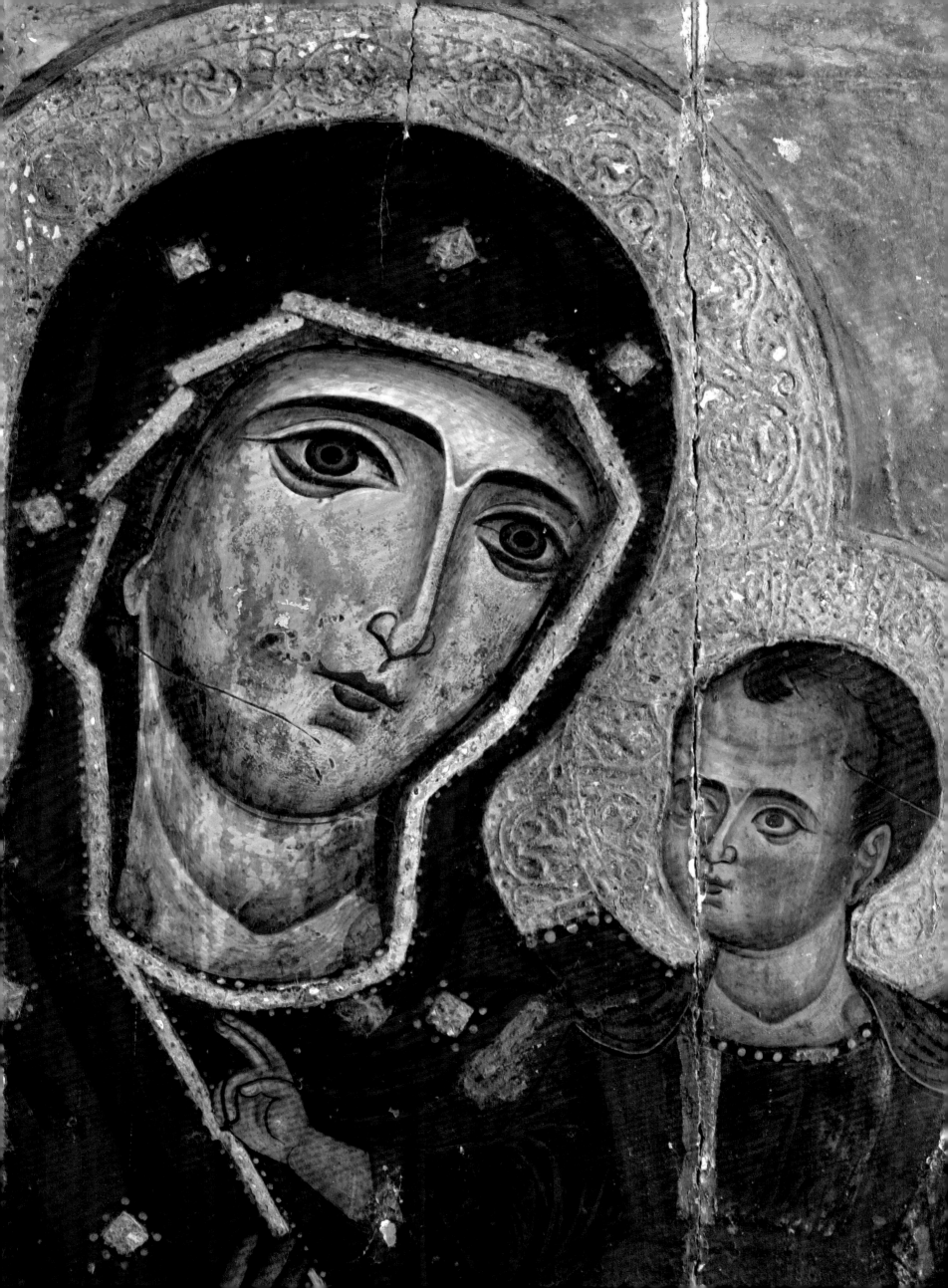

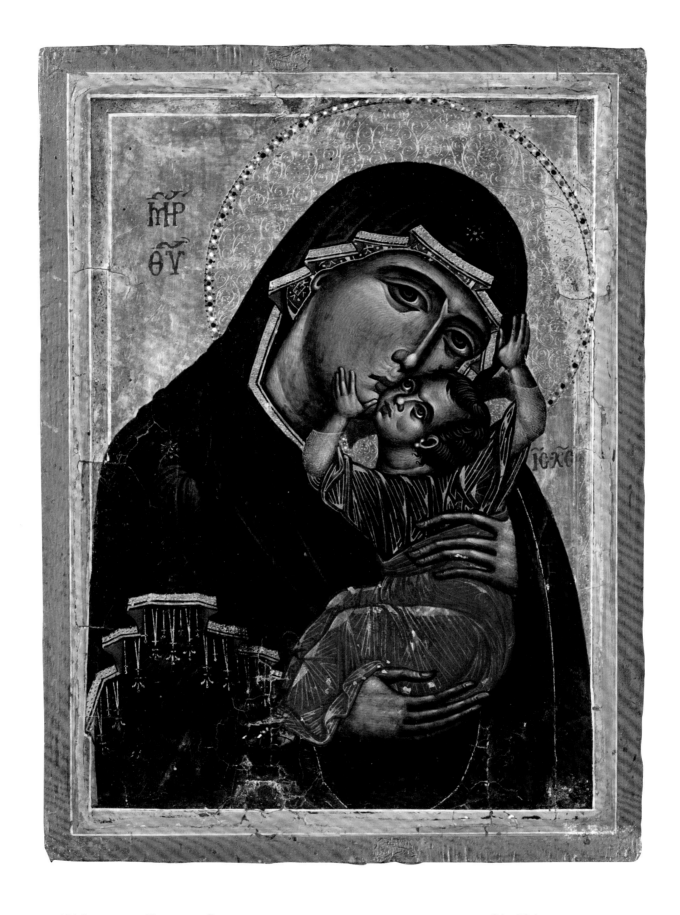

136 ICON OF THE VIRGIN AND CHILD, TEMPERA ON SUPPORT OF WOOD, CANVAS, AND GESSO, 94 X 74.4 CM, LATE THIRTEENTH CENTURY. THIS ICON, RESTORED SEVERAL TIMES OVER THE COURSE OF THE CENTURIES, PRESENTS THE VIRGIN HOLDING THE CHILD IN HER ARMS. FAINT TRACES OF THEIR NAMES, WRITTEN IN GREEK, ARE STILL VISIBLE IN THE UPPER LEFT CORNER. THE ELABORATE DRESS OF THE CHILD, THE DECORATION OF THE VIRGIN'S DRESS, THE LINES OF HER FACE, AS WELL AS THE DECORATIVE TECHNIQUE USED FOR THE HALO SUGGEST THAT THE AUTHOR WAS AN ARTIST OF THE THIRTEENTH-CENTURY CYPRIOT SCHOOL WITH INDICATIONS OF SYRIAN INFLUENCE IN HIS STYLE.

137 ICON OF CARDIOTISSA ("VIRGIN OF THE HEART"), TEMPERA ON WOOD, 31 X 22.2 CM, LATE THIRTEENTH–EARLY FOURTEENTH CENTURIES. THE NAME CARDIOTISSA WAS ATTRIBUTED TO THIS TYPE OF ICON BY THE CRETAN PAINTER ANGELOS AKOTANTOS IN THE FIFTEENTH CENTURY.

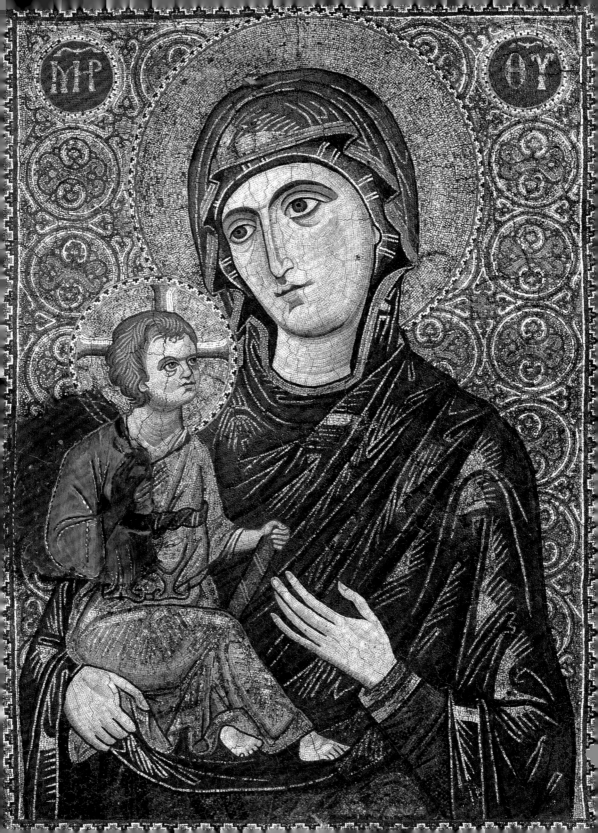

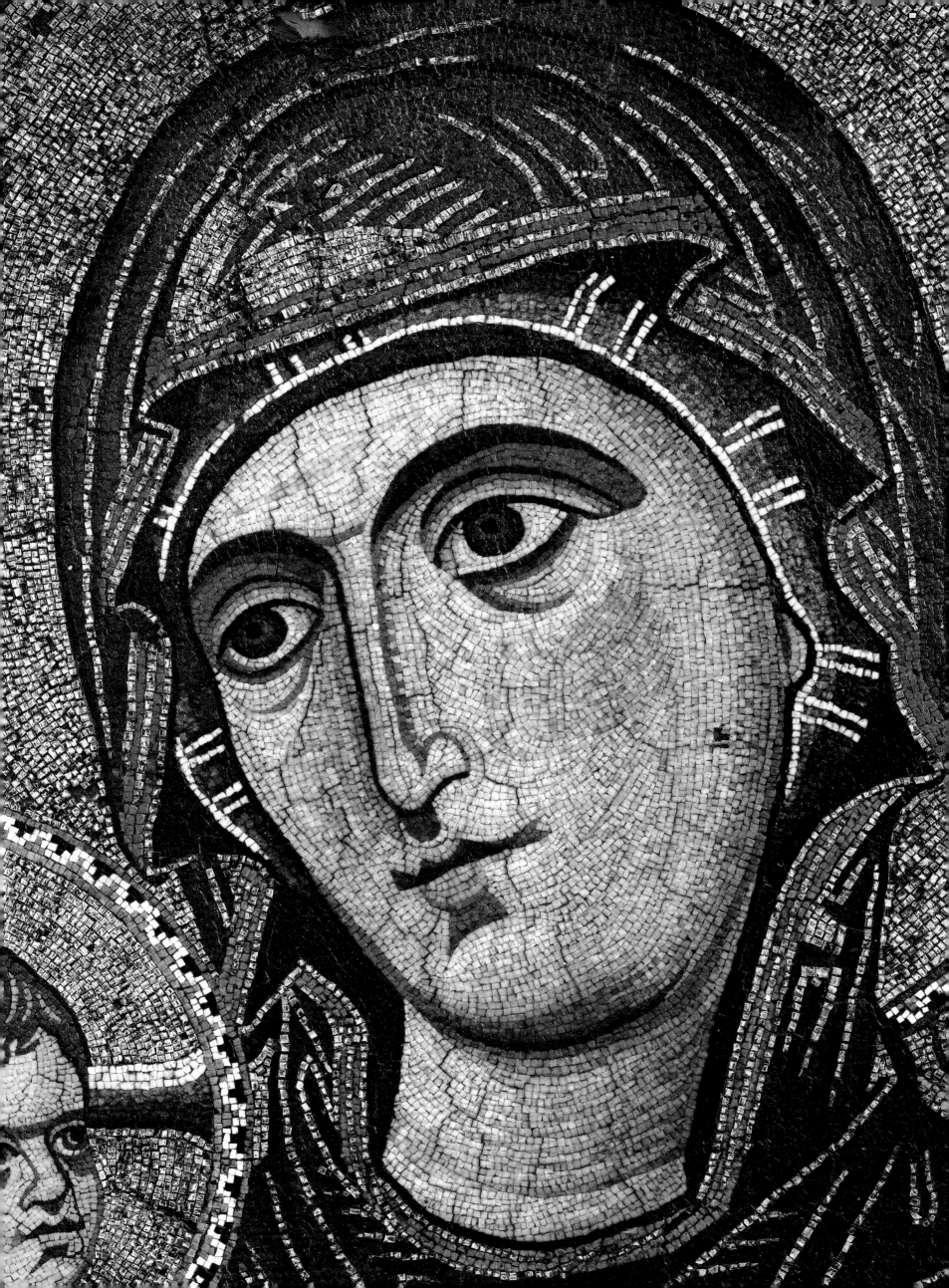

● *138 and 139* Icon of the Virgin and Child, mosaic, 34 x 23 cm without the frame, early thirteenth century. This icon made in mosaic depicts the Virgin holding the Child in her arms against a highly particular background covered by intricate geometric designs. The close-up view of the image reveals both the artist's skill and the refined technique with which he made the face of the Virgin, whose flesh and features are rendered through delicately shaded colors. The drapery of the clothing of both figures is presented with subtle gilt lines following a technique employed in other icons and paintings of the period.

● *140* Icon of Moses and the Burning Bush, tempera on wood, 31.5 x 38.5 cm, seventeenth century. This icon, which is painted on the inner face of the basilica's iconostasis, presents Moses watering his flock and encountering the Burning Bush in the foreground; on the top of the mountain he receives the Tables of the Law, while on the peak of a nearby mountain two angels set down the body of St. Catherine.

● *141* Icon with composite scene of Moses, tempera on wood, 40.5 x 31.5 cm. In a single scene this icon presents Moses kneeling before the Burning Bush, inside which the Virgin and Child appear, and Moses receiving the Tables of the Law on the peak of Mount Sinai. The scene is witnessed from one side by St. Catherine.

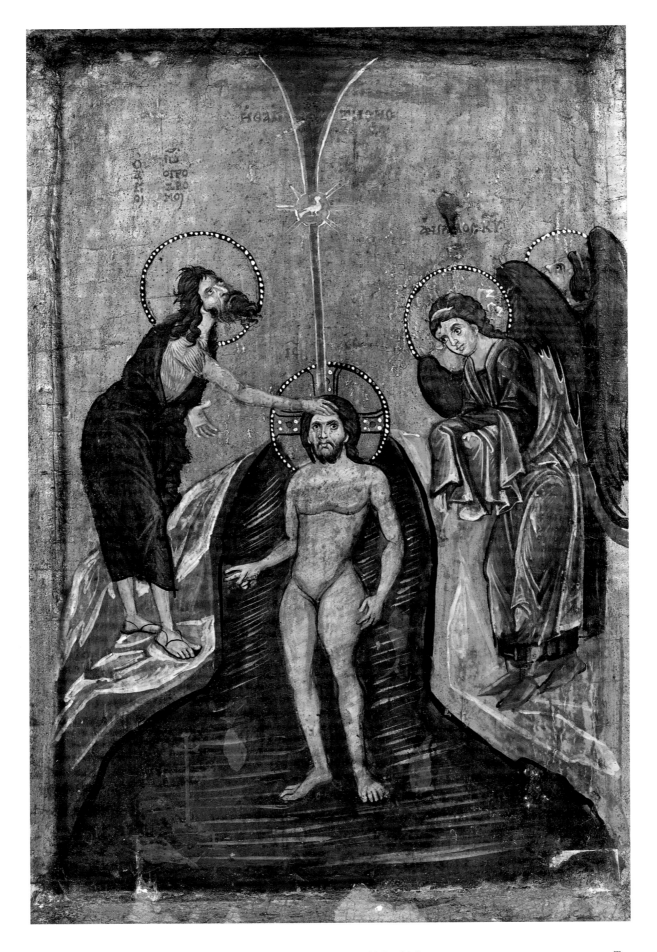

142 ICON OF THE BAPTISM OF CHRIST, TEMPERA AND GOLD ON WOOD, 33.5 X 23.2 CM, SECOND HALF THIRTEENTH CENTURY. THE HEAD OF CHRIST, STANDING IN THE RIVER, IS TOUCHED BY A RAY OF LIGHT THAT INCLUDES THE SHAPE OF THE DOVE, SYMBOL OF THE HOLY SPIRIT. ST. JOHN THE BAPTIST RESTS HIS RIGHT HAND ON CHRIST'S HEAD AND LOOKS UPWARD.

143 ICON OF THE NATIVITY, TEMPERA AND GOLD ON WOOD, 33.7 X 24.9 CM, SECOND HALF THIRTEENTH CENTURY. THIS ICON USES ICONOGRAPHY THAT BLENDS ELEMENTS FROM BOTH THE BYZANTINE AND LATIN STYLES TO PRESENT THE BIRTH OF CHRIST. THE CHILD LIES IN A GROTTO, WATCHED OVER BY THE OX AND DONKEY AND BY THE VIRGIN, RESTING ON ONE SIDE. A RAY OF LIGHT REACHES HIM FROM THE SKY AND, TOUCHING HIS FOREHEAD, INDICATES HIS DIVINE NATURE.

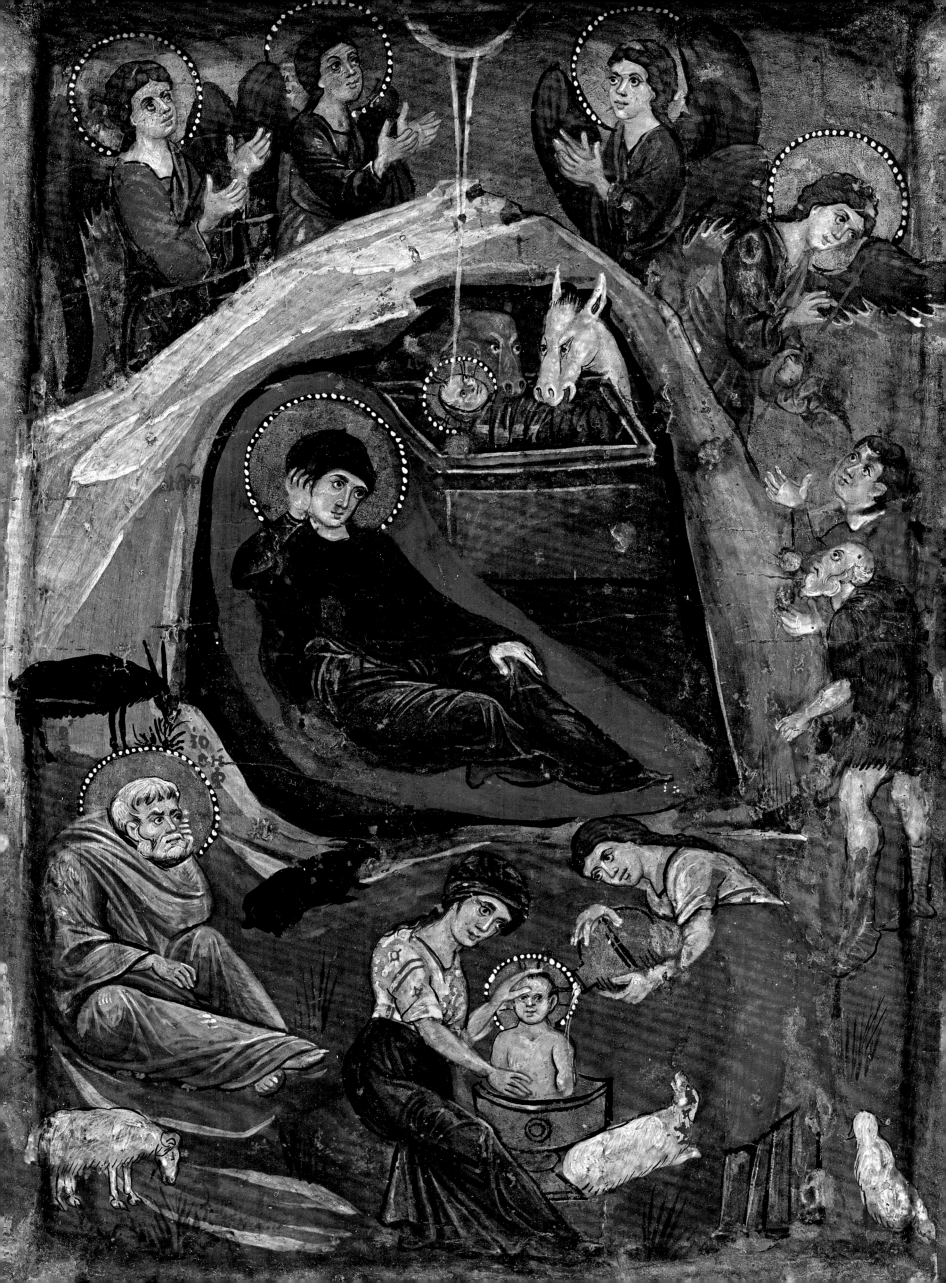

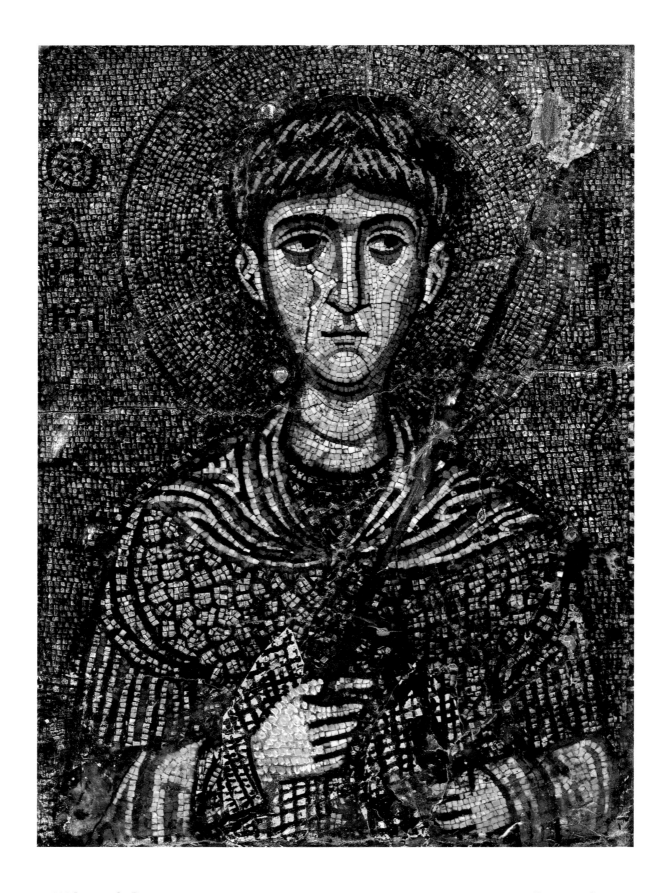

● *144* Icon of St. Demetrius, mosaic on wooden panel, 19 x 15 cm, second half twelfth century. Patron of Salonika, St. Demetrius is presented as a warrior saint in battle armor.

● *145* Icon of St. George, tempera on support of wood and canvas, 35.7 x 29 cm, thirteenth century. This icon presents a detail of the Saint limited to his curly head visible against a gilt background.

● *146* Icon of Saints Peter and Paul, tempera on wood, 25 x 20.8 cm, mid-fourteenth century. This small icon presents the two primary apostles. To the left is Peter, clothed in a bright orange robe, while Paul wears a darker robe that sets off the gospel he holds in his hands.

● *147* Icon of saints, tempera on wood, 33.3 x 23.7 cm, twelfth century. This icon presents a mixed group of saints. At the center above is St. John, flanked by Saints Paul and Stephen. The lower row is composed of Saints Martin of Tours, Lawrence, and Leonard of Noblac. This icon dates from the time of the Latin Kingdom of Jerusalem.

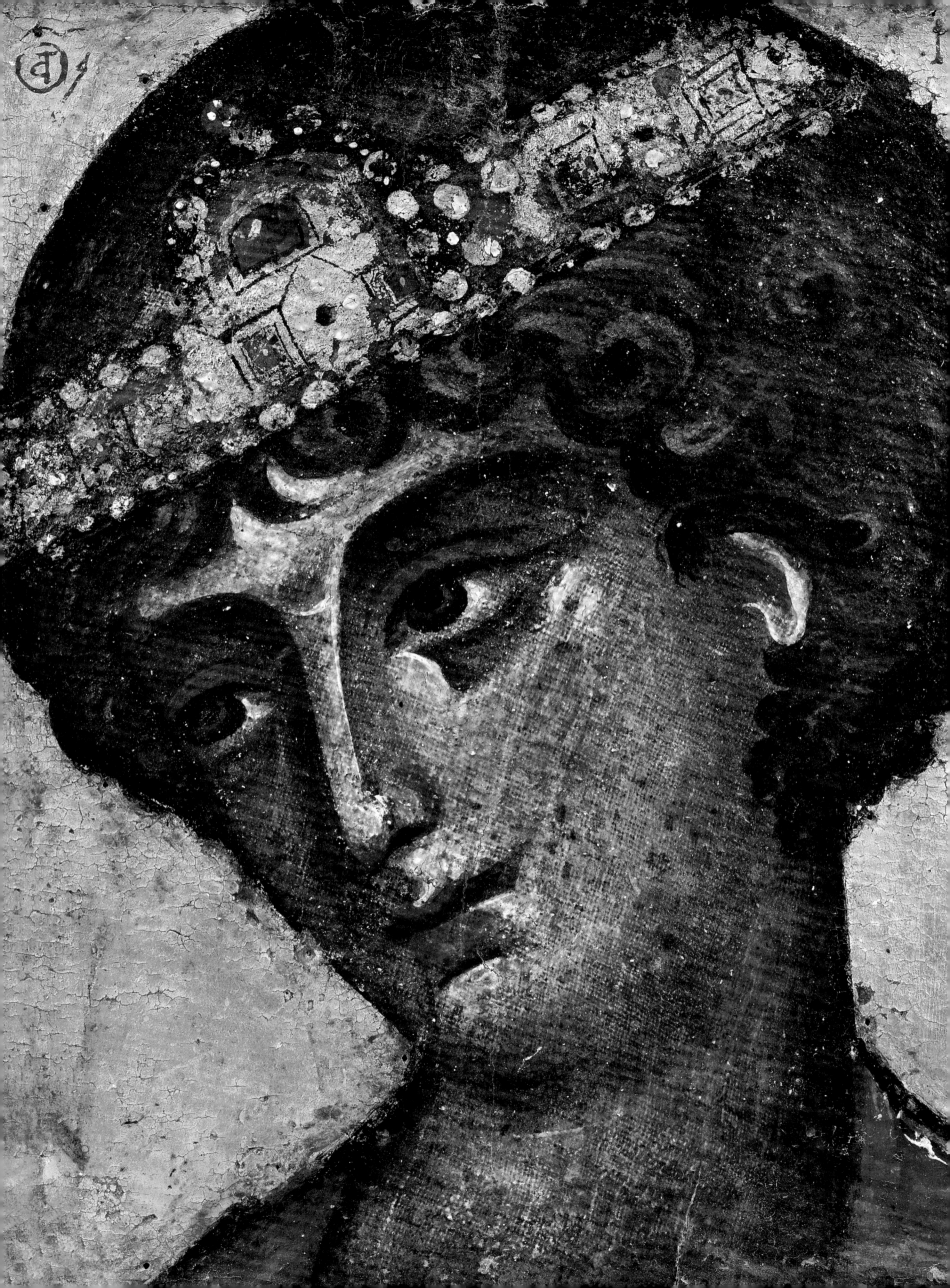

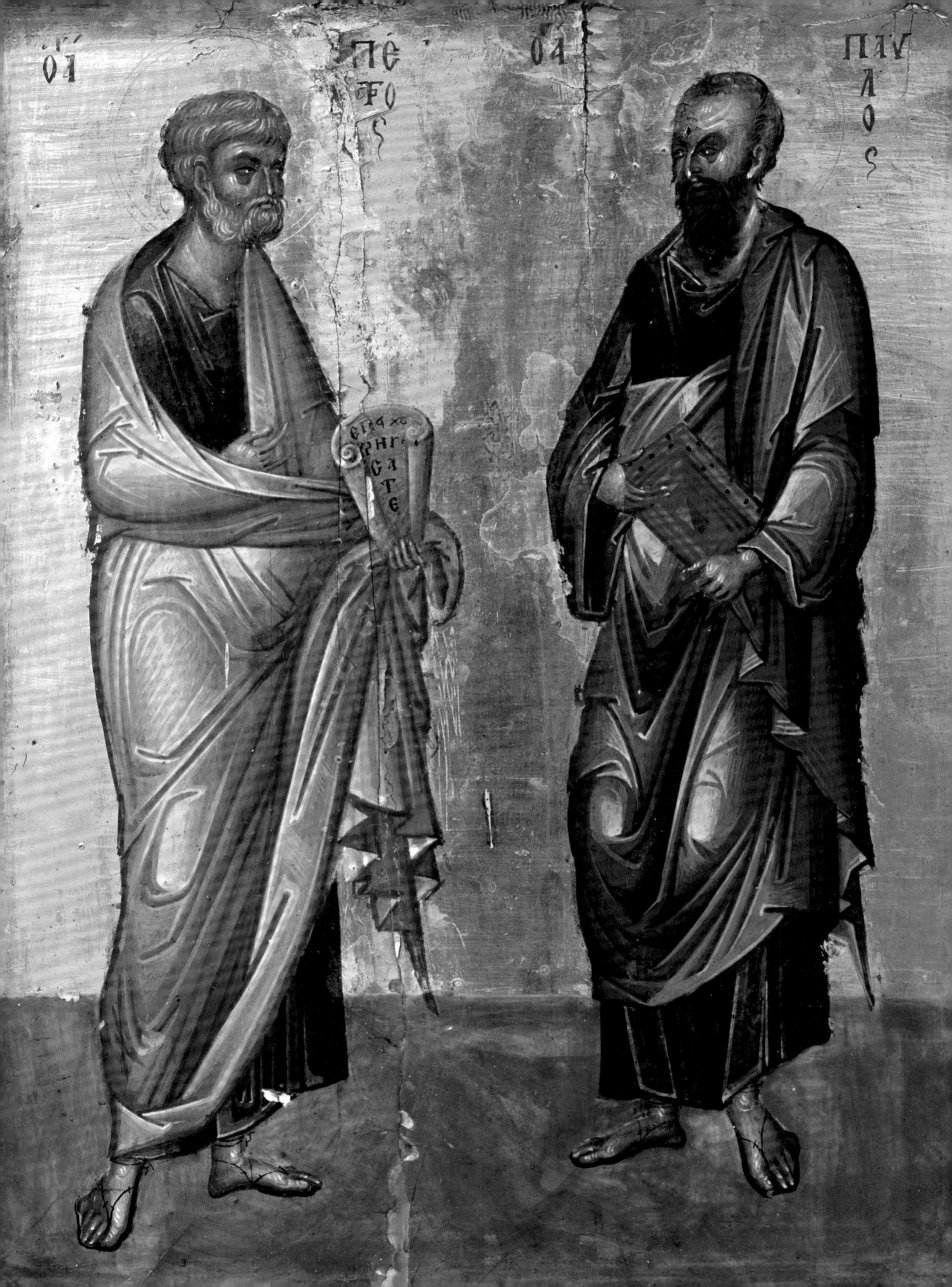

Ὁ ΠΕΤΡΟC · Ο ΑΓ · ΠΑΥΛΟC

148 ICON OF NOAH'S ARK, TEMPERA ON WOOD, 31.5 X 38 CM, SEVENTEENTH CENTURY. THIS ICON, PAINTED ON THE INTERIOR SIDE OF THE BASILICA'S ICONOSTASIS, PRESENTS THE STORY OF NOAH AND THE ARK HE BUILT TO SURVIVE THE UNIVERSAL FLOOD. NOAH IS SHOWN IN THE ACT OF ASSEMBLING THE ANIMALS TO SAVE THEM ABOARD THE ARK. SOME PAIRS OF BEASTS ALREADY ASCEND THE LONG WOODEN ACCESS PLANK TO THE LARGE ARK, UNDER THE EYES OF GOD, WHO LOOKS DOWN FROM A CORNER OF THE SKY WRAPPED IN CLOUDS.

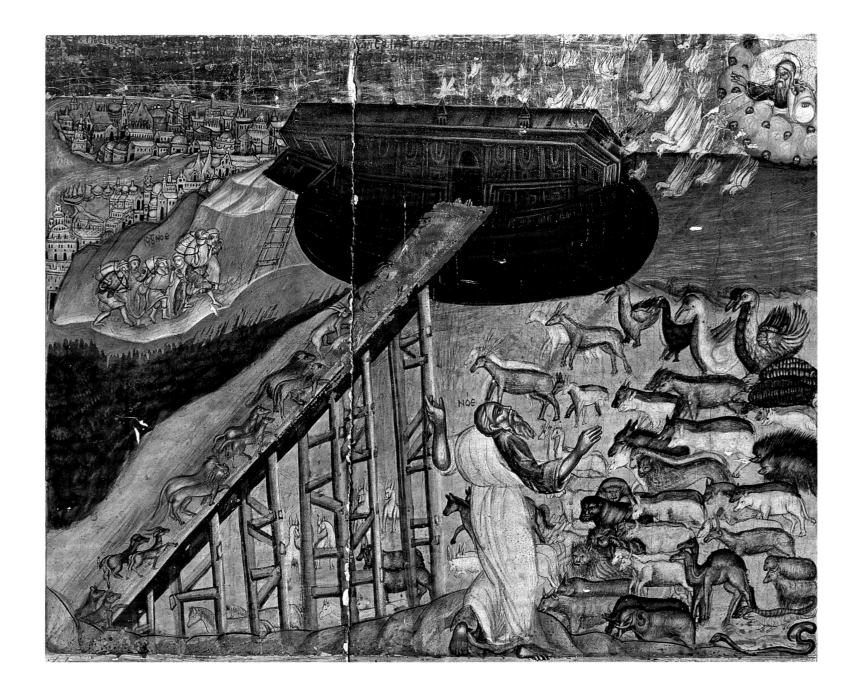

149 ICON OF MOSES, TEMPERA AND GOLD ON WOOD, 34 X 24 CM, SECOND HALF TWELFTH CENTURY. MOSES IS HERE PURPOSEFULLY PRESENTED WITH TRAITS AND ELEMENTS THAT MAKE HIM RESEMBLE A CHRIST PANTOCRATOR.

150 ICON OF THE CRUCIFIXION, TEMPERA AND GOLD ON WOOD, 33.7 X 26.6 CM, LATE TWELFTH CENTURY. THIS DRAMATIC ICON PRESENTS THE CRUCIFIXION IN VIVID COLORS AND SHARP LINES THAT STAND OUT ON THE BRIGHT GOLD BACKGROUND. BRIGHT RED BLOOD FLOWS FROM THE WOUNDS OF THE DYING CHRIST, THE VIRGIN IS PRESENTED OVERCOME BY SORROW, WHILE BEHIND HER MARY MAGDALENE LIFTS HER ARMS TO THE SKY IN A GESTURE OF EXTREME MOURNING.

151 ICON OF THE ARCHANGEL GABRIEL, TEMPERA AND GOLD ON WOOD, 105 X 75 CM, THIRTEENTH CENTURY. THIS ICON IS CONSIDERED A MASTERPIECE OF BYZANTINE ART. IT PRESENTS THE ARCHANGEL GABRIEL, HIS FLOWING HAIR GATHERED BY A DIADEM AND SURROUNDED BY A VERY THIN HALO. SYMMETRICAL WINGS EXTEND FROM HIS SIDES, AND HIS SHOULDERS ARE DRAPED BY A ROBE WHOSE FOLDS ARE ILLUMINATED BY THE CONTRAST OF GOLD AND RED. THE ARCHANGEL'S ROLE AS DIVINE MESSENGER IS SYMBOLIZED BY THE PILGRIM'S STAFF HE HOLDS IN HIS HAND.

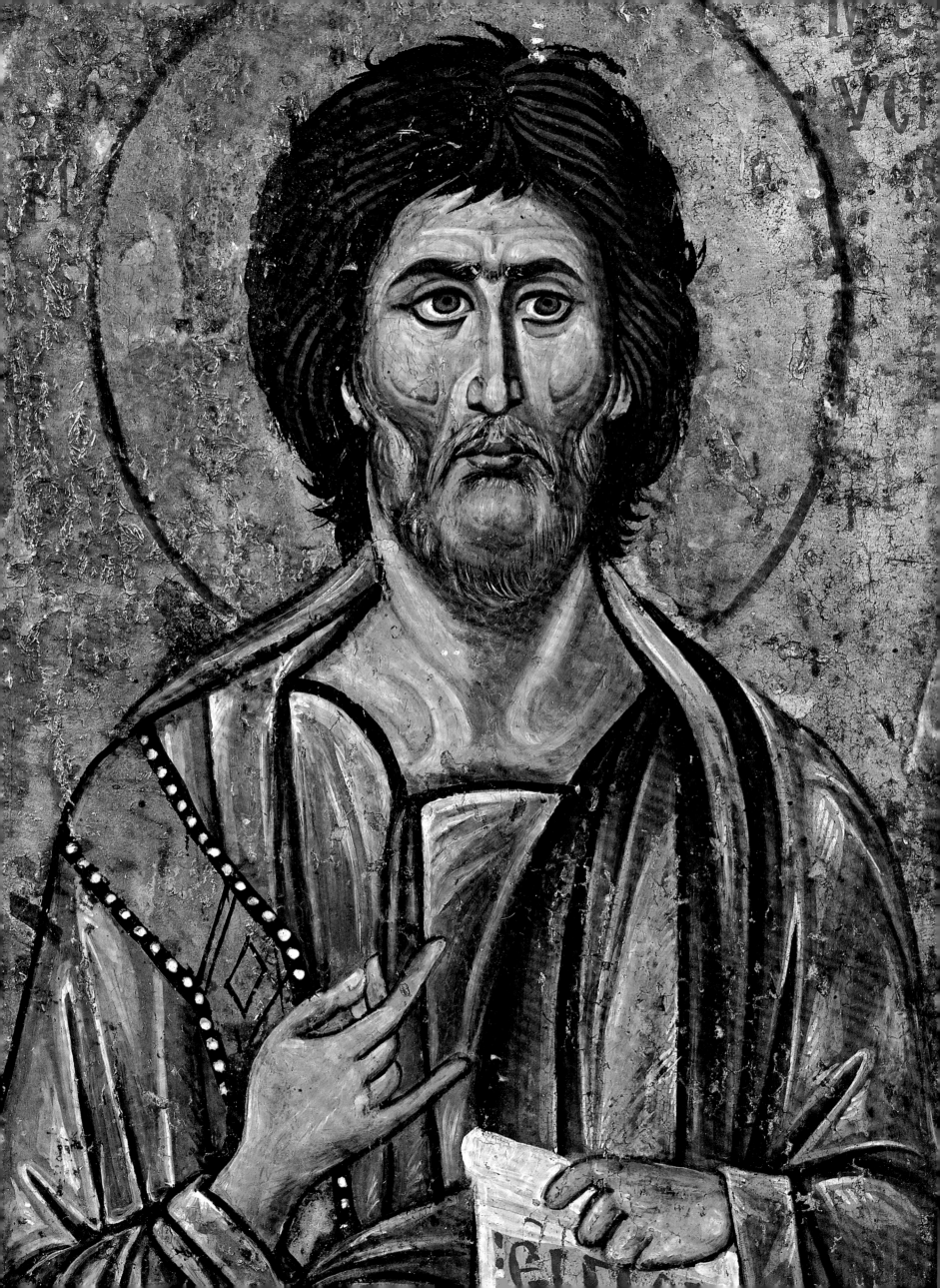

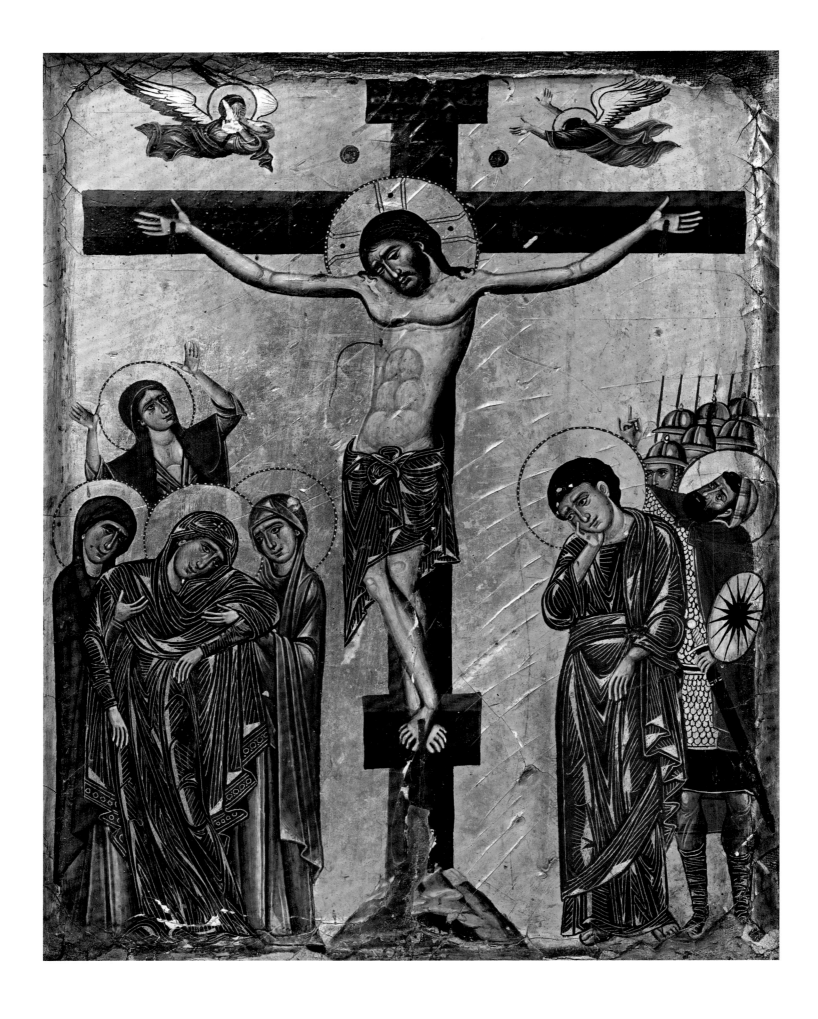

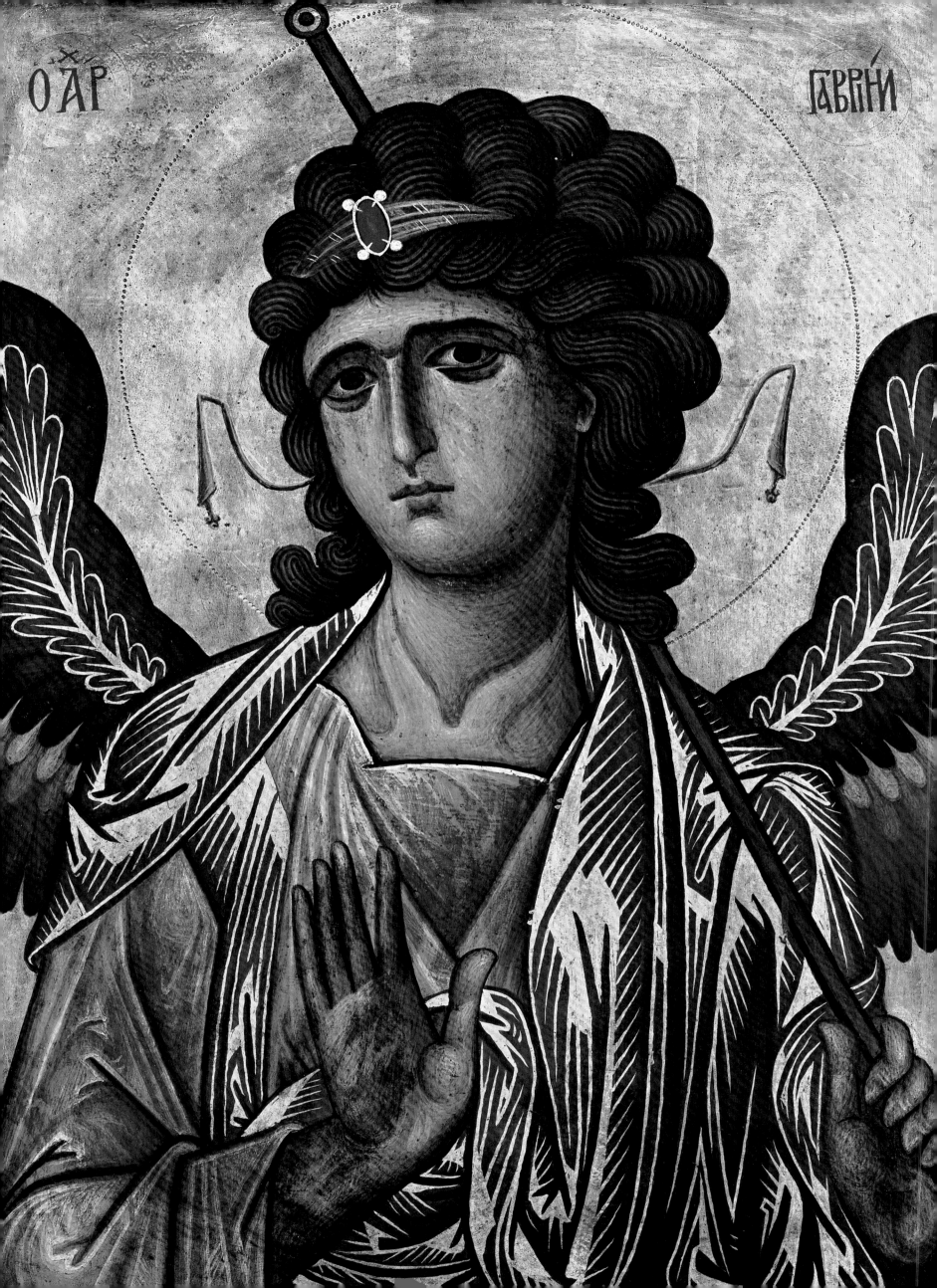

152 ICON OF THEODOSIA, A NUN OF CONSTANTINOPLE MARTYRED IN HER DEFENCE OF THE HOLY ICONS, TEMPERA ON WOOD, 33.9 X 27.5 CM, FIRST HALF THIRTEENTH CENTURY.

153 ICON OF ST. JOHN CLIMACUS, AUTHOR OF THE *LADDER TO PARADISE*, TEMPERA ON WOOD, 23 X 19 CM, FIFTEENTH CENTURY.

154 ICON OF THE CHRIST CHILD IN THE ARMS OF ST. SYMEON THEODOCHOS, TEMPERA AND GOLD ON WOOD, 24 X 16.5 CM, END THIRTEENTH CENTURY.

155 ICON OF THE CRUCIFIXION, WITH THE DYING CHRIST ON THE CROSS, TEMPERA ON WOOD, 28.2 X 21.6 CM.

Ο ΑΓΙΟC ΙΩ ΟΤCΚΛ ΙΝΑΚΟ

Ο CΥΜΕ ... ΘΕΟΔΟΧΟC
ΙС ΧС

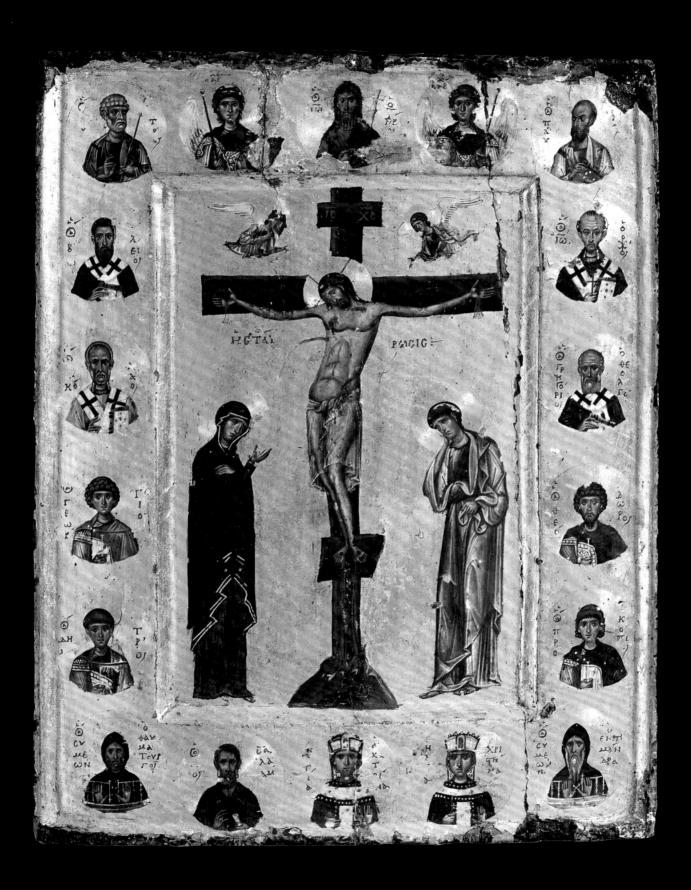

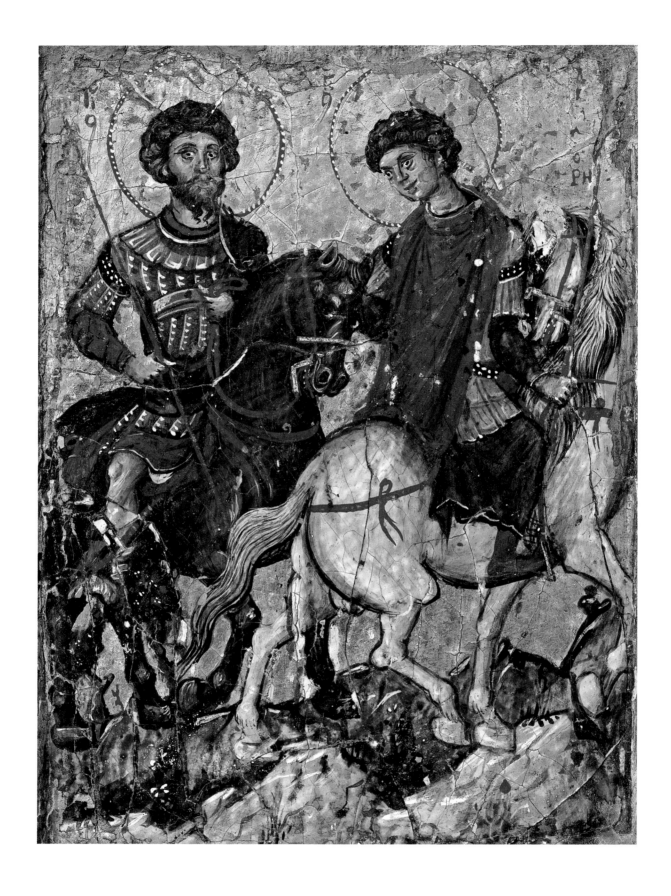

○ *156* ICON OF SAINTS THEODORE AND DEMETRIUS ON HORSEBACK, TEMPERA AND GOLD ON SUPPORT OF WOOD, CANVAS, AND GESSO, 23.8 X 16.1 CM, CA. 1250–60. SAINTS THEODORE AND DEMETRIUS ARE HERE SHOWN DRESSED FOR WAR AND MOUNTED; THE ICON HAS BEEN SLIGHTLY DAMAGED BY THE PASSAGE OF TIME. THE BEARDED THEODORE RIDES A DARK HORSE WHILE DEMETRIUS IS PRESENTED WITH HIS HEAD TURNED BACK, HIS HORSE OF AN EXEMPLARY CLARITY.

○ *157* ICON OF ST. SERGIUS ON HORSEBACK, TEMPERA AND GOLD ON SUPPORT OF WOOD, CANVAS, AND GESSO, 28.7 X 23.2 CM, CA. 1260–70. IN THIS ICON, ST. SERGIUS IS PRESENTED IN THE DRESS TYPICAL OF WARRIOR SAINTS. IN ONE HAND HE BEARS CRUSADER'S EMBLEMS, WITH THE OTHER HE GRASPS THE REINS OF HIS HORSE. HE CARRIES BEHIND A ROUND SHIELD, WHICH ALSO APPEARS IN OTHER ICONS OF THE SAME SUBJECT. BELOW IS THE FIGURE OF A WOMAN, PERHAPS THE DONOR OF THE ICON, HOLDING THE HORSEMAN'S FEET IN A REVERENTIAL ATTITUDE. THE SCENE IS PAINTED ON A GILT BACKGROUND THAT EXTENDS BEYOND THE BROAD BLACK AND GREEN STRIPS THAT REPRESENT THE GROUND.

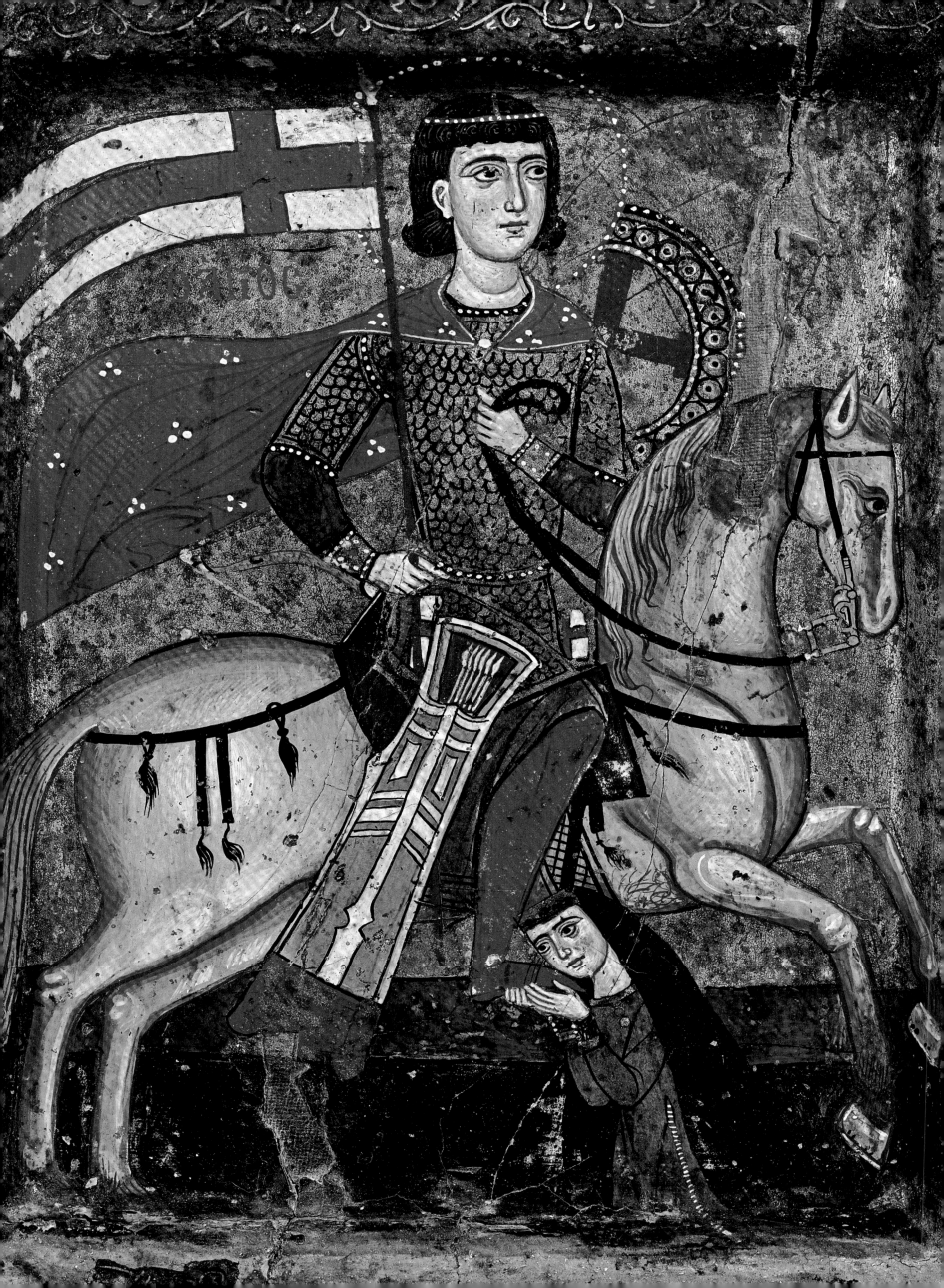

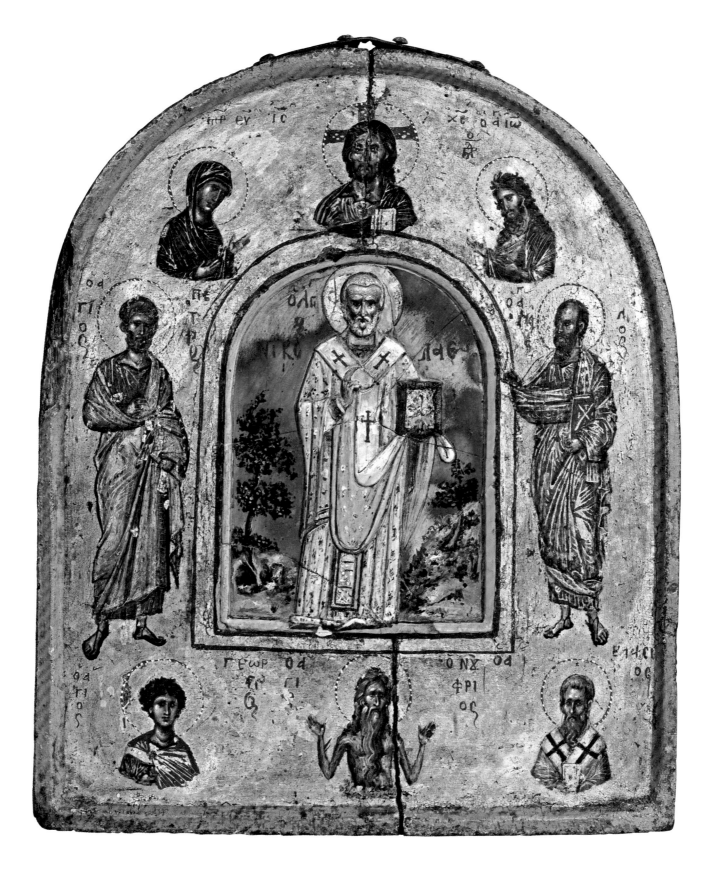

● *158* Icon of St. Nicholas, steatite, wood, tempera, and gilding, 21 x 16 cm, eleventh century (steatite), seventeenth–eighteenth centuries (painting), late thirteenth–fourteenth centuries (frame). This icon has an interesting history. The central image of St. Nicholas was made in the stone known as steatite and was then later inserted in a large gilt-wood frame, on which eight figures are painted in a symmetrical arrangement; Christ at the center above, flanked by the Virgin and St. John, with full-figure images of Saints Peter and Paul at the sides, and at the bottom the three eastern saints George, Blaise, and, at the center, the hermit St. Onophrius. The original image of St. Nicholas dates to the eleventh century, but the style and colors of the saint's dress suggest that the paint was probably applied in the seventeenth to eighteenth centuries.

● *159* Icon of St. Catherine of Alexandria, tempera and gold on wood, 75.3 x 51.4 cm, early thirteenth century. St. Catherine is presented at the center of this pretty icon, surrounded by twelve panels presenting episodes from her life. The narration begins with the scene at upper left, in which the saint kneels before an angel, and continues clockwise to end in the scene of her decapitation. The saint can be easily identified in each scene since she wears the same clothes in all of them, a simplified version of the elaborate outfit she wears in the central portrait.

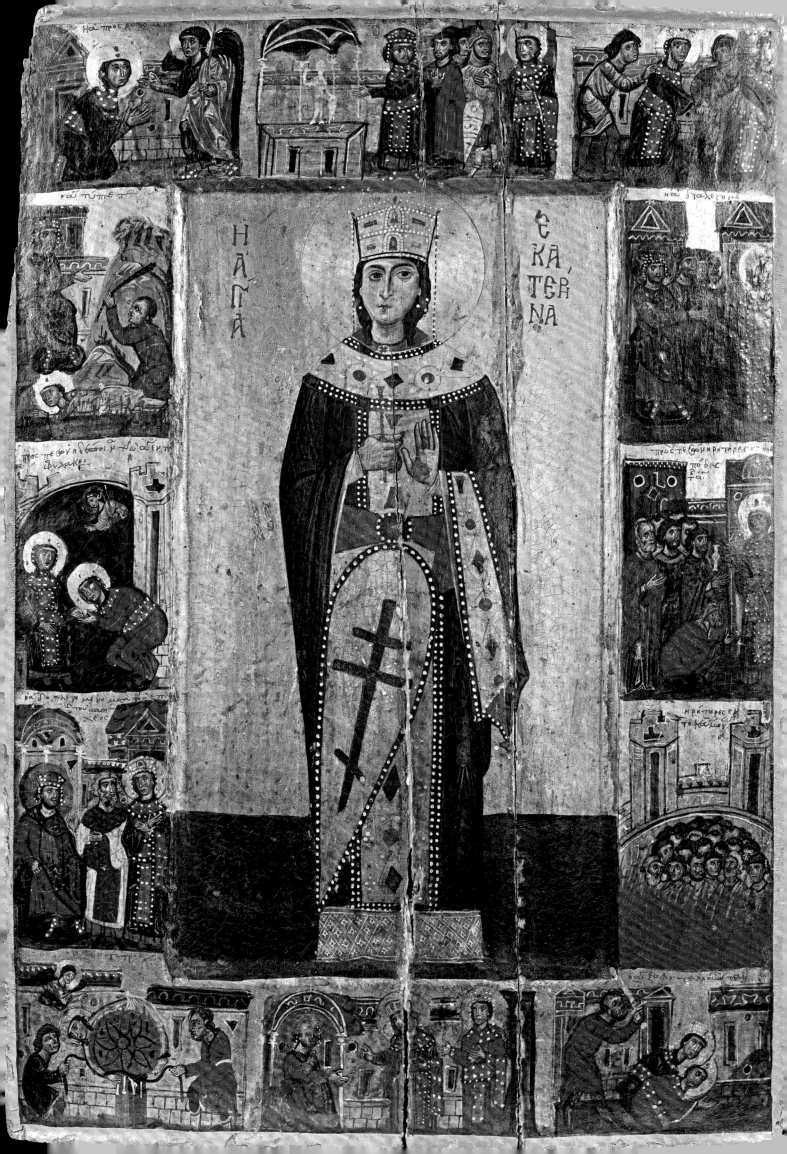

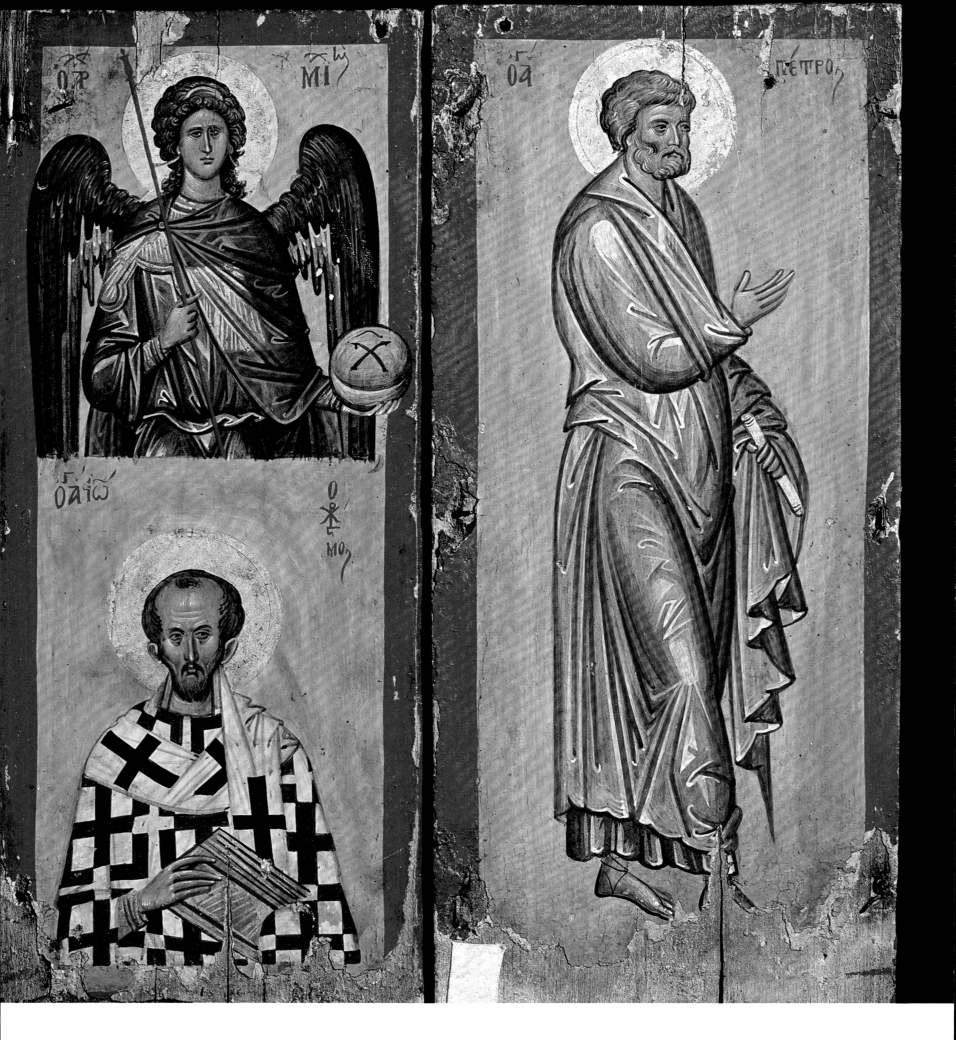

160, 161, and 162 bottom Polyptych icon of apostles, angels, and saints (verso), each panel 31 x 13.5 cm, tempera
and gold on wood, fourteenth century. This composition of six panels was made in the monastery and is decorated
on both sides. To the sides are large portraits of Saints Peter and Paul, and the half-bust portraits of the church
fathers Saints Basil and John Chrysostom, and the Archangels Gabriel and Michael.

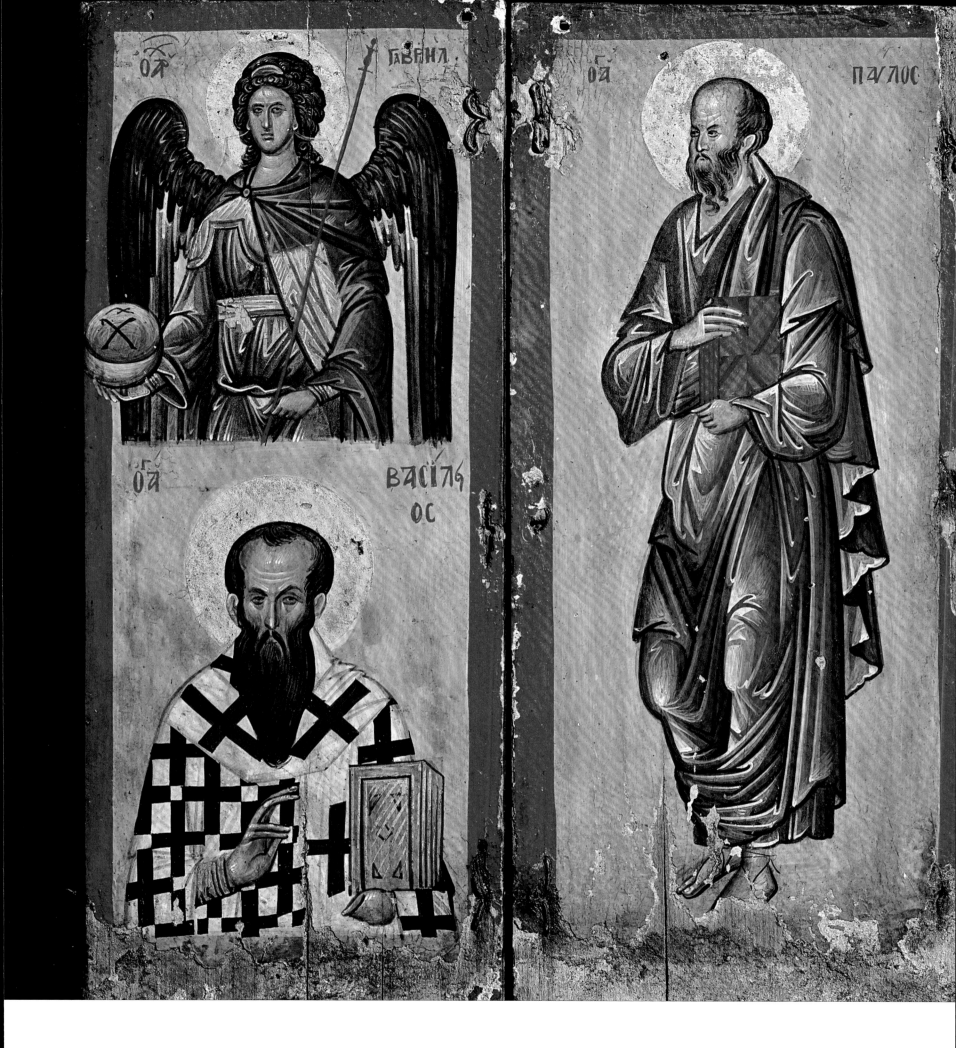

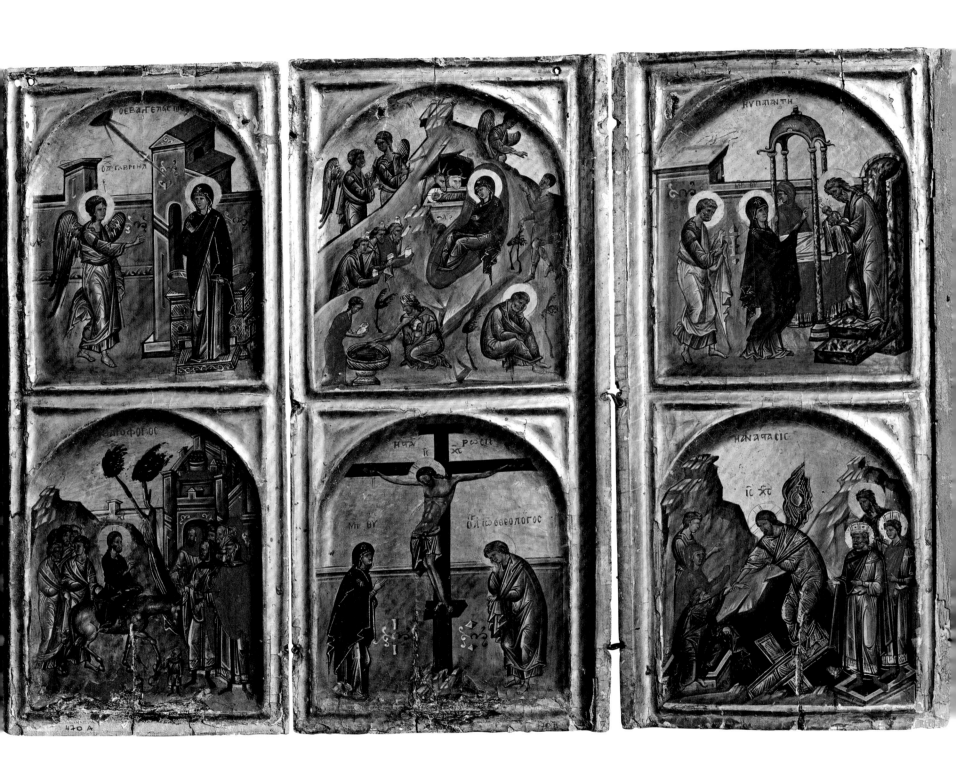

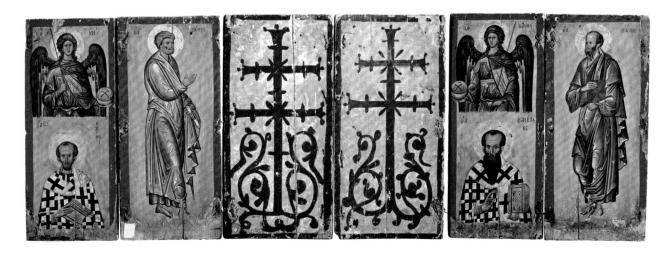

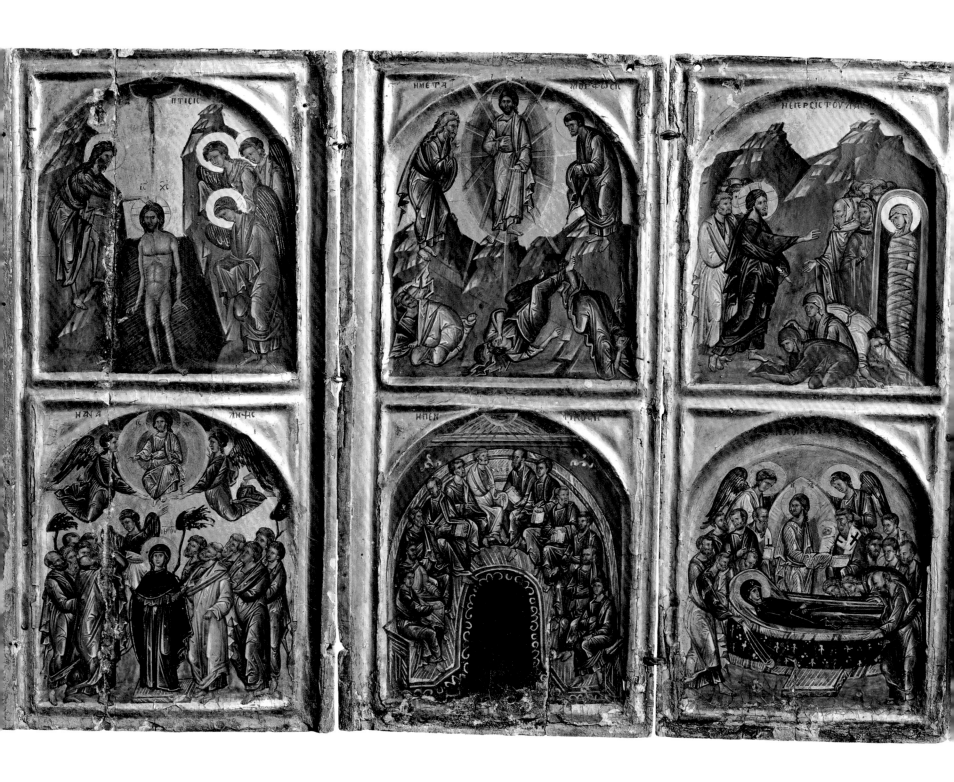

162-163 POLYPTYCH ICON OF THE TWELVE GREAT ORTHODOX FEASTS (RECTO), EACH PANEL 31 X 13.5 CM, TEMPERA AND GOLD ON WOOD, FOURTEENTH CENTURY. THE INNER SIDE OF THE POLYPTYCH IS DIVIDED IN TWELVE SCENES, TWO PER PANEL, EACH FRAMED BY A SMALL GILT ARCH. THESE ARE THE TWELVE GREAT FEASTS OF THE ORTHODOX CHURCH, KNOWN IN GREEK AS THE *DODEKAORTON*, WHICH CORRESPOND TO THE TWELVE GREAT FEASTS OF THE LITURGICAL YEAR. THE FIRST SCENE IS THE ANNUNCIATION, FOLLOWED BY THE NATIVITY, THE PRESENTATION IN THE TEMPLE, BAPTISM, TRANSFIGURATION, RAISING OF LAZARUS, ENTRY IN JERUSALEM, CRUCIFIXION, RESURRECTION, AND ASCENSION. THE LAST TWO SCENES DEPICT PENTECOST, AND THE DORMITION OF THE VIRGIN MARY.

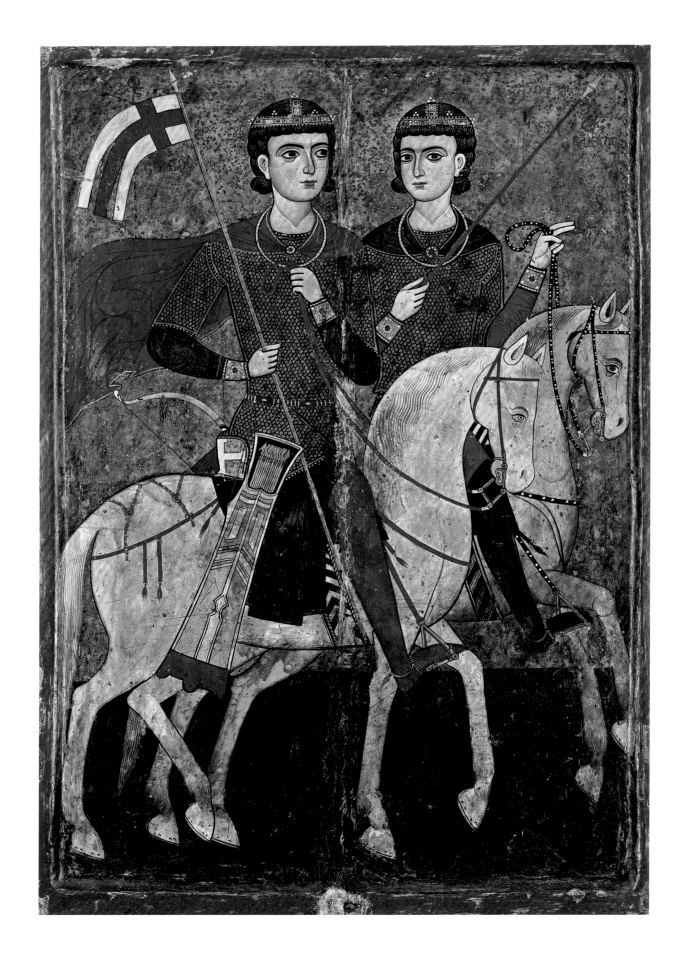

● *164 and 165* ICON OF SAINTS SERGIUS AND BACCHUS ON HORSEBACK, TEMPERA, GOLD, AND SILVER ON WOOD, CANVAS, AND GESSO, 94.2 X 62.8 CM, CA. 1280–90. THIS IS ONE OF THE MOST REFINED SURVIVING ICONS.

● *166-167* DIPTYCH OF ST. PROCOPIUS AND THE VIRGIN, TEMPERA AND GOLD ON SUPPORTS OF WOOD COVERED IN CANVAS AND GESSO, 50.9 X 39.9 CM (LEFT PANEL), 50.5 X 39.9 CM (RIGHT PANEL), CA. 1280. EACH OF THE TWO PORTRAITS IS SURROUNDED BY A SERIES OF FIGURES. AROUND PROCOPIUS ARE CHRIST FLANKED BY THE ARCHANGELS MICHAEL AND GABRIEL FOLLOWED, CLOCKWISE, BY SAINTS PAUL, THOMAS, GEORGE, DAMIAN, CHRISTOPHER, COSMAS, THEODORE, JOHN THE DIVINE, AND PETER. THE VIRGIN IS SURROUNDED BY SAINTS RELATED TO THE SINAI: ANNA AND JOACHIM, JOHN, NICHOLAS, ONOPHRIUS, HELENA, CATHERINE, CONSTANTINE, JOHN CLIMACUS, BASIL, AND MOSES.

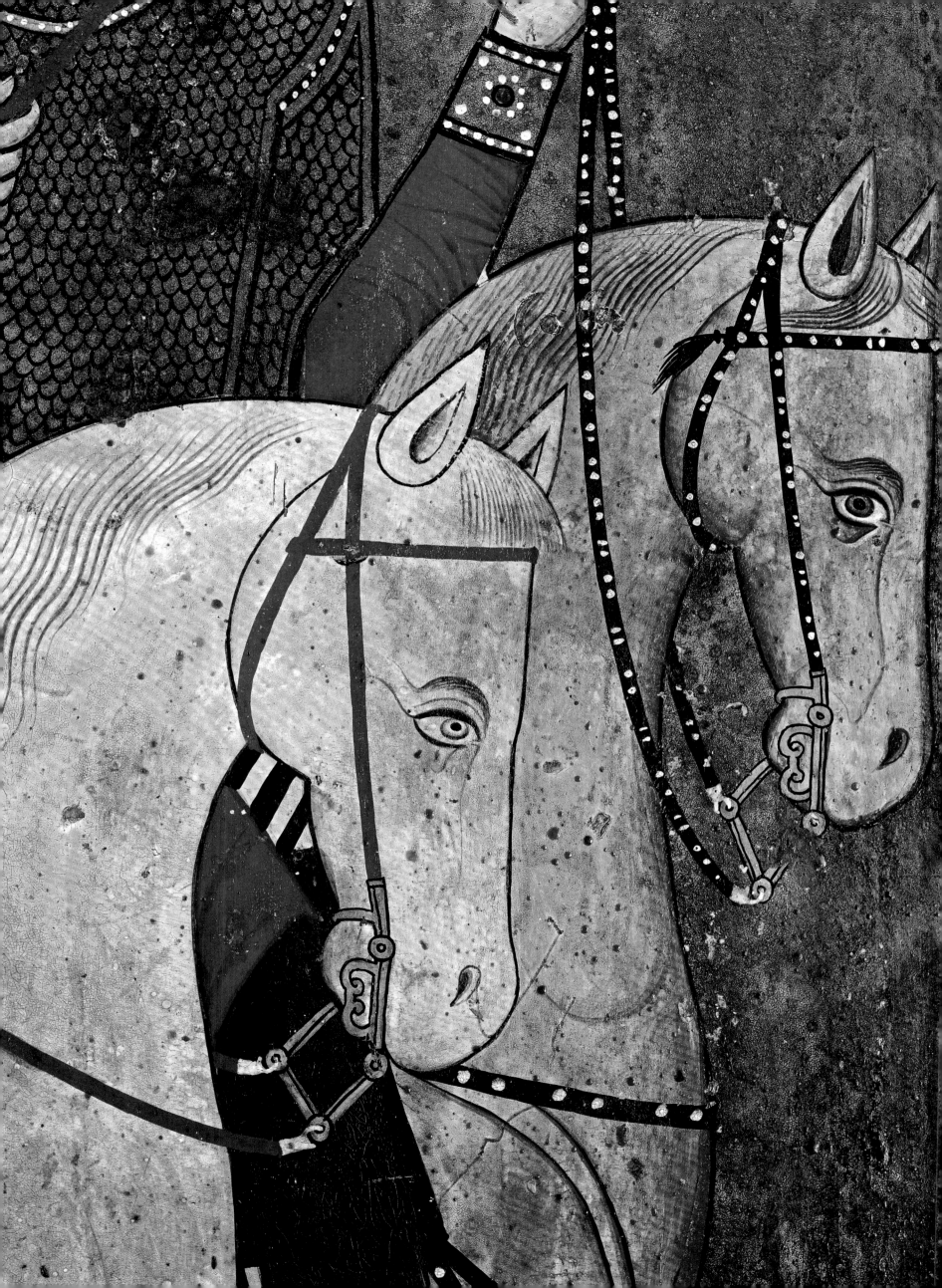

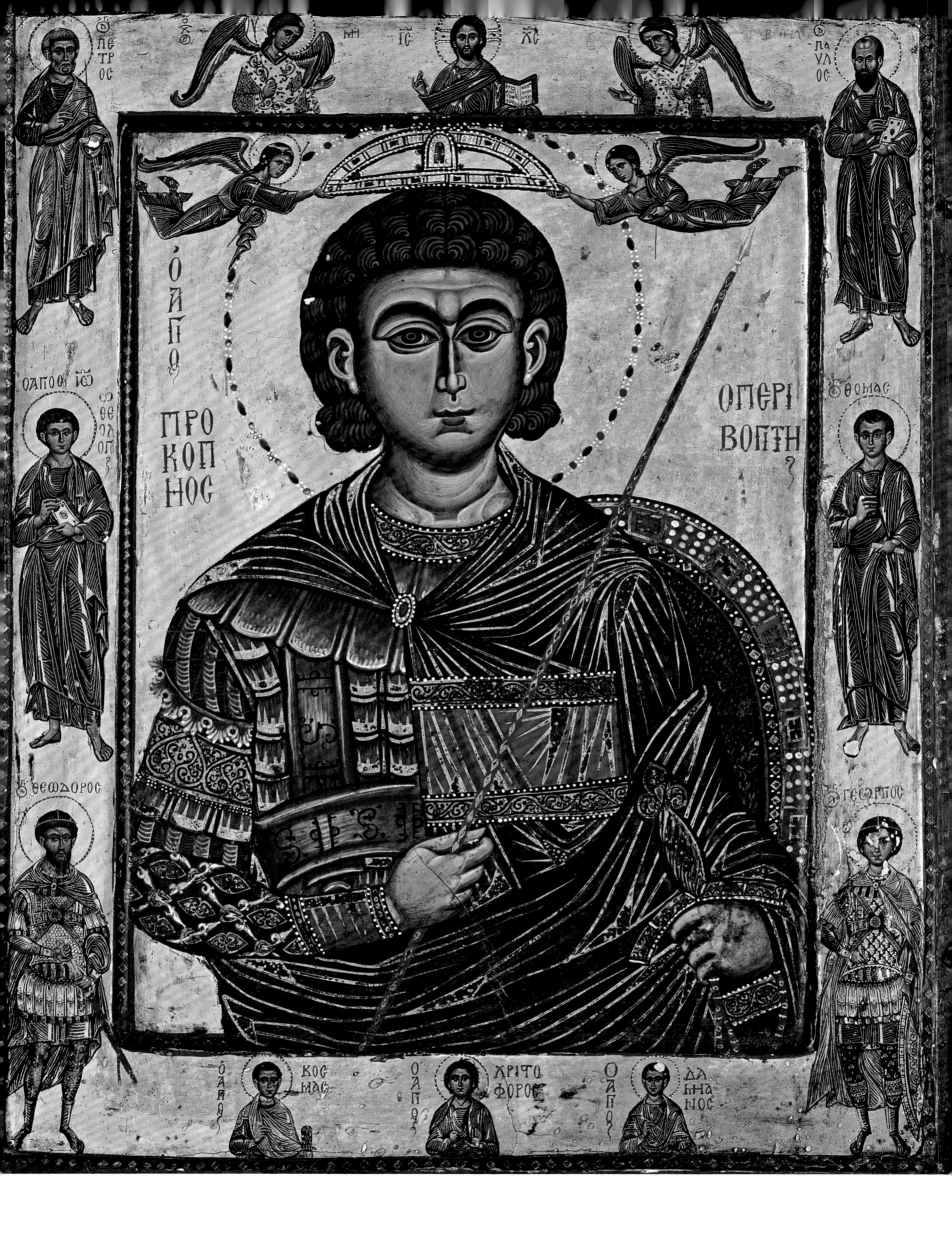

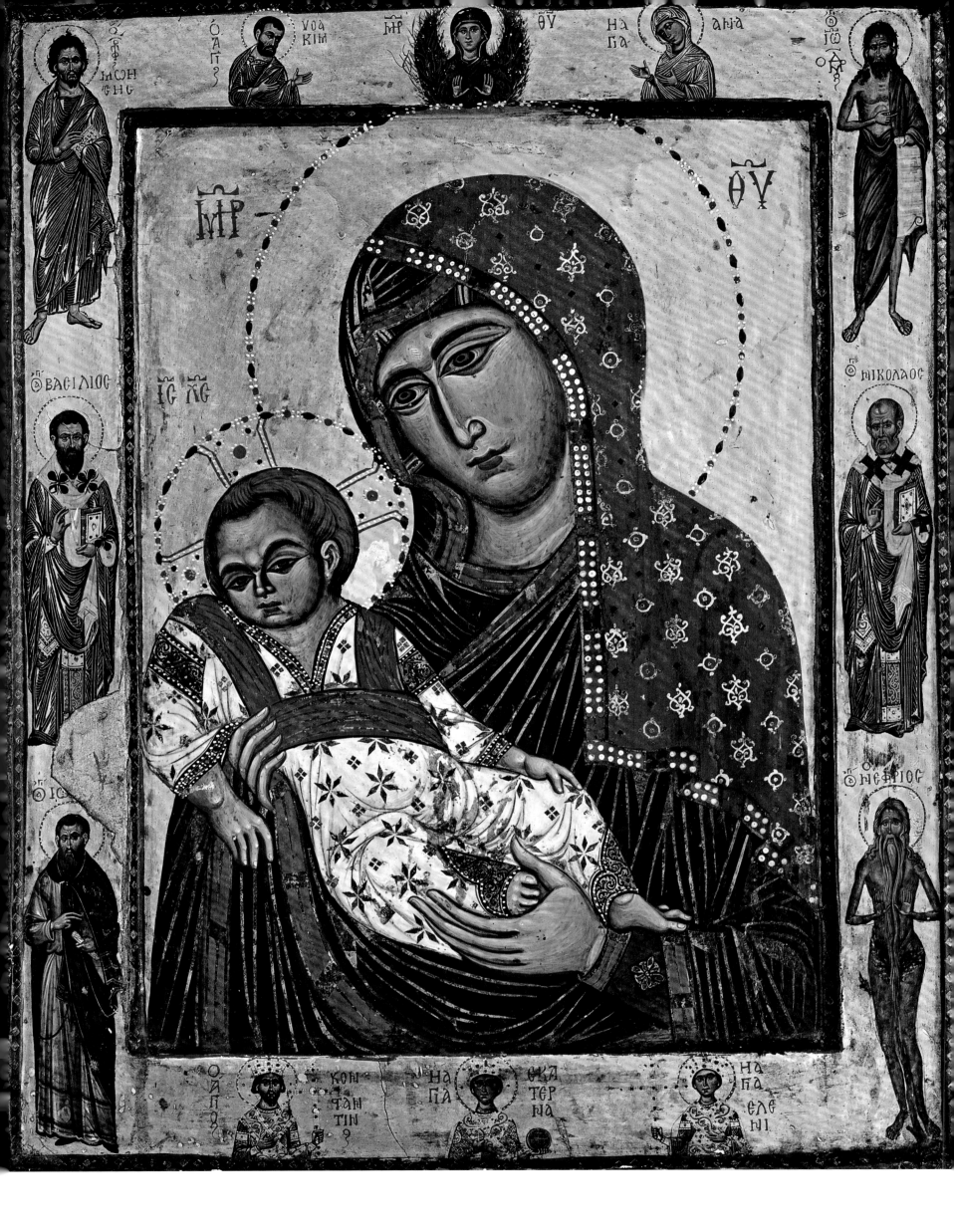

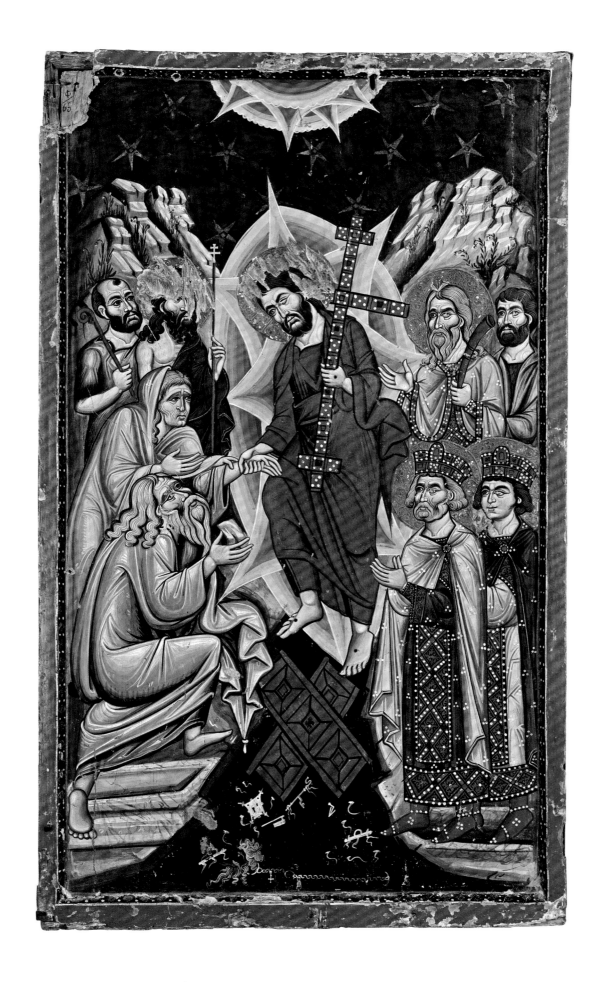

● *168, 169, 170, 171, 172 and 173* Double-sided icon of the Crucifixion and Resurrection, tempera and gold on support of wood, canvas, and gesso, with metal inserts, 120 x 68 cm, ca. 1280–90. The side of the icon depicted on these pages show a vivid representation of the Resurrection. Against the background of high mountains that recall the landscape of Sinai, Christ descends into Hades, bearing a cross studded with precious stones, transformed now into a symbol of victory. The other side of the icon, depicted on the following pages, is occupied by a moving representation of the Crucifixion. The dying Christ is nailed to the cross, blood runs from his wounds and bathes the head of Adam, bringing life to all mankind. The Virgin bows her head in grief, while St. John holds his head in an attitude of wonder and deep mourning.

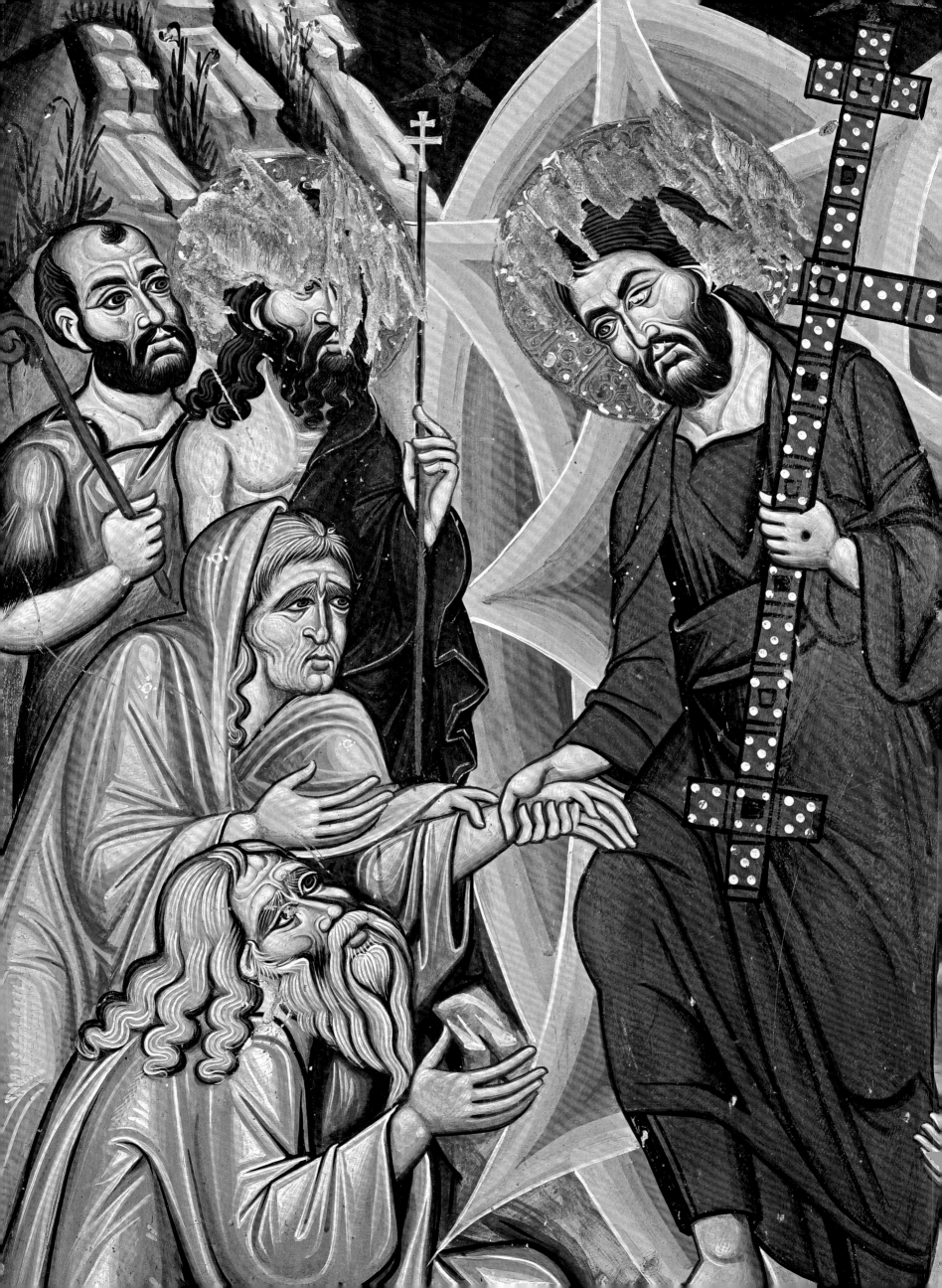

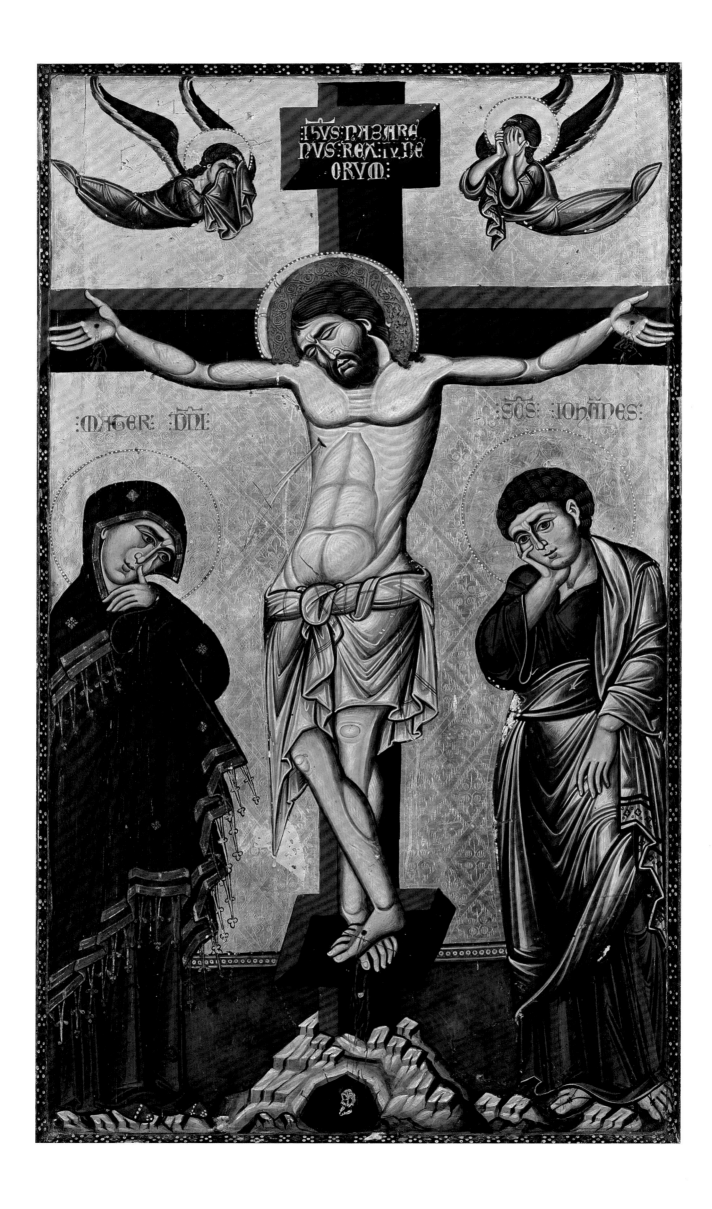

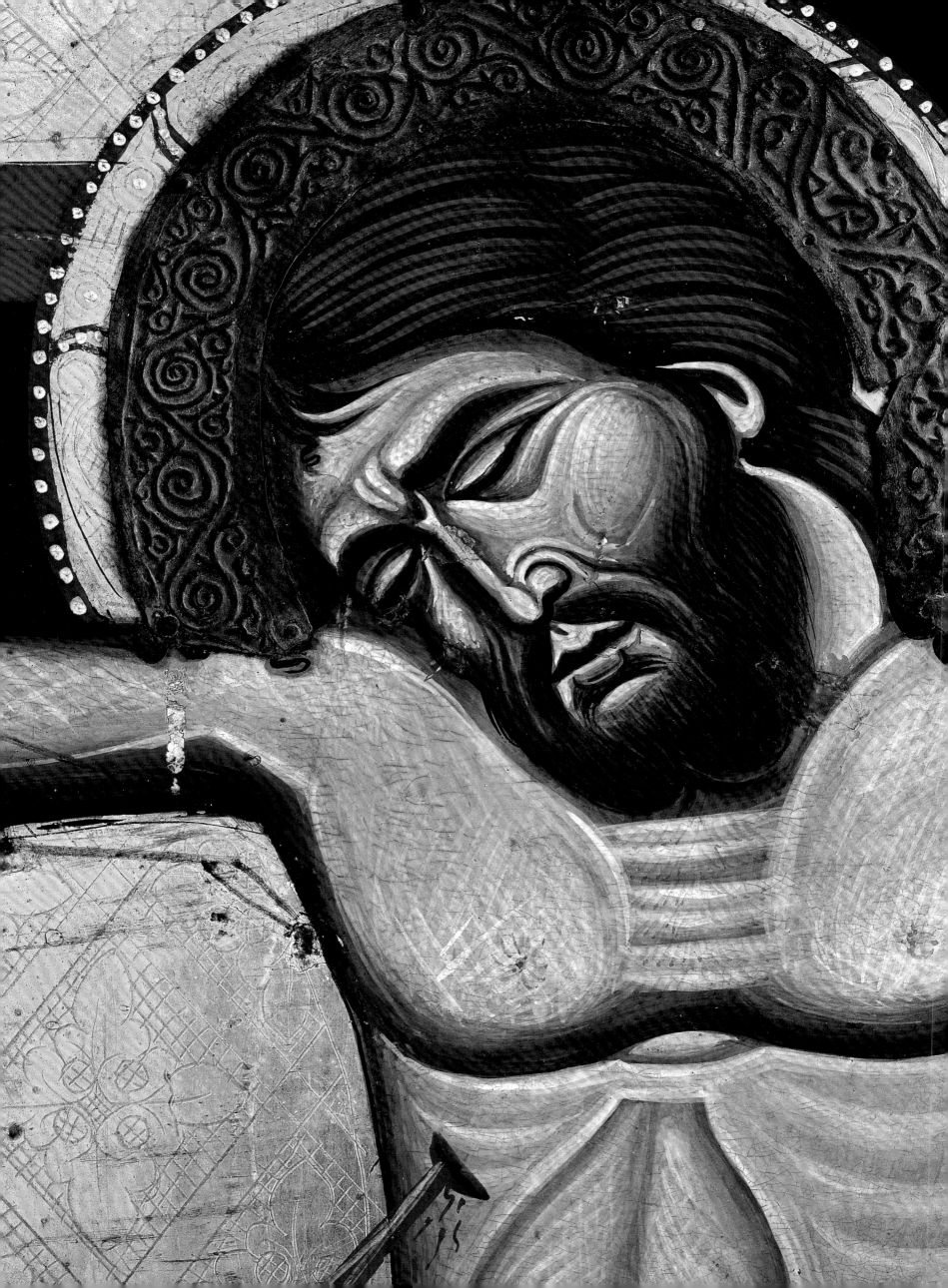

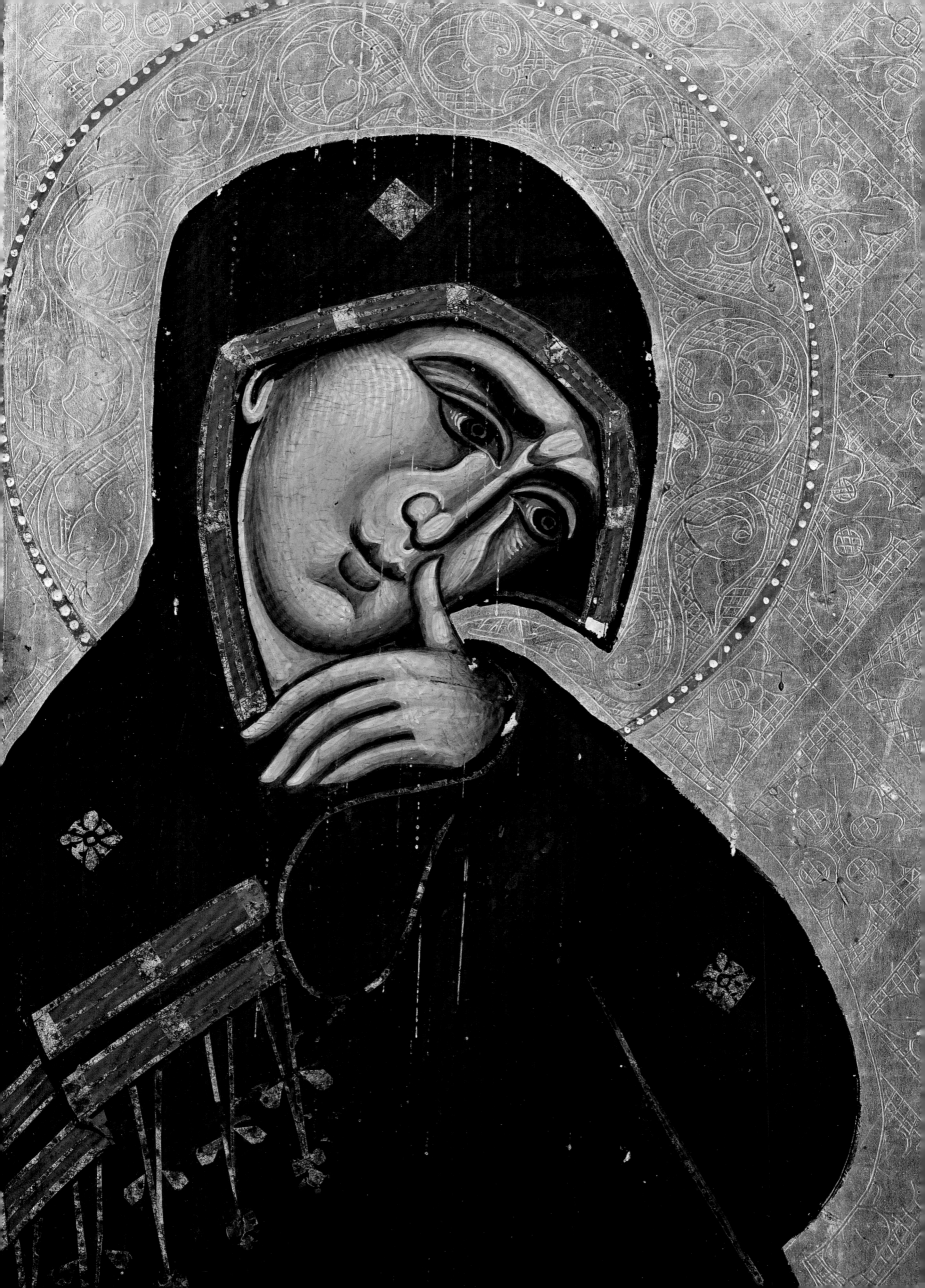

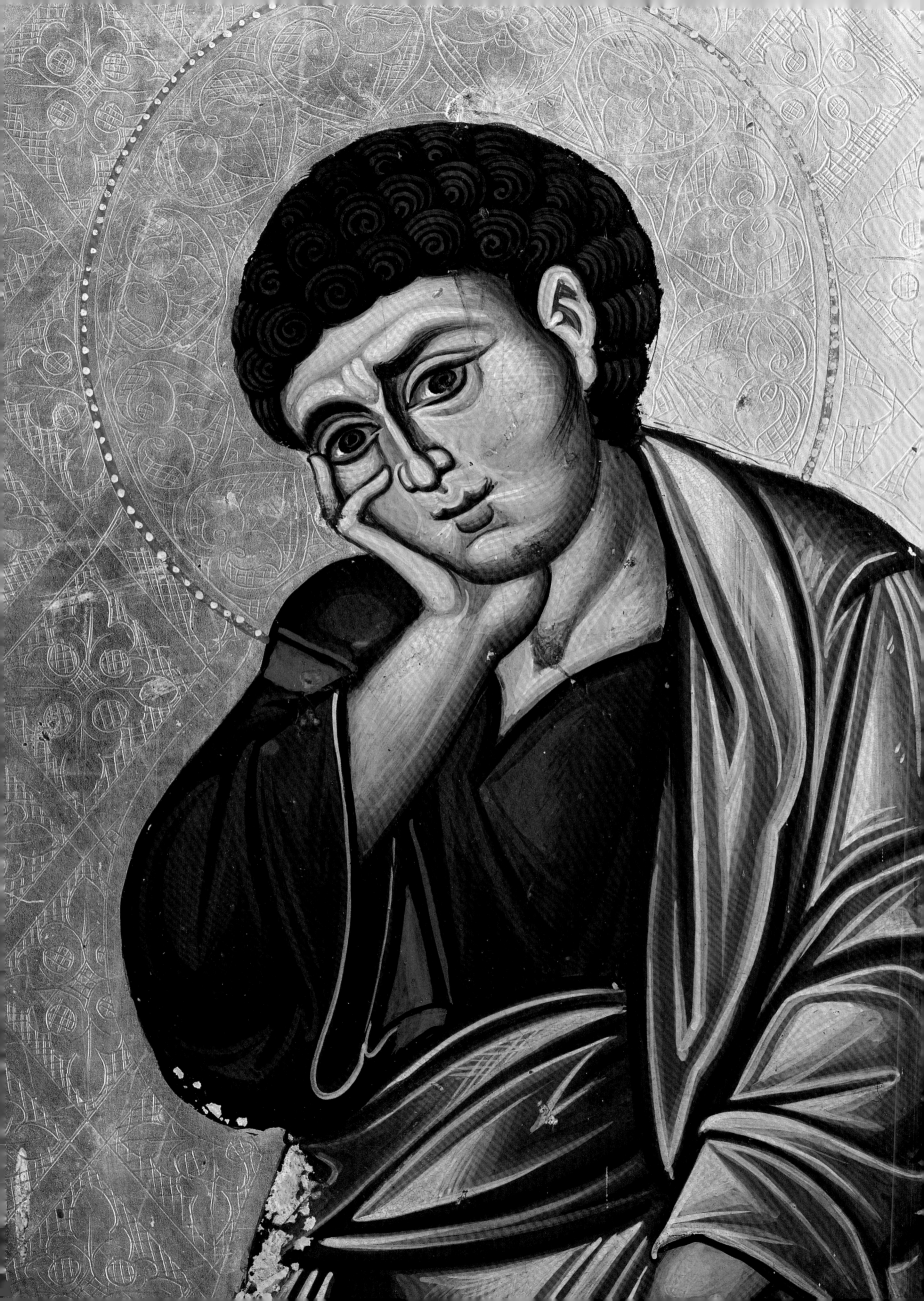

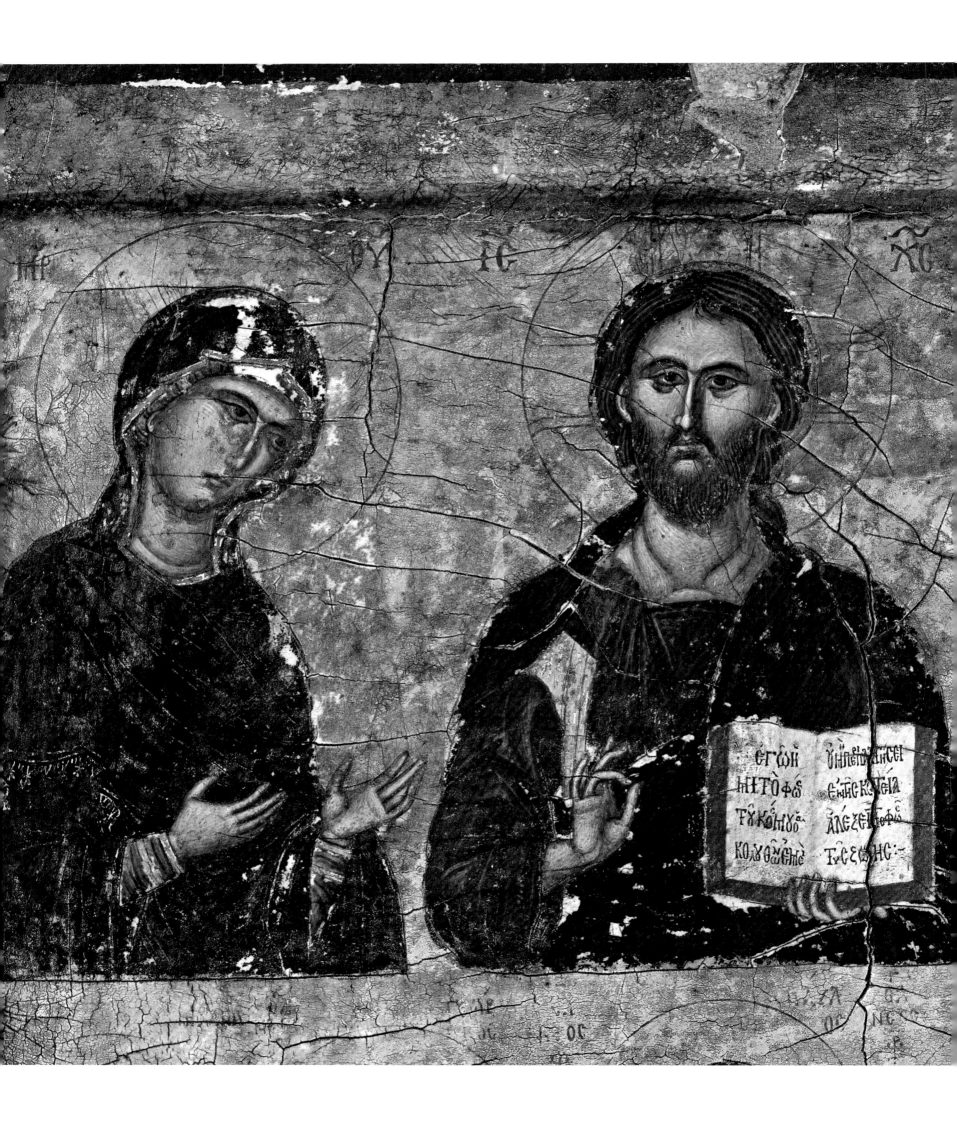

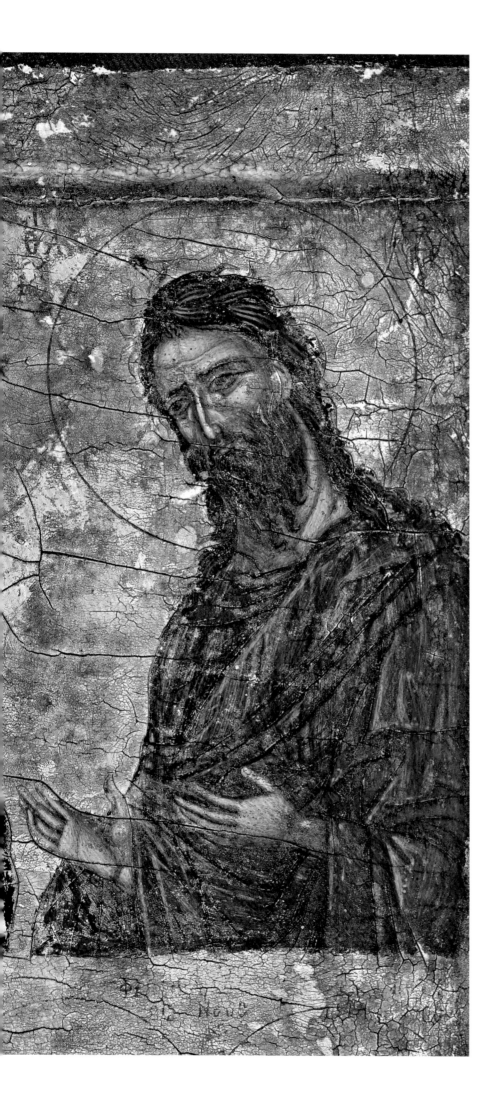

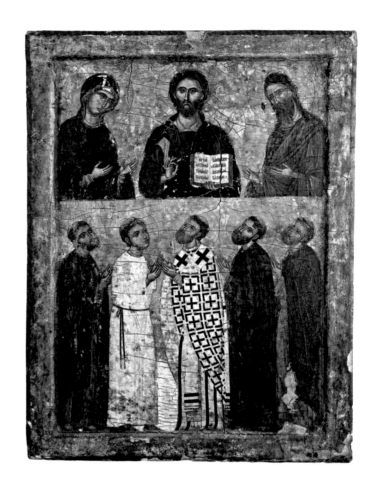

● *174-175 and 175* ICON OF CHRIST, THE VIRGIN, AND SIX SAINTS,
TEMPERA AND GOLD ON WOOD, 50 X 37 CM, LATE THIRTEENTH
CENTURY. THIS ICON, PROBABLY PAINTED IN THE SINAI OR CYPRUS BY
AN ITALIAN ARTIST, IS ORGANIZED ON TWO LEVELS. IN THE UPPER PART,
CHRIST IS FLANKED BY THE VIRGIN AND ST. JOHN THE BAPTIST IN
SUPPLICATING ATTITUDES, WHILE BELOW FIVE SAINTS RAISE THEIR EYES
AND HANDS UPWARD. THE IDENTITY OF THESE FIGURES IS UNCERTAIN.
ACCORDING TO THE FADED GREEK LETTERS WRITTEN IN RED BESIDE
THEIR HALOS, THEY ARE "NEW MARTYR SAINTS" THAT CORRESPOND TO
THE NAMES OF MICHAEL, GEORGE, PAUL, PHILIP, AND MATTHEW.
THREE OF THEM WEAR TUNICS THAT RECALL THE DRESS OF
FRANCISCANS, ONE IS DRESSED IN WHITE LIKE A CISTERCIAN, WHILE
THE CENTRAL FIGURE WEARS AN OUTFIT ASSOCIATED WITH A BYZANTINE
ECCLESIASTIC. THESE MIGHT BE LOCAL SAINTS OF THE SINAI, OR
WESTERN OR EASTERN SAINTS PRESENTED IN AN UNUSUAL MANNER.

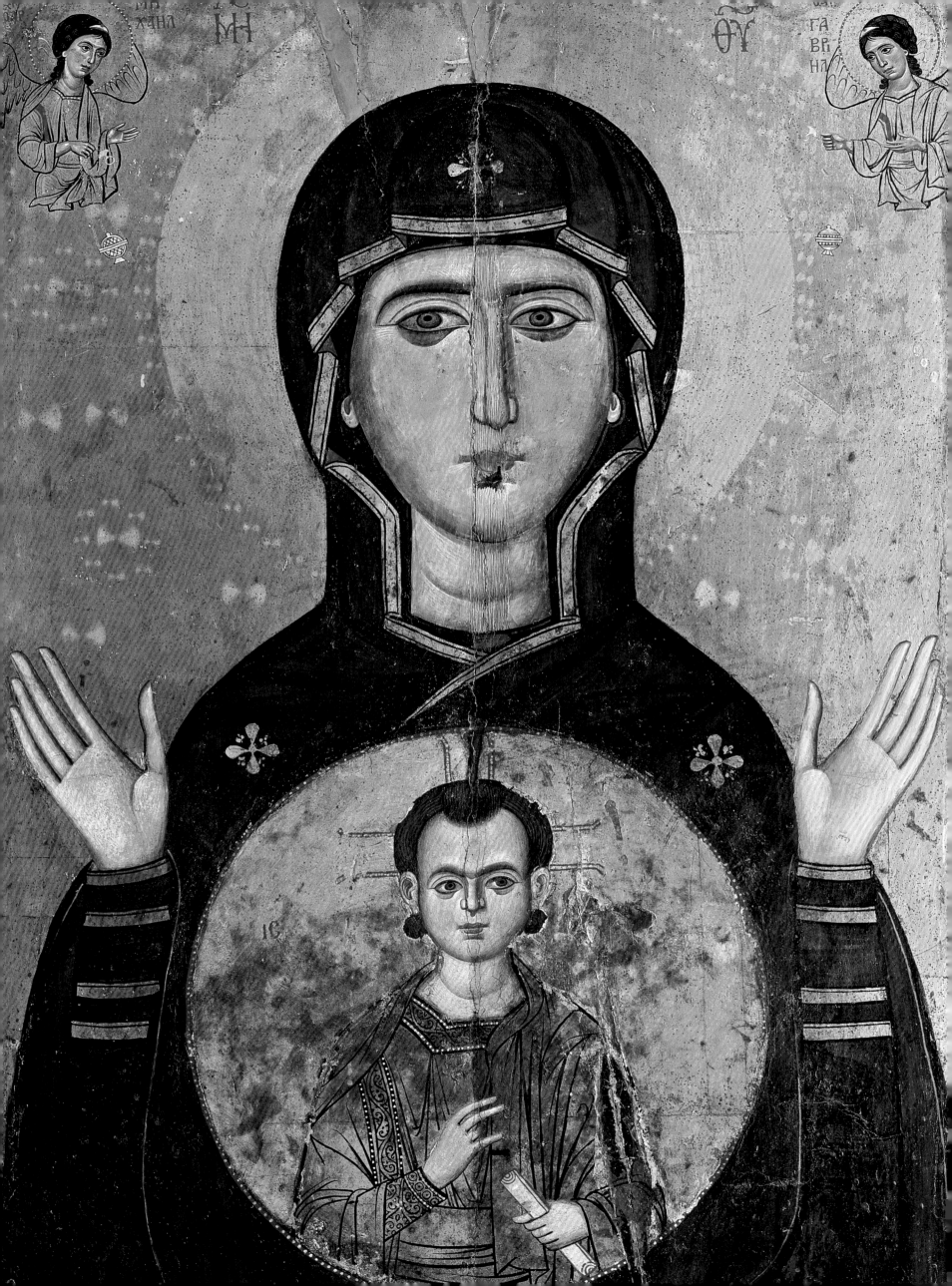

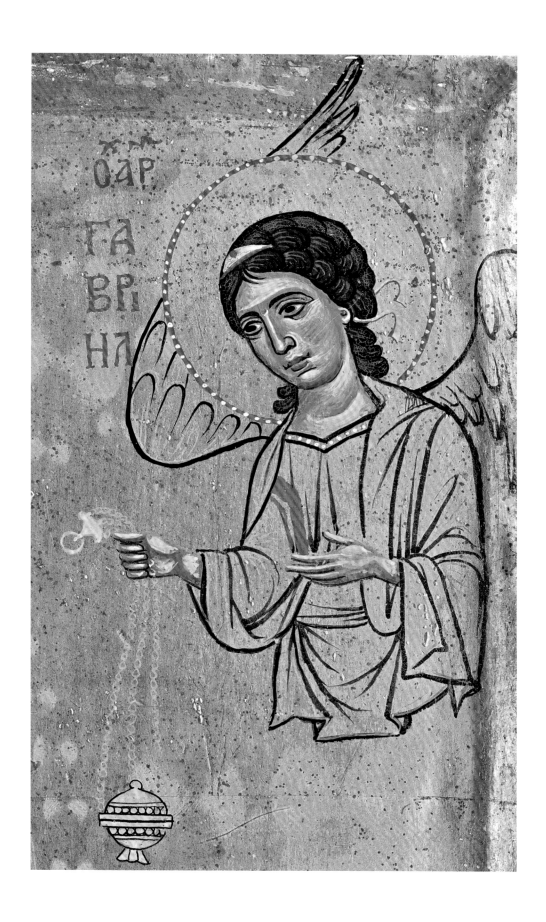

176 and 177 Icon of the virgin and Child, tempera and gold on wood and canvas, 99.2 x 67 cm, thirteenth century. In this icon the Virgin appears with her hands raised in the act of prayer. She is dressed in dark robes covered and wrapped in a red mantle bordered in gold. The Child is presented in a large gilt medallion surrounded by pearls that recall the maternity of the Virgin; he is blessing with one hand while holding a scroll in the other. The gilt background of the composition is decorated with circular motifs that reflect light and illuminate the scene. In the two upper corners to the sides of the Virgin's head are the figures of the two archangels Michael to the left and Gabriel to the right, their heads surrounded by thin red halos decorated with pearls.

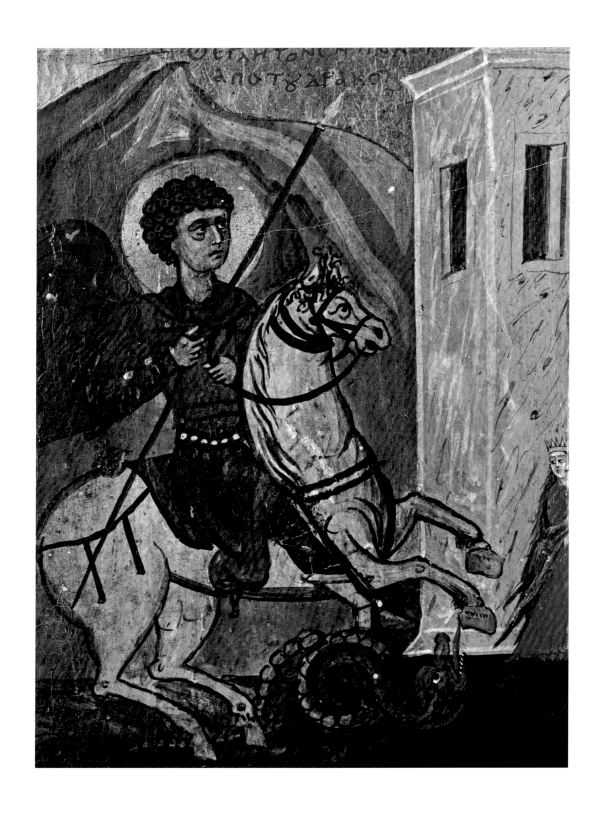

● *178, 179, 180 and 181* ICON OF ST. GEORGE AND SCENES OF HIS LIFE, TEMPERA AND GOLD ON WOOD, 127 X
80.6 CM, EARLY THIRTEENTH CENTURY. ST. GEORGE APPEARS AT THE CENTER OF HIS ICON DRESSED LIKE A YOUNG
WARRIOR IN ELABORATE ARMOR, A RICHLY DECORATED TUNIC, AND A LARGE RED-AND-BLUE MANTLE. HE BEARS A
LANCE IN ONE HAND, A ROUND SHIELD IN THE OTHER; HIS SWORD, ATTACHED TO HIS BACK BY A LOOP, POINTS
DOWN AT THE LEGS. THIS ICON WAS COMMISSIONED BY A MONK WHOSE SMALL EFFIGY DRESSED IN WHITE APPEARS
PAINTED BESIDE THE FIGURE OF THE SAINT. THE CENTRAL SCENE IS ENCIRCLED BY TWENTY PANELS THAT PRESENT
VARIOUS EPISODES IN ST. GEORGE'S LIFE, BEGINNING WITH HIS DONATION TO THE POOR OF HIS GOODS, AT ABOVE
LEFT, AND ENDING WITH HIS DEATH AT BELOW RIGHT. THESE IMAGES INCLUDE SCENES OF THE SAINT BEING
TORTURED AS WELL AS THE FAMOUS EPISODE OF THE SLAYING OF THE DRAGON TO SAVE THE ENDANGERED PRINCESS.

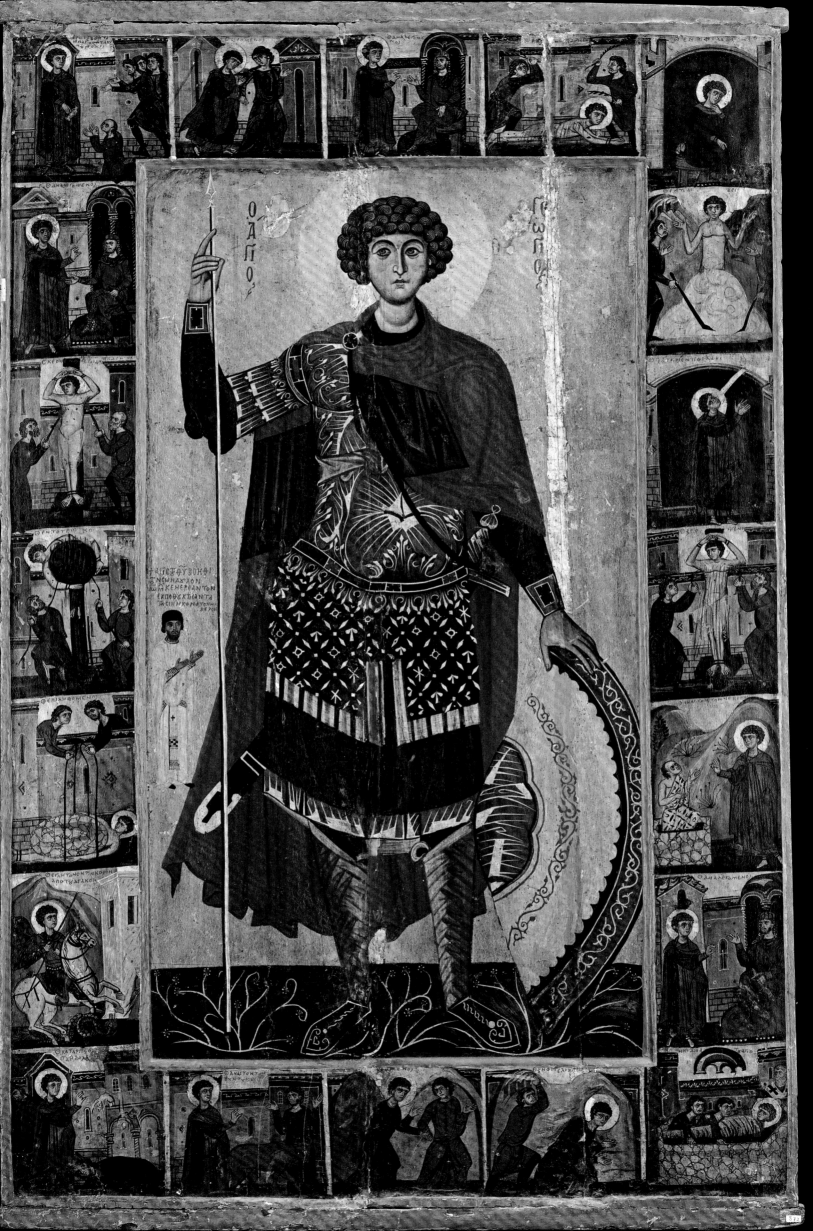

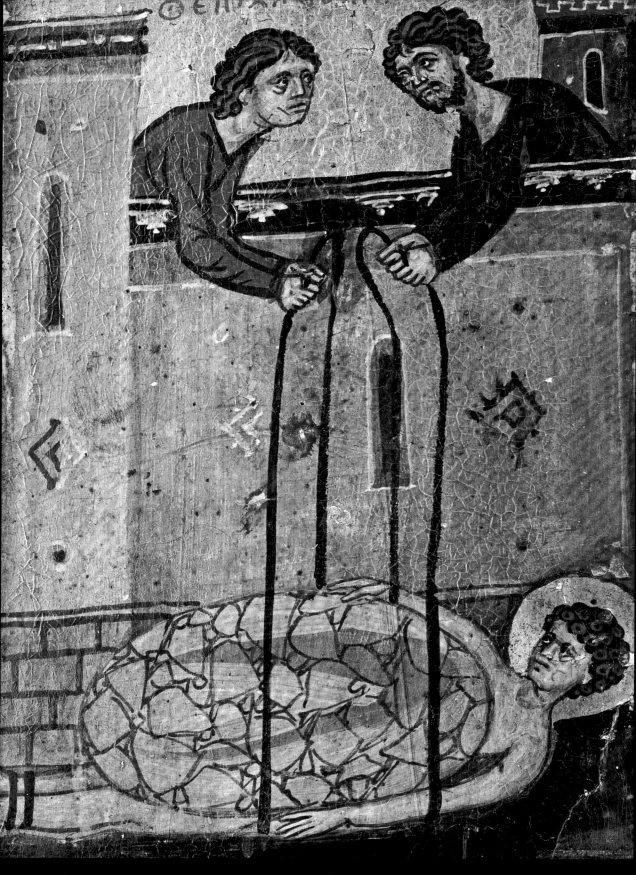

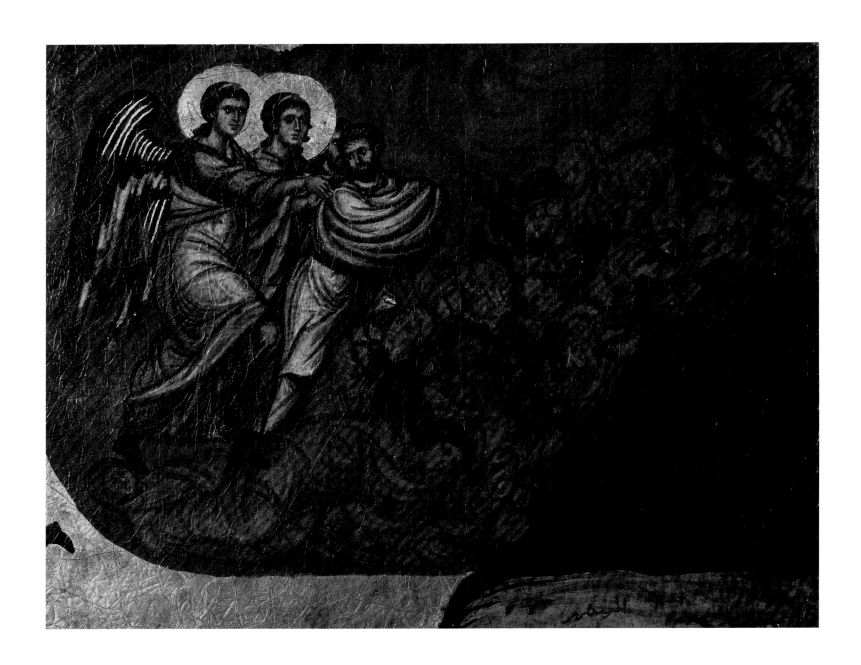

182 DETAIL OF THE ICON OF THE SECOND COMING OF CHRIST AND THE LAST JUDGMENT, TEMPERA ON WOOD, 18 X 12.5 CM, FIFTEENTH CENTURY. THE ENTIRE ICON, 31 X 22.2 CM, DRAWS INSPIRATION FROM THE PARABLE PRESENTED IN MATTHEW (22:11–14) , WHICH GIVES A SYMBOLIC VERSION OF THE LAST JUDGMENT: THE MAN WHO PRESENTS HIMSELF AT THE WEDDING BANQUET OF THE KING (CHRIST) WITHOUT A WEDDING GARMENT IS TAKEN AWAY AND "CAST INTO OUTER DARKNESS" BY THE KING'S SERVANTS (ANGELS). THIS ICON HANGS IN THE CHAPEL OF THE BURNING BUSH.

183 ICON OF THE FORTY MARTYRS OF SEBASTEA, TEMPERA ON WOOD, 38.5 X 29.4 CM, LATE THIRTEENTH–EARLY FOURTEENTH CENTURY. THIS ICON RELATES EVENTS INVOLVING FORTY YOUNG ROMAN SOLDIERS OF CHRISTIAN FAITH THAT TOOK PLACE IN YEAR 320 NEAR SEBASTEA IN ARMENIA. THEY WERE FORCED TO ENTER A FROZEN POND AND REMAIN THERE UNTIL THEY HAD EITHER RENOUNCED THEIR FAITH OR DIED. ONLY ONE, PRESENTED AT THE UPPER RIGHT, FAILED THE TERRIBLE TEST AND ESCAPED TO THE WARM BATHS PREPARED NEARBY, BUT HIS PLACE WAS TAKEN BY ONE OF THE SOLDIERS OVERSEEING THE ORDEAL, WHO INSTANTLY CONVERTED FOLLOWING A DIVINE SIGN.

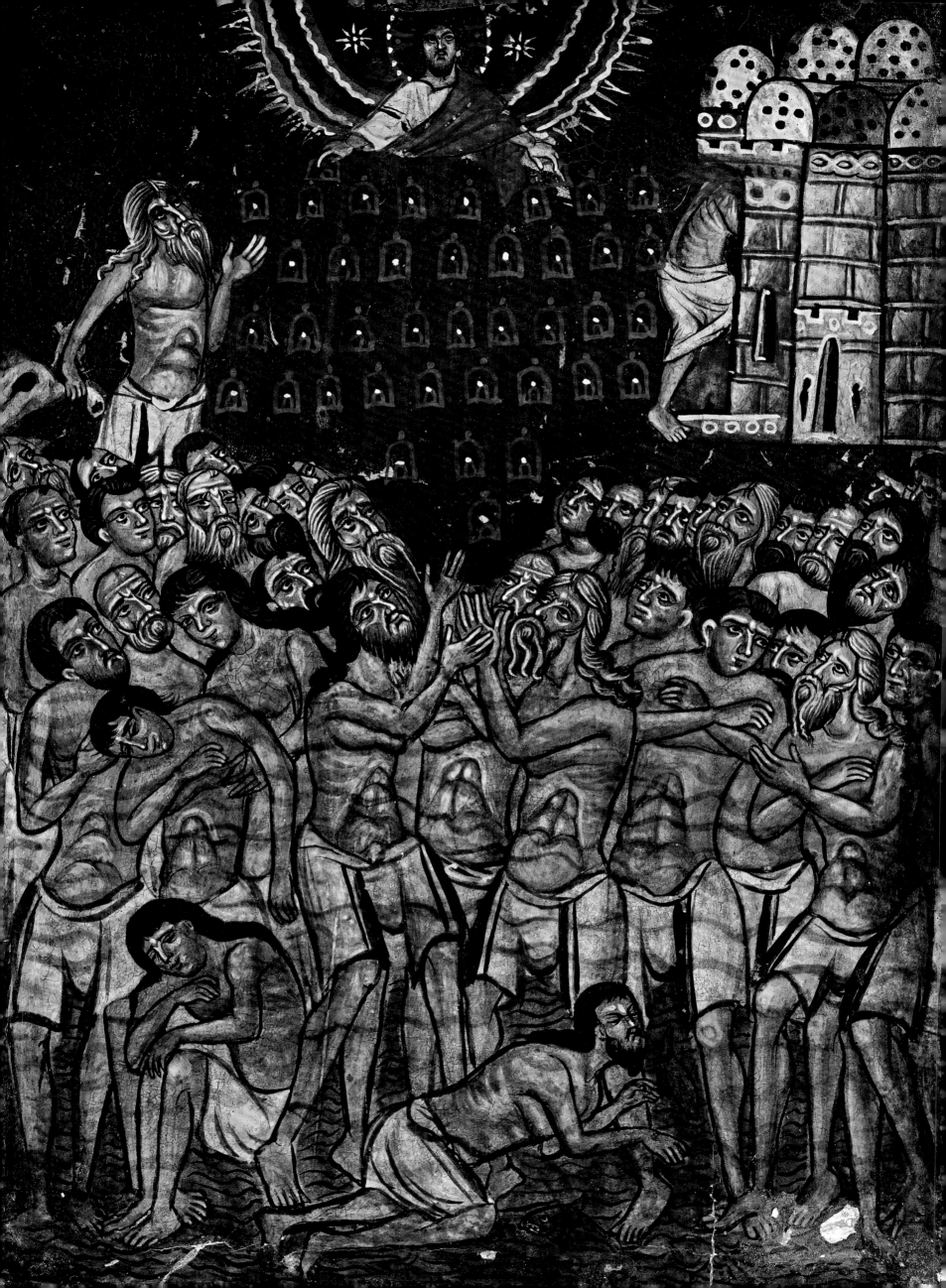

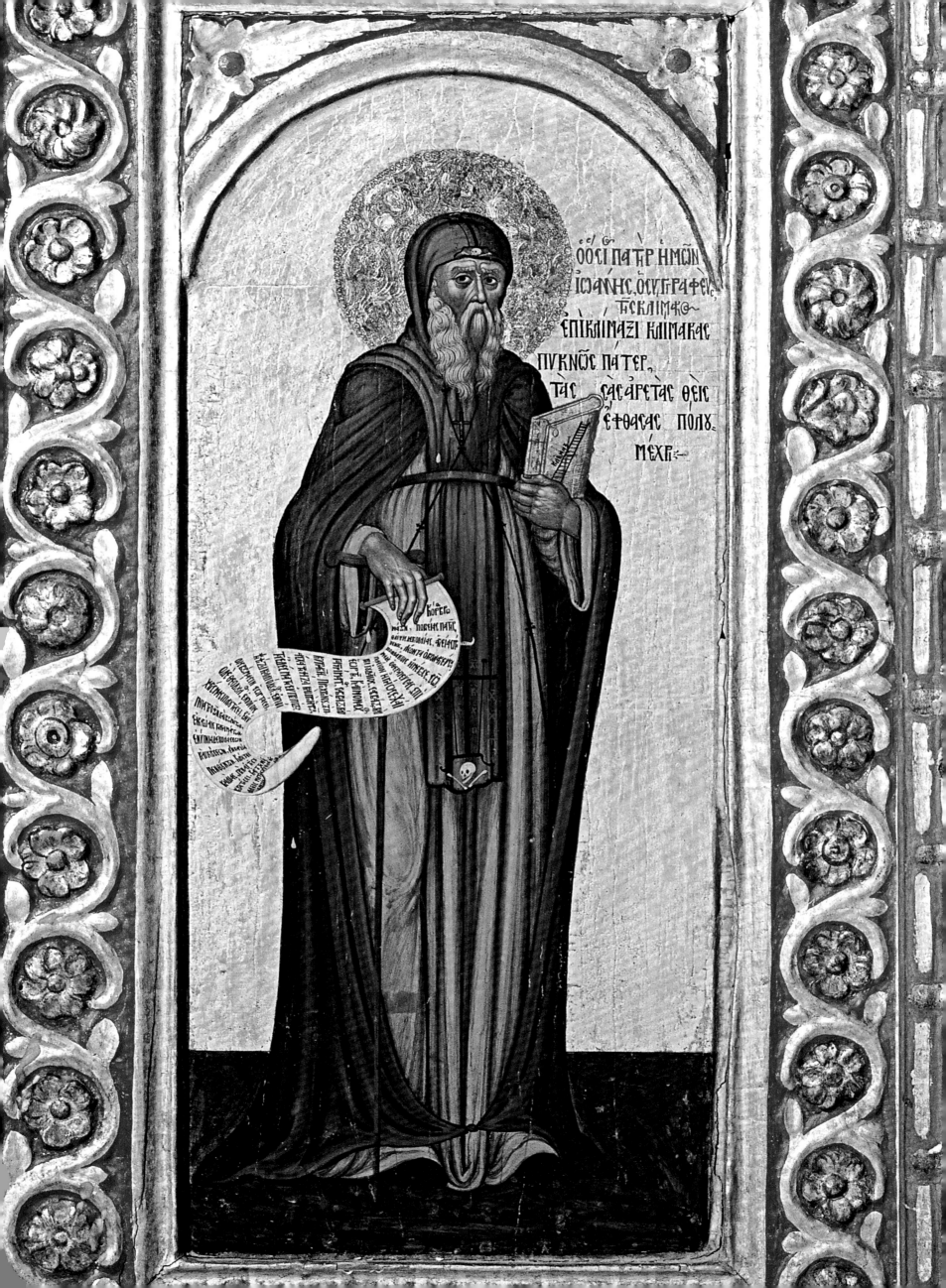

Ὁ ὅσι(ος) πατ(ὴρ) ἡμῶ(ν)
Ἰωάννης ὁ συγγραφεύς
τῆς Κλίμα(κος)
ἐπίκλημαζι Κλίμακος
πυκνὸς πάτερ,
τὰς ἐξ ἀρετὰς θεῖς
ἔφθασας πολὺ
μέχρι

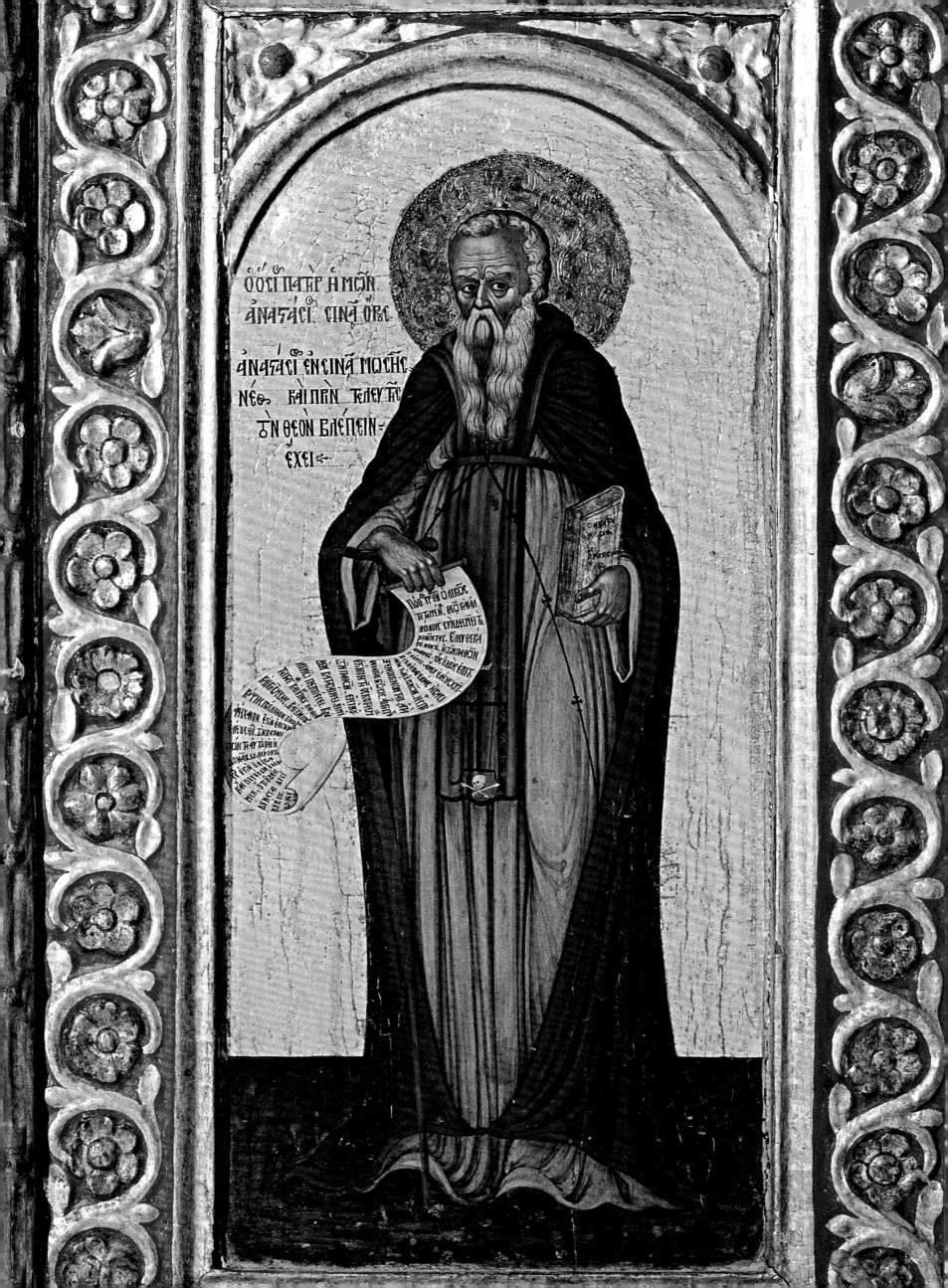

184-185 PAINTED PANELS WITH SAINTS JOHN CLIMACUS AND ANASTASIUS OF SINAI, TEMPERA ON WOOD, EACH PANEL 53 X 22 CM. THE DOOR
OF THE ICONOSTASIS THAT DIVIDES THE CHAPEL OF THE FORTY MARTYRS OF THE SINAI IN HALF IS DECORATED WITH THE SYMMETRICAL FIGURES OF
ST. JOHN CLIMACUS (TO THE RIGHT) AND ST. ANASTASIUS OF SINAI, WHO WERE ABBOTS OF THE MONASTERY. THE TWO SAINTS, PRESENTED WITH
WHITE BEARDS AND HAIR THAT FRAME THEIR SERIOUS, LEAN FACES, ARE DRESSED IN IDENTICAL GARMENTS AND HOLD SCROLLS THAT REPRESENT THE
WORKS THEY WROTE, RESPECTIVELY THE *LADDER TO PARADISE* AND THE *HODEGOS* ("GUIDE").

186 and 187 ICON OF THE VIRGIN, BY GEORGIOS KLONTZAS, TEMPERA ON WOOD, 106.5 X 81 CM, CA. 1604. THIS BEAUTIFUL ICON APPEARS
ON THE INSIDE FACE OF THE ICONOSTASIS IN THE BASILICA. IT PRESENTS THE VIRGIN AT THE CENTER OF A COMPLEX COMPOSITION. THE SCENE IS A
DEPICTION OF THE HYMN IN HONOR OF THE VIRGIN MARY CHANTED IN THE LITURGY OF SAINT BASIL, "IN THEE ALL CREATION DOTH REJOICE".
THE CENTRAL COMPOSITION IS ENCIRCLED BY TWENTY MINUTELY DECORATED PANELS.

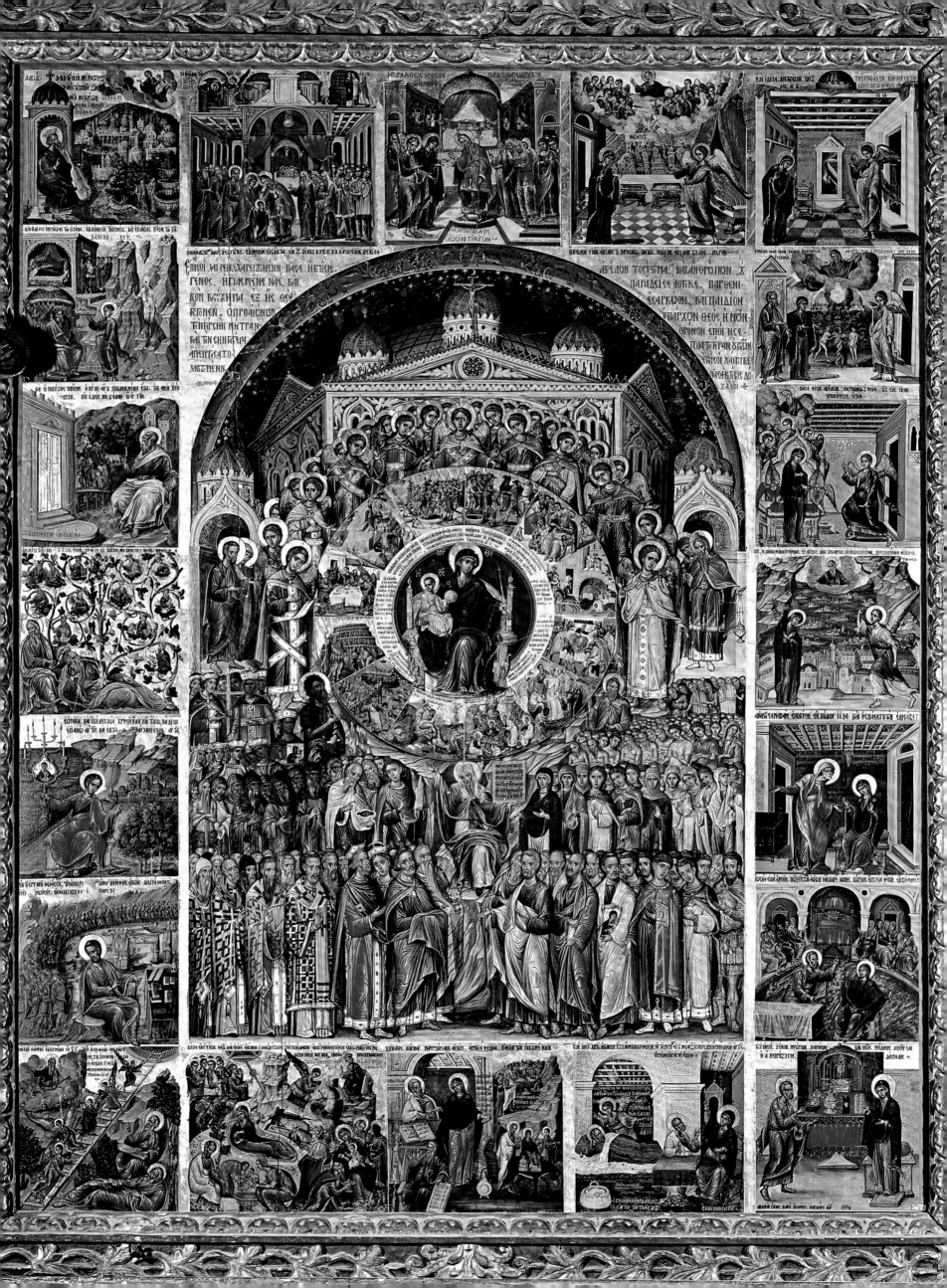

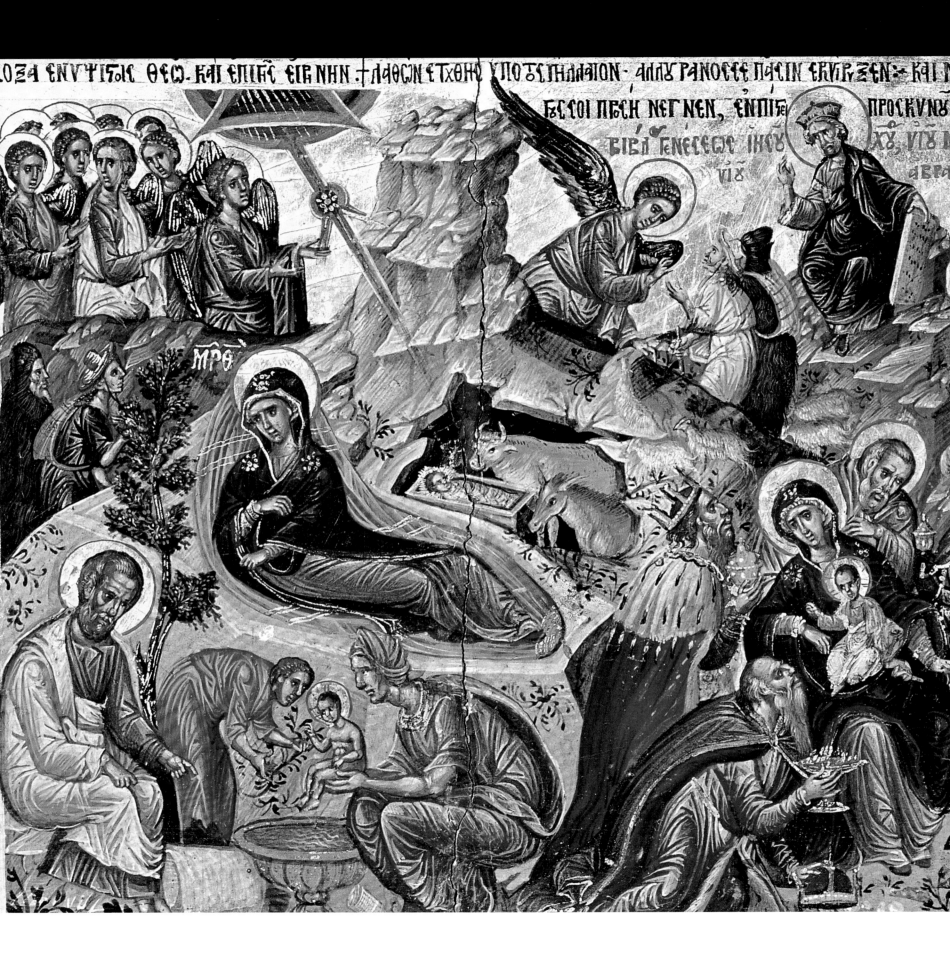

ΔΟΞΑ ΕΝ ΥΨΙCΟΙC ΘΕΩ· ΚΑΙ ΕΠΙ ΓΗC ΕΙΡΗΝΗΝ· ΤΛΦΘΩCΙΝ ΕΤΧΘΗ ΥΠΟ ΤΟ CΠΗΛΑΙΟΝ· ΑΛΛΥ ΡΑΝΟCCΕ ΠΑCΙΝ ΕΡΥΡΞΕΝ· ΚΑΙ Μ

ΒCCΟΙ ΠΒCΗ ΝΕΓ ΝΕΝ· ΕΝΠΙΒ ΠΡΟCΚΥΝΥ

ΒΙΒΛ ΓΕΝΕCΕΩC ΙΗCΥ

ΜΡ ΘΥ

188-189 Icon of the Virgin, tempera on wood, 106.5 x 81 cm, ca. 1604. Close observation of this icon of the Virgin reveals a scene of the Nativity; various episodes are depicted simultaneously in the small image, from the birth in the grotto to the bath of the Child up to the presentation of the gifts of the Magi.

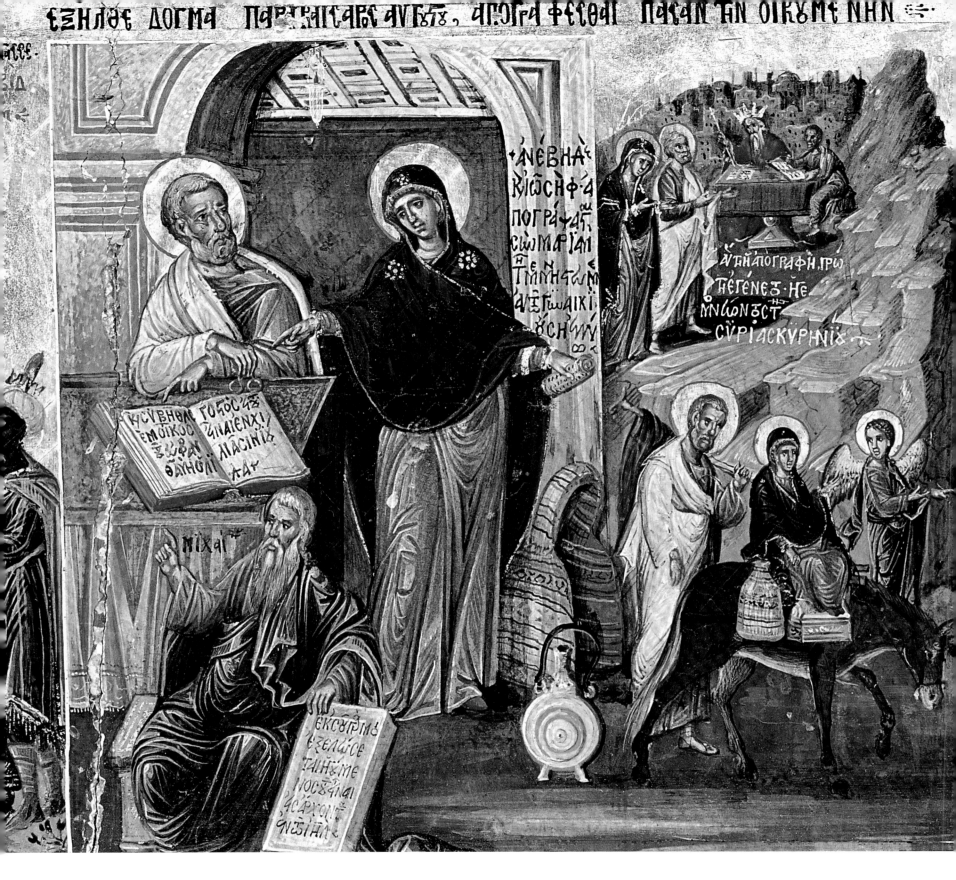

190-191 TRIPTYCH OF ST. NICHOLAS AND JOHN THE BAPTIST (EXTERIOR), TEMPERA, GOLD, AND SILVER ON SUPPORTS OF WOOD, CANVAS, AND GESSO, 56.8 X 47.7 X 5.1 CM (CENTRAL PANEL), 53.7 X 21.7 X 1.1 CM (LEFT PANEL) 53.8 X 21 X 1.1 CM (RIGHT PANEL), CA. 1250–60. THIS TRIPTYCH IS COMPOSED OF A CENTRAL ICON AND TWO NARROWER SIDE PANELS THAT CLOSE LIKE WINGS TO REVEAL FULL-FIGURE PORTRAITS OF ST. NICHOLAS TO ONE SIDE AND ST. JOHN THE BAPTIST TO THE OTHER. ST. NICHOLAS, DRESSED WITH A LONG RED MANTLE DECORATED WITH WHITE BANDS, BLESSES WITH HIS RIGHT HAND, IN THE GREEK MANNER, WHILE ST. JOHN, DRESSED ONLY IN A DARK MANTLE, BEARS IN HIS LEFT HAND A REPRESENTATION OF THE DIVINE LAMB.

191 right ICON OF CHRIST PANTOCRATOR, TEMPERA AND GOLD ON WOOD, 43 X 30 CM, THIRTEENTH CENTURY. THE IMAGE OF CHRIST HOLDING THE GOSPEL IN ONE HAND AND GIVING A BLESSING WITH THE OTHER IS TYPICAL OF THE ICONOGRAPHY OF THE ORTHODOX CHURCH. THE NAME PANTOCRATOR, MEANING "ALL POWERFUL, ALMIGHTY," IS OFTEN APPLIED TO THIS TYPE OF REPRESENTATION, THE OLDEST EXAMPLES OF WHICH DATE TO THE SIXTH CENTURY. THE GOSPEL IS OPEN TO THE VERSES "I AM THE LIGHT OF THE WORLD: HE THAT FOLLOWETH ME SHALL NOT WALK IN THE DARKNESS, BUT SHALL HAVE THE LIGHT OF LIFE" (JOHN 8:12).

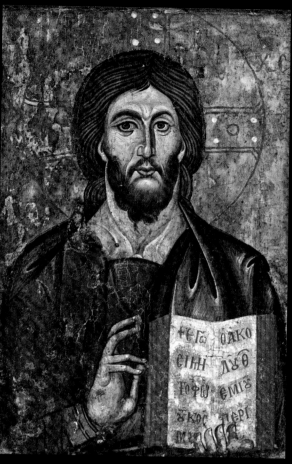

192-193 Triptych with
scenes from the life of the
Virgin (interior), tempera,
gold, and silver on support of
wood, canvas, and gesso, 56.8 x
47.7 x 5.1 cm (central panel),
53.7 x 21.7 x 1.1 cm (left
panel), 53.8 x 21 x 1.1 cm (right
panel), ca. 1250–60. The
interior of the triptych is
richly decorated with scenes
from the life of the Virgin. At
the center, flanked by two
angels, she sits enthroned with
the Child, whose robe is
illuminated by a dense design
of gilt lines.

194 and 195 Triptych with
scenes from the life of the
Virgin (interior). The left
panel depicts the Crowning
of the Virgin Mary and her
Dormition. The right panel
depicts Christ among the
Doctors in the Temple, and
the lamentation at the Tomb
following the Crucifixion
of Christ.

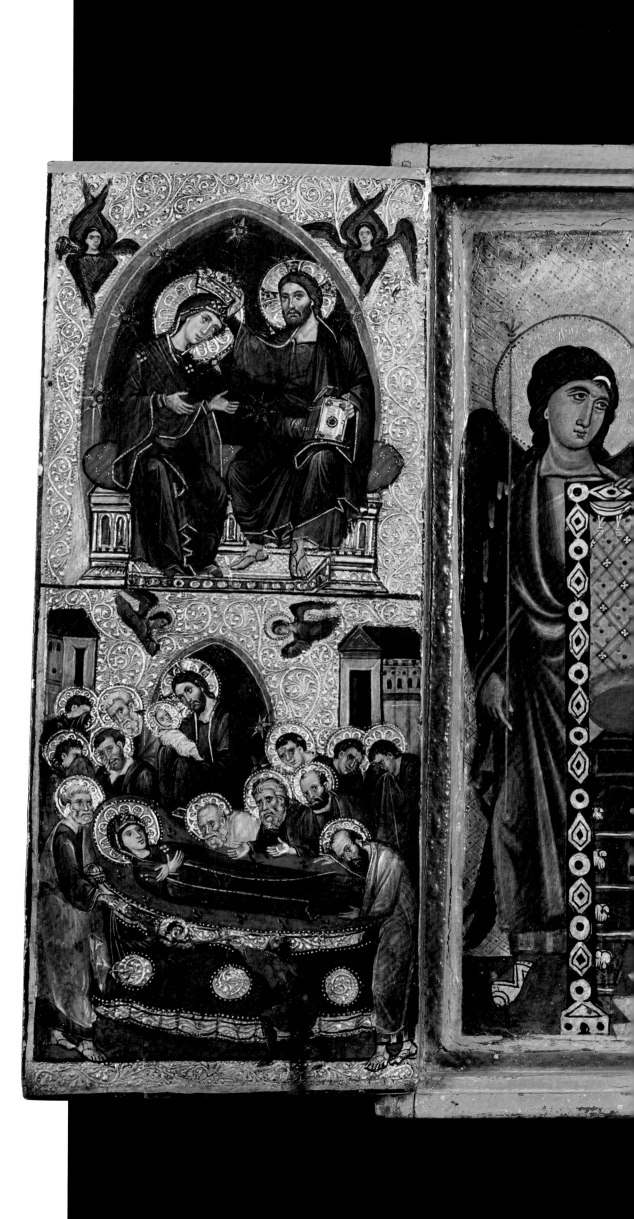

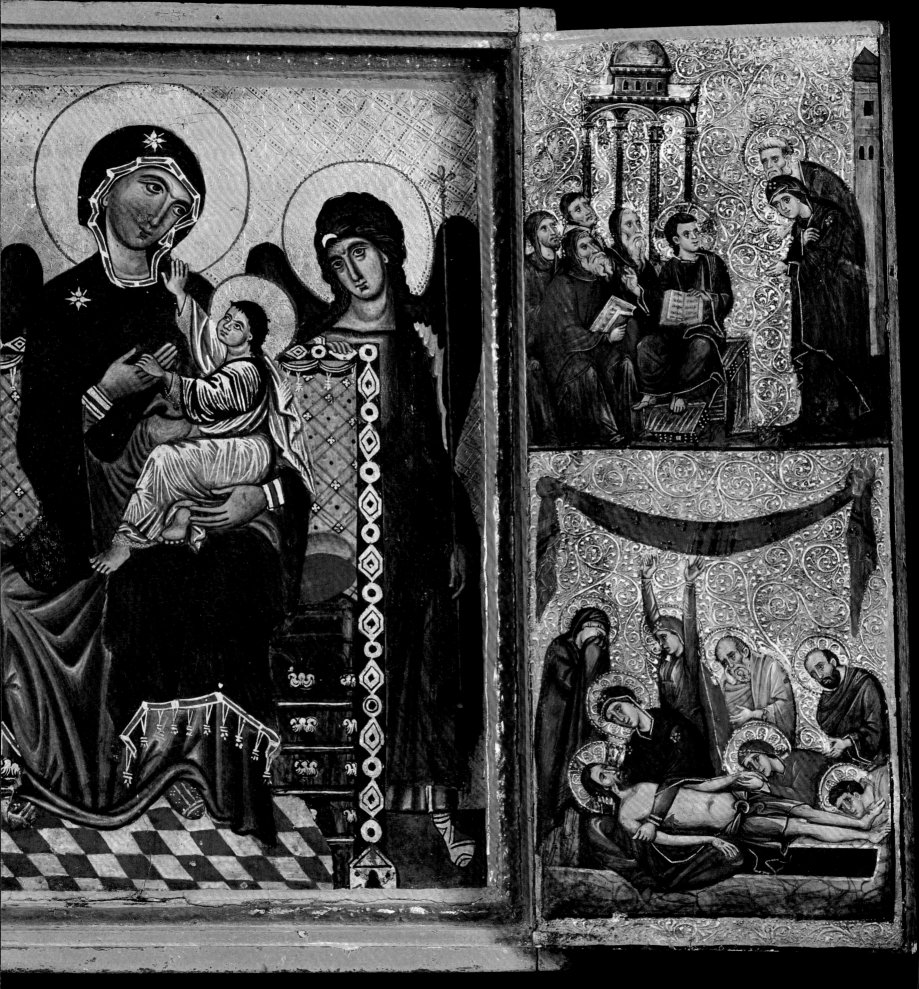

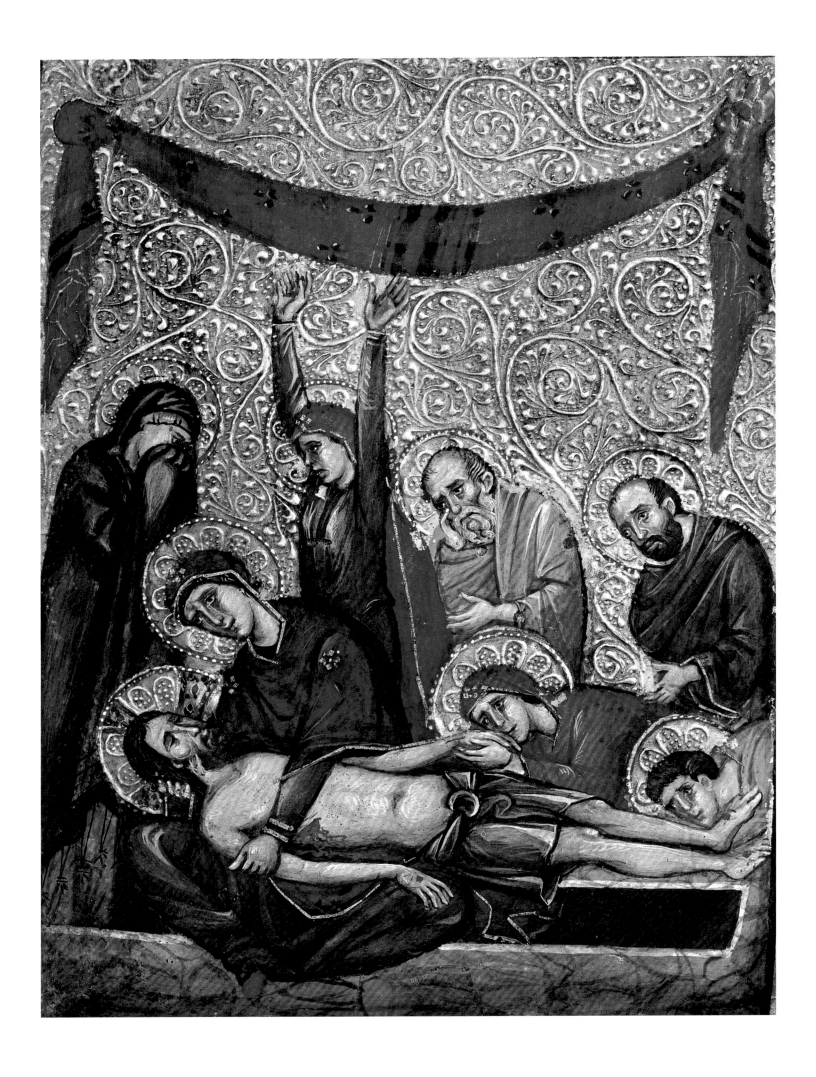

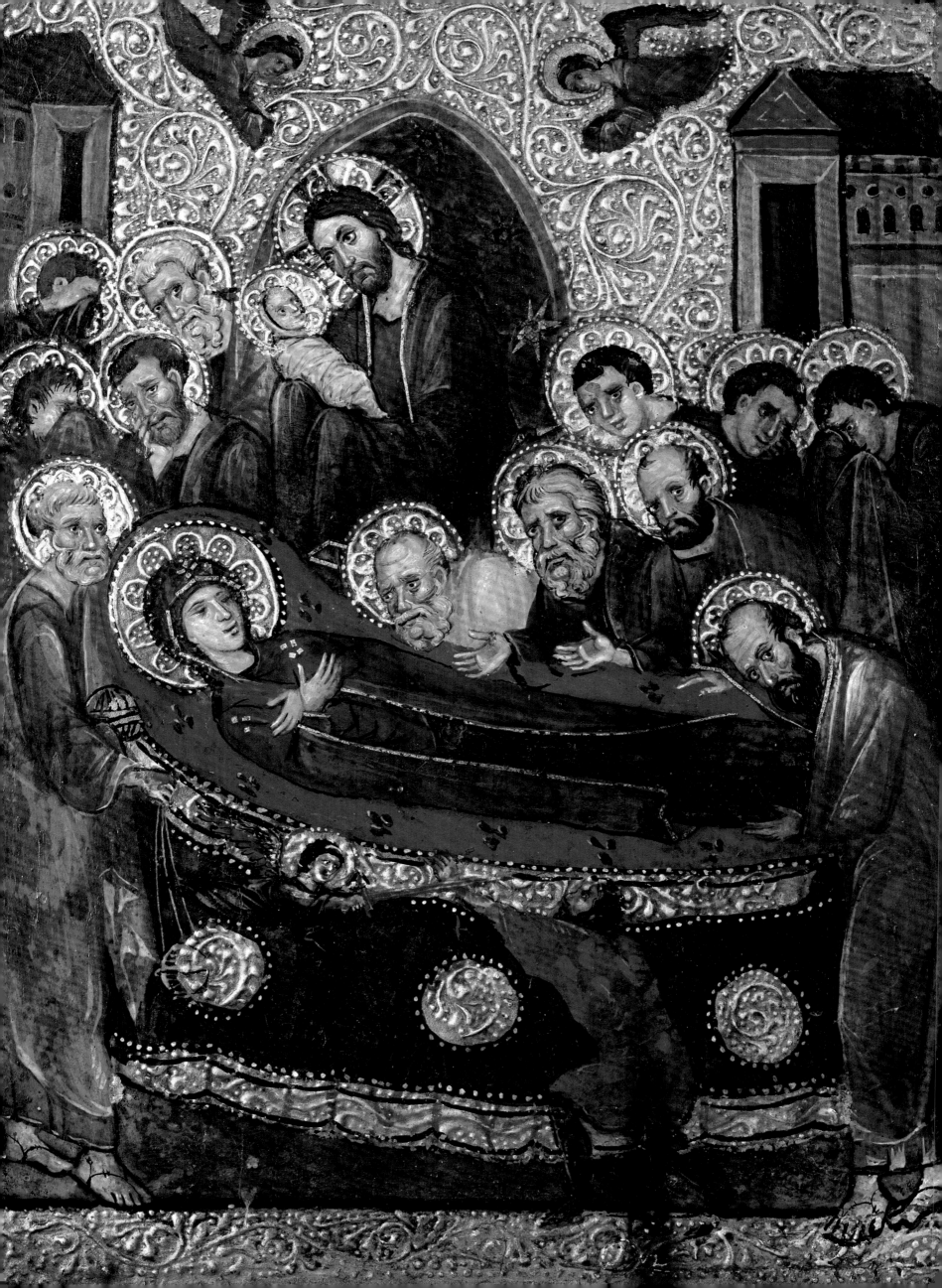

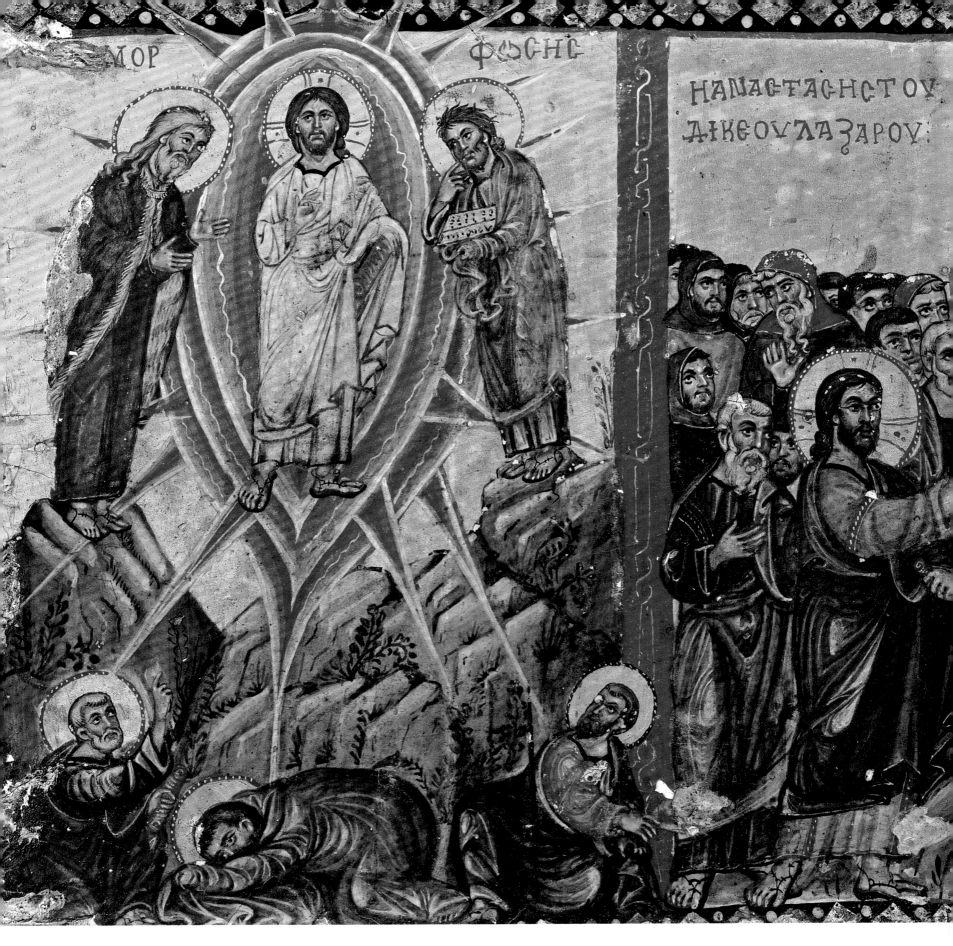

ΜΟΡ ΦΩΣΗΣ

Η ΑΝΑCΤΑCΗC ΤΟΥ
ΔΙΚΕΟΥ ΛΑΖΑΡΟΥ

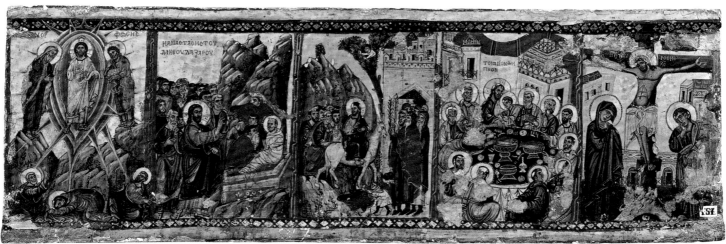

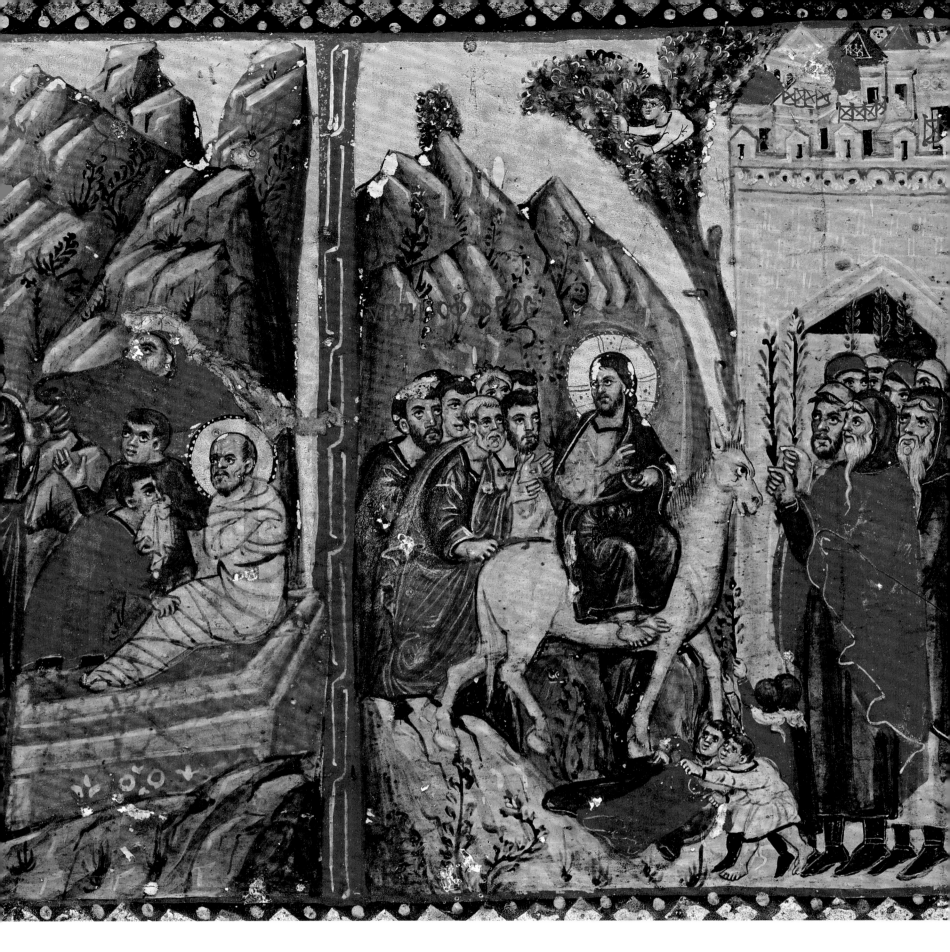

○ *196-197 and 198-199* Beam of a *templon* with liturgical feasts, tempera and gold on wood, 28.9 x 232.4 cm, ca. 1260. The *templon* was the partition in Byzantine churches that separated the sanctuary from the central nave; it evolved into the iconostasis. This decoration in three panels is divided in thirteen scenes that present the twelve great feasts of the Orthodox Church (the *dodekaorton*), which commemorate twelve events in the life of Christ, with the addition of a depiction of the Last Supper.

○ *200-201* Beam of an iconostasis with pointed arches, tempera and gold on support of wood, canvas, and gesso, 43.3 x 168.5 x 6.4 cm, ca. 1280–90. This wooden beam once adorned an iconostasis but was then trimmed off at the ends to be positioned in a small chapel. Christ is at the center, to the side the Virgin and St. John the Baptist. Past the Virgin the sequence of saints continues with Peter, the two evangelists John and Luke, and finally the warrior saint George. On the other side, in a symmetrical array, are St. Paul, the evangelists Matthew and Mark, and the warrior saint Procopius.

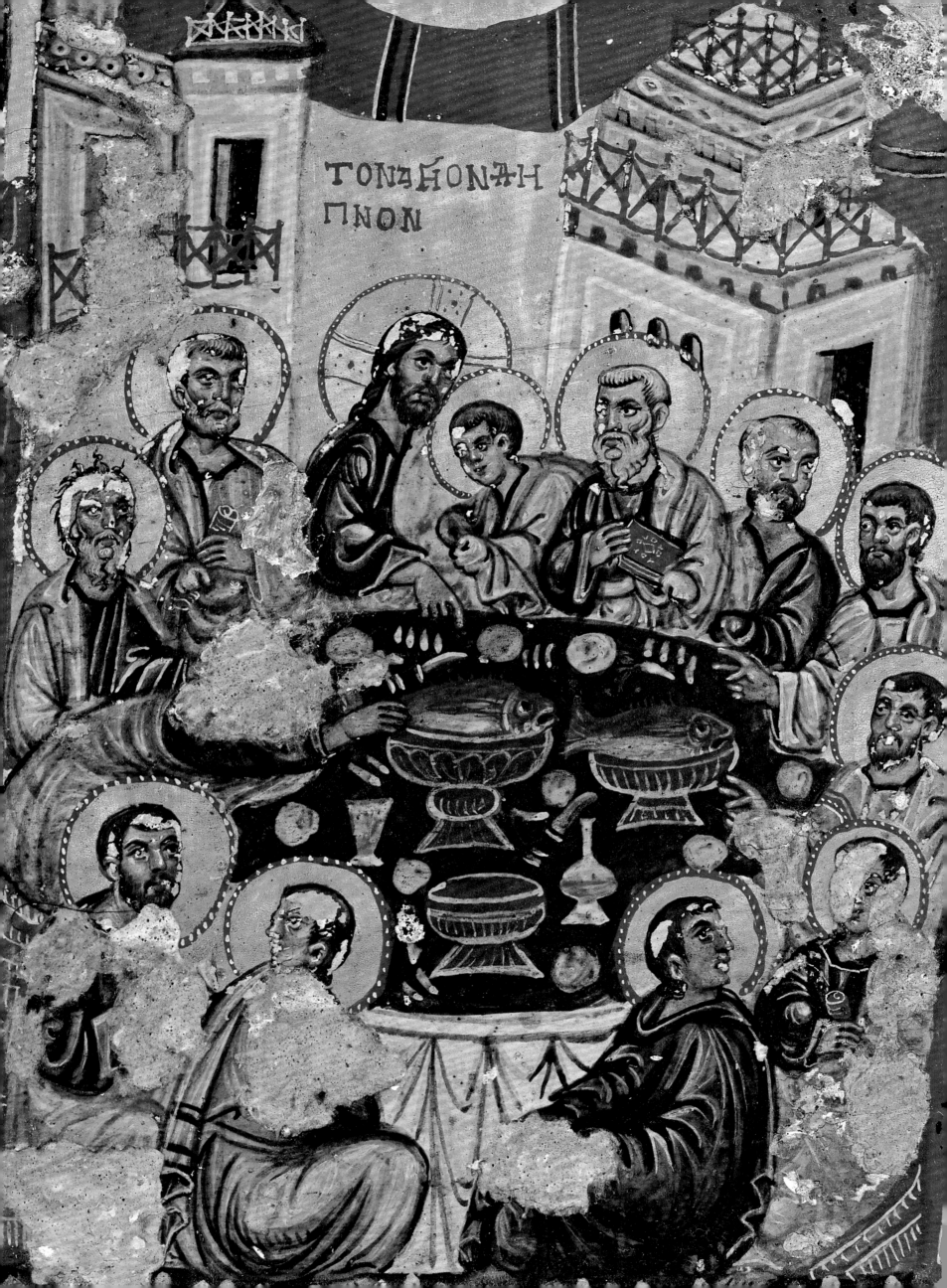

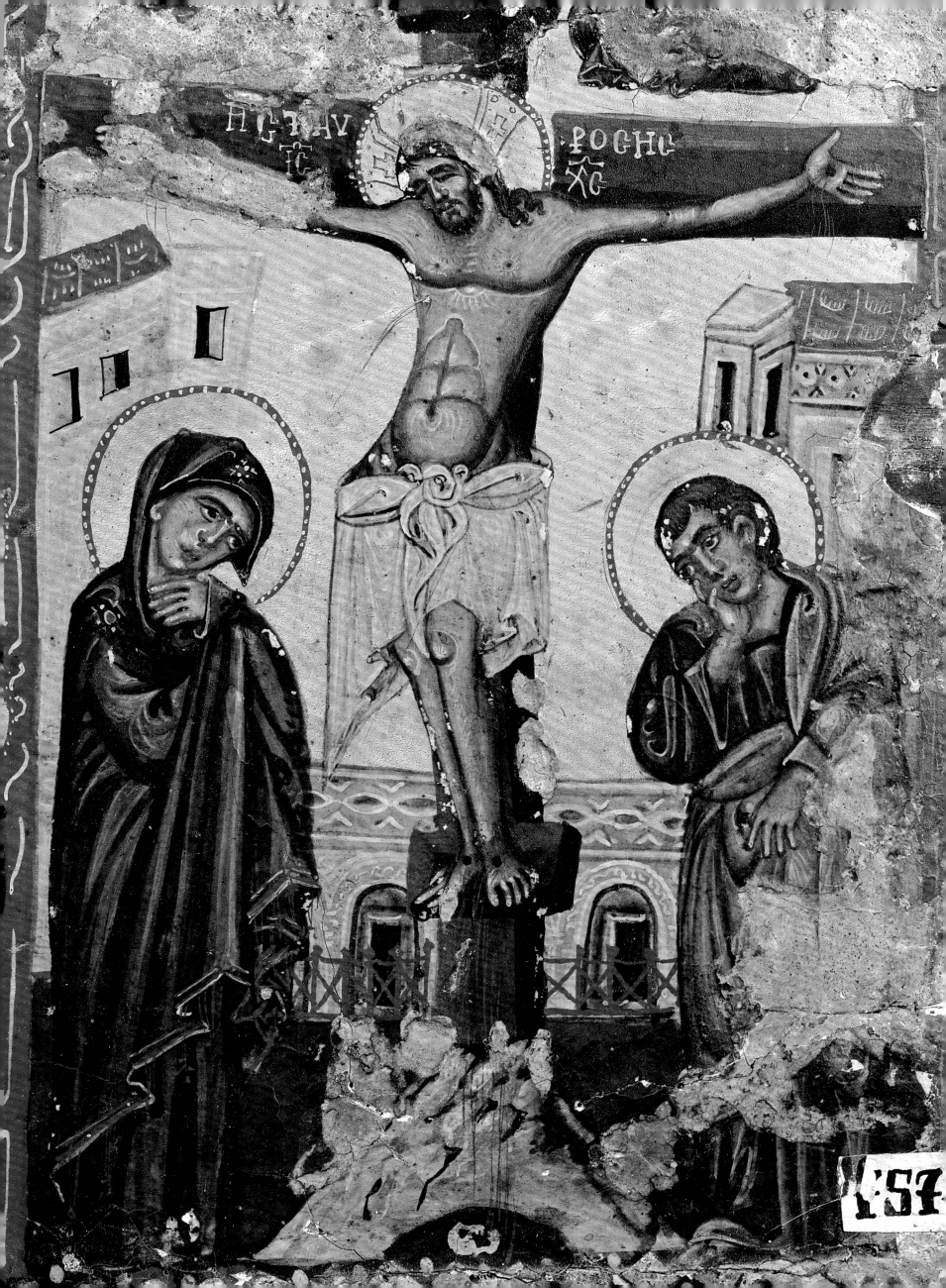

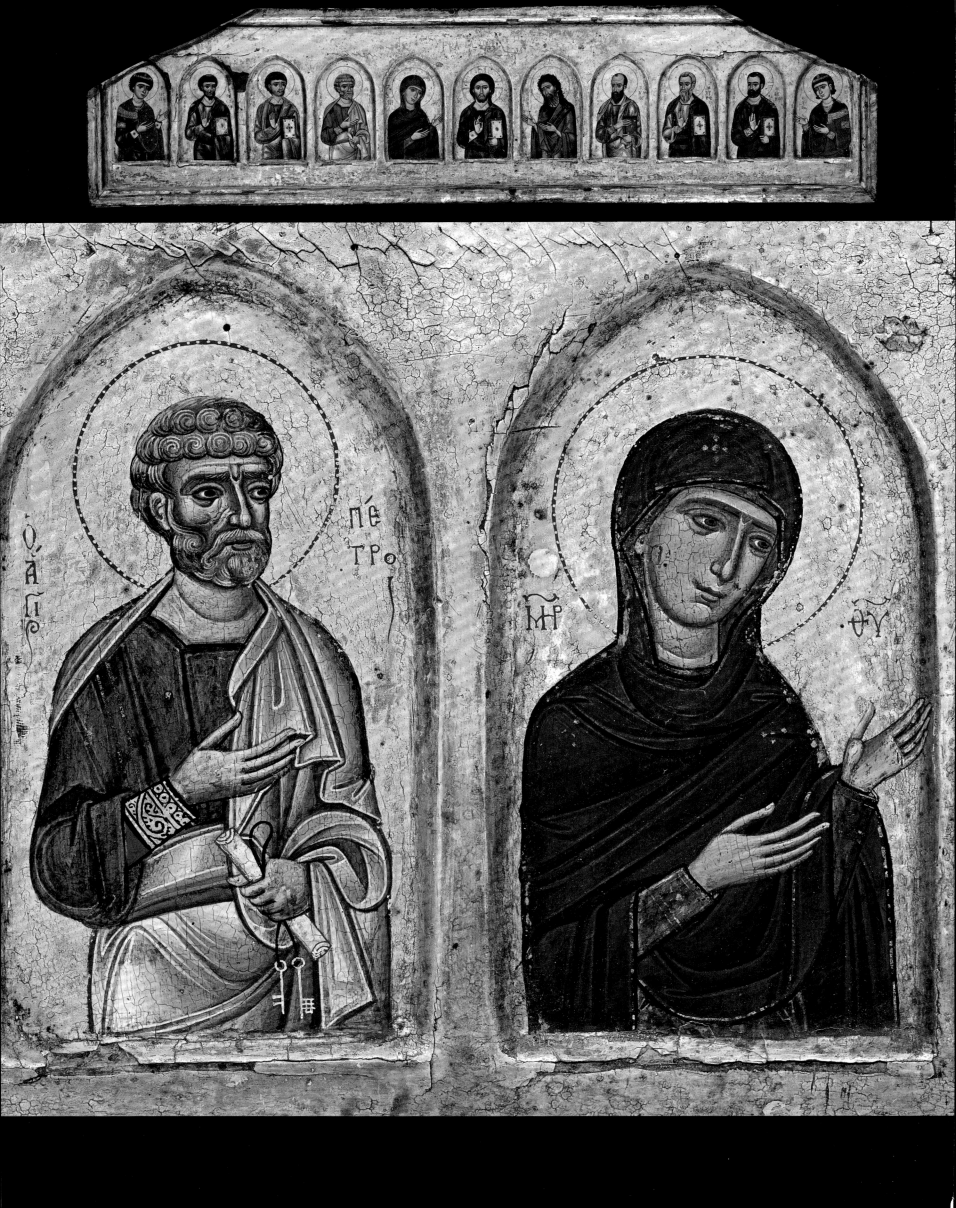

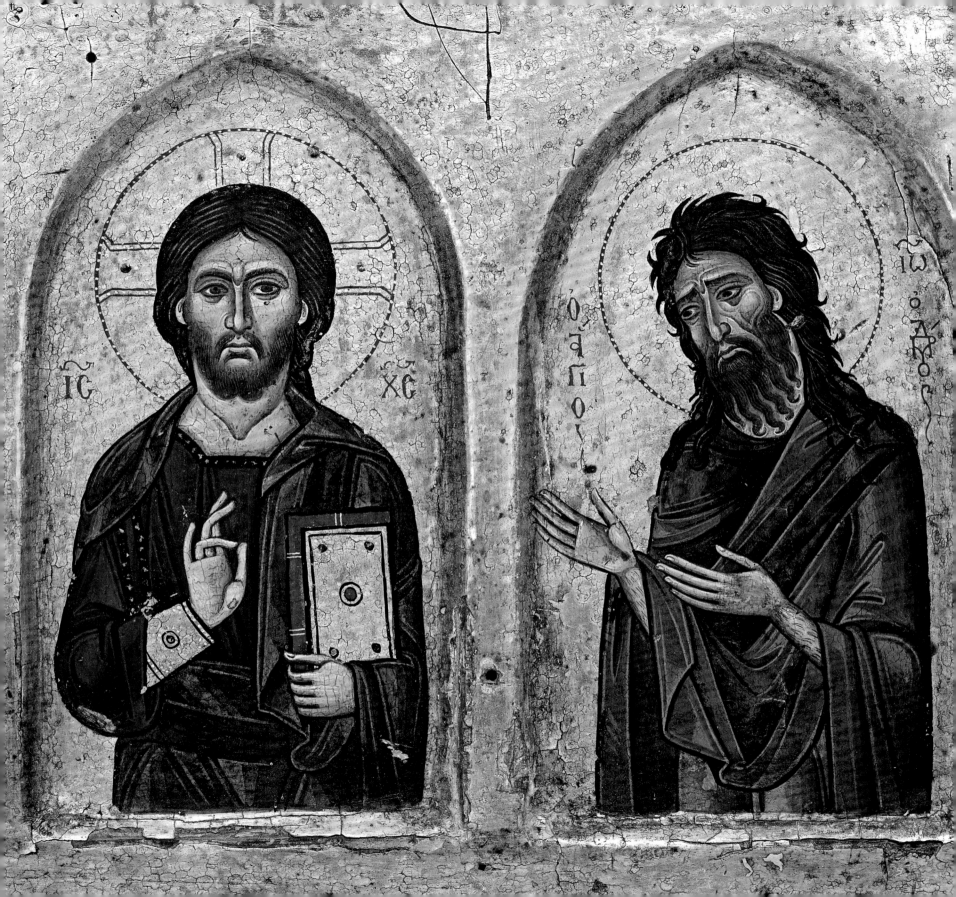

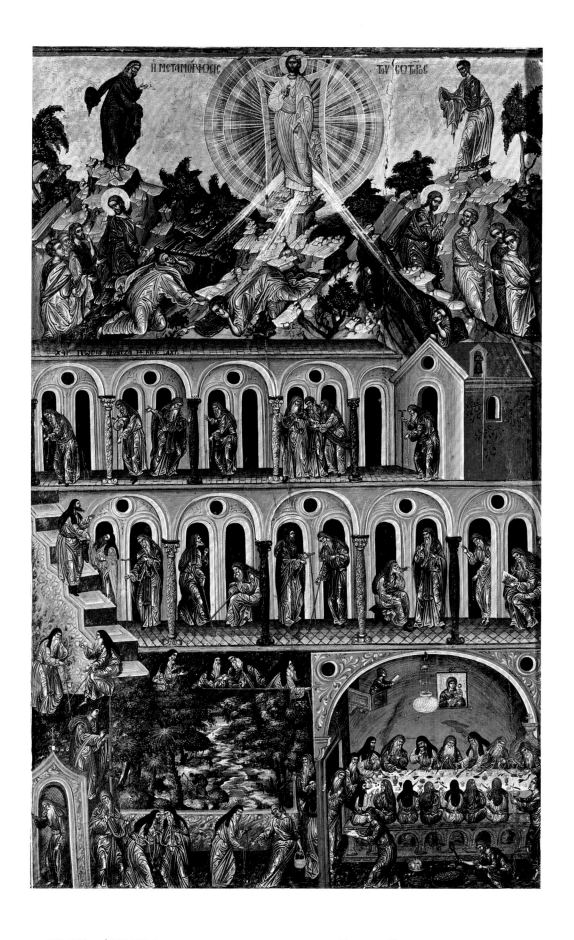

202, 203 and 204-205 Icon with scenes of monastic life, by Georgios Klontzas, tempera on wood, 63 x 39 cm ca. 1603. This icon is in the chapel of the Forty Martyrs of the Sinai. The composition is dominated by a representation of the Transfiguration that is centered on the figure of Christ, wrapped in white robes and surrounded by a halo of blue light. The lower registers present scenes of the life of the monks, which take place in the church, the porticoes, and in the monastery's refectory. The bearded figures in flowing mantles meet for discussions under a double row of arches, along stairs, and finally around a long table illuminated by a lamp hanging from the ceiling, with an overlooking icon of the Virgin and Child.

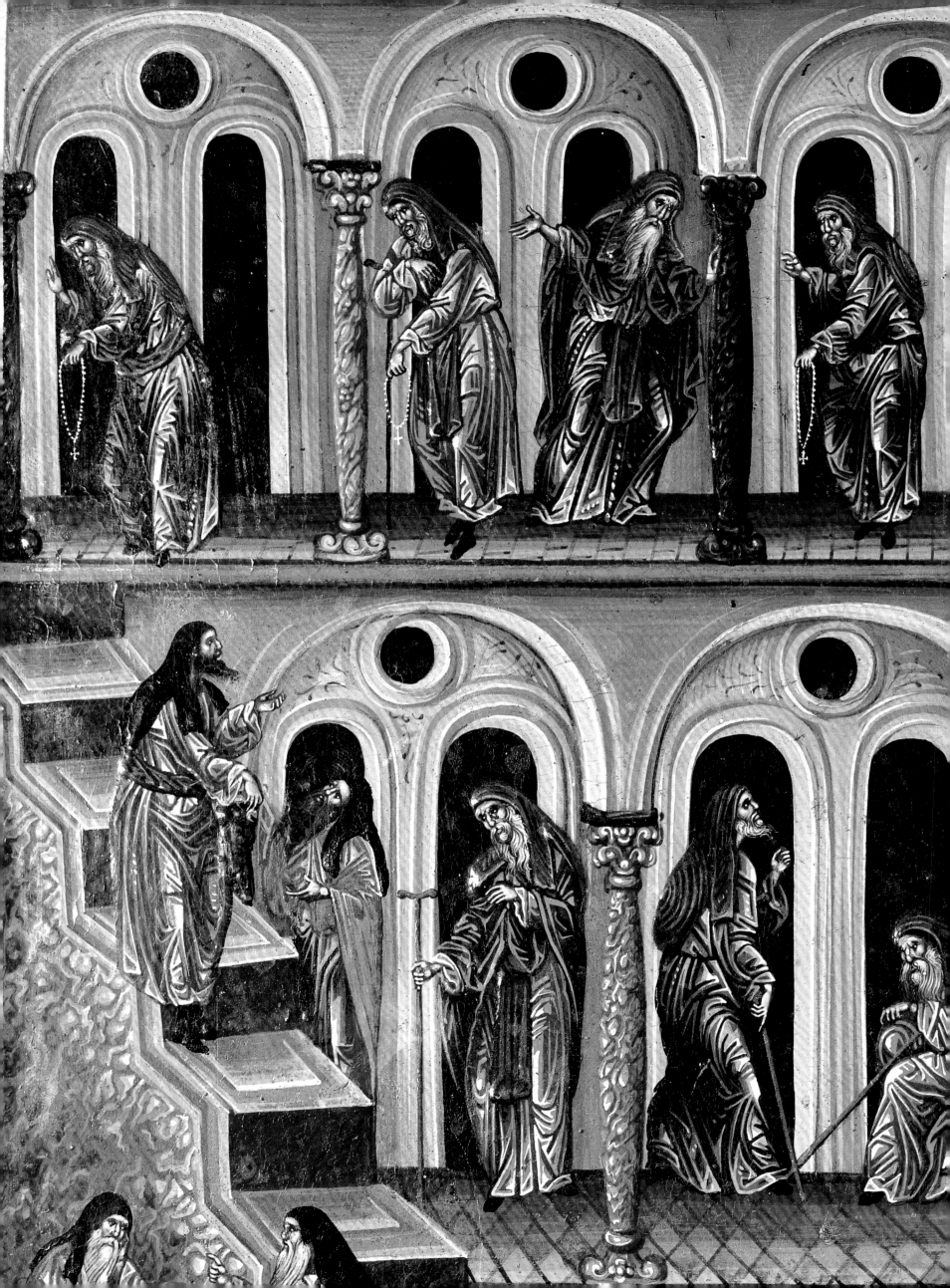

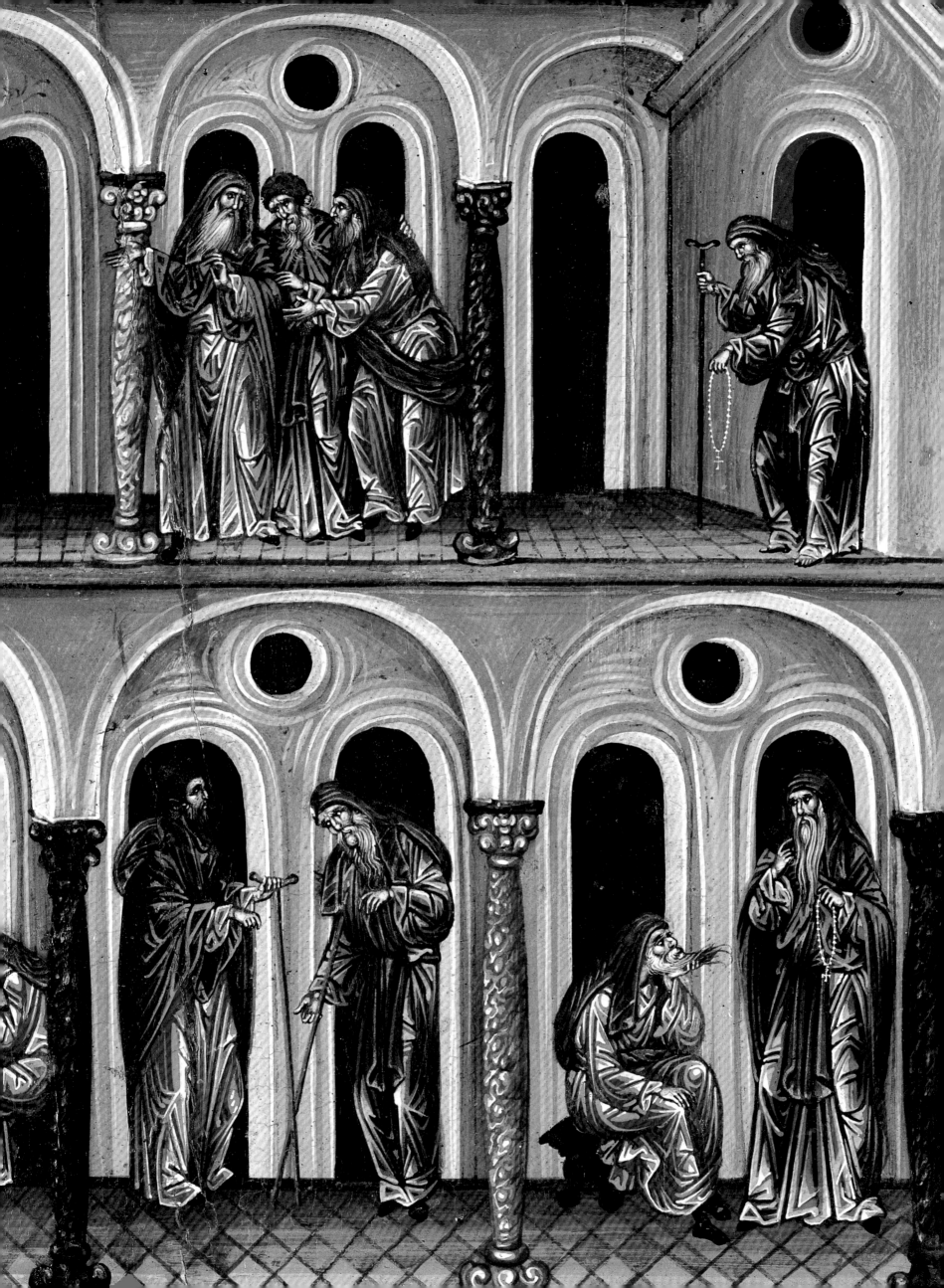

INDEX

PHOTO CREDITS

All photographs are by **Araldo De Luca/Archivio White Star** except the following:

Antonio Attini/Archivio White Star: pages 2-3, 6-7, 8, 18-19, 24, 24-25, 26, 26-27, 28-29, 29, 30-31, 32-33, 33, 34-35, 36 top and bottom, 36-37, 46, 47, 48-49, 50, 50-51, 61 bottom left, 94 bottom, 98-99.

Aisa: pages 62, 94 top.

Archivio Scala Firenze: pages 41, 44.

Akg-images: pages 118, 123.

Marcello Bertinetti/Archivio White Star: pages 14-15, 16-17, 86-87, 110-111, 112-113.

British Library: page 122.

G. Dagli Orti: page 119.

Lessing Archive/Contrasto: pages 42, 43, 62-63.

Francis G. Mayer/Corbis/Contrasto: page 45.

Mary Evans Picture Library: pages 120-121, 121 top and bottom.

Nasa: pages 22-23.

Topham Picturepoint/Double's/ICP: pages 40-41.

Giulio Veggi/Archivio White Star: pages 23, 38-39, 52-53, 56, 56-57, 58-59, 59, 60 top left, right and bottom, 61 top, bottom center and right, 64, 64-65, 66 left and right, 88-89, 89, 90-91, 92-93, 93, 95, 96, 96-97, 99 top and bottom, 100 top and bottom, 101, 102 top and bottom, 103, 110, 114-115, 115, 116, 117 top.

Roger Wood/Corbis/Contrasto: pages 126 top, bottom left and right, 127.

Courtesy of the monks of St. Catherine's Monastery: page 117 bottom.

Illustrations by:

Angelo Colombo/Archivio White Star: pages 65 bottom, 87 bottom.

Cristina Franco/Archivio White Star: page 74 bottom.

WHITE STAR PUBLISHERS

© 2006 White Star S.p.A.
Via Candido Sassone, 22/24
13100 Vercelli, Italy
www.whitestar.it

TRANSLATION: Jay Jaseph Hyams

ISBN 978 88 544 0142 6

Reprints: 2 3 4 5 6 11 10 09 08 07

Printed in Korea
Color separation by Fotomec, Turin

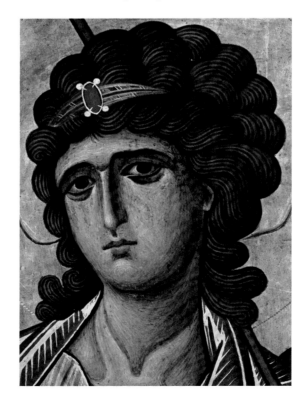